The J. Paul Getty Museum

HANDBOOK OF THE COLLECTIONS

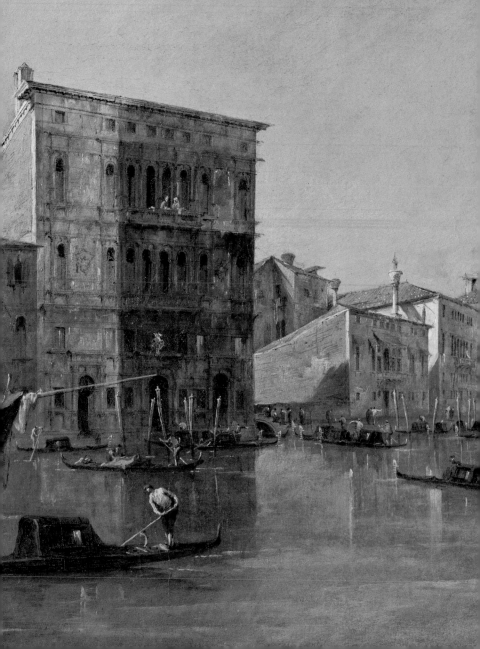

HANDBOOK OF THE COLLECTIONS

The J. Paul Getty Museum

LOS ANGELES

Library of Congress
Cataloging-in-Publication Data

J. Paul Getty Museum.
 The J. Paul Getty Museum
 handbook of the collections.
 — 7th ed.
 p. cm.
 Includes index.
 ISBN-13: 978-0-89236-886-0
 (hardcover)
 ISBN-13: 978-0-89236-887-7
 (pbk.)
 1. J. Paul Getty Museum—
Catalogs. 2. Art—California—
Los Angeles—Catalogs. I. Title.
N582.M25A627 2007
708.194'94—dc22
 2006033432

The Collections

Foreword

I T IS MY GREAT PLEASURE TO PEN THE FOREWORD to the newest edition of the J. Paul Getty Museum's *Handbook of the Collections.* I arrived at the Getty at a historical moment, as the Museum began operating for the first time on two sites simultaneously. The reimagined Getty Villa in Malibu has been inaugurated as the home of the Museum's collection of ancient Greek, Roman, and Etruscan art. There, in a setting masterfully renovated by Machado and Silvetti Associates, the antiquities collection is displayed thematically and contextualized by educational programs based on the latest research in the field. Additional scholarly programs are orchestrated by the Getty Research Institute; also located at the Villa is the first postgraduate program in the conservation of archaeological and ethnographic material, jointly operated by the Getty Conservation Institute and the Cotsen Institute of Archaeology of the University of California, Los Angeles. Meanwhile, the Museum at the Getty Center, opened in 1997, continues to solidify the Getty's position as one of the nation's leading art museums, welcoming well over one million visitors each year with a wide range of experiences, from innovative exhibitions to inspiring programs for families and students, as well as brilliantly installed displays of our permanent collection.

Our collection is at the heart of all that the Museum does. The collection was founded by J. Paul Getty, who, beginning in the 1930s, assembled a modest group of European paintings along with more distinguished holdings of Greek and Roman antiquities and of seventeenth- and eighteenth-century French furniture and decorative arts prior to opening his eponymous Museum in May 1954. Under Mr. Getty's direction and until his death in 1976, the Museum continued to collect in these three key areas.

In the years that followed his death, the magnitude of his bequest —$700 million in Getty Oil stock that, by the time the estate finally was settled in 1982, had grown in value to approximately $1.2 billion—allowed the Museum to transform the scope and quality of its holdings. Under the leadership of John Walsh, director from 1983 to 2000, our collection of paintings, in particular, was gradually converted from an idiosyncratic, small private holding into a public collection of moderate size but great international significance. Within two years of the finalization of Mr. Getty's bequest, the collection also expanded to encompass four new areas: drawings, illuminated manuscripts, sculpture and a broader range of European decorative arts, and photographs. Each of our collections has continued to grow with the selective purchasing of major works of art and a number of very generous donations.

More recently, our collections have expanded to include a significant group of twentieth-century sculpture, generously donated by Fran and Ray Stark. These sculptures are now displayed in the Fran and Ray Stark Sculpture Garden near the lower tram station and in other dramatic sites around the Center. These modern works are complemented by contemporary pieces commissioned by the Museum, among them the large Martin Puryear sculpture *That Profile* (1999), on the Tram Arrival Plaza, and the ever-evolving Central Garden, designed by Robert Irwin. Together with our core holdings of Western art dating back to antiquity, these newer commissions help our visitors begin a dialogue with the art of the present.

Other changes, too, have broadened the scope of what our visitors may now see. The Getty's vast repository of photographs from the invention of the medium to the present is housed in a new suite of galleries in the West Pavilion, called the Center for Photographs. This allows a far greater selection of our permanent collection to be on view and also provides space for special exhibitions that may include loans from other institutions or private collectors. Likewise, the Getty's drawings are now displayed in two galleries in the West Pavilion that provide more than twice the space than the previous gallery. New installations are currently being planned for our collections of medieval and Renaissance sculpture and decorative arts.

The pages that follow contain a selection of the greatest works from our six curatorial areas: antiquities, manuscripts, paintings, drawings, sculpture and decorative arts, and photographs. Each collection area has a short preface, and the reproductions are accompanied by brief commentary by our Museum curators.

I am indebted to my predecessors who have led the Museum since the last edition of the *Handbook* was published—Deborah Gribbon, director from 2000 to 2004, and William Griswold, acting director from 2004 until October 2005—and who further strengthened and improved the collection, and also to the Museum's outstanding curators, who can take credit for the many new acquisitions in this edition. For our visitors, I hope this *Handbook* will serve as a rich souvenir; for those who have yet to visit, I hope it will be an inducement; and for our dedicated, talented family of staff, trustees, docents, and volunteers, may it be a source of pride, as we all continue to pursue the Museum's ambitious mission.

Michael Brand
Director

Introduction

JOHN PAUL GETTY (fig. 1) combined the lives of an oil-field wildcatter, a shrewd and spectacularly successful businessman, a writer, and a member of the international art world. His attitude toward art and collecting was complex. Although he maintained that "fine art is the finest investment," he also felt that "few human activities provide an individual with a greater sense of personal gratification than the assembling of a collection of art objects that appeal to him and that he feels have a true and lasting beauty." When he died on June 6, 1976, at the age of eighty-three, Getty had collected art for more than forty-five years. Collecting was a part of his life that he relished and about which he felt deeply.

Born in Minneapolis in 1892, J. Paul Getty was the only child of George F. Getty, a wealthy attorney-turned-oil tycoon. The son worked summers in the Oklahoma oil fields as a teenager, and after brief stints at the University of Southern California and the University of California, Berkeley, received his diploma in political science and economics at Oxford University in June 1913. After spending the tense early days of World War I in London with his parents, Getty began a trial year of joint ventures in the Oklahoma oil fields with his father. In 1916 he brought in his first producing oil well, becoming a millionaire at age twenty-three. He adopted a pattern of living seven months of the year in Europe and five months in the United States, where he helped make George F. Getty Incorporated, the family oil firm, increasingly profitable. When his father died in 1930, Getty became president. Perhaps as a relief from his business responsibilities, he found his interest in art developing. He read voraciously on the subject and visited museums whenever he could.

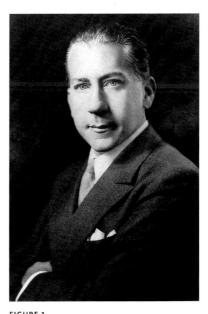

FIGURE 1

The young J. Paul Getty. Photo: University of Southern California, Specialized Libraries & Archival Collections

The United States and Europe were enjoying a period of tremendous prosperity, and great numbers

FIGURE 2

Statue of Hercules
(The Lansdowne Herakles)
Roman (found near Tivoli),
circa A.D. 125.
Marble
H: 193.5 cm (76³/₁₆ in.)
Los Angeles, J. Paul Getty
Museum 70.AA.109

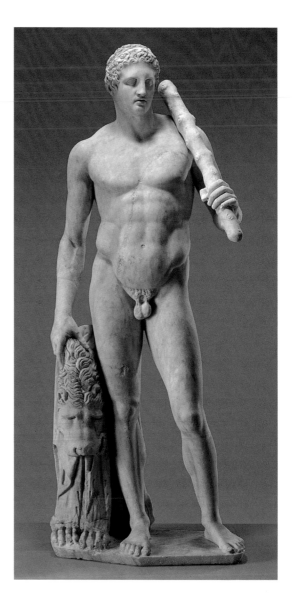

of wealthy collectors—including William Randolph Hearst, the Mellons, and the Rothschilds—bid against each other enthusiastically for anything great that came on the market. Following the panic of 1929 and the Depression, Getty thought the time was right to begin collecting works of art. In March 1931 he purchased his first art object of value—a landscape by the seventeenth-century Dutch painter Jan van Goyen—at auction in Berlin for about $1,100. Two years later he bought ten paintings by the Spanish Impressionist Joaquin Sorolla y Bastida at a New York auction.

Getty was inspired to collect decorative arts after leasing a penthouse in 1936 from a Mrs. Frederick Guest on Sutton Place South in New York that was furnished with French and English eighteenth-century pieces; he

FIGURE 3

Statue of a Female Figure
(The Elgin Kore)
Greek, circa 475 B.C.
Gray marble
71 × 28 × 19 cm
(28 × 11 × 7½ in.)
Los Angeles, J. Paul Getty
Museum 70.AA.114

responded enthusiastically to living with them. He acquired in one stroke the beginnings of a significant collection of French eighteenth-century furniture at the Mortimer Schiff sale in London in June 1938. Among the purchases were a magnificent Savonnerie carpet, a rolltop desk by Bernard Molitor, two tables with Sèvres porcelain plaques by Martin Carlin, and a settee with four chairs by Jacques-Jean-Baptiste Tilliard fils.

In succeeding months Getty bought a large number of paintings, the start of the Museum's collection. World War II temporarily curtailed his collecting, however. He threw his energies into expanding and running the Spartan Aircraft Corporation in Tulsa, manufacturing aircraft and training pilots. By 1947 Getty was back in Europe, living in hotel rooms and negotiating deals with the burgeoning European oil market and for the development of oil fields in North Africa and Arabia. A fully integrated worldwide oil network—producing, transporting, refining, and marketing—soon made Getty's company a strong competitor to the giants of the oil world.

Getty's avocation continued to be art. He visited museums, archaeological sites, and art dealers, recording in his diary works of art that impressed him—and often their prices. In the early 1950s he made his first important purchases of antiquities: the life-size marble Lansdowne Herakles (fig. 2); three sculptures from the Earl of Elgin's collection at Broomhall, including a Kore (fig. 3); and the fifth-century-B.C. Cottenham Relief. Greek

FIGURE 4

Antiquities gallery in the Ranch House, circa 1965. Photo: JPGM Archives

and Roman sculpture was to be a continuing passion for Getty; the Herakles remained a personal favorite until the end of his life.

In the early 1950s, colleagues, notably Norris Bramlett, persuaded Getty to establish a museum in his own name. The ranch he had purchased in Los Angeles in 1945 seemed an ideal location. He executed a trust indenture in late 1953, the only document in which he specified how his money was to be used; it authorized the creation of a "museum, gallery of art and library" and stated the purpose of the trust simply as "the diffusion of artistic and general knowledge."

The original J. Paul Getty Museum, located in the Ranch House on Getty's Malibu property, was opened to the public in May 1954 (fig. 4). Although he continued to buy works of art for his private residences, the best pieces began to appear in the Museum, which also acquired a small staff. In the mid-1950s Getty actively built his three collections—paintings, decorative arts, and antiquities. Influenced by the great art connoisseur Bernard Berenson, Getty began to acquire Italian Renaissance pictures to add to his Dutch and English paintings. His thoughts on art and the art market at this time are expressed in *Collector's Choice*, a book he wrote with Ethel LeVane in 1955. His approach to collecting was a simple one: "I buy the things I like—and I like the things I buy—the true collector's guiding philosophy."

For the last thirty years of his life, Getty lived at Sutton Place, a manor house twenty-five miles southwest of London built in 1521–26 by one of Henry VIII's courtiers that was purchased by Getty Oil to be its international headquarters. He continued to acquire art. One major purchase was the Rembrandt *Saint Bartholomew* (see pp. 112–13), in 1962.

FIGURE 5

Outdoor Theater. View looking toward the refurbished Ranch House, 2006. Photo: Richard Ross

By 1967 he had resumed buying at auctions. His interest in the Getty Museum also revived, and in the ensuing years he earmarked large sums for the purchase of works of art, notably the portrait of Agostino Pallavicini by Anthony van Dyck (see p. 109).

Gradually Getty developed the idea of building a major art museum that he could leave as a gift to the people of Los Angeles. One evening at Sutton Place in 1968 he announced to some guests that he wished to build an accurate re-creation of the Villa dei Papiri in Herculaneum on the ranch property. Ground was broken in December 1970. During construction Getty and the trustees realized that the new building would provide an increase in gallery space. From 1970 to 1974, they purchased numerous works of art and enlarged the professional staff.

The new J. Paul Getty Museum building opened its doors to the public in January 1974 (fig. 5). Greek and Roman art set the tone because of the architecture and gardens, and the main floor was devoted to antiquities, with decorative arts and paintings occupying the second floor. At his death in June 1976, Getty bequeathed four million shares of Getty Oil stock, worth about $700 million, to his Museum, leaving it to the trustees' discretion to decide how the legacy should best be used.

Early in 1981 the trustees appointed Harold M. Williams, chairman of the Securities and Exchange Commission during the Carter administration, to be president and chief executive officer of the J. Paul Getty Trust. In April 1982, with the receipt of the proceeds of Getty's estate, the Trust began to prepare for its transformation from a small museum into a visual arts institution of international significance. Williams and the trustees moved to set up organizations that could operate in tandem with the Getty Museum

FIGURE 6
The Getty Center complex, 2007. Photo: Richard Ross

in furtherance of Getty's mandate for "the diffusion of artistic and general knowledge." They created an art research library and new programs dedicated to advanced scholarship in the arts and humanities, and to conservation and cultural heritage preservation. They also established a grant program to support a range of projects and publications across the entire spectrum of interests of the Getty Trust.

The opportunity to expand the Museum's collections dramatically with the income from Getty's legacy and the space requirements of the new programs of the Trust suggested that a new building be constructed elsewhere, allowing the original building in Malibu to house the Museum's antiquities collection. Williams and the trustees envisioned a complex similar to a university campus where all the Getty organizations would be together, a place where the many approaches to art—display, scholarship, conservation, education—could flourish, and where new forms of collaboration would come naturally. A dramatic, 750-acre spur of the Santa Monica Mountains in west Los Angeles was purchased in 1983, and plans for the Getty Center were set in motion. John Walsh, who had been a paintings curator at the Metropolitan Museum of Art and the Museum of Fine Arts, Boston, as well as a university professor, became the director of the Getty Museum in 1983. In October 1984, after a lengthy selection process, the trustees named Richard Meier of New York the project architect.

The Getty Center, whose construction began in 1989 after six years of planning, opened to the public in December 1997 (fig. 6). Since that time,

more than twelve million people have visited the spectacular new Center. Harold Williams retired in January 1998, just weeks after the official opening. He was succeeded by Barry Munitz, former chancellor of the California State University system. The Getty embarked on a number of exciting changes under Munitz's leadership, including actively pursuing opportunities for partnerships. He resigned in 2006.

John Walsh retired in the fall of 2000. During his excellent tenure, all the Museum's collections grew substantially and three new departments were formed, those of photographs, European sculpture, and illuminated manuscripts. His legacy is especially evident in the Museum's paintings collection, however, which now includes many masterpieces. He was succeeded by longtime associate director and chief curator Deborah Gribbon, formerly chief curator of the Gardner Museum, Boston. Gribbon left the Getty in late 2004. After an international search for a new director, Australian-born Michael Brand, director of the Virginia Museum of Fine Arts, was chosen to head the Museum in the autumn of 2005.

The renovated Getty Museum at the Getty Villa and its gardens in Malibu, which began welcoming visitors to a world of new discoveries in early 2006, now houses the Getty Museum's Greek, Roman, and Etruscan antiquities collection. For those who work at the Getty Center and the Getty Villa, J. Paul Getty's legacy has brought the professional adventure of a lifetime. For the Museum's visitors it will go on furnishing new surprises, pleasures, and rewards.

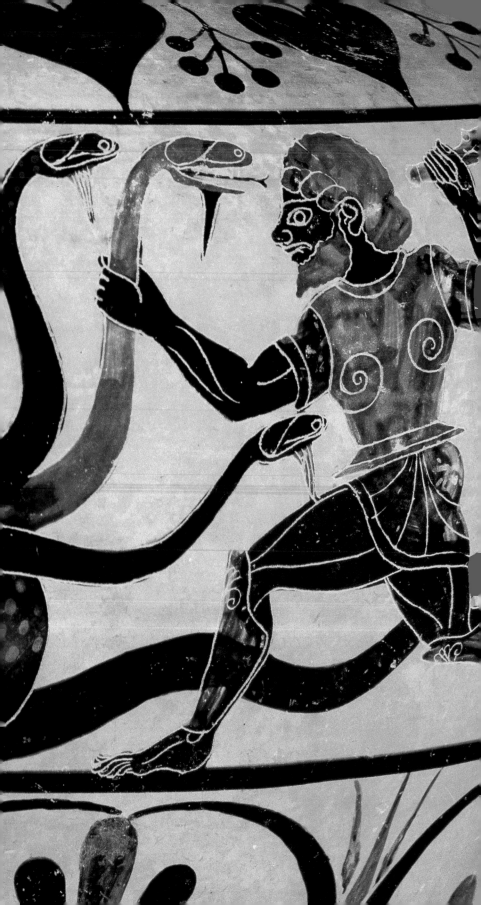

Antiquities

THE MUSEUM'S ANTIQUITIES collection began with J. Paul Getty's purchase of a small terracotta sculpture at a Sotheby's auction in London in 1939. The thirty-eight years that passed between that time and his last direct acquisition, a marble head of a Roman youth, witnessed the creation of a collection of ancient Greek, Roman, and Etruscan art that was the third most important of its kind in the United States.

For many years the collection's greatest strength was in sculpture. It was the heart of the antiquities collection when Getty was alive, and many of the Museum's most interesting examples of ancient sculpture, including a portrait of Alexander the Great and the head of a young woman from a grave monument (see p. 5), were acquired under Getty's personal direction.

In the years since his death, the collection has continued to grow. Several major acquisitions of Greek and Roman sculpture have been made, including the Victorious Youth (see pp. 16–17) and the Achilles sarcophagus (see p. 10). Other additions have included several Cycladic marble sculptures of the Aegean Bronze Age (see pp. 3–4) and the Portrait of a Bearded Man from the Hellenistic period (see p. 6).

Important acquisitions have also been made in other areas—for example, the collection of vases, which has grown to be one of the department's strongest holdings, featuring such masterpieces as the footed *dinos* attributed to the Syleus Painter (see p. 32) and the "Chalcidian" neck *amphora* attributed to the Inscription Painter (see p. 27). Other noteworthy acquisitions have been made in the areas of Roman bronze sculpture, ancient gems, and such luxury wares as Hellenistic and Roman gold and silver. The most recent and substantial additions have been the important collection of Lawrence and Barbara Fleischman—consisting of some three hundred objects made in a variety of media and ranging in date from the Bronze Age to late antiquity—and more than three hundred and fifty striking pieces of ancient glass from the collection of Erwin Oppenländer. The scope of the Museum's collection has also been extended to include fine examples of Romano-Egyptian portrait painting and cast bronzes from Northern Europe, but its focus has been and will continue to be art of the Classical period.

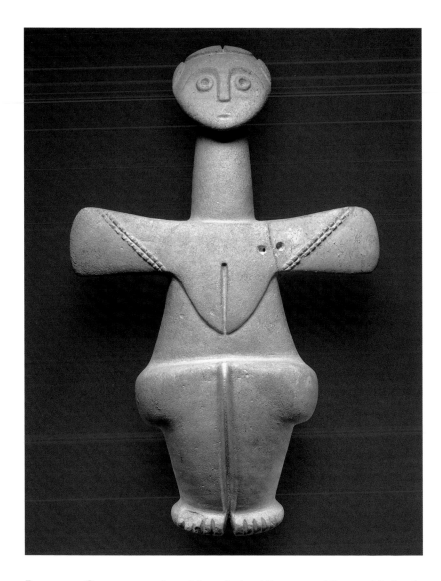

FERTILITY GODDESS

Cypriot (made in Cyprus),
3000–2500 B.C.
Limestone
39.1 × 26 × 8.9 cm
(15³⁄₈ × 10¹⁄₄ × 3¹⁄₂ in.)
83.AA.38

Carved from the local limestone of Cyprus, this female figurine is one of the largest and most imposing sculptures from the Chalcolithic period (ca. 3900–2500 B.C.). Although the symbolic significance of its cruciform shape is unknown to us, the various elements of the figure stress fertility. With head raised, arms extended, and legs drawn up, the figure appears to be squatting, perhaps giving birth, and the configuration of the breasts implies female genitalia. Holes drilled in the left shoulder and arm are part of an ancient repair, attesting to the figure's importance. The detailed rendering of the face further highlights its uniqueness among the earliest sculpted objects of artistic importance from the eastern Mediterranean area.

HEAD OF A FIGURE OF THE EARLY SPEDOS TYPE

Greek (made in the
Cyclades), 2600–2500 B.C.
Marble with pigment
22.8 × 8.9 × 6.4 cm
(9 × 3½ × 2½ in.)
96.AA.27

This head from a figure is rare in that it is almost
life-size, but its features follow the abstract sim-
plicity that is typical of statues fashioned in the Early
Bronze Age (ca. 3000–2200 B.C.) on the Greek islands
known as the Cyclades. The piece also preserves
much of the colorful detailing that most likely deco-
rated all Cycladic sculpture: a fringe of hair across the
brow, dotted tattooing on the cheekbones, and a
stripe along the bridge of the nose. Such finely carved
figures have been found throughout the Aegean.

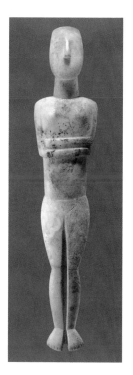

FEMALE FIGURE OF THE LATE SPEDOS TYPE

Greek (made in the
Cyclades), 2500–2400 B.C.
Marble
H: 59.9 cm (23⁹⁄₁₆ in.)
88.AA.80

Female statuettes of this kind have been found in both
burial sites and sanctuaries on the Cycladic islands,
although their exact purpose remains unknown. This
piece belongs to the best-known and most common
type, reclining with folded arms. The details of
the human body are reduced to a minimum, and the
figure is a flattened, schematic representation that
approaches pure abstraction. Incisions delineate the
arms, separate the thighs, and define the abdomen
and pubic triangle. The feet are bent forward in such
a way that the figure cannot stand. Many statuettes
originally were enhanced with brightly colored
pigments that accentuated anatomical features and
decorative markings.

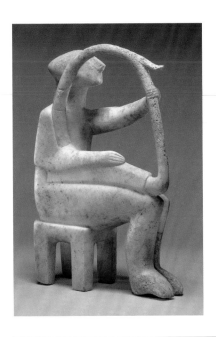

HARPIST

Greek (made in the
Cyclades), circa 2500 B.C.
Marble
35.8 × 9.5 cm (14⅛ × 3¹¹/₁₆ in.)
85.AA.103

This seated harpist, with head raised
as if singing, is the sole male Cycladic
figure in the Museum's collection,
and one of only ten harpists known.
The original purpose of the figure is
unknown. Such sculptures may have
been created as protective images
that accompanied their owners to the
grave. Originally, the visual impact of
the statuette would have been quite
different, because the figure's eyes and
hair were added in paint.

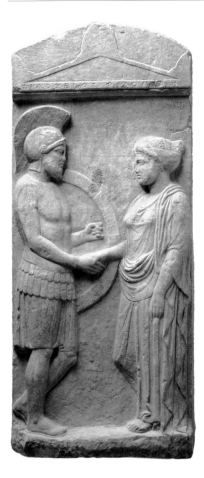

GRAVE *STELE* OF PHILOXENOS WITH HIS WIFE, PHILOUMENE

Greek (made in Attika),
circa 400 B.C.
Marble
102.2 × 44.5 cm
(40¼ × 17½ in.)
83.AA.378

Philoxenos, wearing the armor and
shield of a warrior, solemnly shakes
hands with his wife, Philoumene,
on this *stele* (gravestone). The names
of the couple are carved above their
heads, and both figures were origi-
nally elaborated with painted details.
The handshake was a symbolic and
popular gesture on gravestones of
the Classical period. It could represent
a simple farewell, a reunion in the
afterlife, or a continuing connection
between the deceased and the living.
Their calm, expressionless faces
reproduce the idealized features and
detachment that prevailed in the
sculptural style of Athens and its sur-
rounding region, Attika, at this time.

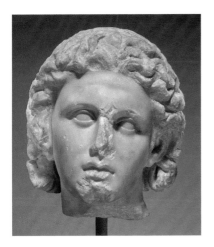

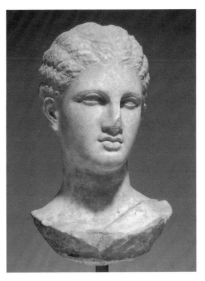

PORTRAIT OF ALEXANDER THE GREAT

Greek, circa 320 B.C.
Marble
H: 29.1 × 25.9 × 27.5 cm
(11¹/₂ × 10³/₁₆ × 10¹³/₁₆ in.)
73.AA.27

Identifiable by the manelike, swept-back hair and the deep-set, upturned eyes, this head is a portrait of Alexander the Great (r. 336–323 B.C.). Alexander was the first Greek ruler to understand and exploit the propagandistic power of portraiture. This portrait type was created by Lysippos, the only sculptor permitted by Alexander to depict him during his short life. It combines elements of the conqueror's actual appearance with ideal representations of gods and heroes. The head belongs to a statue that was probably part of a commemorative monument composed of several figures, including Alexander's companion, Hephaistion. The ensemble is likely to have served a votive or commemorative function, possibly even as an elaborate funerary monument.

HEAD OF A YOUNG WOMAN FROM A GRAVE MONUMENT

Greek (made in Attika),
circa 320 B.C.
Marble
34.3 × 15.6 × 22.2 cm
(13¹/₂ × 6¹/₈ × 8³/₄ in.)
56.AA.19

This life-size head of a beautiful young woman was carved to fit into the neck cavity of a full-length statue. A flat area on the back of the head indicates that the figure was originally placed within a roofed, three-sided structure called a *naiskos*, where the head rested against the back panel.

Her hair is styled in what is known as a "melon coiffure," because of its resemblance to a lobed melon. This distinctive hairstyle was introduced by Athenian sculptors in the second half of the fourth century and was used by, among others, Praxiteles (active 375–340 B.C.) and Silanion (active 360–320 B.C.). It seems to symbolize vigorous youthfulness and can be seen on figures of Muses and the virgin goddess Artemis. On funerary figures, the hairstyle emphasizes the community's loss of a young woman of child-bearing age.

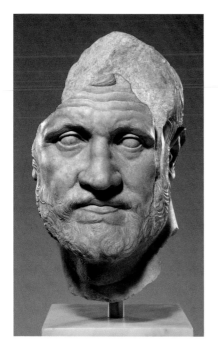

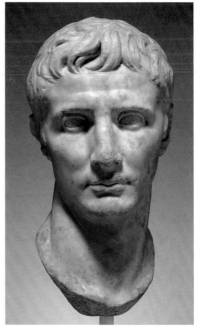

PORTRAIT OF A BEARDED MAN

Greek, circa 150 B.C.
Marble
40.7 × 25 cm (16¹/₁₆ × 9⁷/₈ in.)
91.AA.14

This portrait head is all that remains of a larger-than-life-size, full-length statue. The furrowed brow and an intense gaze distinguish the sitter, whose irregular nose, square jaw, and folds between cheeks and mouth seem to capture his individual character. Still, his identity cannot be determined with certainty. Stylistically, the head relates to sculpture produced at Pergamon, a Greek kingdom on the west coast of modern Turkey, ruled by the Attalid dynasty. The subject of this portrait may have been a high-ranking member of the family, perhaps even Attalos II (r. 158–138 B.C.), portrayed without a diadem, shortly before he became king. Traces of a cloak remain on the back of the neck.

PORTRAIT OF AUGUSTUS

Roman, circa A.D. 50
Marble
H: 39 cm (15³/₈ in.)
78.AA.261

The adopted son of Julius Caesar, Augustus became Rome's first emperor in 27 B.C., bringing a golden age of peace, prosperity, and expansion. Augustus used art to validate his claim to power, and his portraits were erected throughout the empire. Here, he is depicted as youthful and heroic, recalling Classical Greek sculpture from the fifth century B.C. His face is smooth and idealized, and his hairstyle is distinguished by comma-shaped locks that form a pincer at the center of his forehead. The wide-open eyes and concave temples of this portrait, however, are more consistent with images of the emperor Caligula (r. A.D. 37–41), suggesting that this portrait may have originally been an image of Caligula that was later recarved to depict Augustus.

STATUE OF A POURING SATYR

Roman (excavated at Castel
Gandolfo), A.D. 81–96
Marble
H: 165 cm (64¹⁵/₁₆ in.)
2002.34

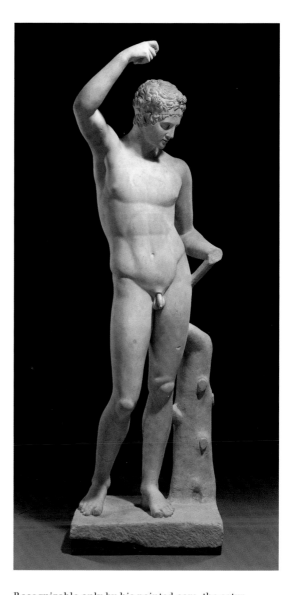

Recognizable only by his pointed ears, the satyr—
traditionally a wild, lusty companion of the wine god
Dionysos—is shown here as a civilized adolescent.
Originally, he was pouring wine from a jug into a
cup that he held in his left hand (both jug and cup are
now lost). The figure is a Roman version of a statue
by the Greek sculptor Praxiteles (active 375–340 B.C.),
who created the first large-scale depiction of a satyr
about 370 B.C. Found with three identical but better-
preserved statues in the villa of the emperor Domitian
(r. A.D. 81–96) at Castel Gandolfo, this nude figure's
head and right hand were carefully restored by a
seventeenth-century Italian sculptor, probably
Ercole Boselli.

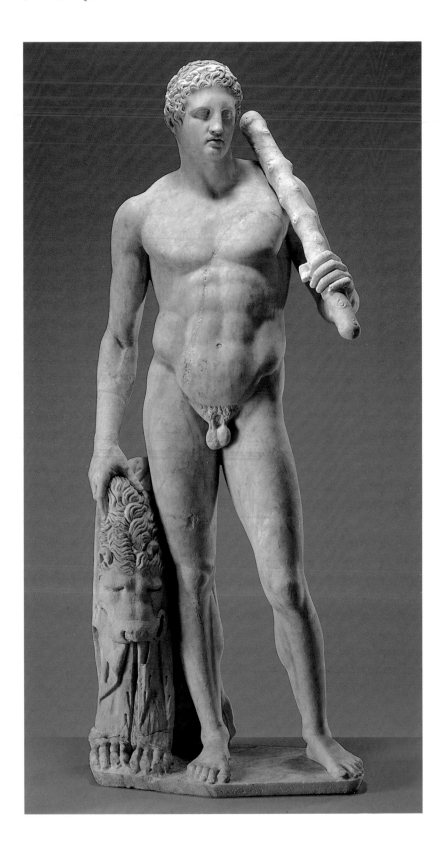

PORTRAIT BUST OF A WOMAN

Roman, A.D. 150–60
Marble
H: 67.5 cm (26⁹/₁₆ in.)
83.AA.44

This beautiful, highly polished portrait of an unidentified Roman lady, carved from a single block of marble, presents many clues about the sitter's status and the sculpture's date. The elaborate coiffure, with a braided bun atop the head, is carved in the fashion of Faustina the Elder, wife of Emperor Antoninus Pius (r. A.D. 138–61). The undulating waves of hair surrounding the face were typical of portraits of their daughter, Faustina the Younger. This woman wears a *stola* (loose-fitting tunic) fastened by a circular brooch on the right shoulder, and a *palla* (rectangular shawl). The bust may have been placed in a house as part of a shrine, or it may have been incorporated into a tomb.

STATUE OF HERCULES (THE LANSDOWNE HERAKLES)

Roman (found near Tivoli), circa A.D. 125
Marble
H: 193.5 cm (76³/₁₆ in.)
70.AA.109

The young Hercules, son of Jupiter and a mortal woman, Alcmene, appears larger than life, carrying his club and the skin of the Nemean lion. Although this statue was carved in a Roman workshop in the second century A.D., it was probably modeled on a now-lost bronze figure produced by the followers of the Greek sculptor Polykleitos in the 300s B.C. Found in 1790 near the ruins of the villa at Tivoli of the emperor Hadrian (r. A.D. 117–38), it was restored in Rome and sold to the English marquess of Lansdowne. The statue was acquired in 1951 by J. Paul Getty, who considered it one of his favorite pieces. It inspired him to build his Museum in Malibu in the style of an ancient Roman villa.

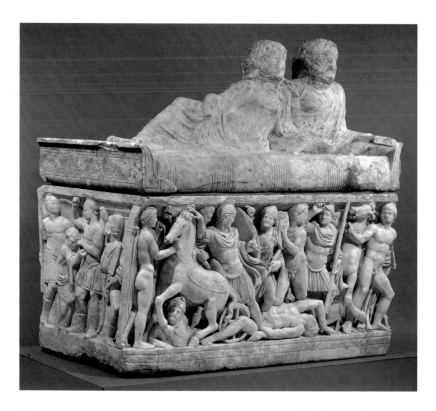

Sarcophagus with Lid

Roman (made in Athens),
A.D. 180–220
Marble
H (total): 234 cm (92⅛ in.)
Box: 134 × 211 × 147 cm
(52¾ × 83¹/₁₆ × 57⅞ in.)
Lid: 100 × 218 × 95 cm
(39⅜ × 85⅞ × 37³/₈ in.)
95.AA.80

Scenes from the legend of Achilles, the greatest Greek hero of the Trojan War and a central figure in Homer's *Iliad*, are carved in high relief on three sides of the box of this sarcophagus. On one end (not pictured), Achilles is discovered by Odysseus among the daughters of King Lykomedes on the island of Skyros before joining the Greek expedition against Troy. On the other end, the hero arms for battle as a spear carrier looks on. The front shows the result of Achilles' confrontation with the great Trojan hero Hektor: Achilles mounts his chariot to drag Hektor's body around the walls of the city. The back of the sarcophagus has a shallower relief scene of Centaurs fighting their neighbors the Lapiths, which may also be understood as a reference to Achilles, who was educated by the Centaur Chiron. On the lid, two figures recline on an elaborate couch. Their heads were left unfinished in antiquity so that the portraits of the deceased could be carved after the sarcophagus was purchased.

PORTRAIT OF A BALDING MAN

Roman
(made in Asia Minor),
circa A.D. 240
Marble
H: 25.5 cm (10 in.)
85.AA.112

This beautifully carved and well-preserved portrait depicts a mature man with lined brow and curly beard. The striking blue-gray marble from which it is carved comes from the area around the island of Marmara in modern Turkey, indicating that the subject may have been a Roman citizen of Asia Minor. The unknown artist skillfully utilized the contrasting techniques of deep drill work and high polish to differentiate between the textures of the subject's smooth skin and curly hair. The convincing lifelike features suggest that we are looking at a specific individual, but the overall composition emphasizes certain standard components, stock features in the portrayal of classical Greek intellectuals. Thus, the careful selection of details in this portrait successfully presents the character of the subject as much as his physical appearance.

STATUETTE OF A LYRE PLAYER WITH A COMPANION

Greek (perhaps made
in Crete), 690–670 B.C.
Bronze
H: 11.5 cm (4½ in.)
90.AB.6

Cast in solid bronze, this statuette of a male lyre player and a smaller companion of uncertain gender was originally attached by the holes in its base to another object, perhaps a bronze vessel. Group compositions and depictions of musicians are rare in Greek art of this early, so-called Geometric, period. Certain deities, such as Apollo, were later depicted as musicians, but this bronze bard and his companion must be mortals. He is an *aoidos* (minstrel), like Demodokos, the blind singer described by Homer in the *Odyssey*. Homer himself was said to be blind, and the sightless Demodokos was assisted by a herald, suggesting that this lyre player is a blind bard assisted by a young companion or apprentice.

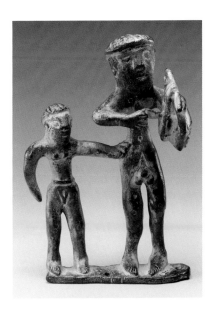

FURNITURE SUPPORT REPRESENTING A WINGED FELINE

Tartessian (made in
Tartessos), 700–575 B.C.
Bronze
61 × 33 cm (24 × 13 in.)
79.AC.140

Details on the wings and head of this
fierce, pantherlike creature and the
general method of its manufacture
suggest that it came from the kingdom
of Tartessos on the Atlantic coast of
modern Spain. Due to its rich mineral
resources, Tartessos was an impor-
tant port on Greek, Phoenician, and
Etruscan trade routes in the western
Mediterranean. The art of Tartessos
combines native Iberian elements with
influences brought by traders and
colonists. This beast was cast in two
separate pieces, which are joined with
rivets just below the wings. The
pierced projections behind the head
and below the front paws indicate that
it was part of a larger structure, per-
haps a tripod base. Such ceremonial
furniture was often embellished with
fearsome, fantastic animals.

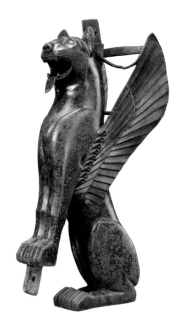

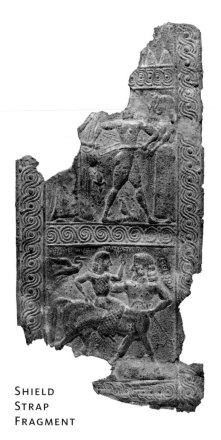

SHIELD STRAP FRAGMENT

Signed by
Aristodamos of Argos
Greek (made in Argos),
circa 575 B.C.
Bronze
16.2 × 8 cm (6⅜ × 3⅛ in.)
84.AC.11

This small relief fragment once deco-
rated the strap on the inside of an
Argive warrior's shield. It contains the
earliest surviving signature of an
ancient Greek metalworker. At the top
edge of the lower square, the name of
the bronzeworker, Aristodamos of
Argos, is written from right to left. The
strap preserves representations of two
myths. The lower square shows the
Centaur Nessos abducting Deianeira,
the wife of Herakles. The scene above
it depicts the recovery of Helen of
Troy by her Greek husband, Menelaos,
king of Sparta. Athena, protectress of
the Greeks, stands watching at the
right, with her name inscribed beside
her.

STATUETTE OF A SEATED LION

Greek (made in Lakonia),
circa 550 B.C.
Bronze
9.3 × 13.3 × 5 cm
(3⅝ × 5¼ × 1¹⁵⁄₁₆ in.)
96.AB.76

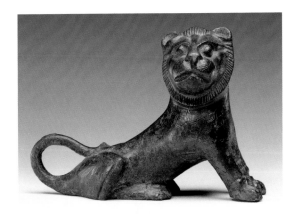

This hollow-cast bronze statuette of a lion is seated in an alert pose, emphasized by its upright ears, arched eyebrows, and bulging eyes. Like other representations of lions manufactured in Lakonia, the region around the ancient city of Sparta in southern Greece, this one has an incised mane, flamelike lines on its body, and a mild demeanor. The statuette was originally attached to another object, perhaps the rim of a large metal vessel. The remnants of a pin are preserved on the bottom of its left front paw.

STATUETTE OF A FALLEN YOUTH

Greek, 480–460 B.C.
Bronze with copper inlays
7.3 × 13.3 cm (2⅞ × 5⁵⁄₁₆ in.)
86.AB.530

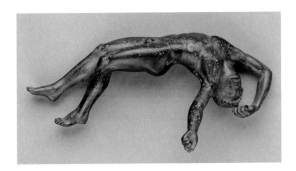

This figure is unique among surviving bronzes of the Early Classical period. The closed eyes, prostrate pose, and twisted torso of the fallen youth suggest that he is dead. He may be a fallen warrior holding his weapons (now missing) who was part of a group composition, although there are no attachment marks to indicate how he was joined to a larger ensemble. The beautifully articulated details are the work of a master craftsman. Copper inlays were used for curls of the hair and the nipples. Now lost or altered by oxidation and burial, these inlays once created a rich contrast with the golden tones of the figure's polished bronze flesh.

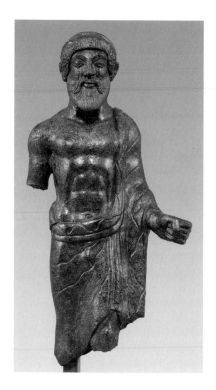

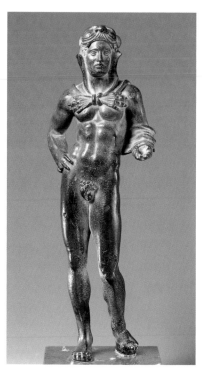

STATUETTE OF A BEARDED MAN, PROBABLY TINIA

Etruscan, circa 480 B.C.
Bronze
H: 17.2 cm (6¹³/₁₆ in.)
55.AB.12

Wearing a *tebenna*, the Etruscan precursor of the Roman toga, this stately bearded figure originally held an object in his clenched left hand. A scepter would have identified him as Tinia, the Etruscan equivalent of Zeus, the Greek king of the gods. The advanced left leg and rigid frontality of the pose are vestiges of the earlier Archaic style, recalling the pose of Greek *kouroi* (youths), but the more naturalistic treatment of the torso and face place this figure in the Early Classical period.

STATUETTE OF HERCLE

Etruscan, 325–275 B.C.
Bronze
H: 24.3 cm (9⅝ in.)
96.AB.36

Hercle is the Etruscan name given to the Greek hero Herakles. The raised ears of the lion's skin and the way that it frames Hercle's face like a collar are typically Etruscan, as is the delight in textural embellishment, especially in the treatment of the lion's skin across the back. This figure probably held the Apples of the Hesperides in his left hand. Representing the last of his Twelve Labors, the golden apples he had obtained from a garden at the far end of the world were proof that Hercle had completed his deeds and was now prepared to take on immortality, as suggested by his youthful and godlike physique.

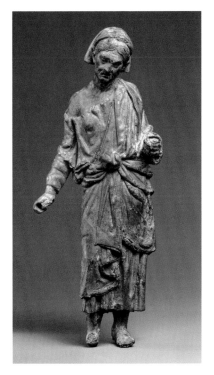

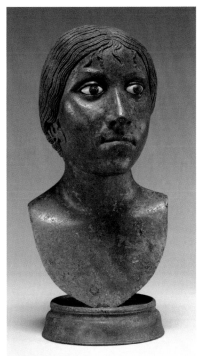

STATUETTE OF
AN OLD WOMAN

Greek or Roman,
100–1 B.C.
Bronze
H: 12.6 cm (5 in.)
96.AB.175

This statuette of an elderly woman
poignantly depicts old age. Her sagging
cheeks, sunken eyes, and wrinkled
neck and tendons attest to a long, hard
life. Although the objects once held in
her hands are now missing, the pose of
this frail old woman suggests that she
is spinning wool. She tilts her head
downward, following the movement of
the thread. Her clothing is typical of
the humble attire worn by women
engaged in domestic and agricultural
tasks. Representing people of varying
ages and status in a variety of poses
was of great interest in the art of the
period from 300 to 1 B.C., but it is also
possible that this figure represents
Klotho, one of the three Fates, who
spins the thread of life.

MINIATURE
PORTRAIT BUST
OF A YOUNG
WOMAN

Roman, 25 B.C.–A.D. 25
Bronze with glass-paste
inlays
H: 16.5 cm (6⁷/₁₆ in.);
DIAM of base: 6.7 cm (2⁵/₈ in.)
84.AB.59

This small bust of a Roman lady attests
to the sensitivity of the craftsman
responsible for its manufacture. After
casting, it was engraved with many
details. The earrings that originally
adorned the pierced earlobes are lost,
but the inlaid eyes of glass paste, which
do not usually survive from antiquity,
are preserved, adding to the head's
strikingly realistic impression. Small
portraits such as this one were pro-
duced in various media throughout the
Roman Empire. Most were intended
for shrines that commemorated the
notable deeds of family members or for
other semiprivate, domestic settings.

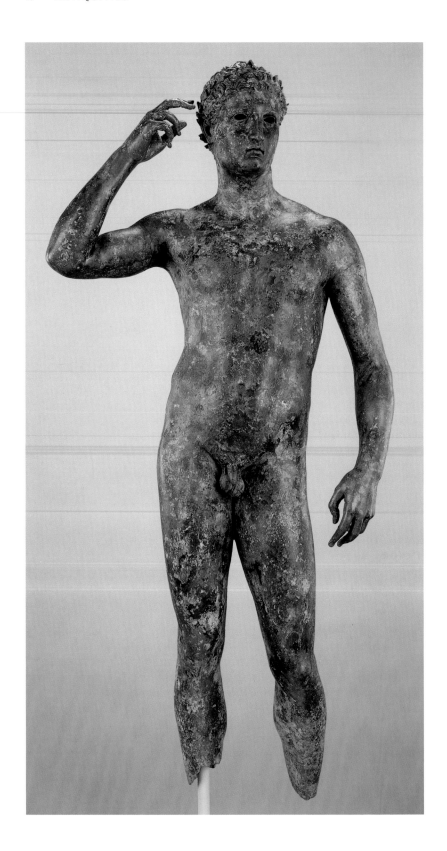

STATUE OF AN INFANT, PERHAPS CUPID

Roman, A.D. 1–50
Bronze with silver
and copper
H: 64 cm (25³/₁₆ in.)
96.AB.53

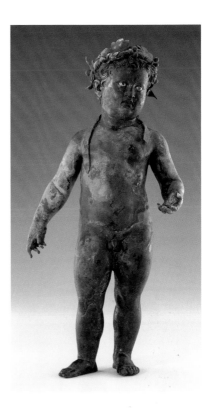

Depicted as a chubby toddler, the subject of this bronze sculpture is not immediately clear, because the attributes that he may have worn or carried are now missing. Various Roman gods and heroes were depicted as children, including Hercules and Bacchus, but none appeared as frequently as Cupid. This identification of the boy is supported by the remains of metal attachments, poorly preserved on the back of the infant, that most likely were for fastening wings onto the body.

Empty holes now mark the place where inset pupils of stone or glass paste once lay, lending an unfocused, almost dreamy quality to his gaze. The irises are silvered, and the figure once had silver teeth, both testaments to the fine quality of workmanship and detail lavished upon this sculp- ture. The child's wreath incorporates the nuts and leaves of a plane tree. The ribbons hanging over his shoulders are made of hammered sheet-copper.

STATUE OF A VICTORIOUS YOUTH

Greek, 300–100 B.C.
Bronze with copper inlays
H: 151.5 cm (59⁵/₈ in.)
77.AB.30

Standing in a relaxed pose, this nude youth crowning himself with an olive wreath in the traditional gesture of a victorious athlete is a rare and outstanding example of large-scale ancient Greek bronze statuary. Its slim proportions and relatively small head are characteristic of the style of Lysippos (active 370–315 B.C.), the court sculptor of Alexander the Great.

This kind of statue is typical of the extravagant dedicatory offerings that victors in athletic games commissioned and dedicated after significant successes. Yet only a fraction of the thousands of votive and commemorative statues that adorned the public and private spaces of cities and sanctuaries have survived, making this figure especially important. The Victorious Youth was found in an ancient shipwreck in the Adriatic Sea, encrusted with shells, corals, and mud. It was probably en route to Rome from a sanctuary, such as Olympia or the hometown of the dedicator, when the ship transporting it sank.

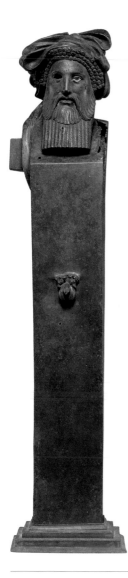

HERM OF
DIONYSOS

Attributed to the
Workshop of Boëthos
Greek, 100–50 B.C.
Bronze with ivory inlay
H: 103.5 cm (40¾ in.);
W of base: 23.5 cm (9¼ in.)
79.AB.138

A herm was a rectangular pillar surmounted by a
head, often of Hermes, the god of travelers, commerce,
and thieves. Herms stood at crossroads to protect
travelers and at the entrances of homes to keep away
evil. The Getty herm is unusual in featuring a bearded,
turbaned image of Dionysos, the god of wine and
theater. His eyes were inlaid with ivory. This herm
is very similar to one discovered in an ancient ship-
wreck found near Mahdia on the coast of Tunisia,
and its metal contains identical trace elements. The
Mahdia herm was signed by the sculptor Boëthos
of Kalchedon (in modern Turkey), whose works were
highly prized by ancient Roman collectors of Greek
art. The Getty herm must have come from the same
workshop.

LEBES

Greek, 50–1 B.C.
Bronze with silver inlays
H: 58 cm (22¹³⁄₁₆ in.)
96.AC.51

Adorning the front of this *lebes* (cauldron) is a half-
length figure of a young satyr, a member of the reti-
nue of Dionysos, the god of wine. The handsome
rustic holds a drinking cup in one hand and snaps the
fingers of the other while baring his teeth in a wild,
impudent grin; his eyes and teeth are silvered. This
figure and the monumental flowers, grape leaves, and
spiraling tendrils (inlaid in silver) all imply that the
object functioned in some aspect of the Dionysiac cult,
possibly for serving wine. A brilliant and richly orna-
mented example of metalworking, this *lebes* signaled
the affluence and status of its owner.

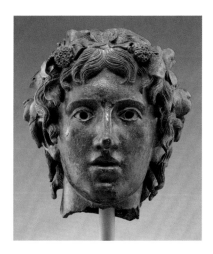

HEAD OF THE YOUNG BACCHUS

Roman, A.D. 1–50
Bronze with silver inlays
H: 21.6 cm (8½ in.)
96.AB.52

The twisted vine wreath covered with leaves and berries worn in the hair indicates that this beautifully wrought, life-size head represents the youthful god of wine and fertility, Bacchus (Dionysos to the Greeks). The whites of his eyes are silvered, and his pupils and irises would have been inlaid in glass paste or colored stone to create a realistic image. The long, curling locks of hair hanging down over the neck were cast separately. The head, with its intense gaze, was probably originally attached to a full-length statue of the god that might have formed part of a decorative household ornament, such as an elaborate lamp or tray bearer. Similar statues of youths have been found in Italy, Spain, and Morocco.

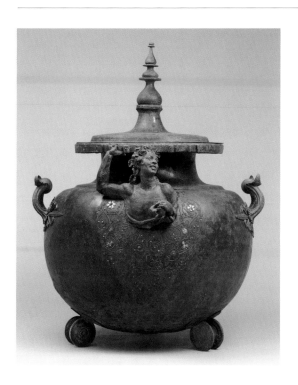

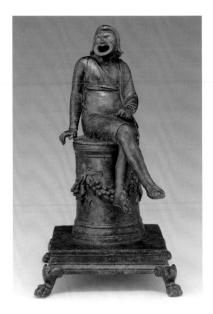

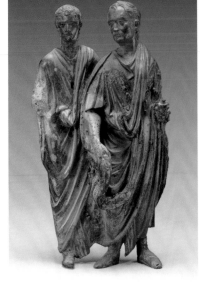

THYMIATERION

Roman, A.D. 1–50
Bronze with silver inlays
H: 23.3 cm (9⅛ in.);
w of base (with feet):
13.3 cm (5¼ in.)
87.AC.143

This *thymiaterion* (incense burner)
depicts an actor who wears the
clothing and mask associated with
productions of Greek New Comedy.
The mask, with knitted brow over sil-
ver inlaid eyes, would have been used
for the role of a leading slave. The
figure sits on an altar, a standard fea-
ture of Greek and Roman comedies,
where slaves sought sanctuary from
angry masters. The statuette itself is
hollow, and the altar on which it sits is
pierced underneath for ventilation.
As the incense smoldered inside the
altar, the perfumed smoke would
emerge through the figure's open
mouth.

RELIEF WITH TWO TOGATE MAGISTRATES

Roman, A.D. 40–68
Bronze
H: 26 × 13.8 cm
(10¼ × 5⁷⁄₁₆ in.)
85.AB.109

The togas and shoes worn by these
dignified men indicate their status as
members of the upper class. One holds
a scroll, implying that he may be a
civic official or priest participating in a
solemn ceremony. The detailed treat-
ment of faces may have been intended
to represent specific individuals, but
these images are more likely depic-
tions of generic, well-known types.

Similar figures appear on Roman
marble reliefs from the mid-first
century A.D., and this bronze is dated
to the same period by the style of
the drapery and hair. The closest
parallels date to the reign of Nero
(A.D. 54–68). Because of its open back,
this piece must have been affixed to
a larger monument, but whether that
was a trophy, altar, chariot, funerary
wagon, or piece of furniture cannot
be ascertained.

STATUETTE OF COBANNUS

Roman (made in Gaul),
A.D. 125–75
Bronze
H with base: 76 cm (30 in.)
96.AB.54

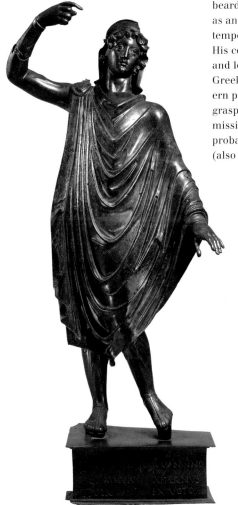

Unusual in its size, style, and the excellence of its craftsmanship, this dedicatory statue was clearly a valuable commission for an important shrine. The Latin inscription on its base identifies this figure as Cobannus, a local Gallic god identified with Mars, the Roman god of war: "Sacred to the venerable god Cobannus, Lucius Maccius Aeternus, *duumvir*, [dedicated this] in accordance with a vow." The dedicator of the statue, Lucius Maccius Aeternus, was a *duumvir*, one of the two chief magistrates of a Roman colony.

In style, the sculpture is a distinctly Gallo-Roman creation. Instead of the customary image of Mars as a mature, bearded man, the god appears here as an idealized youth wearing a contemporary Roman legionary helmet. His costume—a long-sleeved tunic and long leggings worn under a Greek-style cloak—is typical of northern provincial dress. He is shown grasping the top edge of a shield (now missing) with his left hand while probably holding a staff or a spear (also missing) in his right hand.

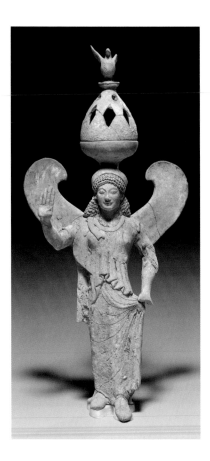

THYMIATERION SUPPORTED BY A STATUETTE OF NIKE

Greek (probably made in Taras, South Italy), 500–480 B.C.
Terracotta with pigment
H: 44.6 cm (17⁹/₁₆ in.);
DIAM of incense cup:
6.9 cm (2¾ in.)
86.AD.681

The figure of Nike, the winged goddess of victory, functions here as a caryatid. She supports the bowl of a *thymiaterion* (incense burner) and its egg-shaped openwork lid, on which a dove perches. One finds parallels with the exquisitely detailed features of the statuette among the large-scale marble *korai* (maidens) from the late Archaic period, from whom she is distinguished only by her outspread wings. Traces of its original pink, purple, red, and blue pigments are preserved. This object may have been intended for use in religious rituals.

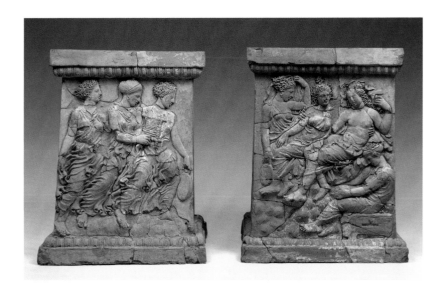

PAIR OF ALTARS

Greek (probably made
in Taras, South Italy),
400–375 B.C.
Terracotta
Altar .1: 41.8 × 31.6 × 27 cm
(16⁷/₁₆ × 12⁷/₁₆ × 10⁵/₈ in.)
Altar .2: 41.8 × 31.5 × 27.8 cm
(16⁷/₁₆ × 12³/₈ × 10¹⁵/₁₆ in.)
86.AD.598.1–.2

The imagery on these two altars forms a single com-
position. On the right altar (.2), the goddess of love
and sexuality, Aphrodite, and her lover Adonis sit side
by side with his right arm around her in a rocky land-
scape, while two women attend them. On the left
altar (.1), three women dance toward the lovers. These
scenes emphasize the sadness and joy of the myth
of Adonis, a beautiful youth who was also the lover of
Persephone, queen of the Underworld (who perhaps
is represented by the figure of the attendant seated
in a mournful pose on the right altar). To appease the
competing deities, Zeus decreed that Adonis spend
half the year with one goddess and half with the other.
Thus, like a plant, he was fated to die and be reborn
each year. These small altars were used for the burn-
ing of offerings or incense.

RED POLISHED WARE BOWL WITH HIGH-RELIEF DECORATION

Cypriot (made in Cyprus),
2000–1900 B.C.
Terracotta
H: 42.5 cm (16³/₄ in.);
DIAM of rim: 38.1 cm (15 in.)
2001.78

This bowl features figural scenes modeled in high
relief around its neck. On one side, four men are
accompanied by a deer and another animal, perhaps a
fawn or a dog. Interspersed between the figures are
several unidentifiable objects, including two circular
ridges enclosing several small, conical lumps that
may represent troughs filled with piles of crude copper
ore. The men may be refining the ore, an important
industry in copper-rich Cyprus. These males contrast
with the figures on the other side of the bowl, which
are thought to be female. They are at work processing
small lumps of clay, perhaps in a scene of breadmak-
ing. Thus, the two sides may depict complementary
views of men's and women's tasks.

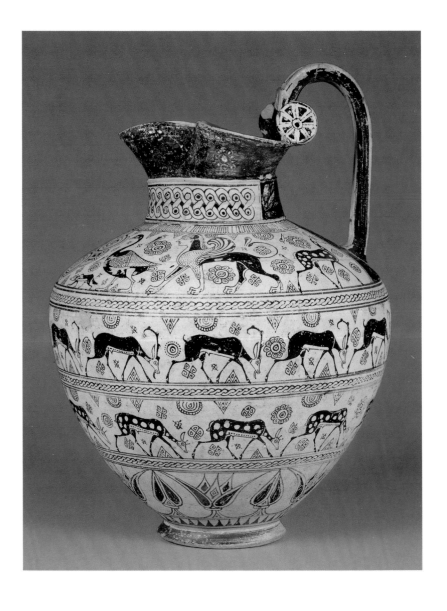

CORINTHIAN *ARYBALLOS*

Greek (made in Corinth),
600–575 B.C.
Terracotta
H: 11.4 cm (4½ in.);
DIAM: 11.7 cm (4⁹⁄₁₆ in.)
92.AE.4

This small oil container depicts Herakles battling the serpentine Hydra of Lerna, a monster whose multiple heads took the form of snakes. One snake bites his shoulder as he grabs another by the neck, preparing to decapitate it with his sword. Behind him stands Athena, his patron goddess, drawn in outline, while a crab sent by Hera bites his right ankle. Behind Athena are the horses of a chariot, and Herakles' nephew Iolaos and half-brother Iphikles appear on the other side of the vessel. The names of the figures are all written in the ancient Corinthian alphabet.

EAST GREEK *OINOCHOE*

Greek (made in Miletos),
circa 625 B.C.
Terracotta
H: 35.7 cm (14 in.);
DIAM of body: 26.5 cm
(10⁷⁄₁₆ in.)
81.AE.83

Herds of wild goats and spotted deer arranged single file in discrete registers surround this *oinochoe* (wine pitcher) with a trefoil mouth. On the shoulder of the pitcher, pairs of dogs, enormous water birds, and sphinxes flank an elaborate central floral ornament just below the spout. The cream-colored background is neatly filled with various patterns, including rosettes, some of which are brought to life by small birds perched on the petals. The goats have given their name to this kind of pottery decoration—the Wild Goat style—which was popular in the Greek settlements on the coast and offshore islands of Ionia (modern western Turkey and eastern Greece) during the seventh and sixth centuries B.C. The style is thought to have been patterned after textile designs, but ivory and bronze objects may also have provided sources of inspiration. The disks applied to the rim of this vessel are clearly derived from bronzework.

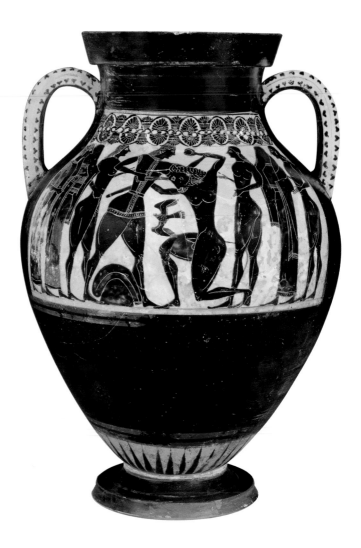

ATTIC BLACK-FIGURED *AMPHORA*

Attributed to Lydos
(as painter) or a painter
close to him
Greek (made in Athens),
550–540 B.C.
Terracotta
H: 45.6 cm (18 in.);
DIAM of body: 32.5 cm
(12 ¾ in.)
86.AE.60

The Battle of Theseus and the Minotaur was a favorite theme of Athenian vase painters, because it represented the most heroic exploit of their city's great hero. On this *amphora* (storage jar), Athenian youths and maidens look on as Theseus stabs the Minotaur— half man, half bull—with his sword. The naked beast falls to its knees as Theseus grabs its wrist to keep it from hurling a stone. An eagle flies toward Theseus, signaling the victory.

The painter of this vessel, Lydos, typically endowed his figures with robust forms, such as broad thighs and articulated musculature that resemble the sculpted Archaic-period *kouroi* (youths). His name means "the Lydian," so, even though he may have been born in Athens and spent a long career there, he seems to have considered his origin to be Lydia (modern Turkey).

CHALCIDIAN BLACK-FIGURED NECK *AMPHORA*

Attributed to the
Inscription Painter
Greek (made in Rhegion,
South Italy), circa 540 B.C.
Terracotta
H: 39.6 cm (15⅝ in.);
DIAM: 24.9 cm (9¹³⁄₁₆ in.)
96.AE.1

A scene from Homer's *Iliad* decorates this storage vessel. During the Trojan War, King Rhesos of Thrace came to assist the Trojans. The Thracians, having arrived too late at night to enter Troy, camped in the fields outside the city, hanging their elaborate armor in the surrounding shrubbery. As they slept, the Greek heroes Odysseus and Diomedes killed them in order to steal their immortal horses. On this side of the colorful *amphora*, Diomedes is about to slay Rhesos, while on the opposite side, Odysseus murders another Thracian. Bold highlights in red and white paint make the composition especially vivid.

"Chalcidian" pottery is named for the Euboean dialect used in the inscriptions, but it was probably made in Rhegion in southern Italy, a colony of the Greek city of Chalkis. This vase has been attributed to the artist known today as the Inscription Painter, who had the habit of labeling the figures in his drawings.

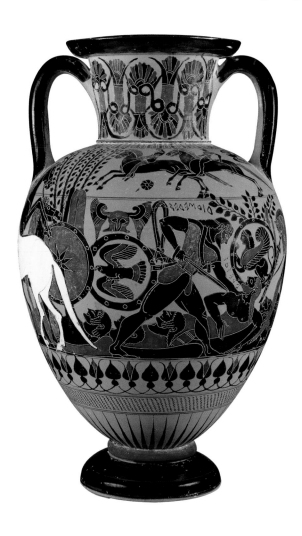

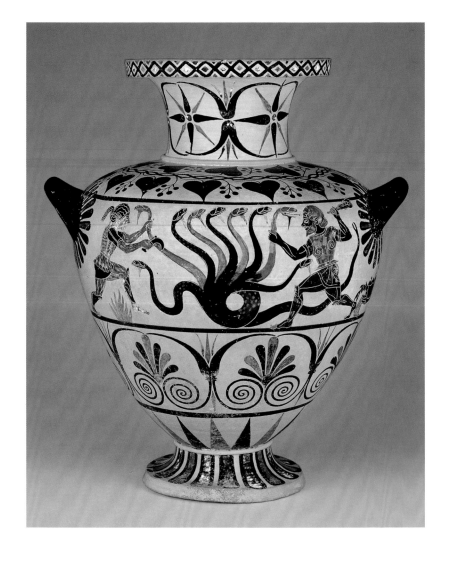

ATTIC WHITE-GROUND *LEKYTHOS*

Attributed to Douris
(as painter)
Greek (made in Athens),
circa 500 B.C.
Terracotta
H: 33.5 cm (13³/₁₆ in.);
DIAM: 12.6 cm (4¹⁵/₁₆ in.)
84.AE.770

In a calm, evenly disposed composition around the body of this *lekythos* (vase used for storing oil or perfume), two young Athenians arm themselves in the presence of a boy and a woman. One of the youths, rendered in fine outline, holds his helmet and shield. A honey-colored dilute wash adds volume to his short tunic and hair. In the field between the figures, an inscription praises the beauty of two youths, Nikodromos and Panaitios. This helps to date the vase early in the career of Douris, who was one of the most skilled and productive vase-painters in Athens during the late Archaic period.

CAERETAN BLACK-FIGURED *HYDRIA*

Attributed to the
Eagle Painter
Etruscan (made in Caere),
circa 525 B.C.
Terracotta
H: 44.6 cm (17⁹/₁₆ in.);
DIAM: 33 cm (13 in.)
83.AE.346

The Labors of Herakles were popular subjects on sixth-century B.C. vases produced throughout the Mediterranean world. This *hydria* (water jar) was made in Etruria by an artist who learned his craft in Ionia (modern western Turkey and eastern Greece). Its colorful and lively composition is typical of a workshop at Caere (modern Cerveteri). Although the painter lavished attention on the large floral ornaments, the main focus is the slaying of the many-headed Hydra of Lerna (see also p. 25). To kill the vicious monster, the bearded hero (right), who wears armor rather than his more characteristic lion's skin, attacks it with a club, while his nephew Iolaos assists with a sickle. The fire below Iolaos is intended to cauterize the Hydra's necks so that new heads could not grow back.

ATTIC RED-FIGURED *KYLIX*

Attributed to the
Carpenter Painter
Greek (made in Athens),
510–500 B.C.
Terracotta
H: 11 cm (4⁵/₁₆ in.);
W (with handles): 38.1 cm
(15 in.);
DIAM: 33.5 cm (13³/₁₆ in.)
85.AE.25

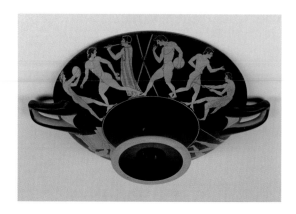

Athletics were an important part of a young Athenian's education. The scenes painted on the outside of this *kylix* (drinking cup) show athletes training. On the side shown here, two discus throwers practice their form while two jumpers (carrying weights) wait for the youth with the pick to soften the dirt of the *palaestra* (stadium). A flutist sways gracefully among them, melodically providing a rhythm for their exercises. Near the handle at the left is an altar, as religion and the gods were central to all facets of Greek life.

ATTIC RED-FIGURED *KYLIX*

Attributed to Onesimos
(as painter)
Greek (made in Athens),
500–490 B.C.
Terracotta
H (restored): 8.3 cm
(3¼ in.);
DIAM: 23.5 cm (9¼ in.);
W (with handles, one
restored): 30.5 cm (12 in.)
86.AE.607

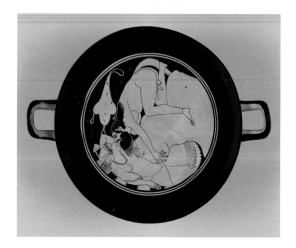

The antics of satyrs were a popular subject for Athenian drinking cups. In the interior of this *kylix*, a satyr creeps up on a nymph who naps on a large striped cushion beneath a rocky outcropping. The Greek inscription above them tells why the satyr is so smitten: "The girl is beautiful." Onesimos takes particular delight in juxtaposing the lovely profile of the sleeping girl with the brutish, pug-nosed face of the satyr attempting to steal a kiss.

ATTIC RED-FIGURED NECK *AMPHORA* WITH DOUBLE HANDLES

Attributed to the Berlin
Painter (as painter)
Greek (made in Athens),
circa 480 B.C.
Terracotta
H: 30.6 cm (12¹/₁₆ in.);
DIAM (body): 17.2 cm (6³/₄ in.)
86.AE.187

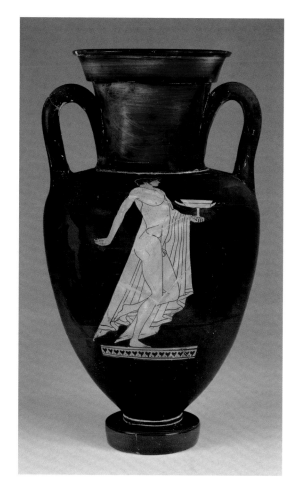

The Berlin Painter was one of the foremost draftsman
in Athens during the late Archaic period. He took full
advantage of the possibilities for anatomical rendering
and expression offered by the red-figure technique.
His style is recognizable by exquisitely drawn single
figures or groups placed on a groundline and silhou-
etted against the black expanse of the clay. Here, a
youthful dancer, crowned with an ivy wreath and
holding a drinking cup by the foot, is juxtaposed with
a foreign man on the reverse. Thus the painter seems
to have deliberately contrasted youth and old age,
beauty and ugliness, and, perhaps, master and slave.

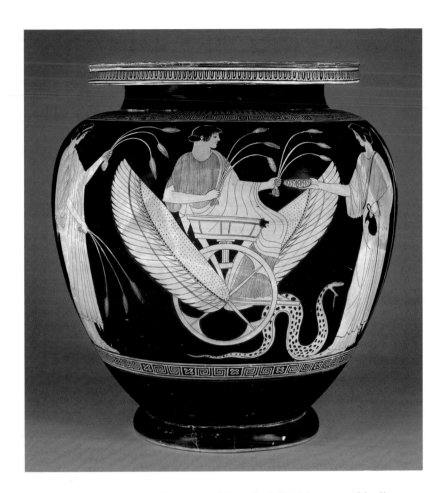

ATTIC RED-FIGURED FOOTED *DINOS*

Attributed to the
Syleus Painter
Greek (made in Athens),
circa 470 B.C.
Terracotta
H: 36.8 cm (14½ cm);
DIAM: 35.7 cm (14 in.)
89.AE.73

Demeter and Kore flank Triptolemos on this *dinos* (bowl for mixing wine and water). Seated on a winged chariot drawn by a large serpent, Triptolemos prepares to journey throughout the world, spreading agricultural knowledge, symbolized by stalks of grain—the gift of Demeter, who stands behind him. Kore, the daughter of the goddess, holds a pitcher and a libation bowl, speeding him on his way. Figures on the other side of the vessel, all identified by inscriptions, are also related to the highly secretive cult of Demeter. They include Theos (Hades), god of the Underworld; his wife, Thea; and the personification of the sacred city of Eleusis.

ATTIC
RED-FIGURED
DINOID
VOLUTE-*KRATER*
AND STAND

Attributed to the
Meleager Painter
Greek (made in Athens),
390–380 B.C.
Terracotta
H of *krater:* 54 cm (21¼ in.);
DIAM of *krater:* 40 cm
(15¾ in.);
H of stand: 16.5 cm (6½ in.)
87.AE.93

The ribbed black body of this elaborately decorated
krater (vase for mixing wine and water) intentionally
imitates metal vessels. It is ornamented with heads
of Ethiopians at the handle bases, female heads in the
handle volutes, and floral and figural decoration
on the neck, shoulder, and base, all copiously gilded.
On the front of the neck is a scene featuring Adonis
lying on a couch between his rival lovers, Aphrodite
and Persephone. Echoing the scene on the neck, the
stand shows a reclining Dionysos attended by Eros
and accompanied by satyrs, maenads, and the gods
Hephaistos and Apollo. Scenes of mythical and real
combat decorate the shoulder of the stand, which was
cut down in antiquity and has been restored on the
basis of ancient parallels.

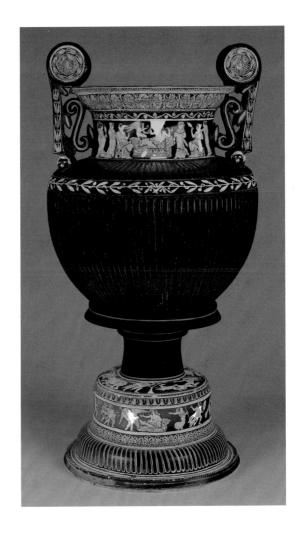

PANATHENAIC PRIZE *AMPHORA* AND LID

Attributed to the Painter
of the Wedding Procession
(as painter); signed by
Nikodemos (as potter)
Greek (made in Athens),
363–362 B.C.
Terracotta
H (with lid): 89.5 cm
(35¼ in.);
DIAM of body: 38.3 cm
(15⅛ in.)
93.AE.55

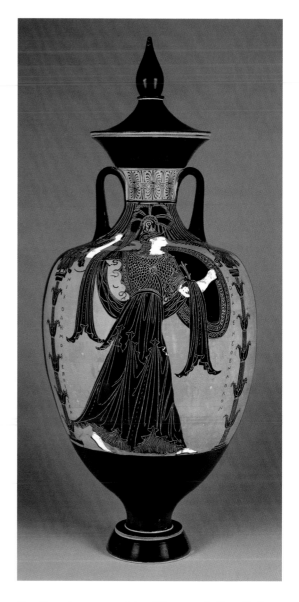

Panathenaic vases contained the sacred olive oil given
as prizes for athletic contests held every four years
during the Panathenaic festival in Athens. Athena, the
patron goddess of the city, was always depicted on
the front, and the competitive event commemorated
by the vase, on the back. The date of this *amphora* has
been determined by the two figures of Nike, the god-
dess of victory, standing atop the acanthus columns
flanking Athena. They are unique to the years 363/362
B.C. The inscriptions alongside the column behind
the goddess identify Nikodemos as the maker of the
vessel, while those along the column in front state that
the vase was "from the games at Athens."

ATTIC RED-FIGURED *PELIKE* OF KERCH STYLE

Attributed to the Painter of the Wedding Procession (as painter)
Greek (made in Athens), circa 360 B.C.
Terracotta and pigment
H: 48.3 cm (19 in.);
DIAM of body: 27.2 cm (10¾ in.)
83.AE.10

The front of this tall *pelike* (storage jar for oil) depicts the Judgment of Paris. Dressed in rich oriental attire, Paris, the young prince of Troy, sits on a rock and looks toward Athena, the goddess of wisdom and warfare, who wears a long green garment and gilded breastplate and helmet. Behind her stands Aphrodite, goddess of love, accompanied by her son, the winged Eros. To the left stands Hera, queen of the gods, followed by Hermes, the messenger of the gods. Paris's task was to choose the most beautiful of the goddesses, and as Helen of Troy was the bribe, he chose Aphrodite, thus precipitating the Trojan War.

Vases in the Kerch style take their name from an area on the Black Sea where numerous examples have been found. The style is characterized by an elaborate and often flamboyant use of pigment, gilding, and relief work to augment the traditional red-on-black scheme of earlier Attic vases.

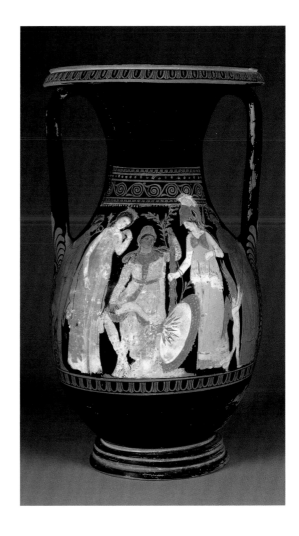

APULIAN RED-FIGURED *LOUTROPHOROS*

Attributed to the
Painter of Louvre MNB 1148
Greek (made in Apulia,
South Italy), circa 330 B.C.
Terracotta
H: 90.2 cm (35½ in.);
DIAM of mouth: 26 cm
(10¼ in.)
86.AE.680

Zeus and Aphrodite, with Eros on her arm, occupy a templelike building on the center of this *loutrophoros* (ritual water jar). Below, Zeus appears disguised as a white swan leaping into Leda's embrace, while Hypnos, a personification of sleep, showers them with drowsiness. Other mythological figures—Astrape (a personification of lightning), Eniautos (the personification of the calendar year), and Eleusis (a personification of an important sanctuary)—are not clearly connected to the story. *Loutrophoroi* like this one were used in preparations for both weddings and funerals. The other side depicts a woman in a small temple-like shrine surrounded by attendants.

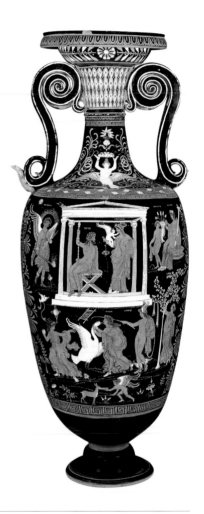

ENGRAVED RING

Greek, circa 350 B.C.
Gold
H of bezel: 2.23 cm (⅞ in.);
W of bezel: 1.76 cm (11⁄16 in.);
DIAM of hoop: 2.07 cm (13⁄16 in.)
85.AM.277

An elegantly clad woman sits on a stool, balancing a scale with two Erotes (winged gods of love). This is the *erotostasia* (weighing of love), which also appears on ancient vases and sculpture. Although the meaning of the scene is unclear, it may symbolize some aspect of love related to the Homeric weighing of souls, the *psychostasia*. Because the only woman capable of judging weight in the realm of love is the goddess Aphrodite, her identity in this context is fairly certain.

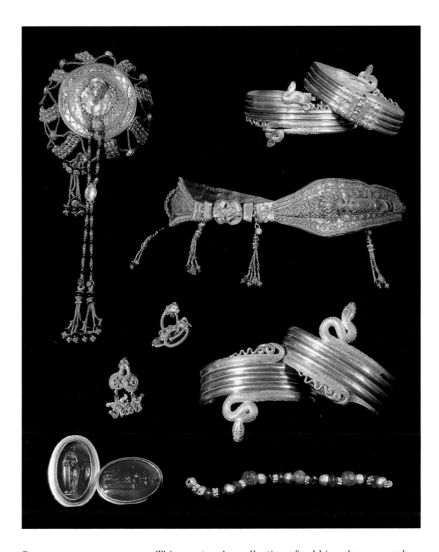

ENSEMBLE OF JEWELRY

Greek (possibly made in Alexandria), 220–100 B.C.
Gold with various inlaid and attached stones, including garnet, carnelian, pearl, and glass paste
92.AM.8.1–.11

This spectacular collection of gold jewelry was probably the prized possession of a Greek woman of high social rank. Signs of ancient repair show that the jewelry was worn. The style and imagery of the pieces suggest that they were made by Greek goldsmiths during the reign of the Ptolemies, the rulers of Egypt descended from one of the generals of Alexander the Great. The group consists of a hairnet (upper left) with a central image of Aphrodite and Eros; an elaborate diadem (center right); four snake bracelets; two pairs of antelope-head earrings and one pair featuring Erotes (winged gods of love); two massive carnelian seal rings, one engraved with an image of Tyche, the goddess of good fortune, and the other representing the Ptolemaic Queen Arsinoe II (316–270 B.C.) as Artemis; and a multi-colored necklace.

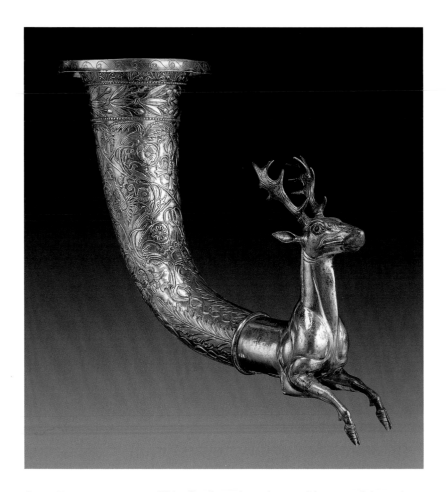

STAG *RHYTON*

Eastern Mediterranean,
50 B.C.–A.D. 50
Gilded silver, garnet, glass
H: 27.5 cm (10¹³/₁₆ in.);
L: 46 cm (18⅛ in.);
DIAM of rim: 12.6 cm (5 in.)
86.AM.753

This gilt-silver *rhyton* is one of the most elaborately decorated drinking horns to survive from antiquity. Relief floral patterns cover the entire surface of the curving horn, which terminates in the forequarters of a stag. Executed with exceptional attention to anatomical detail—particularly apparent in the veins running down the creature's face—the stag is shown in flight. The preserved inlaid eyes of glass paste, with the whites clearly visible, heighten the expression of fear and alertness conveyed by the stag's raised head. This vessel was produced in a workshop on the eastern fringes of the Hellenistic world, but the closest parallels for the ornamental designs are found among the late Hellenistic decorative arts created under the Seleucid rulers who inherited the eastern part of Alexander the Great's sprawling empire.

Preserved on the belly of the animal is an inscription that may be a dedication to Artemis, the goddess of the hunt.

NET PATTERN BOWL

Parthian (made in Parthia),
100–1 B.C.
Gilded silver with garnets
DIAM: 20 cm (7⅞ in.)
86.AM.752.3

Following Alexander the Great's conquest of parts of the Near East and India in the fourth century B.C., the Greek world became increasingly familiar with and fond of exotic materials and ornate patterning. This bowl is a rare and beautiful example of the type of elaborately decorated vessel that an affluent and sophisticated collector in the first century B.C. would obtain to enrich his set of table silver. The net pattern on the bowl's interior is composed of fourteen staggered pentagons, a design typically seen in Greek Hellenistic pieces. Within each pentagon, a different type of gilded flower is inset with a garnet. In the center of the bowl, a single garnet forms the heart of a floral calyx. Although the floral calyx motif was often incorporated into Near Eastern pieces, its use in Greek metalwork is quite rare.

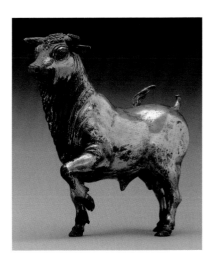

STATUETTE OF A BULL

Roman (excavated at
Pompeii), 100 B.C.–A.D. 75
Silver with gilding
H: 14 cm (5½ in.)
2001.7

Discovered in Pompeii between 1780 and 1790, this statuette became part of the collection of Maria Christina of Savoy, queen of the kingdom of the Two Sicilies from 1830 to 1837. It originally belonged to an ancient Pompeian family who perished during the eruption of Mount Vesuvius in A.D. 79. It would have stood with other statuettes of gods, goddesses, and divinities in a *lararium* (domestic shrine), where it would have been an object of devotion and veneration by household members as well as a luxury item indicative of its owners' social status and wealth. The animal probably represents Jupiter, the king of the gods, whose strength and power it embodies.

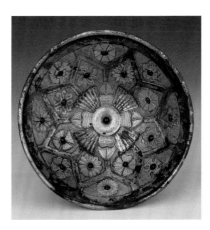

BEAKER

Roman, A.D. 1–100
Gold
H: 13.7 cm (5³⁄₈ in.)
2001.6

This beaker is one of only six Roman
gold vessels known to have survived
from antiquity. Its deep, subtly convex
body rises from a small flanged foot
and ends in a slightly flared rim. The
only decorative embellishments to the
elegant profile are two incised lines
below the rim. An abbreviated dotted
Latin inscription on the underside of
the flanged foot records the vessel's
weight as two *libra*, one *sescuncia*—the
equivalent of 24.54 ounces. The actual
weight of the vessel is 23.15 ounces.
The difference between the inscribed
weight and actual weight may indicate
that the vessel once had a lid.

TWO-HANDLED CUP

Roman, A.D. 1–100
Silver
H: 12.5 cm (4⁷⁄₈ in.);
DIAM: 16.3 cm (6³⁄₈ in.)
96.AM.57

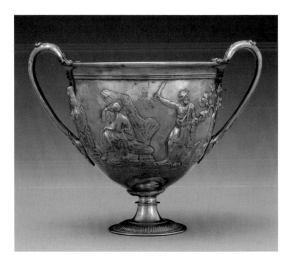

Encircling this drinking cup is a scene
that may be derived from Homer's
Odyssey. Odysseus was instructed by
the sorceress Circe to travel to the
Underworld to consult the ghost of the
blind seer Teiresias, the only one who
could tell the hero when he would
return home. Here, Odysseus holds
aloft his sword, having slain a ram to
summon the ghost, and Teiresias

sits in the center on a rocky outcrop,
gazing sightlessly upward. On the
other side of the cup, five male figures
(probably philosophers) converse.

The cup's relief decoration was
produced by repoussé, the technique
of hammering and punching motifs
from inside. The foot and handles
were made separately.

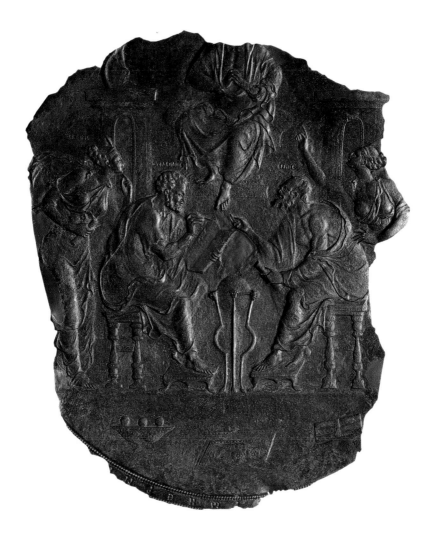

PLATE WITH RELIEF DECORATION

Late Antique, A.D. 500–600
Silver with gilding
45 × 28 cm (17¾ × 11 in.)
83.AM.342

The allegorical scene that decorates this large plate represents the philosophical dispute between Science and Mythology. Seated at the left below an unidentified figure enthroned at the top is a bearded man, designated by a Greek inscription as *Ptolemaios*; behind him stands a woman labeled *Skepsis*. Facing them is a man labeled *Hermes*, but the inscription relating to the woman behind him is lost. Ptolemy, an astronomer, mathematician, and geographer, is the founder of the Alexandrian school of scientific thought. He is engaged in debate with Hermes Trismegistos, the exponent of traditional human wisdom as embodied in myth. Although the style of this plate has been associated by some scholars with the European Mannerist period (A.D. 1525–1600), its silver content, method of manufacture, and a faint pattern of vines and leaves on its underside all confirm its ancient date.

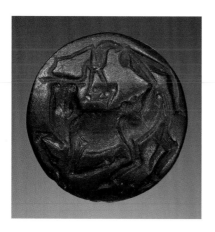

ENGRAVED SEAL

Minoan (made in Crete),
1450–1300 B.C.
Blue-gray hematite
H: 1.9 cm (¾ in.);
DIAM: 7 cm (2¾ in.)
2001.14.1

MINIATURE RELIEF

Greek (perhaps made in
Alexandria), 210–200 B.C.
Rhodolite garnet
H: 1.8 cm (¾ in.)
81.AN.76.59

Here, a male acrobat leaps over a bull, grasping one of its horns with his left hand. Such scenes of *taurokathapsia* (bull leaping) are typical of the art of Bronze Age Crete. They appear not only on engraved gems but also in frescoes and statuettes. Using minute drills and cutting wheels, the ancient gem carver has organized the composition to fill the circular field of the lentil-shaped stone. While the bull's body is seen in profile, its head is depicted frontally. The male leaper, meanwhile, has flipped himself over the animal. Nude but for a loincloth and codpiece, he has the tall, thin proportions and muscular legs found in Minoan art in other media.

Carved in relief, this exquisite bust of a veiled woman probably depicts Queen Berenike II, wife of King Ptolemy III Euergetes, who ruled Egypt from 246 to 221 B.C. She is shown with her hair rolled in a bun and bound by a fillet. Berenike was powerful and independent: ancient historians report that she rebelled against her mother, who wished her to marry a Macedonian prince. After her husband's death, she became joint ruler with her eldest son, Ptolemy IV, but was murdered by him soon after his ascension.

ENGRAVED GEM SET INTO A RING

Signed by Apelles
Roman, 25 – 1 B.C.
Carnelian and gold
Gem: 1.9 × 1.5 cm (³⁄₄ × ⁵⁄₈ in.);
DIAM of hoop: 3.36 cm
(1⁵⁄₁₆ in.)
90.AN.13

 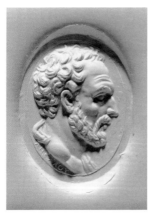

A finely carved portrait of Demosthenes (384 – 322 B.C.), the most famous of Athenian orators, decorates the gem of this large gold ring. Orators rarely appear on Roman gems, but representations of Demosthenes became popular in many media of the early Roman Empire. In fact, similar portraits in marble and bronze have survived, but only four on gems. This detailed engraving is of the highest quality and is signed *Apellou* ("of Apelles") below the neck.

CAMEO SET INTO A RING

Roman, A.D. 1 – 100 (cameo;
the ring is modern)
Sardonyx, gold
L of gem: 1.8 cm (³⁄₄ in.)
2001.28.9

Seated on an altar, Hermaphrodite pulls aside his/her drapery, revealing an erect penis as well as female breasts. The Roman poet Ovid explained in an episode of his *Metamorphoses* how the nymph Salmacis fell in love with Hermaphroditus, the son of Hermes and Aphrodite, and embraced him so tightly that the two eventually became a single bisexual being. The carver of this cameo—a single piece of banded sardonyx—has skillfully cut away the white layer to fashion the figure's body and drapery, leaving the honey-colored layer as a background. The apparent transparency of Hermaphrodite's garment and other stylistic features have led some scholars to attribute this cameo to the ancient carver Protarchos.

ASSEMBLAGE OF GOLD JEWELRY

Roman, A.D. 250–400
Gold with various inlaid and
attached stones, including
sapphire, emerald, garnet,
and glass paste
Various dimensions
83.AM.224–.228

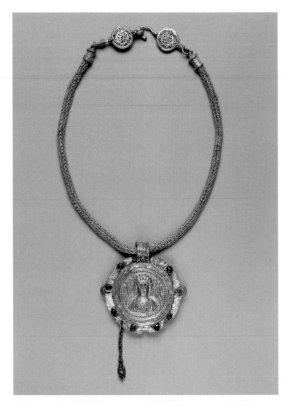

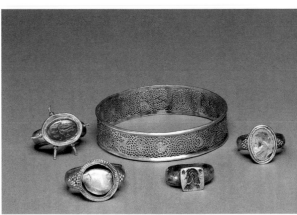

This magnificent hoard of jewelry presents a fascinating mélange of materials and techniques—and also serves as a reminder that, in times of violent uprisings or war, valuables were sometimes buried by an owner who did not survive to retrieve them. An elaborate gold *cingulum* (belt, top right) is the centerpiece of the assemblage. It features a large central medallion set with a sapphire surrounded by stone and glass inlays; the gold coins used in the twenty-three surviving squares span the reigns of the Roman emperors from Constans I (r. A.D. 337–50) to Theodosius I (r. A.D. 379–95). One of two necklaces (top left) has a gold repoussé medallion depict-

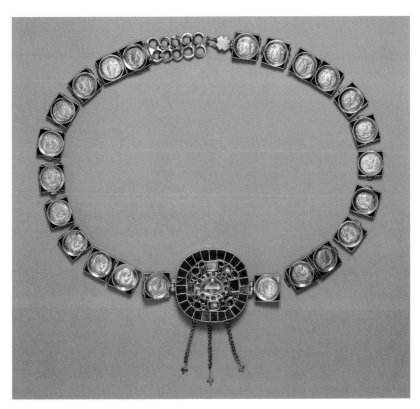

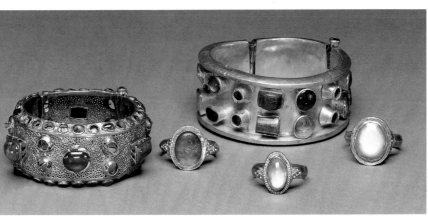

ing the frontal bust of woman, perhaps an empress. There are also two open-work gold bracelets, one decorated with animals within floral scrolls, the other encrusted with vibrantly colored gems. A third bracelet is designed as a solid cuff inlaid with glass and precious stones. One ring has a gold intaglio, while two are set with engraved gemstones, and four are mounted with semiprecious stones. The large size of the rings suggests that they were worn by a man, while the small size of the belt and bracelets indicates that they were made for a woman. Overall, this ensemble clearly evokes the opulence and decadent splendor of the late Roman Empire.

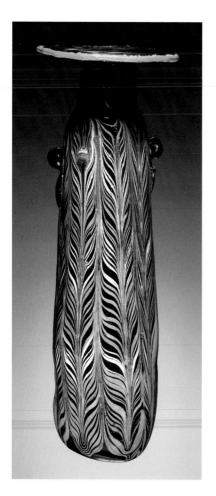

CORE-FORMED *ALABASTRON*

Greek, 400–200 B.C.
Glass
H: 16.5 cm (6½ in.)
2003.193

Elongated glass vessels such as this one were used to hold perfume, much like their counterparts in clay, stone, and metal. This *alabastron* was constructed by encasing a dried core of some composite material, probably clay or dung, in a dark blue glass. Additional trails of white, yellow, and turquoise glass were wound around the vessel's body, and then dragged with a pointed tool to create a feather-like pattern. The pinched neck and flattened rim were formed by pincers; the tool's marks can still be seen. Small handles were added onto the shoulder as a means of attaching a leather cord or bronze chain used to suspend the vessel.

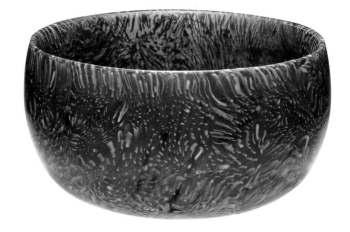

SNAKE-THREAD FLASK

Roman, A.D. 200–300
Glass
H: 14.2 cm (5⁹⁄₁₆ in.);
DIAM of mouth: 3.6 cm
(1⁷⁄₁₆ in.);
DIAM of body: 11.6 cm
(4⁵⁄₈ in.)
96.AF.56

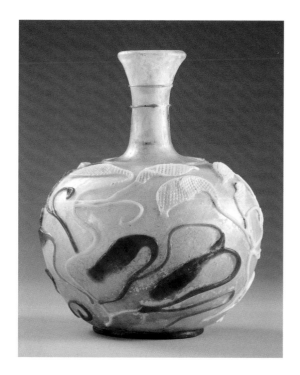

This free-blown flask of colorless glass has a globular body with a narrow neck and slightly flared rim. The neck is ornamented with an applied blue-glass trail, and a similar trail is wound on the base to provide a foot. The decoration on the body consists of blue and white trails arranged in foliate patterns. From undulating stems, flattened leaves spread over the curving surface of the flask.

The vessel is an eclectic mix of shape, color, and patterning that successfully blends elements ascribed to both eastern and western manufacture. Although the use of multicolored trails and the flask's globular shape compare closely to examples excavated in Cologne, Germany, its decoration belongs to the flower-and-bird style and its trails are cross-hatched, suggesting that it was produced in an atelier in the eastern Mediterranean.

BLUE AND WHITE HEMISPHERICAL MOSAIC BOWL

Greek or Roman, 100–1 B.C.
Glass
H: 5.2 cm (2¹⁄₁₆ in.);
DIAM: 10.2 cm (4 in.)
2004.24

A spectacular example of late Hellenistic or early Roman mosaic glass, this bowl was constructed from segments of a blue cane with a central white dot. When reheating the cane segments over a hemispherical mold in the glass kiln, the glassmaker allowed the glass to heat up enough to enable the white dot to run slightly, creating a vessel that almost resembles white sea anemones moving under Mediterranean blue water.

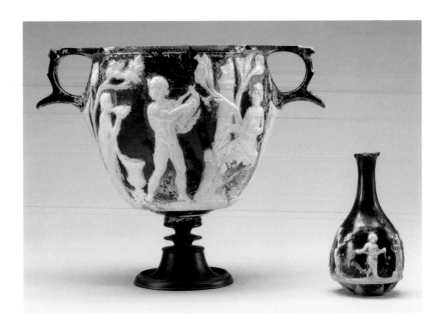

CAMEO GLASS SKYPHOS AND FLASK

Roman, 25 B.C.–A.D. 25
Cameo glass (white on blue)
Skyphos H (preserved):
10.5 cm (4⅛ in.);
DIAM: 10.6 cm (4⅛ in.)
Flask H: 7.6 cm (3 in.);
DIAM: 4.2 cm (1⅝ in.)
84.AF.85, 85.AF.84

Although glassmaking had been known since the mid-third millennium B.C., the method for making cameo glass was one of the highest technical achievements of the glass industry during the Roman period. Two or more layers of hot glass in different colors were overlaid, and then the upper layer was carved away to create a scene in low relief. Cameo glass resembles precious layered stones, such as banded agate, and it is possible that the artisans who carved cameo glass worked primarily in stone.

These two vessels are carved with complex narrative scenes. The *skyphos*, a drinking cup, is appropriately decorated with Dionysiac imagery: Dionysos, satyrs, and female figures. Its foot is a modern reconstruction. The imagery on the flask includes Erotes (winged gods of love), a striding pharaoh, an obelisk, and an altar surmounted by the Egyptian god Thoth. Egyptian imagery was popular in Rome during this period, and while the scene may relate to Egyptian mythology or the arrival of two obelisks in Rome at that time, it might simply be evocative of Egypt.

APPLIQUÉ DEPICTING THE HEAD OF PAN

Greek, circa 100 B.C.
Ivory
8.56 × 6.92 cm (3 ³⁄₈ × 2 ³⁄₄ in.)
87.AI.18

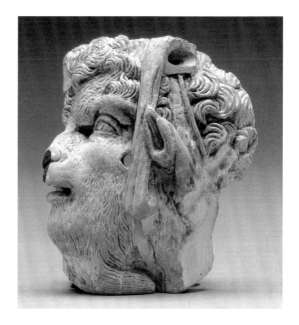

This exquisitely carved disk depicts the head of the
god Pan, a woodland deity associated with fertility.
Half-human and half-goat, he often joined the wine
god, Dionysos, in his drunken escapades. Here, Pan
is nearly all goat, with a flattened nose, his facial
hair and goatee tucked under his chin, and curling
locks resembling fleece on top of his head. His alert
ear is also goatlike and follows the direction of his
piercing gaze. The god's mouth is slightly open and a
row of small, short teeth is visible below his upper
lip. In his hair he wears a flat ribbon, or fillet, an item
associated with revelry. This roundel probably was
used to decorate the fulcrum (armrest) of a banquet-
ing couch, as suggested by the hole for attachment
in the god's cheekbone. Ancient literary sources
describe luxurious couches that were inlaid with
ivory and other precious materials. Ivory from both
African and Asian elephants was imported into
Mediterranean lands. The material's ability to hold
finely carved detail is evident in this expressive
profile portrait.

PAINTED
WALL PANEL

Etruscan, 520–510 B.C.
Terracotta with pigment
88 × 52.5 × 4.5 cm
(34⅝ × 20⅝ × 1¾ in.)
96.AD.140

The Etruscans frequently decorated tombs, temples, and secular buildings with brightly painted panels and terracotta figures. On this panel, a poised and dignified youth wears a light-colored tunic and a darker mantle with a decorated border. His figure is rendered in the composite manner characteristic of the late Archaic period, with his chest shown frontally and the rest of his body in profile. He carries a crooked stick with a forked top, a symbol indicating that he holds a specific office. In some scenes, such staffs are held by officials charged with the education and training of athletes. As athletic competitions were frequently convened in honor of the dead, this figure might have appeared in an athletic scene that decorated the interior of a tomb.

FRAGMENT OF A FRESCO DEPICTING LANDSCAPES

Roman, 50–25 B.C.
Plaster with pigment
91 × 80.5 cm
(35¹³/₁₆ × 31¹¹/₁₆ in.)
96.AG.170

The landscapes depicted on this wall fragment are characteristic of the Second Style of Roman painting. Popular in the first century B.C., this style is marked by illusionism: the wall is meant to appear not as a closed, solid surface but as an opening to a world beyond it. Between two columns, one with vertical flutes, the other with spiraling tendrils, two panels contain representations of colonnaded buildings.

These panels display an unusual greenish tinge. Some scholars have suggested that this color is the natural result of aging—that the pigment was originally blue but, over time, changed to green. However, it is more likely that the uniform green color was selected deliberately and might depict window glass. In antiquity, naturally colored glass (including glass used for windows) often had a greenish or yellowish tinge due to chemical elements present in the sand used to make it. But landscapes with a solid-color wash are characteristic of Second Style paintings, and the green color used here may simply be an expression of that style.

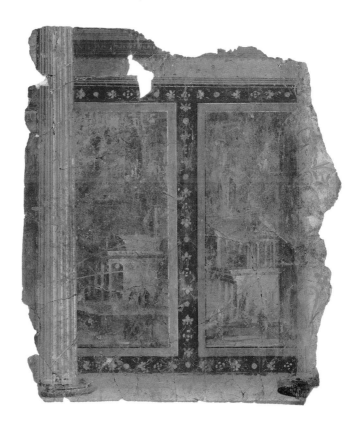

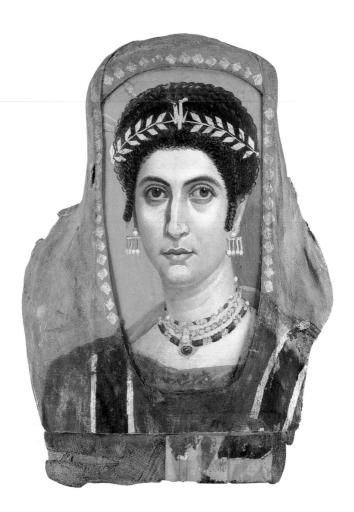

MUMMY PORTRAIT OF A WOMAN

Attributed to the
Isidora Master
Romano-Egyptian
(made in the Fayum, Egypt),
A.D. 100–110
Encaustic and gilding on
a wooden panel; linen
48 × 36 cm (18⅞ × 14³/₁₆ in.)
81.AP.42

Portraits such as this one may have been executed
from life. Perhaps painted on a square wooden panel,
it might have been reshaped after the subject's death
and incorporated into the linen wrappings of the
mummy. The liveliness, directness, and individuality
of the woman portrayed here suggest that this lady
sat for her portrait sometime before her death. She is
shown as an elegant matron elaborately adorned with
gold and silver hairpins, earrings of gold and pearls
dangling from her earlobes, and three separate neck-
laces surrounding her throat. Her jewelry and coiffure
help date the portrait to the early second century A.D.
The diadem was added after the panel was incorpo-
rated into the mummy wrappings.

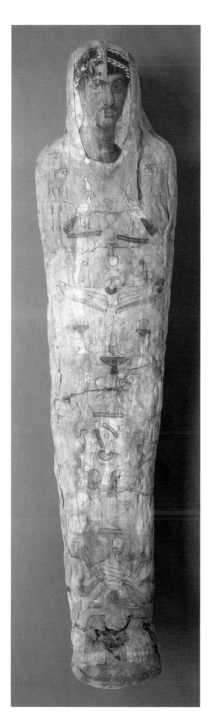

MUMMY WITH PORTRAIT

Romano-Egyptian (perhaps
made in El Hibeh, Egypt)
A.D. 100–150
Wax tempera and gilding
on a wooden panel; linen
and encaustic
175.3 × 44 × 33 cm
(69 × 17⁵/₁₆ × 13 in.)
91.AP.6

Mummies such as this one combine
the Roman tradition of individualized
portraiture with the ancient Egyptian
practice of mummification of the dead.
The portrait depicts a young man with
a light mustache and loose, curly hair.
His name, Herakleides, appears on the
outer edge of his feet. Some areas of
the portrait—such as the background,
wreath, and decorative squares sur-
rounding the panel—have been
enhanced with gilding. Belonging to
a small group of mummies wrapped
in shrouds painted red, this one has
mythological scenes connected with
the Egyptian funerary ritual along the
length of his body. One of them depicts
an ibis; modern CAT (computerized
axial tomography) scans have revealed
a mummified ibis inside the wrap-
pings, suggesting that Herakleides
may have been associated with the
Egyptian god Thoth, possibly as a
priest, scribe, or worshiper.

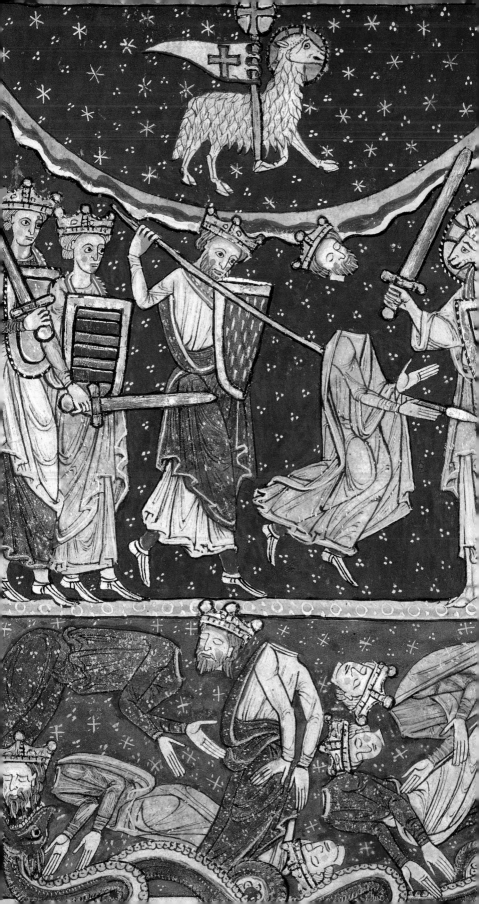

Manuscripts

THE ARTISTIC AIMS of medieval and Renaissance painters often found their purest expression in the pages of manuscripts, books written and decorated entirely by hand. In 1983 the trustees of the Museum began a collection of these precious objects with the purchase of the holdings of Dr. Peter and Irene Ludwig of Aachen, Germany. In order to provide as complete and balanced a representation as possible, almost one hundred further acquisitions have been made since 1984, including entire codices as well as cuttings or groups of leaves from individual books.

In the Middle Ages and the early Renaissance, manuscripts were the most important means of recording not only scripture and liturgy but also history, literature, law, philosophy, and science texts. In turn, the illumination (the painted decoration of a manuscript) of these writings was a major art form of the period, and as such, book illumination provides the most complete record of the accomplishments of medieval painting and important evidence of the achievements of Renaissance painters.

The collection comprises masterpieces of Ottonian, Byzantine, Romanesque, Gothic, International style, and Renaissance illumination found in manuscripts made in Germany, France, Belgium, Italy, England, Spain, Poland, and the eastern Mediterranean. Among the highlights from the early and high Middle Ages are two Ottonian sacramentaries (see pp. 56–57); two German Romanesque manuscripts: a Gospel book from Helmarshausen (see p. 58) and the Stammheim Missal (see pp. 60–61); a French Gothic psalter (see p. 62); and an English Gothic Apocalypse (see p. 63). The holdings of late medieval French manuscripts include illuminations by the Boucicaut Master (see p. 71) and by Jean Fouquet (see p. 75), among others. The collection features a trove of late Flemish manuscripts, including *The Visions of the Knight Tondal*, attributed to Simon Marmion and commissioned by Margaret of York, Duchess of Burgundy (see p. 78); the Prayer Book of Cardinal Albrecht of Brandenburg, with miniatures by Simon Bening (see p. 82); and the *Model Book of Calligraphy*, illuminated by Joris Hoefnagel for Emperor Rudolf II (see p. 83). Among the acquisitions in the area of Italian illumination are a monumental depiction of the Ascension designed by Lorenzo Monaco (see p. 73) and a sumptuous missal illuminated by Matteo da Milano (see p. 81).

The Getty provides one of the most ambitious programs for the display of illuminated books in the world, exhibiting manuscripts on a rotating basis year-round.

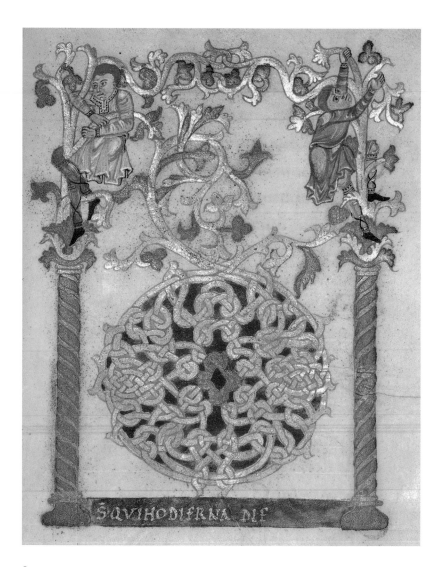

SACRAMENTARY

French (Fleury),
circa 1000–1025
Parchment, ten leaves
23.2 × 17.9 cm
(9⅛ × 7¹/₁₆ in.)
Ms. Ludwig v 1; 83.MF.76
Illustration: Attributed to
Nivardus of Milan,
Decorated Initial *D*
(fol. 9)

The most important type of liturgical book used in the early medieval church, the sacramentary contains the prayers said by a priest at mass. The initial letters introducing the main prayers in this sacramentary fragment are filled with elaborate interlace ornament and foliate sprays. In the lively initial *D* shown here, the artist has also included two young men who clamber through the vines outside the initial, as if they have escaped. The lavish use of gold, silver, and purple in the decoration suggests that the book was made for a member of the royal circle, possibly by Nivardus of Milan, an artist known to have worked in France.

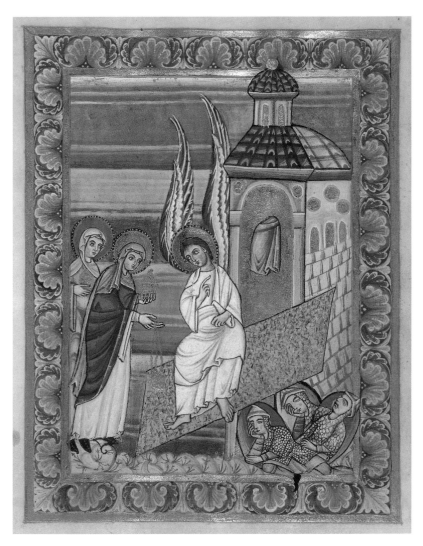

Sacramentary

German (Mainz or Fulda),
circa 1025–50
Parchment, 180 leaves
26.7 × 18.9 cm
(10 1/2 × 7 7/16 in.)
Ms. Ludwig V 2; 83.MF.77
Illustration: *The Women
at the Tomb* (fol. 19v) and
binding cover

The seven full-page
miniatures in this book
reveal the monumental-
ity of painting during
the Ottonian period
(so called after a series
of German emperors
named Otto). Set against
colored bands, these
sacred scenes are
infused with an other-
worldly, timeless quality.
The manuscript's luxur-
ious binding, showing
Christ in Majesty, dates
from the 1100s.

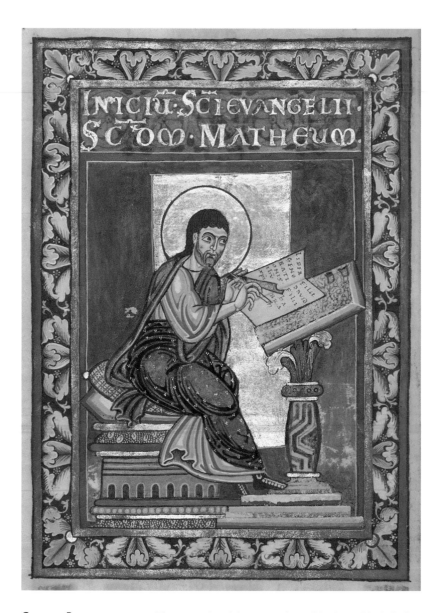

GOSPEL BOOK

German (Helmarshausen),
circa 1120–40
Parchment, 168 leaves
22.9 × 16.5 cm (9 × 6½ in.)
Ms. Ludwig II 3; 83.MB.67
Illustration: *Saint Matthew*
(fol. 9v)

The portraits of the evangelists (Matthew, Mark, Luke, and John) that illustrate this Gospel book exemplify the Romanesque style developed at Helmarshausen Abbey, an important artistic center in northern Germany, which enjoyed the patronage of Henry the Lion, Duke of Saxony and Bavaria (r. 1142–80). The compositions are constructed from lively patterns, the colors are vibrant and saturated, and a firm black outline is used to separate areas of color. Saint Matthew is shown here with the instruments of a medieval scribe: parchment leaves, made from animal skin; a quill pen, which he uses to write the words of his Gospel; and a knife to scrape away any mistakes.

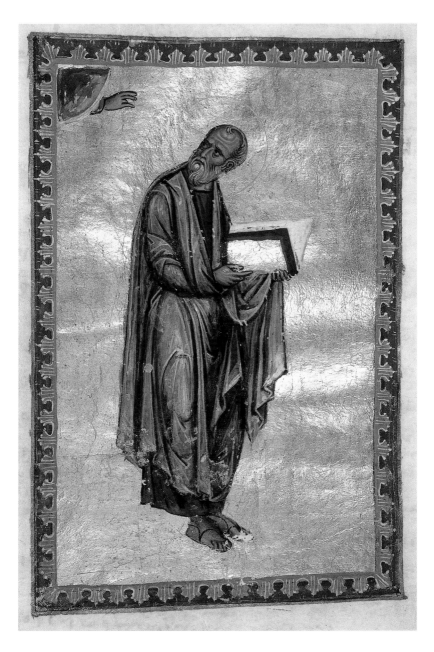

New Testament

Byzantine (Constantinople),
1133
Parchment, 279 leaves
22.1 × 18.1 cm (8 ¹¹/₁₆ × 7 ¹/₈ in.)
Ms. Ludwig II 4; 83.MB.68
Illustration: *Saint John
the Evangelist* (fol. 106v)

The portraits of the evangelists in this copy of the
New Testament are among the finest achievements of
Byzantine illumination (Byzantium was the eastern
half of the Roman Empire after A.D. 395). Here, Saint
John, author of one of the four Gospels, receives
divine inspiration for his text from the hand of God,
which emerges from the heavens at left. The illumi-
nation's radiant golden background, devoid of other
details, contrasts with the figure's naturalism and
carefully modeled features.

BREVIARY

Italian (Montecassino), 1153
Parchment, 428 leaves
19.2 × 13.2 cm
(7⁹⁄₁₆ × 5³⁄₁₆ in.)
Ms. Ludwig IX 1; 83.ML.97
Illustration: Inhabited
Initial C (fol. 138v)

Sigenulfus, the scribe of this breviary, identified himself in a prayer he penned on one of its leaves. He was a member of the monastic community at Montecassino, the cradle of the Benedictine order, which was founded in the sixth century by Saint Benedict. During the eleventh and twelfth centuries, the monastery's scriptorium developed a distinctive style of decorative initial in which the paneled framework of the letter brims over with a frenzied mixture of interlaced tendrils and fantastical creatures.

STAMMHEIM MISSAL

German (Hildesheim),
circa 1170s
Parchment, 184 leaves
28.2 × 18.9 cm
(11⅛ × 7⁷⁄₁₆ in.)
Ms. 64; 97.MG.21
Illustration: The Creation
of the World (fol. 10v)

This missal (a book containing the texts necessary for the performance of the mass) is profusely illuminated with hundreds of decorated initials and a series of stunning full-page miniatures of a rare theological complexity. The miniatures—many of which include numerous figures and inscriptions—are full of variety. In this image of the Creation of the World, the Creator, flanked by seraphim, holds a disk with roundels representing the six days of creation between the spokes. Painted in a Romanesque style characterized by saturated colors, abundant use of gold and silver leaf, and compositions organized geometrically for clarity, the illuminations are dynamic, vibrant, and majestic.

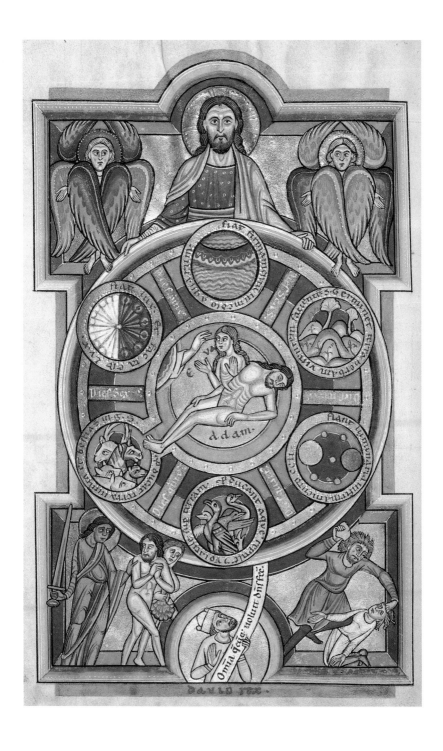

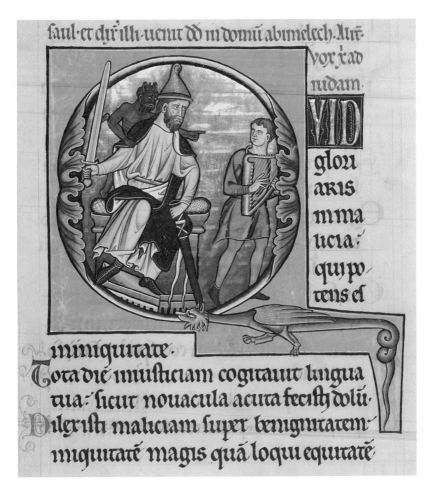

PSALTER

French (probably Noyon),
after 1205
Parchment, 176 leaves
31 × 21.9 cm (12 3/16 × 8 5/8 in.)
Ms. 66; 99.MK.48
Illustration: Master of the
Ingeborg Psalter, *Initial Q:
David before Saul* (fol. 55)

The style of the illuminations in this psalter—a book containing the Psalms of the Bible and other devotional texts—represents a turning point in the history of European art. In this initial, King Saul, jealous of young David's popularity at court following his defeat of Goliath, draws his sword against the youth. David's fear is apparent as he locks eyes with Saul over his shoulder, while his anxious desire to escape is conveyed by the placement of a portion of his left foot outside the initial's outline. The artist gives the scene unusual vividness by portraying both the physical and psychological aspects of the event. The attention to detail heralds the emerging Gothic style, in which illuminators turned from the abstract and highly stylized painting of the Romanesque toward a naturalistic representation of the visible world.

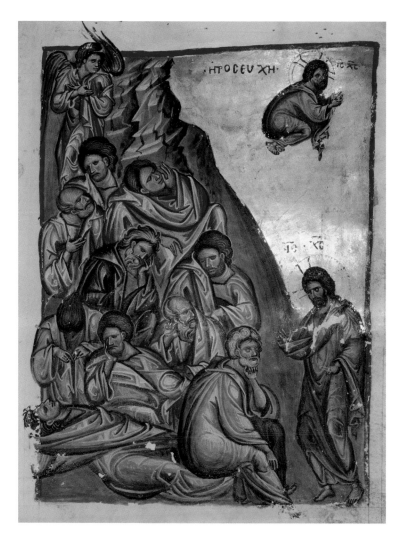

GOSPEL BOOK

Byzantine (Nicaea or
Nicomedia), early and late
thirteenth century
Parchment, 241 leaves
20.6 × 14.9 cm
(8⅛ × 5⅞ in.)
Ms. Ludwig II 5; 83.MB.69
Illustration: *The Agony
in the Garden* (fol. 68)

The extensive decoration in this Gospel book was
executed at different stages over the course of the
thirteenth century and is thus an important witness
to changes in Byzantine art at a pivotal moment in
European history. This miniature from the end of
the century is representative of the Palaiologan phase
of Byzantine art. The style (which flourished after
the Western Crusaders were expelled from Constanti-
nople in 1261 and is named after the imperial family
of the Palaiologi) is noted for the use of large-scale
figures based on classical models and portrayed with
dramatic gestures and intensity of feeling. With the
expansive composition of the apostles arrayed against
the mountain backdrop, the three-dimensionality evi-
dent in the drapery folds, and the care taken to indi-
vidualize each figure, *The Agony in the Garden* stands
as an impressive monument of later Byzantine art.

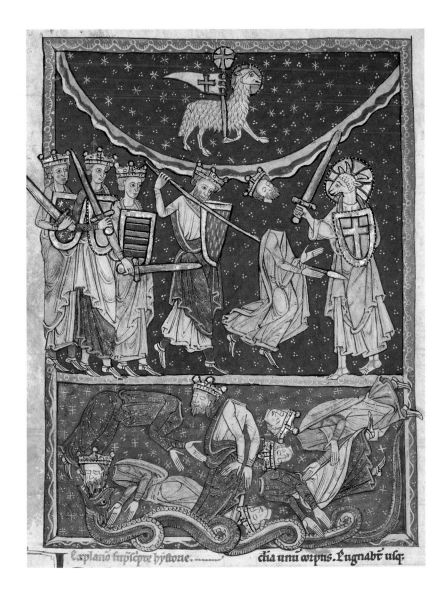

LEAF FROM BEATUS OF LIÉBANA, *COMMENTARIUS IN APOCALYPSIM*

Spanish, circa 1220–35
Parchment
29.4 × 23.5 cm
(11⁹/₁₆ × 9¼ in.)
Ms. 77; 2003.103
Illustration: *The Lamb Defeating the Ten Kings* (recto)

This miniature came from a manuscript containing a commentary on the Apocalypse, the biblical account of the events leading to the end of the world. Skillfully wielding a sword and in the guise of a medieval knight, Christ as the Lamb of God decapitates his foes, while below a monstrous serpent swallows their remains. Characteristic of early Gothic painting are such elements as the expressive figures who fill the scenes with action and the graceful folds of drapery that help define their almost dancelike movements. This particular commentary, by Beatus of Liébana (ca. 730–798), inspired some of the most original and vivid illuminated manuscripts of the entire Middle Ages.

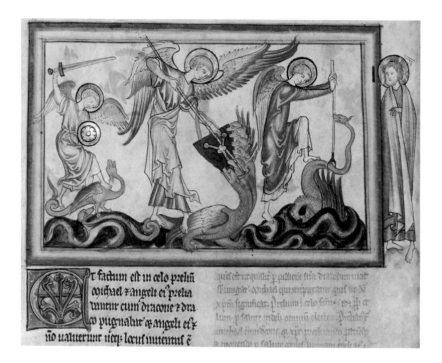

DYSON PERRINS APOCALYPSE

English (probably London),
circa 1255–60
Parchment, forty-one leaves
31.9 × 22.5 cm
(12 9/16 × 8 7/8 in.)
Ms. Ludwig III 1; 83.MC.72
Illustration: *The Battle
between the Angel
and the Dragon* (fol. 20v)

A fashion for richly illustrated copies of the Apocalypse (Saint John's vision of the end of the world as recorded in the New Testament book of Revelation) developed in England in the mid-thirteenth century. Through the pictures and texts of manuscripts such as this one, which contains eighty-two half-page miniatures, aristocratic lay patrons could contemplate the calamitous events described by Saint John.

Remarkable for their lively interpretation of the saint's vision, the miniatures show John witnessing the extraordinary events as they occur. The figures were outlined in pen and ink and then modeled with thin, colored washes. Their elegant poses, the graceful contours of the forms, and the decorative patterns of the drapery folds typify early English Gothic illumination at its finest.

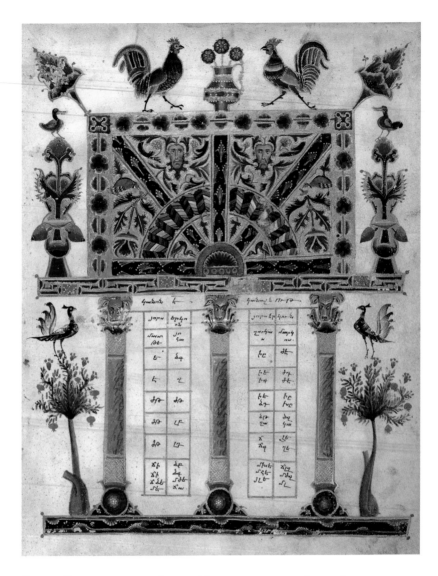

CANON TABLES
FROM THE
ZEYT'UN GOSPELS

Armenian (Hromklay), 1256
Parchment, eight leaves
26.5 × 19 cm
(10 7/16 × 7 1/2 in.)
Ms. 59; 94.MB.71
Illustration: T'oros Roslin,
Canon Table Page (fol. 6)

Canon tables present a concordance of passages
relating the same events in the four Gospels. Canon
table pages were an important field for decoration
in manuscript Bibles and Gospel books throughout
the Middle Ages, the columns of numbers inviting
an architectural treatment. On this page, the Armenian
illuminator T'oros Roslin (active ca. 1256–68) has
placed the text within a grand and brilliantly colored
architecture that includes animal heads and human
faces, and he has enlivened the page with a variety of
plants and birds.

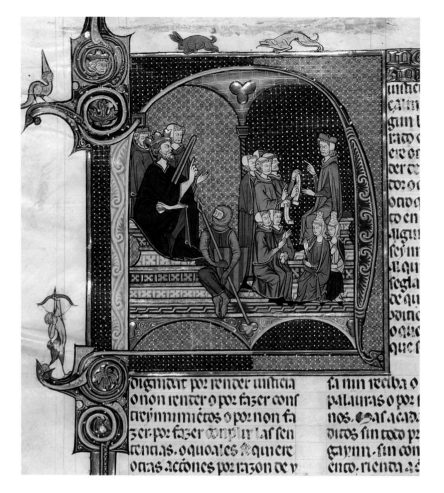

VIDAL MAYOR

Spanish (northeastern
Spain), circa 1290 – 1310
Parchment, 277 leaves
36.5 × 24 cm
(14⅜ × 9⁷⁄₁₆ in.)
Ms. Ludwig xiv 6; 83.mq.165
Illustration: *Initial N:
King James I of Aragon
Overseeing a Court of Law*
(fol. 72v)

This sumptuous volume is the only known copy of the
law code of Aragon, which King James I (r. 1214–76)
ordered Vidal de Canellas, the bishop of Huesca, to
compile in 1247. The manuscript, a translation into
the vernacular (the language native to a region rather
than a literary language such as Latin), was probably
made for one of James's royal successors. It is illus-
trated with ten large and more than a hundred small
scenes set into initials. The style of illumination,
painted in primary colors, emulates Parisian court art
in both the narrative strength of the scenes and the
elegant figural types.

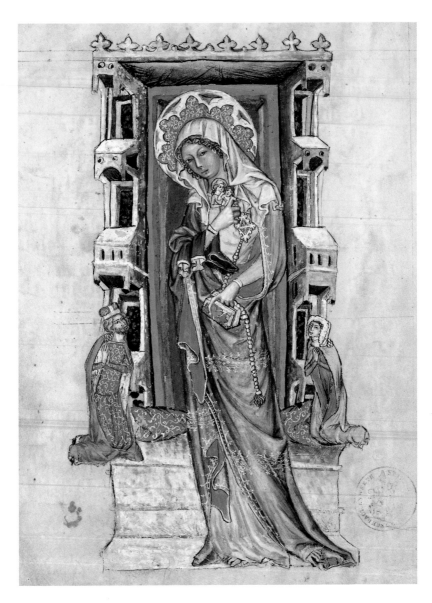

VITA BEATAE HEDWIGIS

Silesian, 1353
Parchment, 204 leaves
34.1 × 24.8 cm
(13⁷/₁₆ × 9¾ in.)
Ms. Ludwig XI 7; 83.MN.126
Illustration: *Saint Hedwig
of Silesia with Duke Ludwig
of Liegnitz and Brieg and
Duchess Agnes* (fol. 12v)

This manuscript is the earliest illustrated copy of
the *Life of the Blessed Hedwig*, whose subject was a
thirteenth-century duchess of Silesia (a duchy on
the border between Poland and Germany). It contains
one of the masterpieces of Central European manu-
script illumination: a full-page miniature of Saint
Hedwig herself. Hedwig, who founded a number of
religious houses in Silesia, carries a book, prayer
beads, and a small statue of the Virgin, all references
to her devout character. The small-scale donor
portraits represent Duke Ludwig I of Liegnitz and
Brieg, the saint's descendant, and his wife, Agnes, who
commissioned the manuscript in 1353.

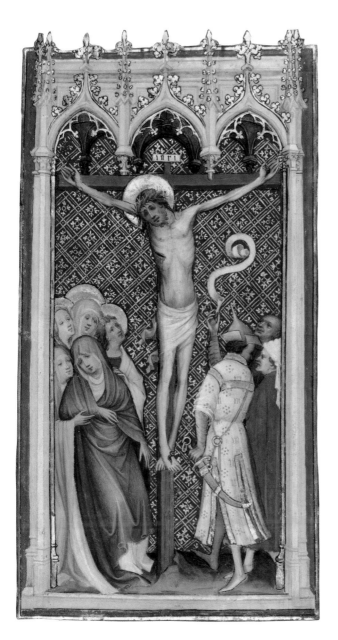

MINIATURE

German (Cologne),
circa 1400–1410
Parchment, one of a pair
of two leaves
23.7 × 12.4 cm
(9⁵/₁₆ × 4⁷/₈ in.)
Ms. Ludwig Folia 2; 83.MS.49
Illustration: Master of
Saint Veronica,
The Crucifixion (leaf 1, recto)

The courtly elegance of the International style is
captured in the rich costumes, brilliantly patterned
background, and softly modeled forms of this
Crucifixion. The attenuated limbs of Christ empha-
size his physical suffering and human frailty, while
the flowing draperies of the Virgin Mary echo her
swooning posture and underscore her grief. Attributed
to the Master of Saint Veronica, a leading artist of
Cologne, this leaf and its companion miniature
depicting Saint Anthony may once have been part
of a liturgical manuscript.

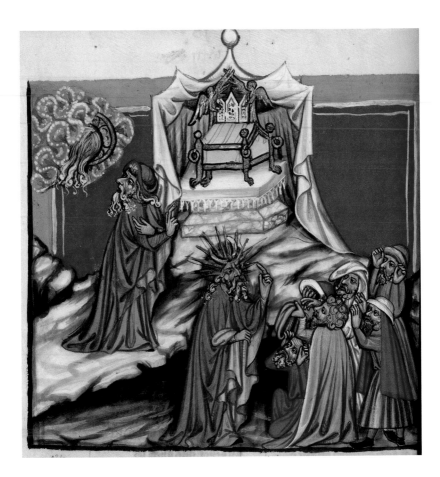

Rudolf von Ems, *Weltchronik*

Bavarian (Regensburg),
circa 1400–1410,
with addition in 1487
Parchment, 309 leaves
33.5 × 23.5 cm
(13³/₁₆ × 9¼ in.)
Ms. 33; 88.MP.70
Illustration: *Moses's Vision
of the Back of God's Head
and the Ark of the Covenant*
(fol. 89v)

The *World Chronicle* of Rudolf von Ems (ca. 1200–
ca. 1254) was written in rhymed couplets that weave
biblical, classical, and other secular texts into a
continuous history of the world beginning with the
Creation. This miniature depicts two scenes: an
unusual representation of Moses's vision of the back
of God's head (Exodus 33:12–23) and Moses after his
descent from Mount Sinai (Exodus 34:29–35). He is
represented with horns, the result of a medieval
misunderstanding of Saint Jerome's translation of the
original Hebrew text. The vigorous, broadly painted
miniatures with contrasting, often incandescent colors
find few parallels in European art of the first half
of the fifteenth century. The miniatures of the *World
Chronicle* have a bold narrative style; the figures
have intense expressions and interact dramatically.

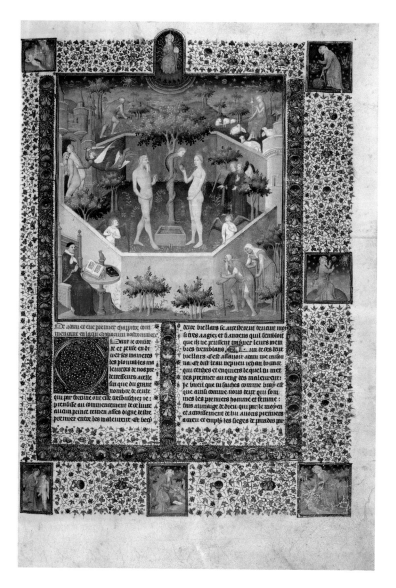

GIOVANNI BOCCACCIO, *DES CAS DES NOBLES HOMMES ET FEMMES*

French (Paris), circa 1415
Parchment, 318 leaves
42 × 29.6 cm
(16 9/16 × 11 5/8 in.)
Ms. 63; 96.MR.17
Illustration: Boucicaut
Master and workshop,
The Story of Adam and Eve
(fol. 3)

The Florentine poet Giovanni Boccaccio (1313–1375) is perhaps best known today for the *Decameron;* however, in the later Middle Ages, *Concerning the Fates of Illustrious Men and Women* was one of his most popular efforts. It relates the stories of notables from biblical, classical, and medieval history. Here, the highly original and influential artist known as the Boucicaut Master skillfully structures scenes from the story of Adam and Eve both inside and outside the wall that bounds the Garden of Eden. In the foreground, the aged couple approaches Boccaccio, who sits to the left, to tell their story.

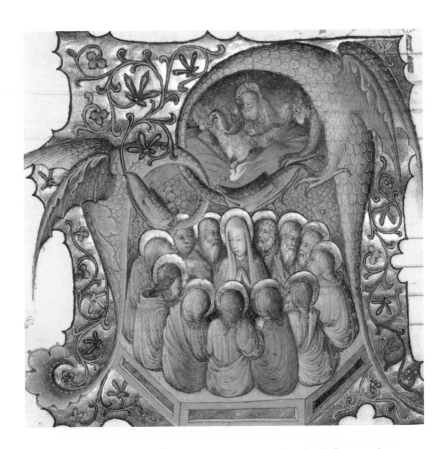

**CUTTING FROM
AN ANTIPHONAL**

Italian (Lombardy),
circa 1430 – 35
Parchment
11.9 × 12.5 cm
(4¹¹/₁₆ × 4¹⁵/₁₆ in.)
Ms. 95; 2005.28
Illustration: Stefano
da Verona, *Initial A:
Pentecost* (recto)

This highly inventive initial *A* with *Pentecost* is
attributed to the Lombard-trained painter Stefano da
Verona (ca. 1374/75–1438?), a major exponent of
the International style in northern Italy. It epitomizes
the poetic, colorful quality of court art in the early
fifteenth century. The tenderness of expression seen
in the figures, the soft palette of colors, the verdant
landscape detailed in gold, and even the sleepy
dragons who enclose the whole are all elements
that imbue the intimate scene of the Holy Spirit
descending upon the apostles with an uncommon
lyricism and sweetness.

CUTTING FROM A GRADUAL

Italian (Florence),
designed circa 1410 and
completed circa 1431
Parchment
40.2 × 32.4 cm
(15⅞ × 12¾ in.)
Ms. 78; 2003.104
Illustration: Designed
by Lorenzo Monaco,
and completed probably
by Zanobi Strozzi and
Battista di Biagio Sanguini,
Initial V: The Ascension
(recto)

This illuminated initial *V* depicts Christ's last appearance to the apostles on earth after his Resurrection, as he is being taken up into heaven. The rising figure of Christ and the gesticulating apostles are all clad in elegant drapery that is so sculptural in feel that it looks as though it could have been made by a goldsmith. The contrasting colors used to enliven the scene and to model the clothing, however, demonstrate a more purely painterly interest. The initial, which originally graced a choir book, was designed by Lorenzo Monaco (Florence's most celebrated late medieval painter; ca. 1370–1423/24) but was finished long after his death.

LEAF FROM THE TURIN-MILAN HOURS

Flemish, circa 1440–45
Parchment
27.2 × 17.6 cm
(10¹¹⁄₁₆ × 6¹⁵⁄₁₆ in.)
Ms. 67; 2000.33
Illustration: Master of the Berlin Crucifixion or circle, and Master of Jean Chevrot or circle, *Christ Blessing* (verso)

This large miniature represents Jesus Christ holding tablets inscribed in Latin with a passage from the Gospel of Saint John: "I am the way, the truth, and the life." The leaf comes from a famous prayer book, the only known manuscript with miniatures by the great Flemish painter Jan van Eyck (ca. 1395–1441), who perfected the technique of oil painting on panel. Here, using an egg-based paint, this illuminator from Van Eyck's workshop has evoked the subtle tonal effects of oil painting by layering thin glazes of color, as in Christ's robe.

HOURS OF
SIMON DE VARIE

French (Tours and
perhaps Paris), 1455
Parchment,
ninety-seven leaves
11.4 × 8.3 cm
(4½ × 3¼ in.)
Ms. 7; 85.ML.27
Illustration: Jean Fouquet,
*The Virgin and Child
Enthroned* (fol. 1v)

One of the great fifteenth-century French painters,
Jean Fouquet (ca. 1425–1478) is famous for the geo-
metric simplicity and monumentality of his minia-
tures. His technical mastery is evident in the tiny
points of gold that shimmer across the Virgin's robe
and in the transparent cascade of hair that falls
down her back. Fouquet, a panel painter as well as
an illuminator, worked successively at the courts
of Charles VII (r. 1422–61) and Louis XI (r. 1461–83)
of France. This manuscript is a portion of a book of
hours made for Simon de Varie, a high official at
the royal court. Separated from the Getty volume in
the seventeenth century, the two other portions of
the book are now in the Royal Library at The Hague.

MINIATURE

Italian (probably Mantua),
circa 1460–70
Parchment
20.2 × 12.9 cm
($7^{15}/_{16}$ × $5^{1}/_{16}$ in.)
Ms. 55; 94.MS.13
Illustration: Girolamo
da Cremona,
Pentecost (recto)

Girolamo da Cremona (active ca. 1455–85) was one of
the major interpreters of the new Renaissance style
in the art of book illumination. An itinerant artist, he
worked for patrons in Ferrara, Padua, Mantua, Siena,
Florence, and Venice. Girolamo's debt to his great
contemporary, fellow painter Andrea Mantegna
(ca. 1431–1506), is clearly seen in this miniature, which
probably came from a devotional or liturgical manu-
script. The pervasive classicism, the sculptural quality
of the modeling, and the sense of symmetry and
order are all trademarks of Mantegna's style. The illu-
sionistic frame and the expansive space of the grand
architectural setting indicate that Girolamo conceived
of this miniature as monumental in its effect.

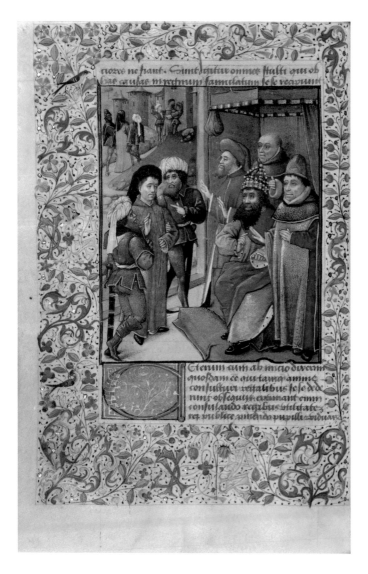

**AENEAS
SILVIUS
PICCOLOMINI,
*DE DUOBUS
AMANTIBUS
HISTORIA***

French, circa 1460–70
Parchment,
forty-six leaves
17.6 × 11.4 cm
(6¹⁵⁄₁₆ × 4½ in.)
Ms. 68; 2001.45
Illustration: *An Emperor
at Court* (fol. 14v)

This manuscript contains two texts written by Aeneas
Silvius Piccolomini (1405–1464) before he became
Pope Pius II, while he was working at the court of the
Holy Roman Emperor. The first of his texts is a letter
to a friend describing in frank terms the dangers of
life at court. In this miniature the unpleasant fate of a
prisoner standing trial before the emperor is revealed
in the background, where he is hauled off to the
city gate and stabbed in the back. The artist imparts
psychological complexity to the scene by portraying
a series of distinctive individuals whose interactions
and responses contribute to the flow of the narrative.
The figures are rather heavy and solid, yet painted
in jewel-like tones and with a light touch, giving the
miniatures an unusual luminosity.

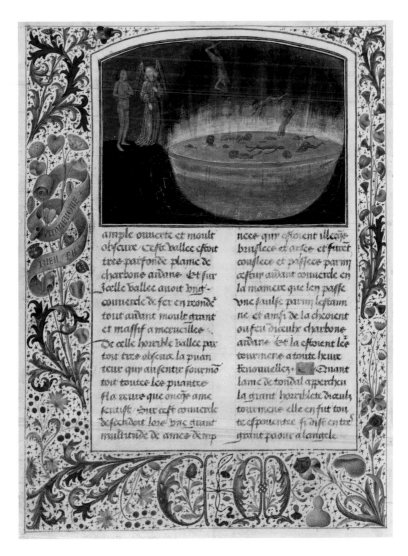

LES VISIONS DU CHEVALIER TONDAL

Franco-Flemish
(Valenciennes and
Ghent), 1475
Parchment, forty-five leaves
36.3 × 26.2 cm
(14 ⁵/₁₆ × 10 ⁵/₁₆ in.)
Ms. 30; 87.MN.141
Illustration: Simon Marmion,
The Torment of Murderers
(fol. 13v)

The Visions of the Knight Tondal is a medieval tale about a wealthy Irish knight whose soul embarks on a journey through hell, purgatory, and heaven, during which he learns the wages of sin and the value of penitence. Written in Latin in the middle of the twelfth century, the popular story was translated into fifteen European languages over the next three centuries. This sumptuous manuscript, commissioned by Margaret of York, Duchess of Burgundy (1446–1503), is the only known illuminated copy of the text and contains twenty miniatures. In the scene illustrated here, Tondal's guardian angel shows the soul of the knight a burning valley in which murderers' souls are cooked on an iron lid. Above it the slim, naked figures of the damned rise and fall in a graceful ballet of torment.

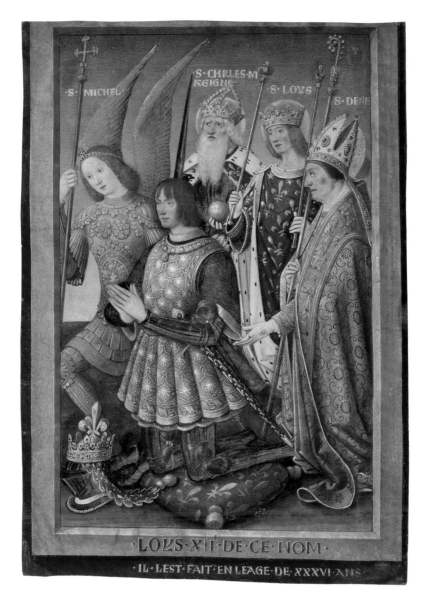

·S·MICHEL·
S·CHRLES·M RGIGNE·
·S·LOYS·
S·DENI

·LOYS·XII·DE·CE·NOM·
·IL·LEST·FAIT·EN·LEAGE·DE·XXXVI·ANS·

MINIATURE FROM THE HOURS OF LOUIS XII

French (Tours), 1498/99
Parchment
24.3 × 15.7 cm
(9 9/16 × 6 3/16 in.)
Ms. 79a; 2004.1
Illustration: Jean Bourdichon,
*Louis XII of France Kneeling
in Prayer, Accompanied by
Saints Michael, Charlemagne,
Louis, and Denis* (recto)

This miniature comes from one of the most impor-
tant manuscript commissions of the last years of the
fifteenth century, the Hours of Louis XII. Jean
Bourdichon (1457–1521), the artist of the miniature,
had a long career spanning nearly forty years and
served as court painter to four successive French
kings, including Louis XII (r. 1498–1515). In this
frontispiece to the manuscript, Louis is shown sur-
rounded by the most important saints associated
with the French monarchy: Saint Denis, Saint Louis,
Saint Charlemagne, and Saint Michael. The finely
observed portrait of Louis XII shows Bourdichon at
the height of his artistic powers.

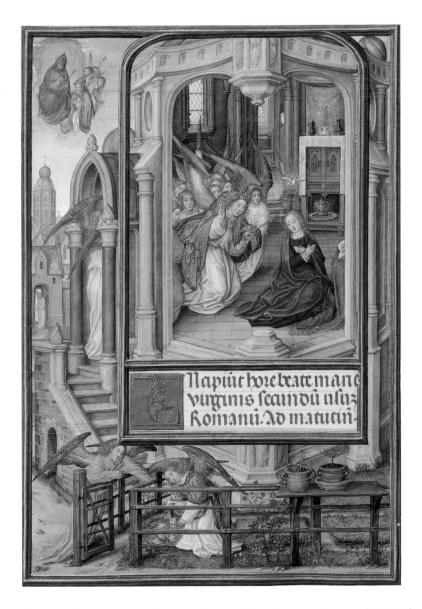

In the image text:

Napiũc hoze beate marie
virginis scam dũ ulũz
Romanu. Ad matutiñ

SPINOLA HOURS

Flemish (Bruges and Ghent),
circa 1510–20
Parchment, 312 leaves
23.2 × 16.7 cm
(9 1/8 × 6 9/16 in.)
Ms. Ludwig IX 18; 83.ML.114
Illustration: Master
of James IV of Scotland,
The Annunciation (fol. 92v)

In one of the most inventive page designs of sixteenth-century manuscript illumination, the anonymous artist known as the Master of James IV of Scotland has unified the traditionally separate zones of the main image and the decorated border. The central scene of the Annunciation is shown taking place inside the Virgin Mary's chamber, while the exterior of the same building, where angels joyously pick flowers in the Virgin's garden, is depicted in the surrounding border. Thus, the setting of the miniature has expanded beyond its traditional boundaries to fill the page and provide the viewer with a playful interaction between illusion and reality.

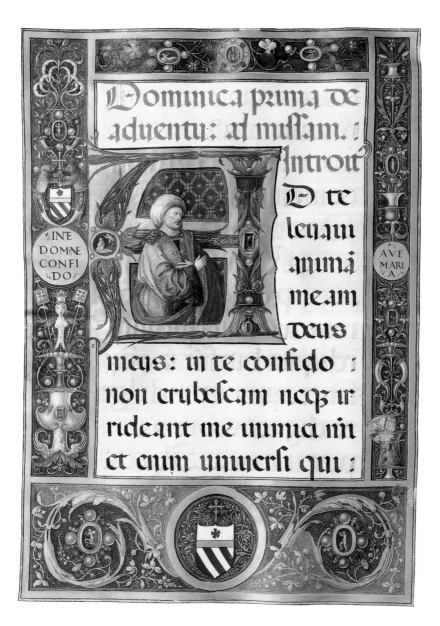

MISSAL

Italian (Rome), circa 1520
Parchment, ninety-eight
leaves
33.6 × 23.4 cm
(13¼ × 9³⁄₁₆ in.)
Ms. 87; 2004.65
Illustration: Matteo da
Milano, *Initial A: King David*
(fol. 52v)

This missal is an exquisitely preserved example of the
work of Matteo da Milano (act. ca. 1492–1523). Matteo
was known for his rich, saturated colors, robust mod-
eling, and a penchant for exotic costumes. His innova-
tive and eclectic style can be seen here in the brilliant
border decoration, with its combination of grotesques,
jewels, cameos, and other objects inspired by classi-
cal antiquity, as well as in the carefully observed flora
and fauna. The manuscript also contains allusions
pertaining to its owner: the coat of arms at the upper
left is flanked by two little bears—*orsini* in Italian—
referring to the well-known Orsini family.

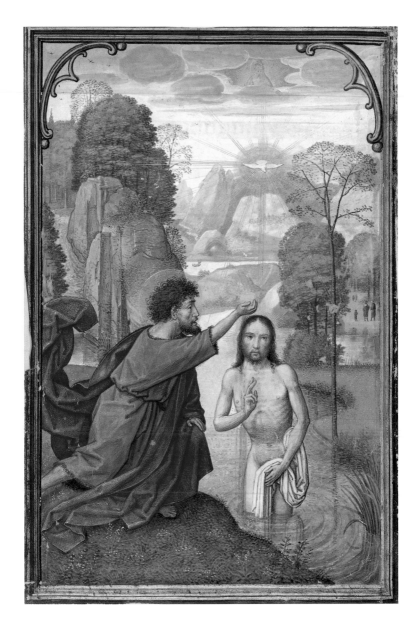

PRAYER BOOK OF CARDINAL ALBRECHT OF BRANDENBURG

Flemish (Bruges),
circa 1525–30
Parchment, 337 leaves
16.8 × 11.4 cm (6⅝ × 4½ in.)
Ms. Ludwig IX 19; 83.ML.115
Illustration: Simon Bening,
The Baptism of Christ
(fol. 58v)

Cardinal Albrecht of Brandenburg's prayer book represents one of the pinnacles in the career of the illustrious Flemish illuminator Simon Bening (ca. 1483–1561). The forty-one full-page miniatures in this book dramatically recount Christ's childhood and ministry, followed by his persecution, Crucifixion, and Resurrection. The artist inspires the reader's compassion and understanding through the depiction of Christ as a vulnerable man. In the Baptism shown here, the spirit of God descends as a shining dove on the frail figure of Jesus.

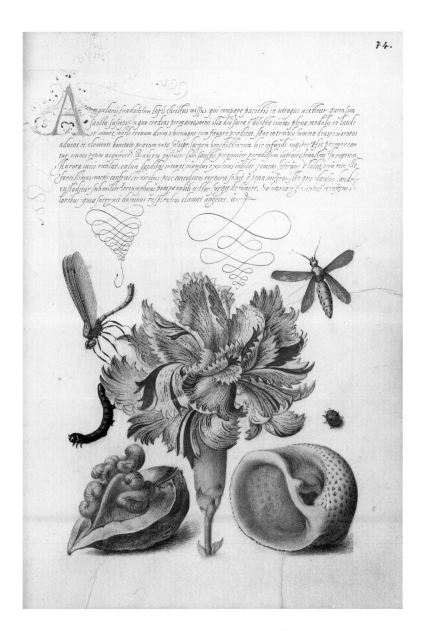

MIRA CALLIGRAPHIAE MONUMENTA

Vienna, written 1561–62 and
illuminated circa 1591–96
Parchment, 150 leaves
16.7 × 12.4 cm
(6 9/16 × 4 7/8 in.)
Ms. 20; 86.MV.527
Illustration: Joris Hoefnagel,
*Carnation, Walnut, Marine
Mollusk, and Insects* (fol. 74)

Originally written for the Holy Roman Emperor
Ferdinand I (r. 1558–64), the *Model Book of Calligra-
phy* is a compendium of display scripts by one of
the great scribes of the Renaissance, Georg Bocskay
(d. 1575). The calligraphy on each page represents
a different style of writing, inventively arranged.
Thirty years later, Emperor Rudolf II (r. 1576–1612),
Ferdinand I's grandson, commissioned Joris
Hoefnagel (1542–1601) to add illuminations to the
pages. Hoefnagel's exuberant depictions of flowers,
shells, insects, and fruit often echo the forms of
Bocskay's imaginative script.

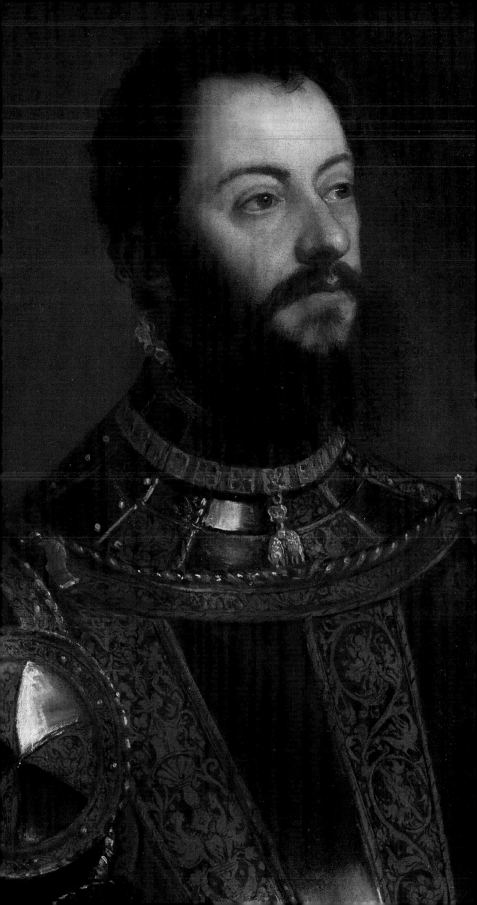

Paintings

URING HIS LIFETIME J. PAUL GETTY purchased paintings representative of every major European school of art between the fourteenth and the twentieth centuries. He did not, however, consider himself first and foremost a collector of paintings, and his writings, especially his diaries, repeatedly cite the decorative arts as his primary love. Nevertheless, Getty began his painting and decorative-arts collections at about the same time—during the 1930s. By World War II Getty owned two major pictures— Gainsborough's *Portrait of James Christie* (70.PA.16) and Rembrandt's *Portrait of Marten Looten* (given to the Los Angeles County Museum of Art in 1953, along with two important carpets)—as well as a number of lesser paintings, mostly seventeenth-century Dutch. Getty began to collect actively again in the 1950s, although it was not until the middle of the following decade that he attempted to buy pictures which equaled in stature individual works in his decorative-arts holdings.

When Getty left the bulk of his estate to the Museum at his death in 1976, the opportunity presented itself to acquire major paintings on a wider scale, with no restrictions. These pictures, which number more than three-quarters of those now on exhibit, have substantially transformed the permanent-collection galleries.

As a collector, Getty succeeded in gathering a representative group of Italian Renaissance and Baroque paintings, plus a few Dutch figurative works of importance. In recent years significant additions have been made to these areas. The seventeenth-century French and Dutch schools have been strengthened, as have the holdings of later French pictures by the Impressionists and their successors. In addition, small groups of important German and Spanish pictures have been acquired. Eighteenth-century French painting—an area that, curiously, Getty never bought to complement the French decorative arts he collected with such enthusiasm—has been much expanded. As a result, there is more of an overall balance to a collection that currently extends from 1300 to 1900. But of greater significance is the fact that the paintings now displayed are often more representative and important than those exhibited in the past. It is expected that the Museum will continue to acquire and exhibit paintings of the highest quality during the coming years, to complete the collection's transformation from a fairly small personal collection into a moderately sized but exceptionally choice repository for the delectation of the museum-going public.

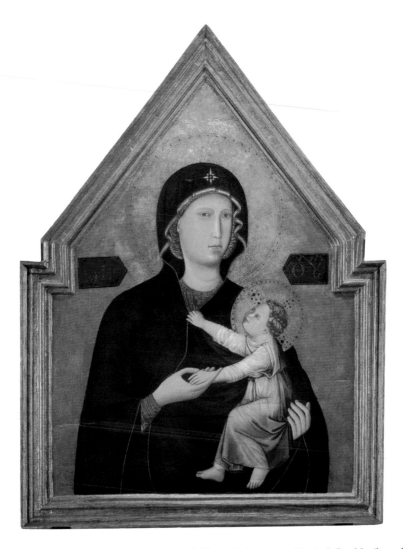

MASTER OF
SAINT CECILIA

Italian, active 1290–1320
Madonna and Child, 1290–95
Tempera on panel
85 × 66 cm (33½ × 26 in.)
2000.35

Although his artistic personality is definable (based on an altarpiece dedicated to Saint Cecilia now in the Uffizi Gallery, Florence), the painter's name has been lost to history. He stands, like his contemporaries Giotto and Duccio, at the threshold of the transition from hieratic devotional images into the more naturalistic depiction of holy figures that defines early Renaissance art in Italy. The basic format of the panel and its Greek inscription (a contraction of *Meter Theou*, or "Mother of God") derive from Byzantine icons. However, the rigidity of those images is here mitigated by the Master's touching gestures of the Virgin holding Christ's hand in her own and the Child grasping the Virgin's cloak as he looks tenderly up at her. *Madonna and Child* is the earliest work in the Getty Museum's painting collection and is one of the best-preserved pictures from this period.

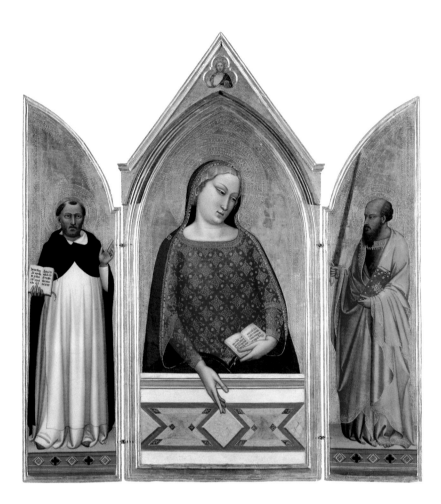

BERNARDO DADDI

Italian, circa 1280–1348
*The Virgin Mary with
Saints Thomas Aquinas
and Paul*, circa 1330
Tempera on panel
Central panel: 120.7 ×
55.9 cm (47½ × 22 in.);
left panel: 105.5 × 28 cm
(41½ × 11 in.);
right panel: 105.5 × 27.6 cm
(41½ × 10⅞ in.)
93.PB.16

Reflecting the burgeoning cult of the Virgin Mary in
fourteenth-century Italy, the triptych with an image of
the Madonna in the central panel, flanked by standing
saints in the wings, was one of the most popular
forms of devotional imagery. Here, the Virgin reads the
Magnificat (Luke 1:46–48) and gestures downward,
perhaps referring to a tomb or an altar over which
the triptych was placed. At the left, gesturing toward
her, is Saint Thomas Aquinas, displaying the text
of Ecclesiastes 12:9–10, one of his attributes. At the
right is Saint Paul, carrying a book of his epistles and
the sword by which he was martyred. These saints
were probably chosen because they had some special
significance to the unknown patron of the triptych.

The leading painter of his generation in Florence,
Daddi was renowned for creating affecting images.
Here, the Madonna is at once serene and majestic. The
elegant and graceful forms of the figures, the reso-
nant colors, and the exquisitely tooled gold all lend to
the ethereal effect of this well-preserved work.

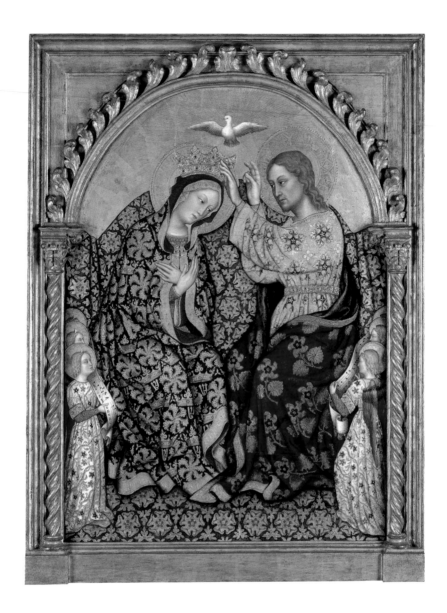

**GENTILE DA
FABRIANO**

Italian, circa 1370–1427
The Coronation of the Virgin,
circa 1420
Tempera on panel
87.5 × 64 cm
(34½ × 25½ in.)
77.PB.92

Probably painted for a church in Fabriano, Italy,
Gentile's *Coronation* once formed part of a double-
sided standard carried on a pole during religious
processions. Stylistically, it occupies the borderline
between the essentially Gothic International style
and the early Florentine Renaissance. Traces of
the former linger in the richly patterned surfaces of
the hanging and robes, which, however, clothe
solidly constructed figures. The folds create a sense
of volume as well as pattern, and the figures gesture
with convincing naturalism.

MASACCIO (TOMMASO DI GIOVANNI GUIDI)

Italian, 1401–1428
Saint Andrew, 1426
Tempera on panel
52.4 × 32.1 cm
(20⅝ × 12⅝ in.)
79.PB.61

This image of Saint Andrew holding his traditional symbols, a cross and a book, comes from the only securely documented altarpiece by Masaccio, a polyptych painted in 1426 for the private chapel of Giuliano da San Giusto, a wealthy notary, in the Church of the Carmine in Pisa. The panel was positioned at the right side of the upper tier, so that Andrew once appeared to gaze sadly toward the central panel depicting the Crucifixion.

The *Saint Andrew* exemplifies Masaccio's contribution to the founding of an early Renaissance painting style. The single figure is endowed with volume and solidity; his simplified draperies fall in sculptural folds. Since the panel stood high above the ground, the figure is slightly foreshortened for viewing from below. Furthermore, Masaccio has abandoned the elegant detachment of earlier styles in favor of a naturalistic treatment of emotion. It was this powerful combination of three-dimensional form and bold expression that so impressed his contemporaries.

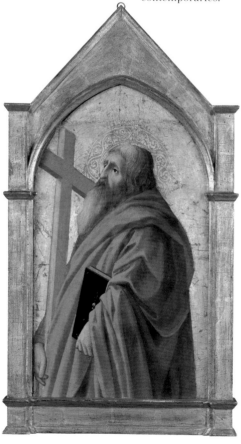

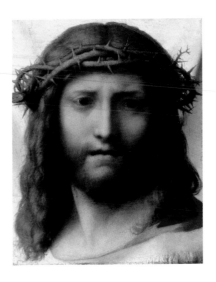

CORREGGIO
(ANTONIO ALLEGRI)

Italian, circa 1489–1534
Head of Christ,
circa 1525–30
Oil on panel
28.6 × 23 cm (11¼ × 9⁹⁄₁₆ in.)
94.PB.74

Correggio, the foremost High Renaissance artist of the Emilian school, invented a type of devotional imagery in which the protagonists seem to be caught in vibrant, realistic moments. The *Head of Christ* is a mature work intended for contemplation and private prayer. The subject derives from the legend of Saint Veronica. When Christ fell on the way to the Crucifixion, he was comforted by Veronica, who wiped his face with her veil and then discovered his likeness miraculously impressed upon it. Instead of depicting the traditional iconic image of the Savior's face imprinted on the veil, Correggio portrays a hauntingly naturalistic Christ who turns toward the viewer and parts his lips as if to speak. Veronica's veil is the folded white-cloth background that wraps around Christ's shoulder and ends in soft white fringes at the lower right. The painting's profound impact as a devotional image depends upon Correggio's bold invention of showing Christ wrapped within the veil the instant before the miracle. It is the living face of Christ and not his image that turns to confront the viewer.

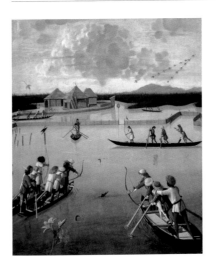

VITTORE CARPACCIO

Italian, circa 1460–circa 1526
Hunting on the Lagoon,
circa 1490–95
Oil on panel
75.4 × 63.8 cm
(29¾ × 25⅛ in.)
79.PB.72

One side of this painting shows bowmen hunting birds; the other is a trompe l'oeil painting of a letter rack. The marks of hinges on the latter side indicate that this panel once functioned as a decorative shutter or cabinet door. It is a fragment of a composition that included two women on a balcony with the lagoon visible between them.

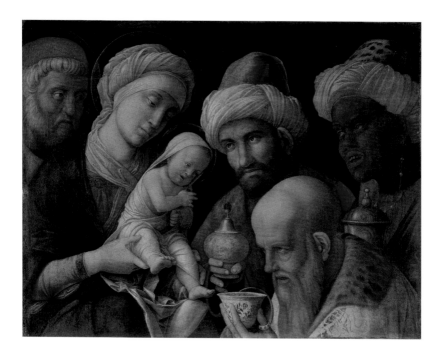

ANDREA MANTEGNA

Italian, circa 1431–1506
The Adoration of the Magi,
circa 1495–1505
Distemper on linen
54.6 × 69.2 cm
(21½ × 27⅜ in.)
85.PA.417

Paintings of the Adoration of the Magi traditionally provided the opportunity to create grandiose scenes of Oriental richness. For this private devotional work, however, Mantegna exhibited the spirit of Renaissance humanism by concentrating on the psychological interactions among the principal characters in the sacred narrative. The close-up scheme of half-length figures compressed within a shallow space and set before a neutral background was created by the artist from his study of ancient Roman reliefs, reflecting the Renaissance interest in reviving classical antiquity.

The magi, or kings, represent the three parts of the then-known world—Europe, Asia, and Africa—and personify royal recognition of Christ's superior kingship. They offer their gifts in vessels of carved agate, Turkish tombac ware, and an early example of Chinese porcelain in Europe. The subject was particularly appropriate for the painting's probable patrons, the Gonzaga family, rulers of Mantua, who employed Mantegna as court painter from 1459 until his death. Mantegna employed an unusual technique—thin washes of pigment in animal glue—resulting in dazzling color and a matte surface emphasizing the refined draftsmanship and brushwork. Although the image is somewhat darkened by varnish added at a later date (now mostly removed), the refinement of painting and the richness of detail still attest to Mantegna's mastery.

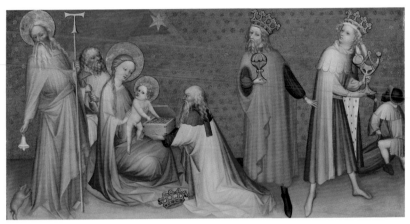

FRANCO-FLEMISH MASTER

Active in Burgundy,
circa 1400
*The Adoration of the Magi
with Saint Anthony Abbott,*
circa 1390–1410
Oil and tempera with gold
and silver leaf on panel
104.6 × 188.5 cm
(41³⁄₁₆ × 74³⁄₁₆ in.)
2004.68

The vibrant red background, patterned with a silver (originally gold) floral motif, serves as a magnificent foil for the animated procession of the Magi. Enthroned on his mother's lap, the new King stands to receive their offerings. Caspar kneels bareheaded in reverence and proffers his gift of gold. He, Balthasar, and Melchior are differentiated by age (sixty, forty, and twenty years old), according to concurrent literary practice. Simply but resplendently dressed, they both reveal contemporary court sensibility and allude to their far-flung kingdoms, suggested by the white "turban" worn by Melchior and particularly by the black page who assists him. A prominent position at the left is assumed by Saint Anthony Abbot, who is identified by the T-shaped staff, the simple robes appropriate to his ascetic life as a hermit and founder of monasticism, the bell with which he repelled Satan, and the pig traditionally associated with his treatment of skin conditions. The inclusion of Saint Anthony, which is highly unusual, suggests that the painting was originally located in a chapel dedicated to the saint or possibly in an Antonine hospital.

**JAN GOSSAERT
(CALLED MABUSE)**

Netherlandish, circa
1478–1532
*Francisco de los Cobos
y Molina,* circa 1530–32
Oil on panel
43.8 × 33.7 cm
(17¼ × 13¼ in.)
88.PB.43

The most accomplished Flemish painter of his generation, Gossaert combined keen observation of form, facile rendering of surface textures, and psychological insight to create portraits remarkable for their strong physical presence. This one probably represents Francisco de los Cobos, a major Spanish patron who was the powerful secretary and chief financial adviser to Emperor Charles V (r. 1519–56).

DIERIC BOUTS

Netherlandish, circa
1415–1475
The Annunciation,
circa 1450–55
Distemper on linen
90 × 74.5 cm
(35 7/16 × 29 3/8 in.)
85.PA.24

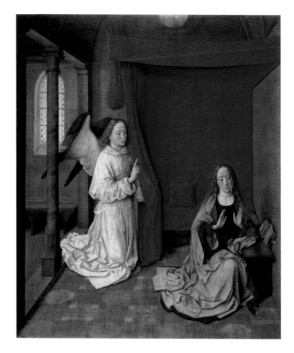

This painting represents the Incarnation, or conception of Christ, which occurred when the archangel Gabriel announced to the Virgin Mary, "You shall conceive and bear a son, and you shall give him the name of Jesus" (Luke 1:31). Mary, seated on the ground to indicate her humility, responds with a gesture conveying her acknowledgment of the miracle and acceptance of God's will. Bouts created a composition of surprising simplicity, minimizing symbolic detail to establish a mood of hushed solemnity. This image was executed in an equally austere technique. Thin washes of pigment in animal glue were applied to fine linen to give the scene a delicate, luminous quality. This was the first scene in an altarpiece relating the Life of Christ; the final scene, *The Resurrection*, is in the Norton Simon Museum, Pasadena.

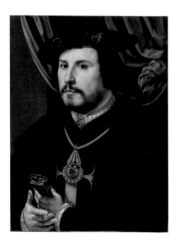

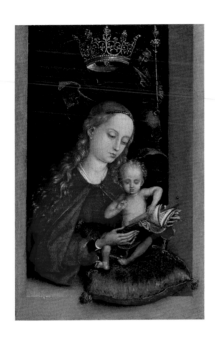

MARTIN SCHONGAUER

German, circa 1450–1491
*Madonna and Child
in a Window*, circa 1485–90
Oil on panel
16.5 × 11 cm (6½ × 4⁵⁄₁₆ in.)
97.PB.23

Madonna and Child in a Window
is one of only seven known paintings
by Martin Schongauer, who was
renowned as a printmaker. A vigorous
linearity animates this devotional
work in which the Virgin appears as
the Window to Heaven. This tiny
panel showcases Schongauer's superb
ability to convincingly render mate-
rials, such as the jeweled crown and
scepter held by the angel, as well
as the delicate features of the Virgin
and the inquisitive Child.

HANS HOFFMANN

German, circa 1530–1591/92
A Hare in the Forest,
circa 1585
Oil on panel
62.2 × 78.4 cm
(24½ × 30⅞ in.)
2001.12

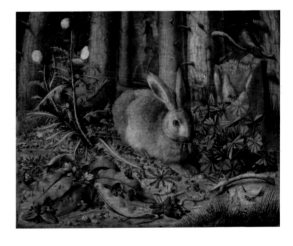

Hans Hoffmann was one of the most innovative artists
to take inspiration from Albrecht Dürer and his ani-
mal studies. Here, Hoffmann animates Dürer's famous
drawing of a hare, situating it in a minutely described
natural setting, nibbling on a leaf. The composition
unites nature and artifice, for while each of the plants,
animals, and insects can be identified, the scene com-
bines elements not usually found together in nature.
A Hare in the Forest was acquired from Hoffmann by
Holy Roman Emperor Rudolf II of Prague, whose col-
lection epitomized the emerging passion among elite
collectors for unique natural objects and works of art.

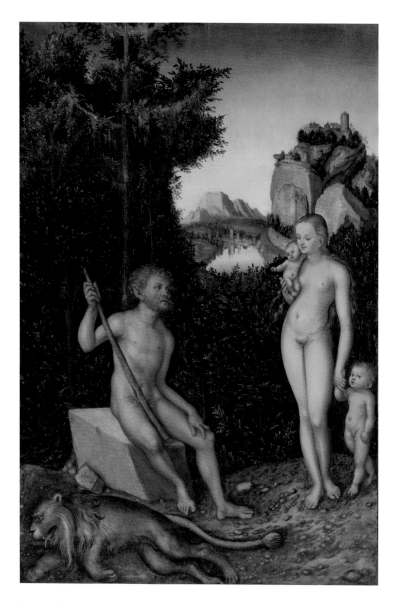

**LUCAS CRANACH
THE ELDER**

German, 1472–1553
*A Faun and His Family with
a Slain Lion*, circa 1526
Oil on panel
82.9 × 56.2 cm
(32⅝ × 22⅛ in.)
2003.100

A Faun and His Family with a Slain Lion epitomizes
the elegant and erudite mythological subjects Cranach
devised in the late 1520s for the Wittenberg court,
where he had been court painter since 1504. Drawing
on classical poetry, he created sophisticated but spe-
cifically northern idyllic landscapes. Dense foliage
and minutely rendered distant structures serve as a
foil for the rough-hewn forest dweller and his com-
panion. The calligraphic strokes that describe the
magnificent slain lion recall the early German graphic
tradition, while the sinuous forms of the female nude
reflect Cranach's absorption and reworking of Italian
models into a modern German style.

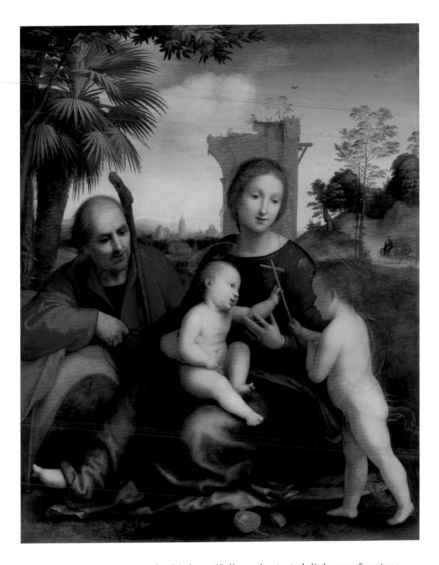

**FRA BARTOLOMMEO
(BACCIO DELLA
PORTA)**

Italian, 1472–1517
*The Rest on the Flight into
Egypt with Saint John
the Baptist*, circa 1509
Oil on panel
129.5 × 106.6 cm (51 × 42 in.)
96.PB.15

In this beautifully orchestrated dialogue of gesture
and glance, the Holy Family, having escaped Beth-
lehem and King Herod's massacre of the innocents,
take their ease beneath a date palm. Mary and Joseph
look on as the infant Baptist greets the Christ child.
The unusual inclusion of John the Baptist in a Rest on
the Flight can be explained by the saint's status as a
patron of Florence. He is also a poignant reminder
that the ultimate purpose of the Child's escape is his
sacrifice on the cross. Fra Bartolommeo reinforces the
pathos by depicting a pomegranate, a fruit that pre-
figures Christ's death, and the sheltering palm, whose
fronds would pave the Savior's final entry into Jerusa-
lem. The ruined arch alludes to the downfall of the
pagan order and the rise of Christ's Church, personi-
fied by Mary.

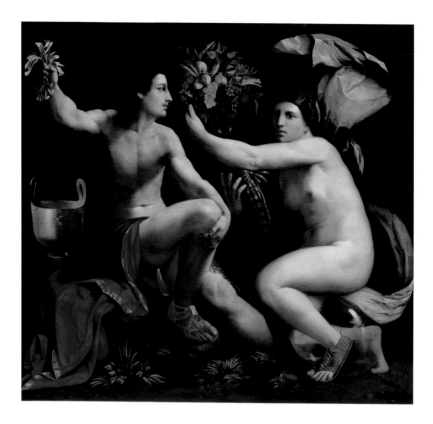

**DOSSO DOSSI
(GIOVANNI
DI NICCOLÒ
DE LUTERO)**

Italian, circa 1490–1542
An Allegory of Fortune,
circa 1530
Oil on canvas
179.1 × 217.2 cm
(70½ × 85½ in.)
89.PA.32

The nude woman represents Fortune, or Lady Luck, the indifferent force that determines fate. She holds a cornucopia, flaunting the bounty that she might bring, and sits on a bubble, which represents the fleeting nature of her favors. The billowing drapery serves as a reminder that she is as inconstant as the wind, and she wears only one shoe to symbolize that she is capable of bestowing not only fortune but also misfortune.

The man, a personification of Chance, looks toward Fortune as he is about to deposit lots or lottery tickets in a golden urn. This was not a traditional attribute, but a reference to the civic lotteries with cash prizes that had recently become popular in Italy. The painting was probably made for Isabella d'Este (1474–1539), Marchioness of Mantua, one of whose emblems was a bundle of lots.

The luminous, poetic coloring and atmosphere of Dosso's earlier work, adopted from Venetian paintings, here gives way to heroically proportioned and posed figures revealed by strong lighting, which the artist developed from studying Michelangelo's work in Rome.

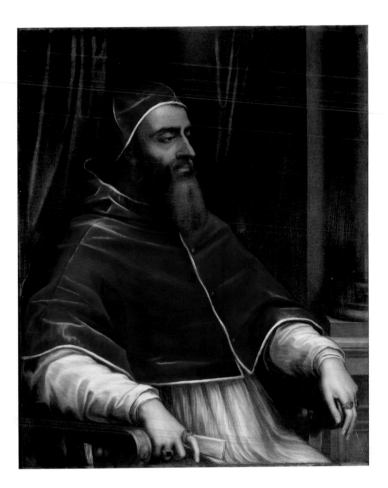

**SEBASTIANO
DEL PIOMBO
(SEBASTIANO
LUCIANI)**

Italian, circa 1485–1547
Pope Clement VII,
circa 1531
Oil on slate
105.5 × 87.5 cm
(41½ × 34½ in.)
92.PC.25

This portrait depicts Giulio de' Medici (1478–1534),
who reigned as Pope Clement VII from 1523 to 1534.
An outstanding humanist, Clement is principally
remembered as one of the greatest patrons of the
Renaissance, commissioning major works from
Raphael and Michelangelo as well as Sebastiano.

Michelangelo regarded Sebastiano as the foremost
portrait painter of his day. The distinctive, monu-
mental grandeur of his style was particularly suited
to state portraits such as this one. Sebastiano's
characterization of the pope reflects the Renaissance
cult of individuality in its bold projection of a power-
ful, unmistakable presence. The pontiff possesses
an innate nobility and self-confidence, befitting both
his position and his personality.

Aspiring to eternalize his works, Sebastiano began
to experiment with painting on stone, rather than
canvas or wood, in about 1530. The pope, apparently
sharing the desire for an immortal image, had com-
missioned this portrait on slate by July 22, 1531, when
the painter wrote to Michelangelo about it.

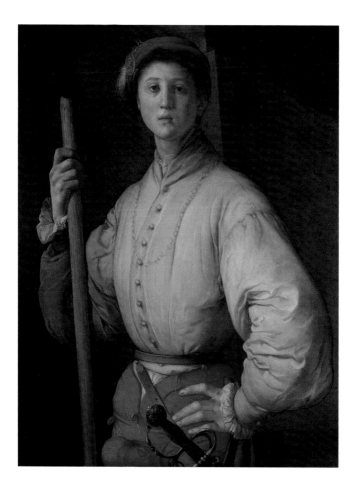

JACOPO PONTORMO (JACOPO CARUCCI)

Italian, 1494–1557
*Portrait of a Halberdier
(Francesco Guardi?)*,
1528–30
Oil or oil and tempera
on panel transferred
to canvas
92 × 72 cm
(36¼ × 28⅜ in.)
89.PA.49

Jacopo Pontormo was one of the founders of the so-called Mannerist style in Italy. After Michelangelo he is recognized as the most important Florentine painter of the sixteenth century. He and his pupil Bronzino excelled as portraitists, and the *Halberdier* is Pontormo's greatest achievement.

In 1568 the most famous contemporary recorder of artists' lives, the painter Giorgio Vasari, noted that Pontormo had painted a most beautiful work, a portrait of Francesco Guardi, during the 1528–30 siege of Florence. We know nothing about Guardi's appearance, yet he was born in 1514, so he could be the teenage sitter.

Pontormo shows his halberdier before a bastion, suggesting the defense of Florence. This youth is posed like some new Saint George or David guarding his city. His casual, swaggering pose is confident. His loose grip on the halberd (spear) and slung sword suggest a control that his expression belies. Pontormo conveys the sitter's unease with such vitality that we too feel startled as we meet his gaze.

TITIAN
(TIZIANO VECELLIO)

Italian, circa 1487–1576
*Alfonso d'Avalos, Marquis
of Vasto, in Armor with
a Page*, probably
January–February 1533
Oil on canvas
110 × 80 cm
(43 5/16 × 31 1/2 in.)
2003.486

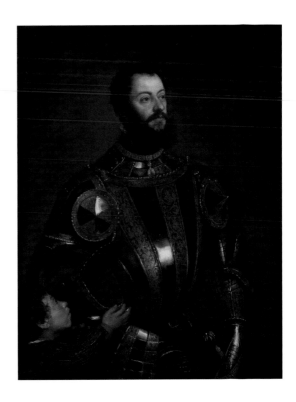

Titian was one of the first painters to
fully comprehend the expressive
potential of oil paint on canvas, and
the Getty Museum is able to display
important examples in the three major
genres in which he excelled—reli-
gious, mythological, and, especially,
portrait painting. The earliest of the
Getty works is the portrait of Alfonso
d'Avalos, mentioned by Giorgio
Vasari in 1568 as having been painted
in the winter of 1533. It depicts the
commander general of Emperor
Charles V's troops in Italy preparing
himself mentally and physically to
do battle. Dressed in battle armor, he
looks to the future as a small page
hands him his helmet. *The Penitent
Magdalene*, a later variation of a
picture originally commissioned by
d'Avalos in 1531, is one of the most
celebrated and influential devotional
depictions of this popular saint. Here,
Titian blends the beautiful with the
devout, the sensuous with the peniten-
tial, in an emotionally powerful image.
Venus and Adonis, painted for a dis-
cerning patron, is among the artist's
most famous mythological composi-
tions designed originally for King
Philip II of Spain. The story is from
Ovid's *Metamorphoses* and tells of how
the goddess of love failed to persuade
the handsome hunter to stay with
her. Instead, he rushed off to his fatal
encounter with a wild boar during
a hunt. Titian's ability to create in
color and light various fantasy worlds
both religious and mythological, as
well as a believable illusion of self
in a patron's mind, made the Venetian
painter one of the most famous and
popular artists of all time.

TITIAN (TIZIANO VECELLIO)

Italian, circa 1487–1576
The Penitent Magdalene,
1555–65
Oil on canvas
106.7 × 93 cm (42 × 36⅝ in.)
56.PA.1

TITIAN (TIZIANO VECELLIO)

Italian, circa 1487–1576
Venus and Adonis,
circa 1555–60
Oil on canvas
160 × 196.5 cm
(63 × 77⅜ in.)
92.PA.42

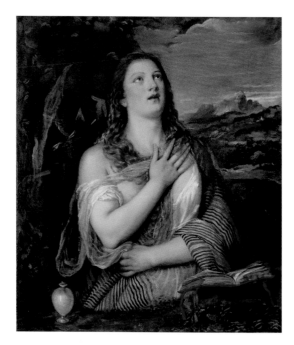

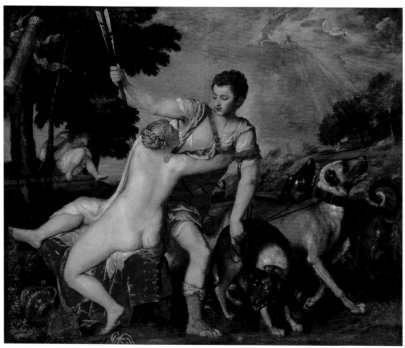

**EL GRECO
(DOMÉNIKOS
THEOTOKÓPOULOS)**

Greek, 1541–1614
Christ on the Cross,
circa 1600–1610
Oil on canvas
82.6 × 51.6 cm
(32½ × 20⁵⁄₁₆ in.)
2000.40

Painting in the fervent religious climate of Counter-Reformation Spain, El Greco developed a style unique for its hallucinatory spiritual intensity. This small-scale work intended for private devotion is an excellent example of the popular "living Christ" theme. The crucified Christ is set dramatically against a turbulent, pitch-black sky shot through with incandescent bursts of light. Christ gazes calmly heavenward, and his languid, attenuated body, modeled in flickering silvery light, seems to rise vertiginously above the spectral landscape, suggesting the ultimate triumph of faith over death.

DOMENICO FETTI

Italian, circa 1589–1623
*Portrait of a Man with
a Sheet of Music*, circa 1620
Oil on canvas
173 × 130 cm (68 × 51⅛ in.)
93.PA.17

Even though the identity of this portrait's sitter remains a mystery, he surely represents either a musician or an actor because he holds a sheet of music and intensely regards the viewer while singing or speaking. In the background, one man gestures for another to keep quiet, as if the protagonist were rehearsing or performing. Based on the overturned cup in the lower left corner, it has been suggested that the sitter may be acting the part of Diogenes, the Greek Cynic philosopher, who despised worldly possessions.

GUERCINO (GIOVANNI FRANCESCO BARBIERI)

Italian, 1591–1666
Pope Gregory XV,
circa 1622–23
Oil on canvas
133.4 × 97.8 cm
(52½ × 38½ in.)
87.PA.38

Baroque portraits of exalted sitters often concentrate on the trappings of power without aiming to represent character. This picture of Pope Gregory XV (r. 1621–23) is a remarkable exception. Instead of merely portraying the pontiff in his official capacity, Guercino depicted him sympathetically in the last months of his life, worn by the cares of office and failing health.

ORAZIO GENTILESCHI

Italian, 1563–1639
Lot and His Daughters,
circa 1622
Oil on canvas
151.8 × 189.2 cm
(59¾ × 74½ in.)
98.PA.10

The artist delights in contrasting Lot's drunkenness with the heightened senses of his daughters as they witness the destruction of Sodom by God. The graceful composition of interlocking figures, along with the luminous harmony of colors and the rich play of textures, characterize the elegant, poetic style that made Gentileschi's works popular in courts across Europe.

BARTOLOMÉ ESTEBAN MURILLO

Spanish, 1617–1682
The Vision of Saint Francis of Paola, circa 1670
Oil on canvas
188 × 146 cm (74 × 57½ in.)
2003.144

Saint Francis of Paola (1416–1507) founded the Minims, a branch of the Franciscan order known for the extreme humility of its members. While experiencing a vision of the word "charitas" (charity), which became the order's symbol, he gestures toward a miraculous event at the left, in which the saint ferried himself and two companions to Sicily on his cloak after a ship denied them passage across the Strait of Messina. The size and subject of this painting suggest that it was an altarpiece, perhaps for a Spanish Capuchin brotherhood, since the saint wears the brown robes of that order rather than the black cope of the Minims. Particularly in the rendering of the saint's face and hands, the painting displays Murillo's characteristic emotional intensity and graceful expressiveness.

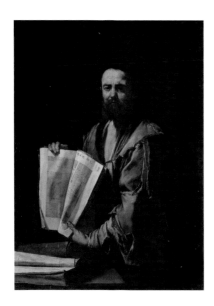

JUSEPE DE RIBERA

Spanish, 1591–1652
Euclid, circa 1630–35
Oil on canvas
125 × 92 cm (49¼ × 36¼ in.)
2001.26

Although the subject of the ragged
philosopher dates back to antiquity,
the type gained popularity in the
early seventeenth century with the
revival of Stoic philosophy. In this
painting, Ribera paints the moral ideal
of stoicism—the neglect of outward
appearances in devotion to intellectual
pursuits. The mathematical diagrams
in this man's book suggest that he
represents Euclid. The strong contrasts
of light and dark; the realistic depic-
tion of blackened, grimy fingers, well-
worn book pages, and tattered garb;
and the figure's penetrating gaze give
him a visceral presence and emotional
immediacy characteristic of Ribera's
powerful early work.

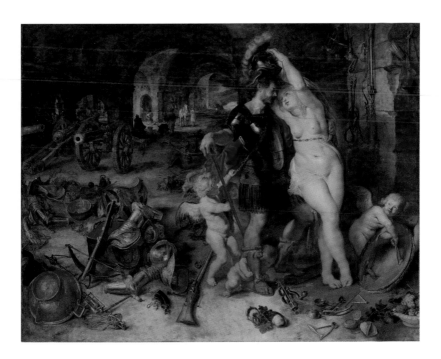

PETER PAUL RUBENS

Flemish, 1577–1640

JAN BRUEGHEL THE ELDER

Flemish, 1568–1625

The Return from War: Mars Disarmed by Venus, 1610–12
Oil on panel
127.3 × 163.5 cm
(50⅛ × 64⅜ in.)
2000.68

Peter Paul Rubens and Jan Brueghel the Elder were dear friends and frequent collaborators. *The Return from War*, the largest and one of the earliest of their joint works, reveals the reciprocal nature of their artistic partnership. Brueghel, a landscape and still-life specialist, painted the vaulted interior of Vulcan's forge and the array of armor on an especially dramatic scale. A portion of the completed interior at the right side of the panel was revised by Rubens when painting the entwined figures of Mars and Venus. The alteration may be connected to the development of the subject, a political allegory of peace. As Venus removes Mars's helmet, amorini playfully disengage the god of war from his martial accoutrements. The setting of the forge and the embrace of the two gods create a second allegory of the sense of touch.

PETER PAUL RUBENS

Flemish, 1577–1640
The Calydonian Boar Hunt,
circa 1611–12
Oil on panel
59 × 90.2 cm
(23¼ × 35½ in.)
2006.4

This work, long believed lost and only recently rediscovered, is Rubens's earliest hunt scene. The subject, rarely depicted in painting about 1600, is the climax of Ovid's tale of the mythological chase of the Calydonian boar, when Meleager delivers the mortal spear thrust into the shoulder of the fearsome beast. Rubens quoted well-known classical sculpture and reliefs and breathed new life into these antique sources. The vividness of the scene derives from his assured brushwork, which has an energetic, sketchy quality in some areas and a polished finish in others.

PETER PAUL RUBENS

Flemish, 1577–1640
The Entombment,
circa 1612
Oil on canvas
131 × 130.2 cm
(51⅝ × 51¼ in.)
93.PA.9

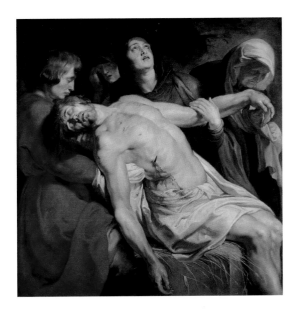

Rubens was a devout Catholic, and his paintings give tangible form to the main concerns of his religion. This powerful work was carefully composed to focus devotion on Jesus Christ's sacrifice and suffering. The head of Christ, frozen in the agony of death, is turned to confront the observer directly. Rubens also compels us to regard the gaping wound in Christ's side, placing it at the center of the canvas. We are thus obliged to join the mourners, whose grief is focused in the Virgin Mary.

Rubens also introduces symbolic elements that reflect the theological and political concerns of the Counter-Reformation in the early seventeenth century. Thus, the slab on which the body is placed suggests an altar, while the sheaf of wheat alludes to the bread of the Eucharist, the equivalent of Christ's body in the Mass. At this time the Roman Church was defending the mystery of transubstantiation against Protestant criticism.

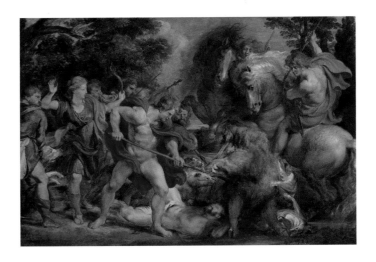

HENDRICK
TER BRUGGHEN

Dutch, 1588–1629
Bacchante with an Ape, 1627
Oil on canvas
102.9 × 90.1 cm
(40½ × 35½ in.)
84.PA.5

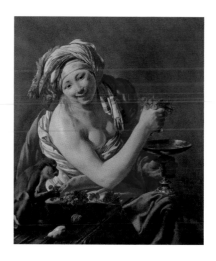

This devotee of Bacchus, with her fruit, nuts, and ape (a symbol of appetite or gluttony), may represent the sense of taste. In Rome at the turn of the century, Caravaggio had set the fashion for half-length figures representing the senses, and his works certainly influenced Ter Brugghen's both in type and style. Coming from a Catholic city in largely Protestant Holland, Ter Brugghen was one of the few Dutch artists to visit Italy in an era of religious controversy and so became instrumental in the spread of new Italian styles to the North. The lively, unidealized portrayal of the model and the sculptural modeling of the flesh in darks and lights are characteristic of the Caravaggesque style that Ter Brugghen adopted while in Rome (1604–14) and carried back to his native Utrecht.

JAN BRUEGHEL
THE ELDER

Flemish, 1568–1625
*The Entry of the Animals
into Noah's Ark*, 1613
Oil on panel
54.6 × 83.8 cm
(21½ × 33 in.)
92.PB.82

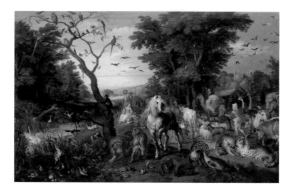

This is the first of a group of paradise landscapes developed by Brueghel, the most important Flemish landscape painter working at the dawn of the Baroque era. In this episode from the story of Noah's ark (Genesis 6–8), the artist celebrates the beauty and variety of God's creations. His encyclopedic representation of animals reflects the new interest in natural history. While court painter to the archduke Albert in Brussels, Brueghel studied the exotic animals and birds in the royal menagerie. This painting exemplifies his meticulous attention to detail and use of vivid colors.

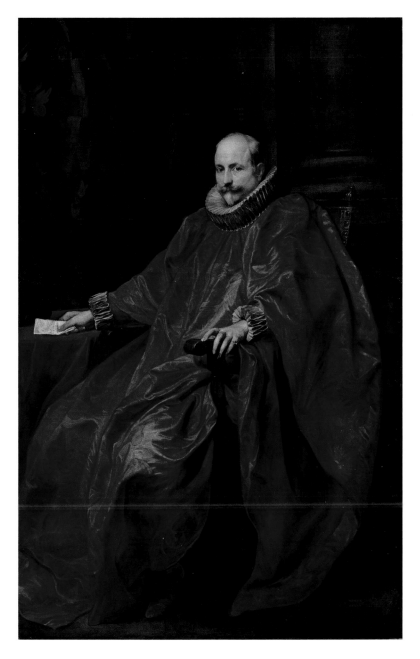

**ANTHONY
VAN DYCK**

Flemish, 1599–1641
Agostino Pallavicini,
circa 1621
Oil on canvas
216 × 141 cm
(85⅛ × 55½ in.)
68.PA.2

Shortly after arriving in Italy, Van Dyck is known to
have painted Agostino Pallavicini dressed in the robes
of an ambassador to the pope. The sketchy curtain
behind the sitter here bears the Pallavicini coat of
arms, and his dramatic robes surely were intended for
ceremonial duties. Van Dyck emulated the rich and
dramatic painting style of his master, Rubens, but
brought to portraiture a unique aristocratic refine-
ment that transformed the genre.

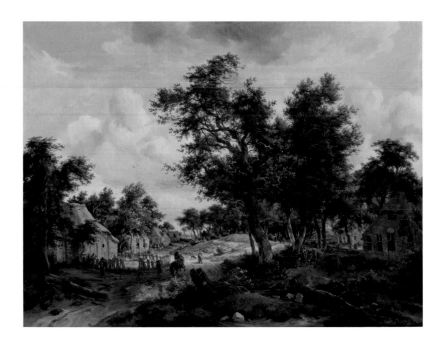

MEINDERT HOBBEMA

Dutch, 1638–1709
*A Wooded Landscape
with Travelers
on a Path through
a Hamlet*, circa 1665
Oil on canvas
96.5 × 130.8 cm
(38 × 51½ in.)
2002.17

One of the foremost Dutch landscape painters of the seventeenth century, Hobbema captured the breezy and atmospheric qualities of a bright day. Using a wide variety of brushwork, he described the muddy soil, dry bark, crumbling brick, and diverse foliage. Hobbema never painted outside, and complex scenes such as this one were executed in his Amsterdam studio. Two separate vanishing points are employed to lead the eye into the composition. Populated by an assortment of travelers, from mounted gentry to peasants journeying with their animals (the work of the Amsterdam painter Abraham Stork), *Landscape with Travelers* was intended to engage the viewer in a visual meander through the countryside.

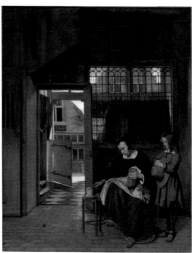

PIETER DE HOOCH

Dutch, 1629–1684
*A Woman Preparing Bread
and Butter for a Boy,*
circa 1660–63
Oil on canvas
68.3 × 53 cm
(26⅞ × 20⅞ in.)
84.PA.47

GERARD TER BORCH

Dutch, 1617–1681
The Music Lesson, circa 1668
Oil on canvas
67.7 × 54.9 cm
(26⅝ × 21⅝ in.)
97.PA.47

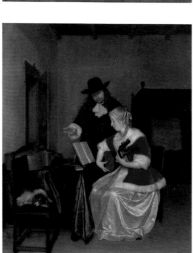

These two paintings exhibit the inter-
est in social and domestic concerns
typical of many genre scenes produced
in the seventeenth-century Nether-
lands. Pieter de Hooch's work depicts a
clean and orderly home in which a
mother and child interact in a quiet
scene of domestic harmony. The
serene quality of the image, together
with the interior's clean geometry
and the passageway out into the sun-
drenched street, invite the viewer into
the space of the painting. Gerard ter
Borch presents a woman clad in a lux-
urious satin gown playing music with
her male companion, who uses his
hand to mark time. Ter Borch is care-
ful to keep their precise relationship
ambiguous, deliberately maintaining
the delicate balance between inno-
cence and seduction. The artist has
lavished attention on the shimmering
fabric while describing the decorum
and proper deportment exhibited by
the couple.

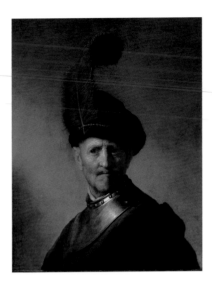

REMBRANDT HARMENSZ. VAN RIJN

Dutch, 1606–1669
An Old Man in Military Costume, circa 1630–31
Oil on panel
66 × 50.8 cm (26 × 20 in.)
78.PB.246

An unknown model served as the subject for this sophisticated character study, or *tronie*. Rembrandt described the varied textures of polished steel, whiskers, and watery eyes of the self-assured sitter, whom he situated against a neutral backdrop as in a portrait. The fanciful attire, probably drawn from Rembrandt's own collection of costumes, suggests a martial theme in keeping with ideals of Dutch fortitude during the struggle for independence from Spain.

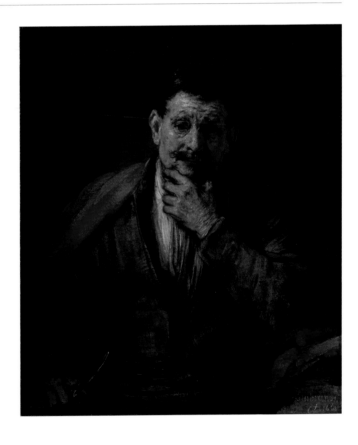

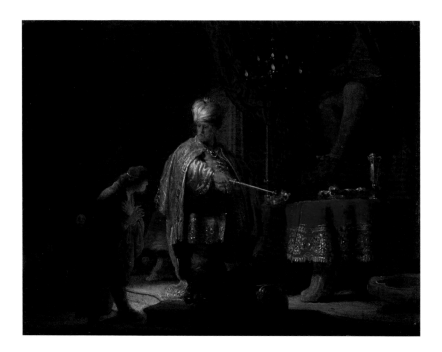

**REMBRANDT
HARMENSZ.
VAN RIJN**

Dutch, 1606–1669
*Daniel and Cyrus
before the Idol Bel*, 1633
Oil on panel
23.4 × 30.1 cm (9¼ × 11⅞ in.)
95.PB.15

Rembrandt evokes a mood of mystery with flickering light and only a partial view of the statue of Bel to tell the story of Daniel's unmasking of idolatry at the court of Babylon from the apocryphal book of Daniel. The painter contrasts the large, powerful Cyrus with the small, humble Daniel, and through the play of gesture and expression, he captures the moment of revelation when Cyrus begins to realize he may have been deceived. Modest in size, this work, along with *The Abduction of Europa*, epitomizes Rembrandt's genius as a storyteller.

**REMBRANDT
HARMENSZ.
VAN RIJN**

Dutch, 1606–1669
Saint Bartholomew, 1661
Oil on canvas
86.5 × 75.5 cm
(34⅛ × 29¾ in.)
71.PA.15

The highly individualized features of Saint Bartholomew, said to have been martyred by being skinned alive, suggest that this imposing work is a portrait of a subject in the guise of a saint. Rembrandt painted several life-size, half-length images of religious figures about 1660, perhaps as a loosely conceived or organically devised series of apostles. The broad brushwork of the artist's late "rough" manner economically describes the saint's torso, in contrast to the short and broken brushwork of his face.

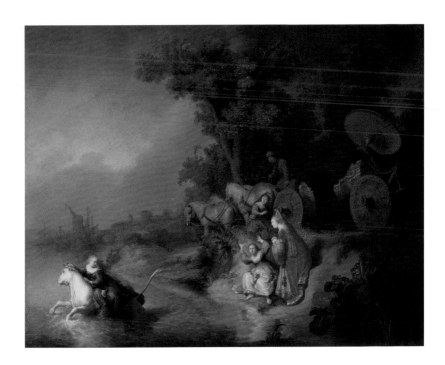

REMBRANDT HARMENSZ. VAN RIJN

Dutch, 1606–1669
The Abduction of Europa, 1632
Oil on panel
62.2 × 77 cm
(24½ × 30⁵⁄₁₆ in.)
95.PB.7

The young and ambitious Rembrandt turned to subjects from classical mythology soon after his arrival in Amsterdam. In *The Abduction of Europa*, inspired by Ovid's *Metamorphoses*, Jupiter, king of the gods, transforms himself into a beautiful white bull in order to seduce Europa, princess of Tyre. Beguiled, she climbs onto the bull's back and is spirited away to the continent that will bear her name. Rembrandt enriches the narrative through his vivid characterization of human emotion and by contrasting the looming, shadowed landscape with the fluttering figure of Europa and the shimmering surface of the sea. The brilliant, jewel-like palette and fine brushwork are reminiscent of his earlier work in Leiden.

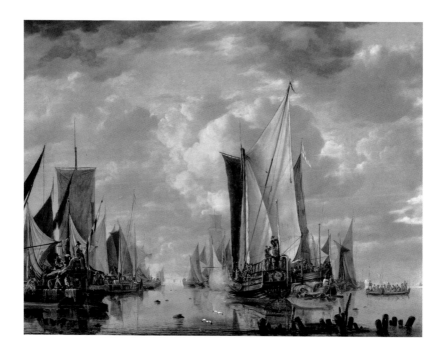

JAN VAN DE CAPPELLE

Dutch, 1626–1679
Shipping in a Calm at Flushing with a States-General Yacht Firing a Salute, 1649
Oil on panel
69.7 × 92.2 cm
(27 ³/₈ × 36 ¹/₄ in.)
96.PB.7

In the mid-seventeenth century, when the Dutch Republic had reached its height of power as a global trading empire, its domination of the seas found expression in the nascent specialization of marine painting. In 1649, Jan van de Cappelle and Simon de Vlieger changed the course of Dutch seascapes with an innovation known as the "parade" picture, which showed grand ships convening for special occasions under towering, cloud-filled skies.

In *Shipping in a Calm*, a stately yacht fires a salute to announce the arrival of a dignitary, who is conveyed to shore in a launch at the right. Unaffected by the shot, porpoises glide peacefully through the calm waters. They were known to frequent Flushing (Vlissingen), the busy port used by the Dutch East India Company, which was frequently portrayed in Van de Cappelle's paintings.

As one of his earliest known signed and dated works, this painting displays Van de Cappelle's highly developed style and remarkable technical virtuosity. The painter demonstrates an accomplished graphic handling of form in the detailed ships, rigging, and sails and his mastery of optical effects in the treatment of reflections in the water. This dramatic avenue of ships framing an infinite vista of the sea is a pioneering contribution to the genre of marine painting.

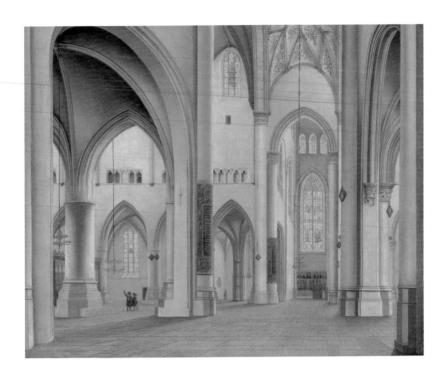

**PIETER JANSZ.
SAENREDAM**

Dutch, 1597–1665
*The Interior of the
Church of Saint Bavo,
Haarlem*, 1628
Oil on panel
38.5 × 47.5 cm
(15¼ × 18¾ in.)
85.PB.225

Pieter Saenredam, the great renovator of architecture painting in the Netherlands, transformed the idealized, artificial perspective of earlier pictures done mostly by Flemish artists. By minimizing anecdote and adopting an unusually low viewpoint, he concentrated on the depiction of light, color, and space in monumental buildings.

The Interior of the Church of Saint Bavo, Haarlem is the earliest known painting by Saenredam. It is the first of twelve pictures of the interior of this church—one of the finest Gothic buildings in Holland—that he made between 1628 and 1660. Saenredam conceived his views of church interiors with the help of detailed, on-the-spot studies, extensive measurements, and perspective drawings. In this painting, the artist transcends mere architectural portraiture by merging two distinct views of the church: from the north transept straight ahead into the south transept, and to the east, into the choir. Different shades of white paint—ranging from bluish white to creamy yellow—suggest the northern and southern light shining into the building. Remarkably, Saenredam substituted an altarpiece for the doors in the church's south transept and included a stained-glass window with a depiction of the Immaculate Conception. These elements suggest a Catholic patron for this painting.

JAN STEEN

Dutch, 1626–1679
The Drawing Lesson,
circa 1665
Oil on panel
49.3 × 41 cm
(19 ⅜ × 16 ¼ in.)
83.PB.388

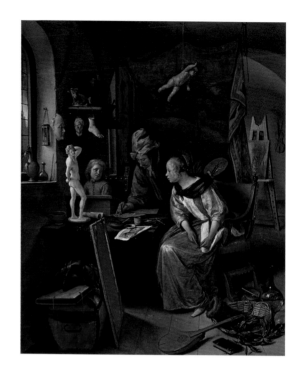

FRANS VAN MIERIS THE ELDER

Dutch, 1635–1681
An Allegory of Painting, 1661
Oil on copper
12.5 × 8.5 cm (5 × 3 ½ in.)
82.PC.136

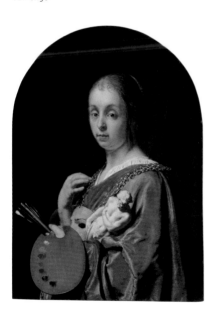

These two compositions are both alle-
gories of the painter's art. The Steen
shows the interior of a painter's studio,
cluttered with symbolic objects, while
the painter, his apprentice, and a
young woman concentrate on correct-
ing a drawing. Several of the symbolic
objects in *The Drawing Lesson* also
appear as attributes of Pictura, a
personification of the art of painting.
Depicted with her palette, brushes,
and statue, this figure also wears a
mask hung on a chain around her
neck. The mask may be an emblem of
deceit or illusion (the painter creates
an illusion of reality), or it may refer to
the dramatic arts (like the dramatist,
the painter must invent and "stage"
convincing scenes).

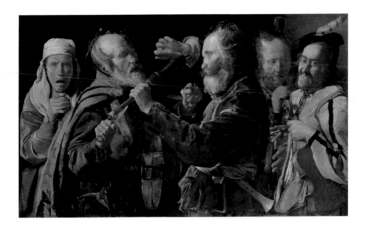

GEORGES DE LA TOUR

French, 1593–1652
The Musicians' Brawl,
circa 1625–30
Oil on canvas
85.7 × 141 cm
(33¾ × 55½ in.)
72.PA.28

This early La Tour composition shows a scuffle between two beggar musicians. Scholars have suggested that the two troupes are fighting for possession of a lucrative street corner; that the scene was taken from comedic theater; and that the man in velvet is unmasking the false blindness of the hurdy-gurdy player by squirting lemon juice in his eye. La Tour illuminates this frieze of beggars with a cold, overhead light. His strange palette, attention to unusual textures (such as the wrinkled skin of the aged beggar), and the detached treatment of characters made La Tour one of the most original and enigmatic artists of the seventeenth century.

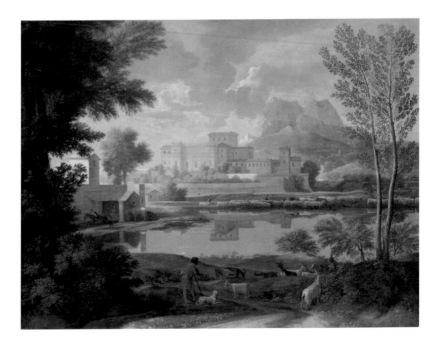

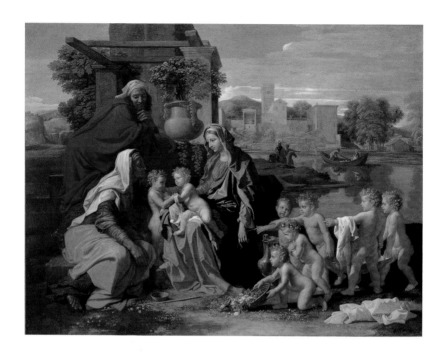

NICOLAS POUSSIN

French, 1594–1665
The Holy Family, circa 1651
Oil on canvas
100.6 × 132.4 cm
(39⅝ × 52⅛ in.)
81.PA.43
(Owned jointly with
the Norton Simon Art
Foundation, Pasadena)

The traditional Holy Family, which includes the
Virgin and Child with Saint Joseph, has here been
extended to include the youthful Saint John the
Baptist with his mother, Saint Elizabeth. Framed by
the passive figures of their parents, the holy children
reach out in a lively embrace. Six putti bearing
a basket of flowers, a ewer, a towel, and a basin of
water may prefigure Saint John's later baptism
of Christ. Painted in Poussin's late classicizing style,
The Holy Family reflects his study of Raphael and
antique sculpture. It exemplifies Poussin's intellec-
tual approach to painting, his insistence on harmony
among all parts of the composition, and his concen-
tration on the ideal and the abstract.

NICOLAS POUSSIN

French, 1594–1665
Landscape with a Calm,
1650–51
Oil on canvas
97 × 131 cm (38³⁄₁₆ × 51⁹⁄₁₆ in.)
97.PA.60

A Calm culminates Poussin's development of the
"heroic landscape," a view of nature idealized
through the application of classical models and optical
principles. Painted as a pendant to *A Storm* (Musée
des Beaux-Arts, Rouen) for the Lyonnaise merchant
Jean Pointel, *A Calm* is without literary subject. One
of Poussin's purest landscapes, its meaning hinges
on the artist's ability to capture the essence of nature's
order. Indeed, the pellucid harmonies of *A Calm*
led Poussin's biographer Félibien to exclaim that in
it, "Nature seems to paint herself in reflections."

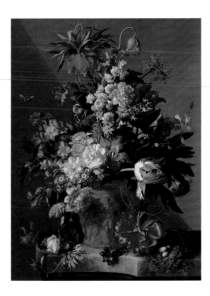

JAN VAN HUYSUM

Dutch, 1682–1749
Vase of Flowers, 1722
Oil on panel
79.5 × 61 cm (31¼ × 24 in.)
82.PB.70

The mania for cultivating flowers in Baroque Europe fostered the development and popularity of flower painters. Jan van Huysum's bouquet includes blossoms from different seasons—roses, tulips, forget-me-nots, cyclamen, violets—along with insects equally beautiful and short-lived, as well as a bird's nest. The artist celebrated the decorative qualities of his subjects but also intended to provoke serious reflection on the transience of life and beauty.

MAURICE-QUENTIN DELATOUR

French, 1704–1788
Gabriel Bernard de Rieux, 1739–41
Pastel and gouache on paper mounted on canvas
Unframed: 200 × 150 cm (79 × 59 in.)
Framed: 317.5 × 223.5 cm (125 × 88 in.)
94.PC.39

Maurice-Quentin Delatour was a highly sought-after portraitist in his day. He worked exclusively in pastel, producing likenesses of the nobility and the wealthy upper classes that were acclaimed both for their technical mastery and for their brilliant verisimilitude. After seeing the portrait of Gabriel Bernard de Rieux at the Salon of 1741, a viewer wrote, "It is a miraculous work, it is like a piece of Dresden china, it cannot possibly be a mere pastel." The fine differentiation between textures, the play of light over reflective surfaces, and the overall high degree of finish were qualities expected from oils, but they were extraordinarily difficult to achieve in fragile pastels. The work was Delatour's successful challenge to the prestigious medium of oil.

This monumental full-length portrait, still in its original massive gilt frame, transcends the intimate conventions of pastel. During his long career Delatour did only one other like it, the portrait of Madame de Pompadour now in the Musée du Louvre, Paris. The Getty Museum's portrait, assembled from separate sheets of paper mounted on canvas, shows Gabriel Bernard de Rieux (1687–1745) dressed in the robes of his office as president of the Second Court of Inquiry in the Parliament of Paris.

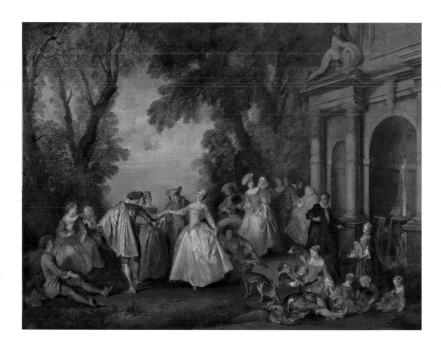

**NICOLAS
LANCRET**

French, 1690–1743
Dance before a Fountain,
by 1724
Oil on canvas
96 × 138 cm
(37¹³⁄₁₆ × 54⁵⁄₁₆ in.)
2001.54

Influenced by his more famous mentor, Jean-Antoine
Watteau, Lancret was a prolific and highly accom-
plished painter of the genre known as the fête
galante—pastoral landscapes with elegantly attired
aristocrats strolling, dancing, and flirting. This
archetypal product of the Rococo is brilliantly exem-
plified by *Dance before a Fountain,* one of Lancret's
most accomplished paintings. With a monumental
fountain in a verdant landscape as a backdrop,
two couples perform a country dance, while others
engage in the arts of conversation and seduction.
The shimmering color of the figures' sumptuous cos-
tumes and the rhythmic weaving of compositional
arabesques through pose, gesture, and gaze create an
effect of high pleasure. Lancret counted among his
elite patrons Louis XV, king of France.

JEAN-ÉTIENNE LIOTARD

Swiss, 1702–1789
Maria Frederike van Reede-Athlone at Seven Years of Age,
1755–56
Pastel on vellum
57.2 × 47 cm
(22½ × 18½ in.)
83.PC.273

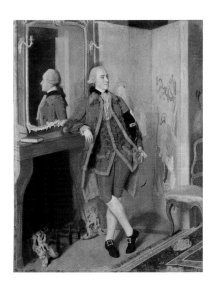

Liotard strove to record three-dimensional objects faithfully, a technique he called "deception painting." His definition of volume through subtle gradations of color and his brilliant description of surface textures create the startling realism that makes his work unique. Here, he captures the alert intelligence of a seven-year-old girl from an aristocratic Dutch family with amazing immediacy. By choosing a plain background, Liotard focuses attention on the sitter, her clothing, and her pet dog. He suggests an enigmatic shyness on the part of the girl, whose averted gaze implies a complex personality about to bloom. The child's refined elegance contrasts with the eager curiosity of the dog, who stares at the viewer. Utilizing the difficult medium of pastel, Liotard masterfully evoked both the physicality and psychology of his subject.

JEAN-ÉTIENNE LIOTARD

Swiss, 1702–1789
John, Lord Mountstuart,
later Fourth Earl and First
Marquess of Bute, 1763
Pastel on parchment
111.5 × 87.5 cm
(43⅞ × 34⁷⁄₁₆ in.)
2000.58

When the nineteen-year-old Lord Mountstuart passed through Switzerland en route to Italy on his Grand Tour, his father, Lord Bute, commissioned this portrait from Geneva's greatest artist. On an enormous single piece of parchment, Liotard executed a full-length portrait, a rarity in the medium of pastel. Liotard fills the work with bravura touches, most notably the complex reflection in the mirror and the carefully described furnishings, including the mussed Turkish carpet, the Chinese folding screen—complete with small tears—and the sitter's winter suit made of blue silk, squirrel fur, and needlepoint lace.

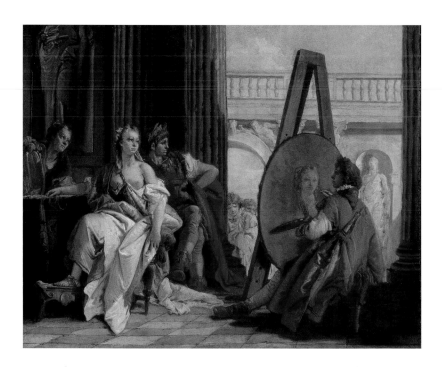

**GIOVANNI BATTISTA
TIEPOLO**

Italian, 1696–1770
*Alexander the Great
and Campaspe in
the Studio of Apelles,*
circa 1740
Oil on canvas
42.1 × 54 cm
(16⁹⁄₁₆ × 21¹⁄₄ in.)
2000.6

In a famous story taken from Pliny's *Natural History*,
Alexander the Great realized that Apelles—the great-
est ancient Greek painter—had fallen in love with
Campaspe, the emperor's mistress. In response, he
graciously conceded her to the painter. Artists often
invoked the story to reflect on the command of the
painter over powerful patrons, although the original
owner of the painting is not yet known. Tiepolo
returned to this subject three times, changing the
emotional tone considerably on each occasion, in this
case conveying the moment when the emperor sees
through Apelles' attempts to restrain his passion for
Campaspe. Painting with his characteristic ease of
handling, Tiepolo added drama to the story with
his lush, varied brushwork; unexpected scale shifts;
surprising contrasts of light and dark; and rich,
saturated color.

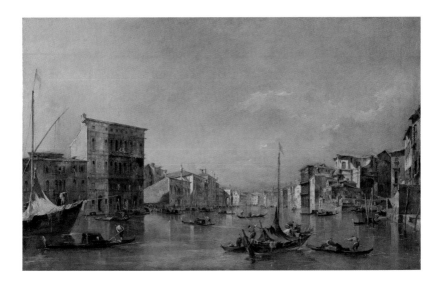

FRANCESCO GUARDI

Italian, 1712–1793
The Grand Canal, Venice, with the Palazzo Bembo, circa 1768
Oil on canvas
46.5 × 76.5 cm (18¼ × 30 in.)
2005.41

From a vantage point in the middle of the Grand Canal, just before it intersects with the Cannaregio waterway, a delicate and complex panorama emerges, bathed in a luminous morning haze. One of the great view painters of eighteenth-century Venice, Guardi developed a way of describing the city that concentrated on transitory effects of weather and human activity. Perhaps symptomatic of his local patronage was his careful attention to new construction, an approach treating the city as a constantly changing site rather than as a tourist destination focused on significant monuments.

Guardi's Venice is lively with commerce and the drama of daily life, with gondolas skimming the canals and two larger boats moving cargo among the islands. The Palazzo Bembo rises at the left; the two tones of the structure mark the recently completed addition to the Renaissance palace. The middle ground features houses of various important Venetian families, gracefully tinted in muted shades of white, rose, and peach, while the Church of San Geremia appears at the right, in the midst of its midcentury renovation. As the channel recedes in evanescent atmospheric perspective, gentle reflections of the buildings appear in the placid water, while vertical pilings and masts pierce the air in a lively contrapuntal pattern.

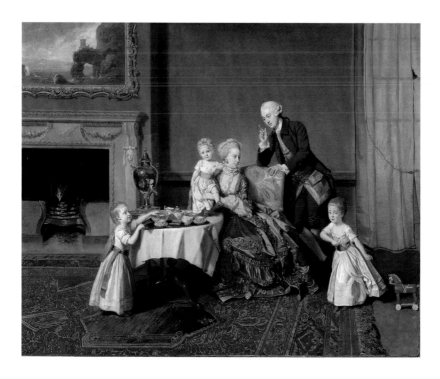

JOHANN ZOFFANY

German, 1733–1810
*John, Fourteenth Lord
Willoughby de Broke, and
His Family in the Breakfast
Room at Compton Verney,*
circa 1766
Oil on canvas
100.5 × 125.5 cm
(39½ × 49½ in.)
96.PA.312

This painting of an English lord and lady with their
children in the breakfast room of their ancestral home
belongs to a genre known as the "conversation piece,"
a type of informal group portraiture popular in
eighteenth-century Britain. One of the finest practi-
tioners of the genre, Zoffany vividly portrays the
accoutrements of class—the fine costumes, Turkish
rug, Chinese export porcelain tea service, and silver
urn—while describing an actively engaged family.
Young George reaches for a piece of buttered toast
while his father admonishes him; George's brother,
John, enters the room pulling a toy horse while his
mother looks on, absently restraining her one-year-
old daughter, Louisa. Zoffany's lustrous handling
of paint combined with his meticulous illusionism
mark this late painting as one of his finest.

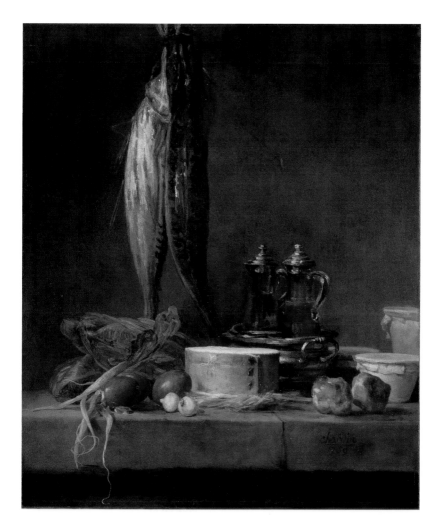

JEAN-SIMÉON CHARDIN

French, 1699–1779
Still Life with Fish, Vegetables, Gougères, Pots, and Cruets, 1769
Oil on canvas
68.5 × 58.5 cm
(27 ¹⁄₁₆ × 23 ¹⁄₁₆ in.)
2003.13

Among the greatest still-life painters in the history of art, Chardin carefully organized mundane household objects into structures that are architectural in their balance and integrity. In this picture he skillfully renders various textures using thick applications of opaque paint in some areas and thin glazes in others. The color harmonies are highly sophisticated, from the strong complement of the red beets and the greens at the left, to the more subtle powder blue ceramic pots against the warm hues of the pastry at the right. This work is the artist's last signed and dated still life.

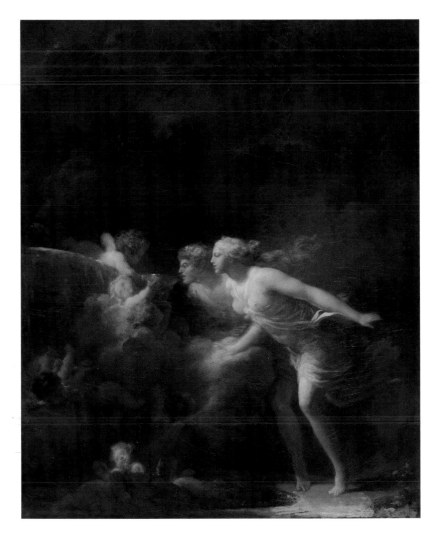

JEAN-HONORÉ FRAGONARD

French, 1732–1806
The Fountain of Love,
circa 1785
Oil on canvas
62.2 × 51.4 cm
(24½ × 20¼ in.)
99.PA.30

Fragonard, best known for delightful Rococo images, responded to the later Neoclassical movement with his own dreamy, moonlit vision of antiquity. In *The Fountain of Love*, luminous effects and fluid brushwork bring softness to figures based on classical sculpture.

The focal point of a poetic allegory of the progress of love, the fountain brings forth the waters from which couples drink and fall in love. During the eighteenth century, artists treated the theme as a genre subject, with lovers in contemporary dress engaged in flirtation. But here, Fragonard returns the allegory to its classical origins, imbuing it with the rush of those thrilling moments of the first taste of love.

JEAN-BAPTISTE GREUZE

French, 1725–1805
The Laundress, 1761
Oil on canvas
40.6 × 32.4 cm (16 × 12⅞ in.)
83.PA.387

Greuze specialized in genre painting —images of daily life—and here he describes the laundress's modest room and humble possessions with loving detail and a luxurious handling of paint. However, washing linens was an arduous, outdoor activity, so the interior setting, as well as the laundress's well-kept garments, delicate hands, and red shoe, do not document the lived reality of laundering. The painting draws on images of domestics by seventeenth-century Dutch and eighteenth-century French artists, as well as a form of contemporary popular literature called the *genre poissard*, which casts the laundress as a sexually charged figure. For his elite clientele, Greuze thus reimagines this lower-class figure in a pleasing, sensual way.

BARON FRANÇOIS-PASCAL-SIMON GÉRARD

French, 1770–1837
Belisarius, 1797
Oil on canvas
91 × 74 cm (35¾ × 29 in.)
2005.10

Gérard, one of the most important students of Jacques-Louis David, sought to breathe new life into familiar classical subjects after the French Revolution. Here, the sixth-century general Belisarius, unjustly disgraced and blinded, wanders on a dirt path along a dangerous precipice. The aged man carries his young guide, bitten by a serpent that dangles from his bleeding leg. In contrast to the boy's feminized, enervated body, the muscular form of Belisarius rises heroically against the spectacular, atmospheric sunset, his sculptural monumentality creating a powerful outline against the sky.

This recently discovered painting is a smaller version of the picture displayed at the 1795 Salon. Gérard revised passages that had been criticized in the first painting, and a celebrated print used the Getty painting as its point of departure, suggesting that the artist considered this work the primary version of the subject.

JACQUES-LOUIS DAVID

French, 1748–1825
*Suzanne Le Peletier
de Saint-Fargeau*, 1804
Oil on canvas
60.5 × 49.5 cm
(23¾ × 19½ in.)
97.PA.36

Despite the demanding obligations of his new position as Napoleon's First Painter, David created this intimate portrait of Suzanne Le Peletier, the daughter of a revolutionary martyr. Posed almost casually, she gazes calmly and frankly out at the viewer— probably intended to be her fiancé. Rapid, loose brushstrokes describe her tousled dark curls and the folds of her simple, stylish clothing.

JACQUES-LOUIS DAVID

French, 1748–1825
*The Farewell of Telemachus
and Eucharis*, 1818
Oil on canvas
87.2 × 103 cm
(34½ × 40½ in.)
87.PA.27

During the final decade of his life, which he spent in voluntary exile in Brussels, David created a series of innovative mythological paintings with themes of erotic entanglements. In *The Farewell,* filial duty requires Telemachus to abandon the nymph Eucharis to search for his missing father, Odysseus. Elegantly interlacing the figures of the lovers, David played his perfection of line and form against Flemish-inspired color harmonies of reds, blues, and cool flesh tones.

Jacques-Louis David

French, 1748–1825
Zénaïde and Charlotte Bonaparte, 1821
Oil on canvas
129.5 × 100 cm (51 × 39⅜ in.)
86.PA.740

This double portrait depicts the daughters of Napoleon's older brother, Joseph Bonaparte, who had fled into exile in the United States following the fall of the empire at Waterloo in 1815. Joseph's wife and daughters lived in Brussels in a tight-knit community of French exiles, several members of whom had their portraits painted by David. Here, the sisters sit close together in the Neoclassical attire fashionable in Napoleon's court, holding a letter from their father sent from Philadelphia. With great skill and empathy, David evokes his subjects' personalities, the protective older sister and the more timid Charlotte sitting close behind her. The empty space above the womens' heads heightens the melancholic tone of this picture of princesses separated from both their father and their homeland.

JOSEPH MALLORD WILLIAM TURNER

English, 1775–1851
*Van Tromp, Going About
to Please His Masters,
Ships a Sea, Getting a Good
Wetting*, 1844
Oil on canvas
91.4 × 121.9 cm (36 × 48 in.)
93.PA.32

Turner united two of his passions, the sea and Holland, in this painting, which he first exhibited at the Royal Academy in 1844. It depicts a combination of events from the lives of two men, Admiral Maarten Harpertszoon Tromp (1598–1653) and his son Cornelis (1629–1691). Both earned renown for their naval victories against British and Spanish fleets during the height of Dutch seafaring power.

CASPAR DAVID FRIEDRICH

German, 1774–1840
A Walk at Dusk,
circa 1830–35
Oil on canvas
33.3 × 43.7 cm
(13⅛ × 17³⁄₁₆ in.)
93.PA.14

Caspar David Friedrich was a leading figure of the German Romantic movement. He is noted for his deeply personal religious imagery in which landscapes and natural phenomena serve as metaphors for the most profound human experiences and sentiments.

A Walk at Dusk shows an isolated figure—dressed as a scholar and perhaps intended as a self-portrait—contemplating a prehistoric grave with its implicit message of death's inevitability.

FRANCISCO JOSÉ DE GOYA Y LUCIENTES

Spanish, 1746–1828
Bullfight, Suerte de Varas,
1824
Oil on canvas
50 × 61 cm (19½ × 24 in.)
93.PA.1

This work is Goya's final painted essay on the theme of the bullfight, a subject that he popularized and that recurs throughout his career. His passion for the sport is here overlaid with horror at the abusive tactics that emerged when bullfighting was considered to be in decline, late in his life.

A horde of men and horses stands in opposition to a lone bull, their battle plan in disarray as the bull has reduced their grim determination and their numbers. Wounded and weakened, the bull is presented not as a fierce, unbridled force of nature but as a noble beast before the rabble. His very presence in the ring assures his death, but he has nonetheless won.

An inscription on the back of the canvas identifies this work as a gift, painted in Paris during the summer of 1824, for Goya's friend and compatriot in exile Joaquín María Ferrer. Goya had only recently left his native land, at age seventy-eight, worried over possible censorship and oppression following Ferdinand VII's return to the Spanish throne in 1823.

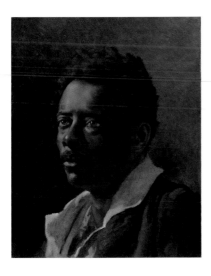

THÉODORE GÉRICAULT

French, 1791–1824
Portrait Study, circa 1818–19
Oil on canvas
46.7 × 38 cm (18⅜ × 15 in.)
85.PA.407

This portrait may represent Joseph, the professional artist's model who posed for Géricault's masterpiece *The Raft of the Medusa* (Paris, Musée du Louvre), completed in 1819. A haunting character study never used in the larger work, this portrait belongs to an important group of paintings and drawings of African men by Géricault.

GUSTAVE COURBET

French, 1819–1877
The Grotto of Sarrazine near Nans-sous-Sainte-Anne,
circa 1864
Oil on canvas
50 × 60 cm
(19¹¹⁄₁₆ × 23⅝ in.)
2004.47

A geological wonder, the grotto of Sarrazine was a popular tourist destination in Courbet's native region of southeastern France. Courbet painted it, and related geological sites, numerous times in 1864. Here, the artist investigates the architecture of nature created over time by erosion and glacial movement. Courbet uses the cave, an unusual subject for a landscape, to propose radical new ideas about composition and technique. He varies his technique, his tools, and his palette to describe the different colors and textures of the site. Dramatic compositional devices—arcs and diagonals—help create a vortex that fills the picture plane, bringing the viewer up close to the cave's mineral-rich, craggy, and moss-covered rock walls. The laborious construction of the picture surface with brushes and palette knives evokes the mosaic-like colors and textures of the rock strata. Here, in this composition, verging on abstraction, the human presence is virtually eliminated; it is suggested only by the delicate wooden scaffolding that hugs the curved back wall.

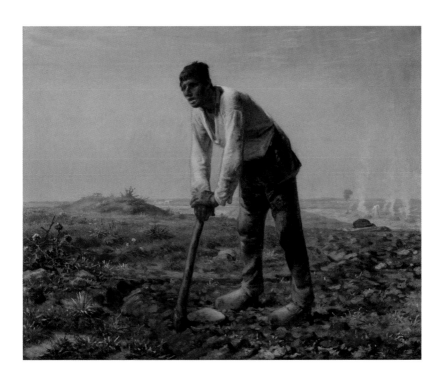

**JEAN-FRANÇOIS
MILLET**

French, 1814–1875
Man with a Hoe, 1860–62
Oil on canvas
80 × 99 cm (31½ × 39 in.)
85.PA.114

When Millet first exhibited *Man with a Hoe* at the
Salon of 1863, it raised a storm of controversy that
lasted well into the twentieth century. The artist
intended his image of an exhausted peasant to repre-
sent the dignity and strange beauty of manual labor.
By contrasting the bent, awkward figure with the
richly painted, broken earth of the field, Millet was
calling attention to the costs and benefits of agrarian
life. The division of the foreground into distinct
patches of stony, thorny terrain and cultivated earth
graphically portrays the results of the peasant's toil.
However, the starkness of the scene and harsh char-
acterization of the peasant were attacked by most
of the critics who reviewed the 1863 exhibition. More-
over, since it concluded a long series of similar
subjects Millet painted during a decade of heated pub-
lic debate over the fate of the peasant in French soci-
ety, *Man with a Hoe* was taken by some to represent
the socialist position on the laboring poor. In response
to claims that his painting was both ugly and politi-
cally radical, Millet stated: "Some tell me that I deny
the charms of the country. I find more than charms,
I find infinite glories.... But I see as well, in the plain,
the steaming horses at work, and in a rocky place
a man, all worn out, whose 'Han!' has been heard
since morning, and who tries to straighten himself
for a moment and breathe. The drama is surrounded
by beauty."

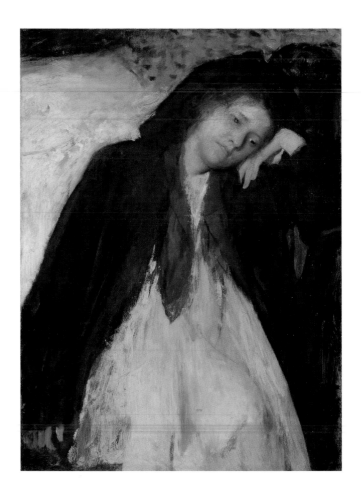

EDGAR DEGAS

French, 1834–1917
The Convalescent,
circa 1872–January 1887
Oil on canvas
65.1 × 47 cm (25⅝ × 18½ in.)
2002.57

When he sold this painting to a commercial art gallery in 1887, Degas identifed it as *The Sick Woman (The Convalescent) (La Malade [La Convalescente]).* Although he never named the sitter, visual, technical, and historical evidence suggests that she was Estelle Musson, one of his New Orleans cousins. Estelle suffered from terrible eye maladies that eventually rendered her completely blind. Married to Degas's brother, René, with whom she had four children, she was later abandoned by him. Estelle gave birth to her third child while Edgar Degas was visiting New Orleans in late 1872. The painting conveys the heavy weight of illness (possibly after childbirth). Confined to her sickroom, the woman gazes listlessly into space with unfocused, watery eyes. Sadness registers in her face and in her draped, obscured body. Degas's compressed composition and dark palette create an atmosphere of melancholy and isolation. An accomplished and committed portraitist, he depicted this intensely private moment with poignant empathy.

EDGAR DEGAS

French, 1834–1917
Waiting, circa 1882
Pastel on paper
48.2 × 61 cm (19 × 24 in.)
83.GG.219
(Owned jointly with
the Norton Simon Art
Foundation, Pasadena)

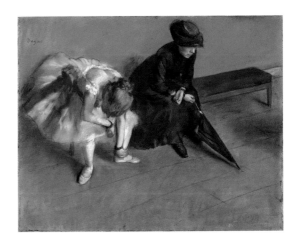

Unlike his contemporaries the Impressionists, Degas arranged his subjects into compositions of great formal beauty laden with emotional power. In this pastel Degas may have intended the juxtaposed figures on the bench to contrast the brilliant, artificial world of the theater with the drabness of everyday life. If the suggestion is correct that the scene shows a dancer and her mother from the provinces awaiting an audition at the Paris Opera, then a contrast between the ephemeral glamour of the opera dancer and the dreary respectability of the provincial woman may also be implied. Each figure is absorbed in her own thoughts, yet they share a sense of tension and anticipation.

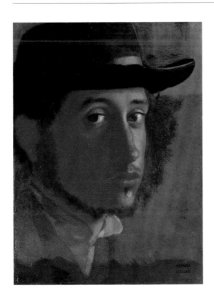

EDGAR DEGAS

French, 1834–1917
Self-Portrait, 1857–58
Oil on paper, laid down
on canvas
20.6 × 15.9 cm (8⅛ × 6¼ in.)
95.GG.43

Painted during Degas's student years in Italy (1856–59), this early self-portrait reveals the ideal of sensitive draftsmanship and subtle chiaroscuro characteristic of the Italian Renaissance masters. Degas made at least fifteen self-portraits in various media during his time in Italy. This is among the most intimate of them, with the young painter gazing out intently from beneath the broad rim of his felt hat.

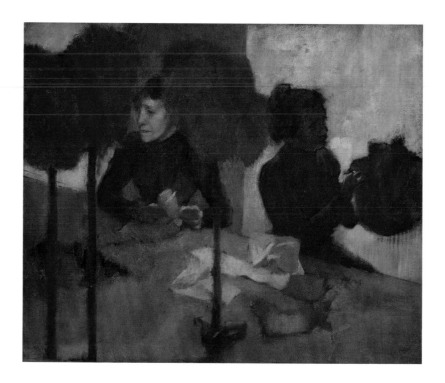

EDGAR DEGAS

French, 1834–1917
The Milliners,
circa 1882–before 1905
Oil on canvas
60 × 74.9 cm
(23⅝ × 29½ in.)
2005.14

After the Bath, circa 1895
Oil on canvas
65.1 × 81 cm
(25⅝ × 31⅞ in.)
2001.20

The Milliners and After the Bath were in Degas's studio when he died in 1917. They were subsequently purchased by the shrewd art dealer Ambroise Vollard for his own collection. Vollard, who represented Paul Cézanne and Pablo Picasso, among others, never sold these late, challenging paintings. Both Milliners and After the Bath attest to Degas's interest in complex forms and dynamic compositions that verge on awkwardness. These works also evince the artist's career-long interest in the lives of women, particularly women of the lower echelons of French society. Although perhaps best known for his representations of ballet dancers, Degas was also intensely inspired by women at work, by private moments, and by physical and psychological complexity.

Fascinated by the millinery trade, Degas made numerous images of female hatmakers and buyers. The Milliners was continuously rethought and repainted from its inception in the 1880s until he stopped working on it in the early 1900s. What began as an image of shoppers was transformed into a complex double portrait of workers. Typically, Degas treated the figures with varying levels of finish: the woman at the left is more fully realized and emotionally resonant than the shadowy figure at the right.

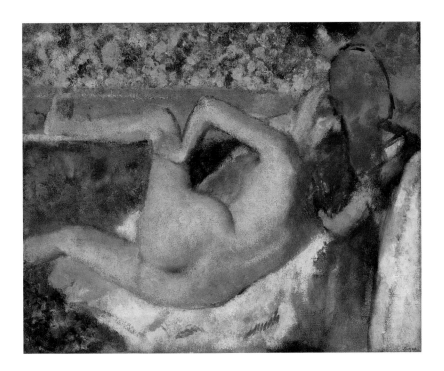

His process was continually and progressively to reduce anecdotal detail; only the looming hat stands and vibrantly colored ribbons remain in a composition that was once filled with finished hats. The result is an austere painting, thoroughly modern in its sensibility, composition, and technique.

After the Bath poses many questions about the bather and her attendant. No clues are offered as to their individual identities or the nature of their relationship. Further, we wonder: Why is the bather in that painful-looking pose? What is wrong with her hip? Indeed, Degas spent more than fifty years drawing, painting, and observing female bodies and had a deep understanding of anatomy. The disjunctions and awkwardness of this pose can only be read as intentional on his part. Here, the nude is not an object of erotic or aesthetic desire but rather a challenging question to the viewer.

Degas's compositional choices are resolutely modern. Both works emphasize flatness, reject clear narrative readings, and celebrate angularity. These late paintings address the viewer with a kind of aggressive formal rigor and are as much about the process of representation as they are about the thing represented.

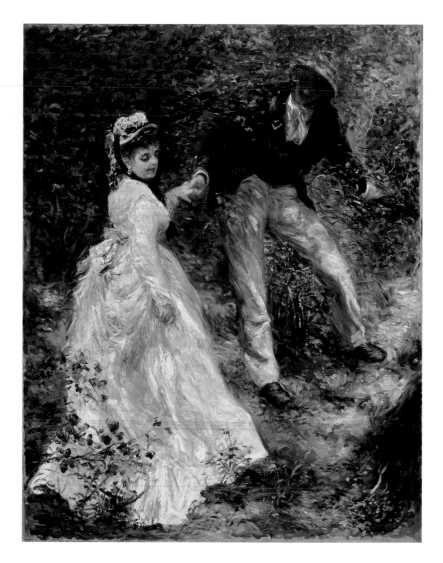

**PIERRE-AUGUSTE
RENOIR**

French, 1841–1919
La Promenade, 1870
Oil on canvas
81.3 × 65 cm (32 × 25½ in.)
89.PA.41

Renoir's promenading couple heads for the under-growth. Although the subject owes its inspiration to Watteau, Courbet, and Monet, the technique of using different brushwork for different purposes was entirely Renoir's. Thus he defined the white dress with long, flowing strokes but created the landscape with short touches that skitter and dance on the surface. Light, atmosphere, and the diagonal move-ments of the lovers unify the composition. The artist's vigorous enjoyment of pleasure—both amorous and painterly—animates every aspect of this early Impressionist work.

ÉDOUARD MANET

French, 1832–1883
The Rue Mosnier with Flags,
1878
Oil on canvas
65.5 × 81 cm (25¾ × 31¾ in.)
89.PA.71

On June 30, 1878, the day of a national celebration, Manet painted two canvases of his street with its decoration of flags. This deceptively casual rendering, executed as late-afternoon shadows advanced down the rue Mosnier, captures the scene with brilliant economy. Virtuoso brushwork describes the scene with minimal fuss and maximum effect. Manet's commitment to subjects from modern life makes this painting more than a cityscape, however; the poignant juxtaposition of the quartier's one-legged veteran with elegant facades and carriages along the street suggests the inequities of life in the new urban environment.

ODILON REDON

French, 1840–1916
Baronne de Domecy,
circa 1900
Pastel and graphite on light
brown laid paper
61 × 42.4 cm (24 × 16¹¹⁄₁₆ in.)
2005.1

This portrait depicts Cécile-Jeanne-Marie Frotier de Bagneux, the wife of Redon's patron and friend, Baron Robert de Domecy. It is sensitively rendered in a style that merges illusionism, visible in the portrait itself, with abstraction, visible in the vibrant floral background. This delicate balance is accentuated by Redon's use of the pastel medium to create soft ethereal forms that blend into one another and unify the composition.

PAUL CÉZANNE

French, 1839–1906
Still Life with Apples,
1893–94
Oil on canvas
65.5 × 81.5 cm
(25 3/4 × 32 1/8 in.)
96.PA.8

Still life held an important, even obsessive, position throughout Cézanne's career. The immobility and long-lasting nature of the objects he chose allowed him the time and control to pursue his pictorial analysis of the relationship between space and object, between visual experience and pictorial rendering.

Still Life with Apples is an elegantly composed, powerfully rendered image of familiar objects. The graceful rhythms created by the swinging black arabesques of the blue cloth, the looping rattan, and the swelling curves of the pots and fruit are played against the strong horizontals and verticals of the composition. Cézanne self-consciously integrates the objects to lock the composition together; a black arabesque "escapes" from the blue cloth to capture an apple near the center; the sinuous curves of the blue ginger pot's rattan straps are visually continued in the bottle. The green of the vase is counterbalanced by the red and yellow apples in this predominantly blue painting. His careful orchestration results in an image of balance, stasis, and control. Cézanne's professed goals "to do Poussin again after nature" and to make of Impressionism "something solid and enduring" are here achieved in the classical stability of this masterful work.

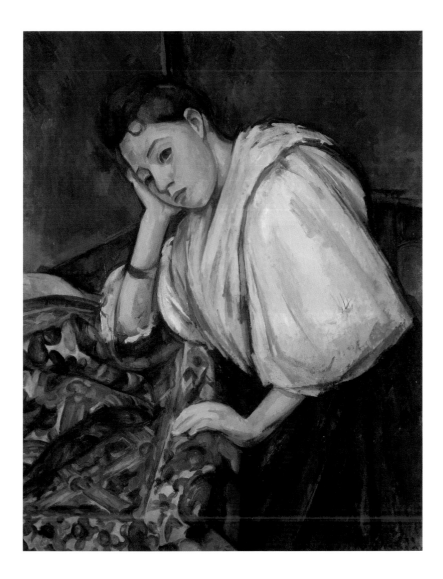

Paul Cézanne

French, 1839–1906
Young Italian Woman at a Table, circa 1895–1900
Oil on canvas
91.7 × 73.3 cm
(36⅛ × 28⅞ in.)
99.PA.40

Cézanne has been celebrated as the greatest figure of the Impressionist generation, as the artist who laid the foundations of Cubism, and as the father of abstract art and the modern movement. His best-known and most influential work dates from the last decades of his life and unites an objective recording of the artist's visual experience with controlled, unified structure and monumentalizing grandeur. *Young Italian Woman* reveals Cézanne at his most enigmatic and poignant. Although the woman's physical presence is compelling, her withheld thoughts and emotions create a mood of profound melancholy.

CLAUDE MONET

French, 1840–1926
Sunrise (Marine), 1873
Oil on canvas
49 × 60 cm
(19¼ × 23½ in.)
98.PA.164

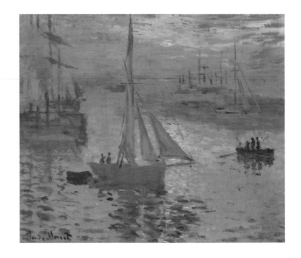

A keen pleasure in evoking the interplay of light, atmosphere, and water shaped Monet's approach to painting seascapes. Early in his career, in the spring of 1873, he traveled to the bustling port of Le Havre, where he painted *Sunrise* and six other early-morning views of the harbor. The broken brushwork of these scenes appeared to lack "finish" and was derisively called "Impressionist" by critics, heralding the beginning of an artistic movement.

CLAUDE MONET

French, 1840–1926
*The Portal of Rouen
Cathedral in Morning
Light*, 1894
Oil on canvas
100 × 64.9 cm
(39⅜ × 25⁹⁄₁₆ in.)
2001.33

*Wheatstacks, Snow Effect,
Morning*, 1891
Oil on canvas
65 × 100 cm
(25½ × 39¼ in.)
95.PA.63

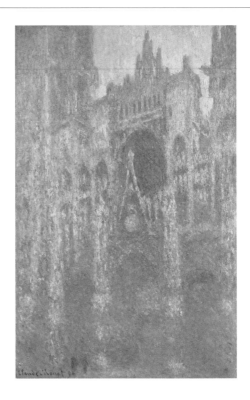

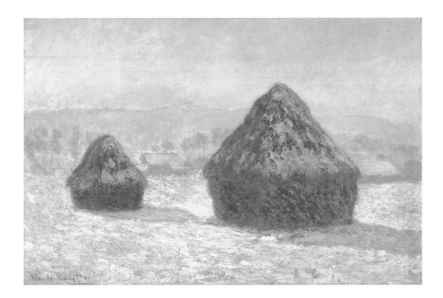

In the fall of 1890, Claude Monet, the pioneer of Impressionism in the 1870s (see *Sunrise [Marine]*, facing page), embarked on his most ambitious project to date. Once again he introduced an important innovation, that of serial painting. Monet's series of wheatstack and Rouen Cathedral paintings confirm his interest in the fleeting effects of light and the changeability of the landscape.

In *Wheatstacks, Snow Effect, Morning*, Monet employs thick brushstrokes to describe the crusty frozen ground, the imposing if impermanent wheatstacks, and the long, blue shadows cast by the cold morning light. The artist's vision, revealed in his series of wheatstacks rendered at different times of day and seasons of the year, attests to the inevitable changes wrought by the passing of hours, days, months, and seasons. This virtuoso, luminous work results both from Monet's direct observations in nature and intense efforts in the studio.

In 1892, after the commercial and critical success of his wheatstacks and poplars series, Monet abandoned such pure landscape subjects and turned his attention to Rouen Cathedral. Whereas wheatstacks are inherently temporary,

Rouen Cathedral, an architectural monument from the medieval past, has endured. For Monet, however, the fascination lies in pictorial possibilities, not in literal or symbolic associations. Wheatstacks and the cathedral facades become vehicles to explore color and light and its effects—what Monet referred to as "the envelope" of atmosphere. In choosing these subjects, the art critic Aurier observed, Monet transforms the mundane into "radiant poems."

In *The Portal of Rouen Cathedral in Morning Light*, Monet builds a thick impasto to convey the stony grandeur of the church front. The paint surface describes the craggy recesses of the clifflike stone facade so that the man-made structure shimmers with morning light. Narrow shafts of peach and pink warm the predominantly blue-gray surface and hint at the stronger light to come. From his up-close view in an improvised studio across the street from the cathedral, Monet produced thirty versions over the course of two years. The series was met with both critical and commercial success.

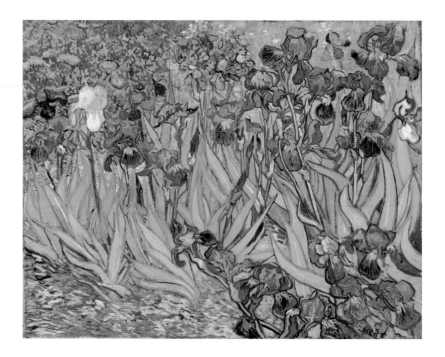

VINCENT van GOGH

Dutch, 1853–1890
Irises, 1889
Oil on canvas
71 × 93 cm (28 × 36⅛ in.)
90.PA.20

Van Gogh painted *Irises* in the garden of the asylum at Saint-Rémy, where he was recuperating from a severe attack of mental illness. Although he considered the work more a study than a finished picture, it was exhibited at the Salon des Indépendants in September 1889. Its energy and theme—the regenerative powers of the earth—express his deeply held belief in the divinity of art and nature. However, the painting's vivid color contrasts, powerful brushwork, and frieze-like composition reflect Van Gogh's study of other artists, notably Paul Gauguin (French, 1848–1903) and the Japanese master Hokusai (1760–1849).

LAWRENCE ALMA-TADEMA

Dutch/English, 1836–1912
Spring, 1894
Oil on canvas
178.4 × 80 cm
(70¼ × 31½ in.)
72.PA.3

Born in Holland, in 1870 Alma-Tadema moved as a successful artist to London, where he became a British citizen, a member of the Royal Academy, and eventually a Knight of the Realm. *Spring*—with the artist's characteristic wealth of detail and careful finish—depicts a flower-bedecked procession of rosy-cheeked children, musicians, and elegant women moving through a Victorian fantasy of ancient Rome. This celebration of spring reflects traditional May Day festivities in England, which were enjoying renewed popularity in the late nineteenth century.

JAMES ENSOR

Belgian, 1860–1949
*Christ's Entry into Brussels
in 1889*, 1888
Oil on canvas
252.5 × 430.5 cm
(99½ × 169½ in.)
87.PA.96

James Ensor's enormous canvas imagining Christ's entry into the capital city of the artist's native Belgium presents us with a complex and terrifying vision of the society of the future. Christ, whose face appears to be the artist's self-portrait, rides a small donkey in the midst of a teeming procession of Mardi Gras revelers. Many in the crowd wear masks, Ensor's device for suggesting the deceptiveness and artificiality of modern life.

The picture's bold color contrasts and thick crusts of paint give the impression of spontaneity, yet Ensor planned every figure in advance. In both subject and technique, this masterpiece shocked nineteenth-

century viewers, and it could not be publicly exhibited
until 1929. Yet its reputation brought many visitors to
the artist's studio, and its visual and emotional impact
contributed to the development of Expressionism
early in the twentieth century.

Drawings

D RAWING IS PERHAPS THE MOST UNIVERSAL, spontaneous, and direct of all art forms. It embraces a wide variety of techniques, including metalpoint, graphite, pen and ink (often used in conjunction with wash), colored chalk, and watercolor. It is, moreover, the only art form practiced by most people, if only at a rudimentary level. The Museum's collection of drawings was begun in July 1981, five years after the death of J. Paul Getty, when Rembrandt's red-chalk study *Nude Woman with a Snake* was purchased (see pp. 166–67). A year later the Department of Drawings was formed. The collection now comprises more than 650 sheets, including two sketchbooks. The purpose is to create as representative a collection as possible of the different schools of western European drawing from the fourteenth to the end of the nineteenth century, with an emphasis on works by the most important and accomplished draftsmen.

With only a few exceptions, the great artists of the past—painters, sculptors, printmakers, and architects alike—employed drawing as an integral part of the creative process. It was used to study nature as well as the human figure, to explore rough ideas prior to their realization in the more durable media of paint or stone, and as an end in itself, as in the magnificent watercolor *Still Life* by Paul Cézanne (see p. 178). The German Renaissance painter Albrecht Dürer drew a highly finished gouache study of a stag beetle (see p. 163) directly from nature as a record in its own right. In contrast, Raphael's deft *Saint Paul Rending His Garments* (see p. 154) was created as a preliminary study for a figure in a tapestry design. Many of the drawings are compositional studies for pictures. The *Sheet of Studies for "The Martyrdom of Saint George"* by the Venetian painter Paolo Veronese (see p. 156), for example, explores a multitude of possible solutions. Drawings after the nude model have always been considered a fundamental step in the training of an artist. Either as preparatory sketches for larger compositions or as independent works, they are particularly well represented in this collection. Pierre-Paul Prud'hon's *Study of a Female Nude* (see pp. 172–73) is one of the most spectacular drawings of this type.

Drawings are sensitive to light and can be exhibited only for short periods. Visitors to the Getty Museum can always see drawings from the permanent collection in an ongoing series of thematic exhibitions.

FILIPPINO LIPPI

Italian, circa 1457–1504
Standing Saint, circa 1482
Metalpoint with
lead white heightening
on gray prepared paper
27.1 × 17.5 cm
(10 ¹¹⁄₁₆ × 6 ⅞ in.)
91.GG.33

Son of the artist Filippo Lippi and an apprentice of Botticelli, Filippino was an exceptional draftsman. In this sheet he has drawn a heavily draped studio assistant holding a pole, specifically concentrating on showing the fall of light and shade on the complex folds of cloth. Several figures of standing draped saints in Lippi's painted work maintain poses similar to this youth's, and it is likely that drawings such as this were kept in the studio and used for reference. Lippi was a master of the technique of metalpoint, in which the artist used a metal stylus to make marks on a slightly rough prepared surface. The technique was popular in the early Renaissance before chalk became widely available and required great skill, since the lines could not be erased.

LEONARDO DA VINCI

Italian, 1452–1519
*Studies for the Christ Child
with a Lamb*, circa 1503–6
Pen and brown ink and
black chalk
21 × 14.2 cm (8¼ × 5⁹⁄₁₆ in.)
86.GG.725

Three of the studies in this drawing are in ink, while
another three are faintly drawn in black chalk. The
child wrestling with the lamb is either the infant Saint
John the Baptist or the Christ child. The number of
different sketches for the same figural group indicates
Leonardo's painstaking approach to the planning of
his compositions. He probably made this drawing
in preparation for a painting of the Virgin and Child
with Saint John, now lost but known through copies.
Leonardo inscribed the drawing at the top of the sheet
and on the verso in his characteristic mirror script.

RAPHAEL
(RAFFAELLO SANZIO)

Italian, 1483–1520
Saint Paul Rending His Garments, circa 1515–16
Metalpoint with white gouache heightening on pale violet-gray prepared paper
23 × 10.3 cm (9⅟₁₆ × 4⅟₁₆ in.)
84.GG.919

This study by Raphael was made in preparation for the figure of Saint Paul in *The Sacrifice of Lystra*, one of a series of tapestries commissioned to decorate the walls of the Sistine Chapel in the Vatican. The violent twisting of the saint's body is convincingly rendered by the highlighted drapery folds that accentuate his movement. Here, Raphael not only elucidates the pose but gives an insight into the saint's emotional state.

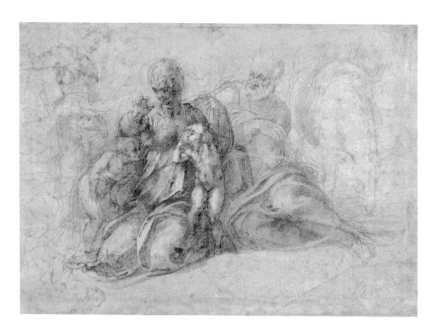

MICHELANGELO BUONARROTI

Italian, 1475–1564
The Holy Family with the Infant Saint John the Baptist (The Rest on the Flight into Egypt), circa 1530
Black and red chalk with pen and brown ink over stylus underdrawing
28 × 39.4 cm (11 × 15½ in.)
93.GB.51

Michelangelo treated the subject of the Madonna and Child many times during his long career—in painting and sculpture, as well as in drawing. Here, he chose to represent an unusual variant of the theme, not specifically related in the Bible, in which the infant Baptist and two angels join the Holy Family on an interlude in their flight into Egypt to escape Herod's persecution. At the right, the ass grazes contentedly, the packsaddle still on its back.

The drawing's purpose is unknown, although it may have been made for a low relief. From its style it may be dated about 1530, during the artist's third Florentine period (1516–34). Michelangelo studied the same composition in a number of other sketches, and a sculpture of the seated Virgin suckling the Christ child, in the Medici Chapel, Florence, shares a number of analogies with the two figures in this drawing.

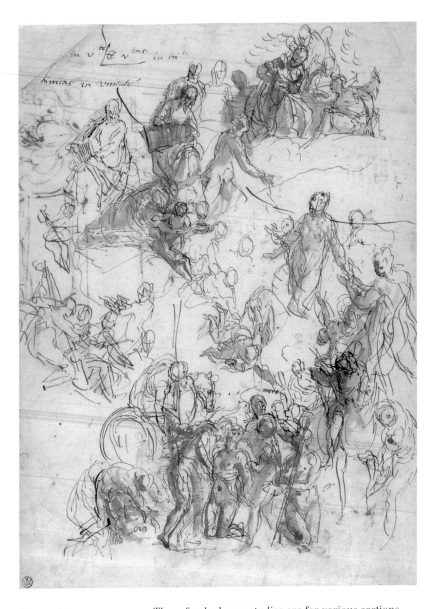

PAOLO VERONESE

Italian, 1528–1588
*Sheet of Studies for
"The Martyrdom of
Saint George,"* 1566
Pen and brown ink
and brown wash
28.9 × 21.7 cm
(11⅛ × 8⁹⁄₁₆ in.)
83.GA.258

These freely drawn studies are for various sections
of Veronese's altarpiece *The Martyrdom of Saint
George* in the Church of San Giorgio, Verona. The rapid
pen strokes of the sketches reflect the artist's crea-
tive energy as he explored varying solutions to the
different figural problems posed by the composition.
With great sensitivity he made subtle changes in
the medium used for the various studies; some are
done in pen and wash, others in pen alone. Although
the individual sketches are distinct in character,
they are unified by the overall rhythmic flow of
Veronese's hand as it moved quickly across the page.

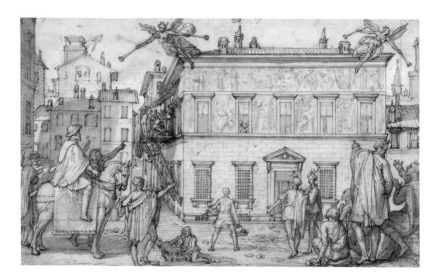

FEDERICO ZUCCARO

Italian, circa 1541–1609
Taddeo Decorating the Facade of the Palazzo Mattei,
circa 1595
Pen and brown ink and brown wash over black chalk with touches of red chalk
25 × 42.2 cm (9⅞ × 16⅝ in.)
99.GA.6.19

During the 1590s Federico Zuccaro made a series of twenty drawings depicting the early life of his older brother and teacher, Taddeo (1529–1566), who is one of the greatest Italian Mannerist artists. These drawings, all in the Museum's collection, are a moving tribute, tracing Taddeo's hardships as a young artist in Rome to his first artistic triumph at age eighteen. The series culminates with this scene showing Taddeo decorating the now-destroyed facade of the Palazzo Mattei with scenes from the life of the Roman hero Furius Camillus. As young Taddeo paints on the scaffold, the Three Graces with Spirit and Pride stand around him, while allegories of Fame fly above. Marveling at his work are the greatest painters of Rome: Michelangelo on his horse at the left, with his servant Urbino, as well as Girolamo Siciolante and Daniele da Volterra. At the right is the famed artist-biographer Giorgio Vasari, shown discussing the facade with Francesco Salviati.

PIETRO DA CORTONA (PIETRO BERRETTINI)

Italian, 1596–1669
*Christ on the Cross, with
the Virgin Mary, Mary
Magdalene, and Saint John,*
circa 1661
Pen and brown ink and
gray wash over black chalk,
heightened with white
gouache, on light-brown
paper, squared in black
chalk, the oval reinforced
in red chalk
40.3 × 26.5 cm
(15⅛ × 10⁷⁄₁₆ in.)
92.GB.79

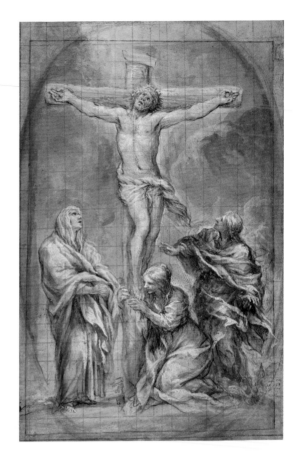

Pietro da Cortona was one of the leading artists of the
Roman Baroque. Here, seeking to convey the final
moments of Christ's life on earth, Cortona creates a
powerfully atmospheric scene featuring the Virgin
Mary, Saint John, and Mary Magdalene, who kneels
to kiss Christ's feet. A strong, heavenly light emanat-
ing from above is expressed through the use of thick
white gouache, and the drawing gives a finished,
pictorial effect. It was made by Cortona as the model
for two paintings of this scene; the black-chalk grid
covering the entire sheet would have been used
to transfer the design to the large-scale canvases.
Evidence of each of the two paintings remains here
in the form of the oval and square border lines drawn
by the artist: the first canvas, made for a church at
Castelgandolfo, the summer residence of the popes
near Rome, was oval; the second, for a church within
Rome, was rectangular.

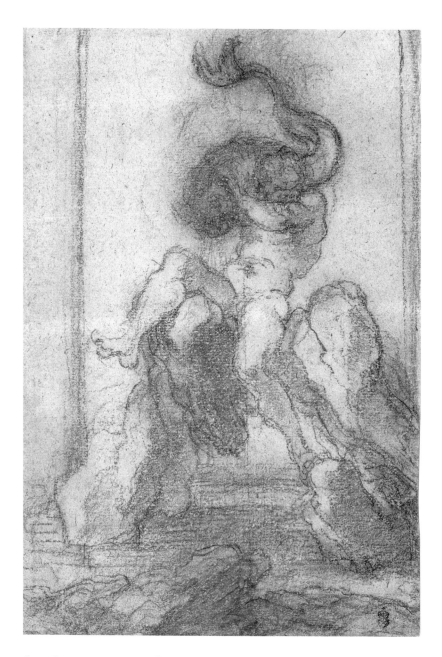

GIAN LORENZO BERNINI

Italian, 1598–1680
Design for a Fountain, with a Marine God Clutching a Dolphin, 1652–53
Black chalk
34.9 × 23.8 cm
(13 ¹¹⁄₁₆ × 9 ⅜ in.)
87.GB.142

Bernini was an architect and a painter as well as the most successful Italian sculptor of his day. The subject of this drawing corresponds with a fountain that he designed for the central niche of the palace of Duke Francesco I d'Este at Sassuolo. The liveliness of the figure as it struggles with the dolphin is typical of Bernini's vigorous High Baroque style.

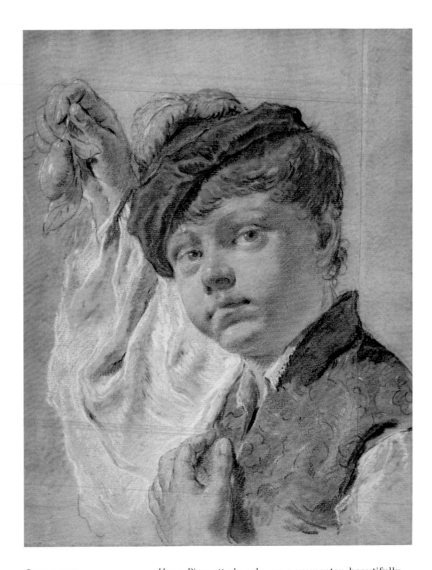

**GIOVANNI
BATTISTA
PIAZZETTA**

Italian, 1682–1754
*A Boy Holding a Pear
(Giacomo Piazzetta?),*
circa 1737
Black and white chalk
on blue-gray paper
(two joined sheets)
39.2 × 30.9 cm
(15 7/16 × 12 3/16 in.)
86.GB.677

Here, Piazzetta has drawn a youngster, beautifully dressed in a brocade vest, full-sleeved shirt, and feathered cap. The boy holds up a pear as he gazes meaningfully at the viewer. This same sitter, recognizable from his good-natured demeanor, appears in a number of Piazzetta's other works and has been tentatively identified as the artist's son, Giacomo. The drawing seems to have been made to be enjoyed in its own right. Piazzetta applied the chalk with varying degrees of pressure. In some areas it is lightly shaded and as a result seems soft and diffused. Elsewhere, it is applied more heavily in rich, velvety patches. Piazzetta further enlivened the sheet with white-chalk highlights—in the lace collar and linen sleeves, in the pear, and on the tip of the boy's nose.

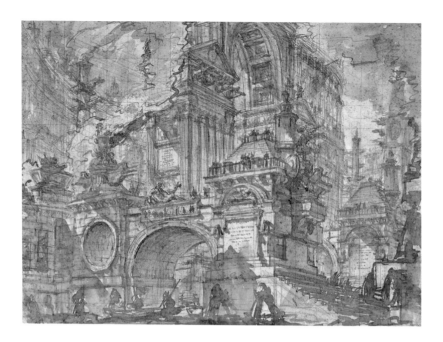

GIOVANNI BATTISTA PIRANESI

Italian, 1720–1778
An Ancient Port,
circa 1749–50
Red and black chalk, brush
and brown and reddish
wash; squared in black chalk
38.5 × 52.8 cm
(15⅛ × 20¹³⁄₁₆ in.)
88.GB.18

Piranesi was one of the greatest etchers in Europe during the eighteenth century. His best-known prints are his views of Rome and his architectural fantasies. This drawing of an ancient port served as a preparatory study for an etching entitled *Part of a Large Magnificent Port* that was first published in 1750 in a series entitled *Opere varie.* The composition is made up of huge interlocking architectural forms, including a portal and bridge in the foreground, a triumphal arch in the center, and a coliseum-like structure, truncated pyramid, and obelisk in the distance. Each section of this building complex is decorated with an elaborate sculptural program, and the whole is further dramatized by clouds of smoke. In the foreground are boats reminiscent of those found in the artist's native Venice.

Piranesi first drew the main outlines in chalk, then liberally added brown and red wash for shading and some of the details. The black-chalk grid lines throughout were made to assist the process of transferring the design to the copperplate. The wash gives a vibrancy to the whole that was not transmitted to the etching. Piranesi made at least two drawings preparatory to this finished sketch.

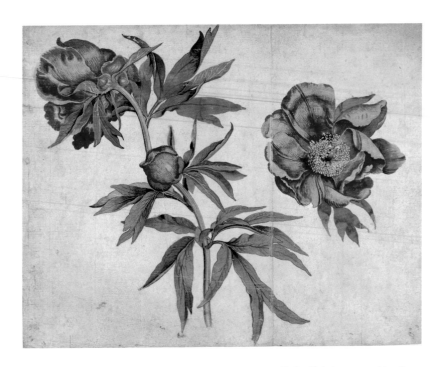

MARTIN SCHONGAUER

German, 1450/53–1491
Studies of Peonies,
circa 1472/73
Gouache and watercolor
25.7 × 33 cm (10⅛ × 13 in.)
92.GC.80

These flowers (*Paeonia officinalis* L.) were evidently drawn from life. At the left is a stem with one blossom fully open, the head turned away, and one bud; at the right, a separate study of an open blossom, seen from the front. The blossoms and foliage are delicately modeled and colored. This large sheet, the only surviving nature study by Schongauer, is a singularly important drawing in the German Renaissance period. It was used as the model for some of the flowers in the background of his great altarpiece, *The Madonna of the Rose Garden*, painted in 1473 for the Dominican church at Colmar. The drawing is among the earliest manifestations of the movement toward the realistic depiction of nature in Northern Renaissance art and, as such, constitutes a crucial precedent for Albrecht Dürer's nature studies of the early sixteenth century, for example the *Stag Beetle* (see facing page).

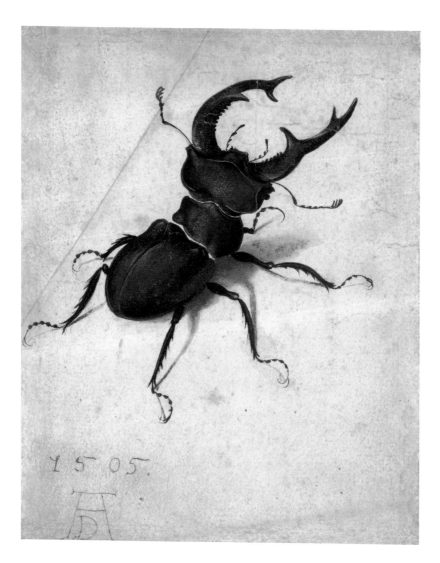

ALBRECHT DÜRER

German, 1471–1528
Stag Beetle, 1505
Watercolor and gouache;
top-left corner added;
tip of left antenna
painted in by a later hand
14.2 × 11.4 cm
(5⁹⁄₁₆ × 4½ in.)
83.GC.214

This startling image is typical of Dürer's many studies
drawn directly from nature. His drawings of this
type form an illuminating counterpart to the more
obviously scientific renderings of plant and animal
life by his Italian near-contemporary Leonardo
da Vinci. In this drawing Dürer presents a living
creature illusionistically; the beetle casts its own
shadow on the plain ground of the paper as if actually
crawling across it. The modulations of tone along
the insect's ridged wing cases are also faithfully
rendered.

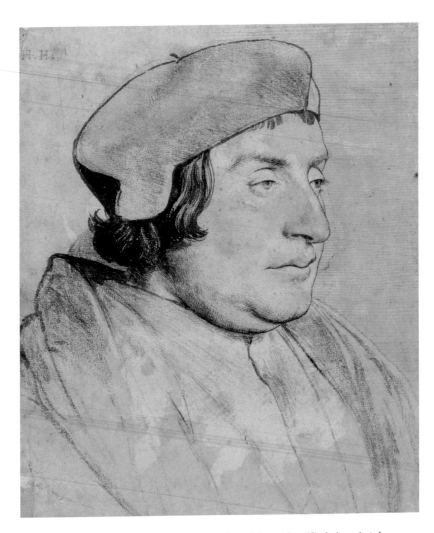

HANS HOLBEIN THE YOUNGER

Swiss, 1497–1543
*Portrait of a Scholar
or Cleric,* circa 1532–43
Black and red chalk, pen
and brush and black ink, on
pink prepared paper
21.9 × 18.5 cm (8⅝ × 7¼ in.)
84.GG.93

Because of his hat, this unidentified sitter is taken
to be either a cleric or a scholar. Holbein probably
made the portrait during his second English period
(1532–43), when he served as painter to King Henry
VIII, and the sitter may well have been connected
with the Tudor court. Holbein sketched the con-
tours of the man's face in black chalk and then deftly
went over them in black ink. The face was softly
modeled in red chalk, using the pink of the paper as
a middle tone. Outside the face, the handling is broad
and painterly, as in the hair and robe. Holbein was
attuned to the uniqueness of the features of each
of his sitters, which he rendered with unparalleled
precision and objectivity.

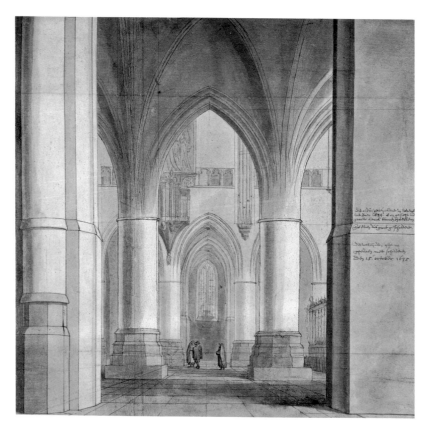

PIETER JANSZ. SAENREDAM

Dutch, 1597–1665
The Choir and North Ambulatory of the Church of Saint Bavo, Haarlem, 1634
Red chalk, graphite, pen and brown ink, and watercolor, the outlines indented for transfer (recto); rubbed with black chalk for transfer (verso)
37.7 × 39.3 cm
(14¹³⁄₁₆ × 15⁷⁄₁₆ in.)
88.GC.131

Saenredam specialized in painting architectural subjects. Between 1628 and 1660, he made a number of drawings and paintings of the Church of Saint Bavo in Haarlem, one of Holland's largest and most venerated Gothic buildings. This elaborate watercolor drawing, which is dated November 1634, is based on a sketch the artist drew on the spot in October 1634, now in the Gemeentearchief, Haarlem. The Museum's drawing is a finished preparatory study, which the artist traced directly onto a panel, now in the Muzeum Narodowe, Warsaw. Yet in the painting Saenredam dramatically altered the proportions of the design and focused on the church interior instead of the piers in the foreground. An inscription on the Museum's drawing states that the painting was completed on October 15, 1635.

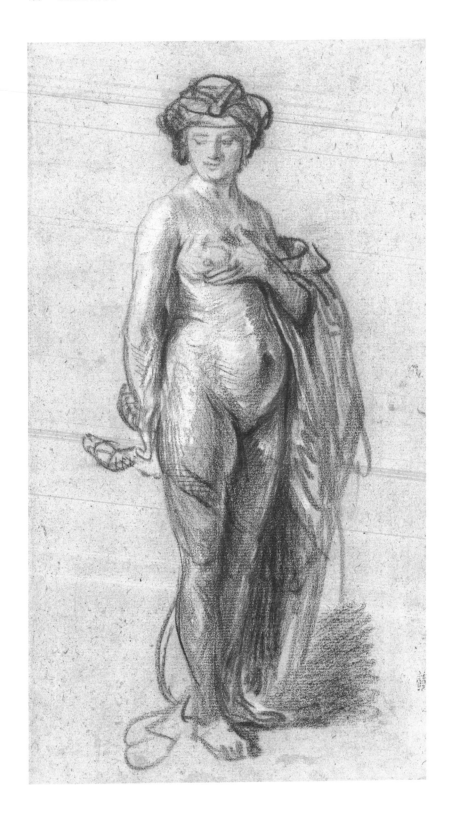

REMBRANDT HARMENSZ. VAN RIJN

Dutch, 1606–1669
Landscape with the House with the Little Tower,
circa 1650–52
Pen and brown ink and brown wash
9.7 × 21.5 cm (3¹³⁄₁₆ × 8⁷⁄₁₆ in.)
83.GA.363

Rembrandt drew this extremely sensitive and abstract landscape drawing on one of his frequent sketching jaunts in and around Amsterdam. Space and atmosphere in the foreground are suggested by only a few lines, while a complex mixture of thinner lines, dots, and touches of wash creates a richer and more varied background. The drawing illustrates how a great artist can evoke vast space with a supreme economy of means.

REMBRANDT HARMENSZ. VAN RIJN

Dutch, 1606–1669
Nude Woman with a Snake,
circa 1637
Red chalk with white gouache heightening
24.7 × 13.7 cm
(9¹¹⁄₁₆ × 5⁷⁄₁₆ in.)
81.GB.27

This is one of the best preserved and most fluent of all of Rembrandt's red-chalk drawings. The figure's identity is enigmatic, as she wears an antique headdress, while other aspects may allude to Eve. An ordinary woman and not an idealized type, she presents her bare breast to the spectator and grips the neck of a large snake that coils around her leg. The range of draftsmanship is striking, from the fine modeling of the figure to the virtuoso passages of freely sketched drapery.

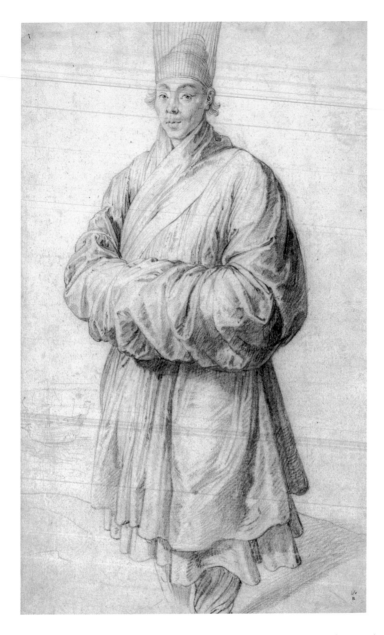

**PETER PAUL
RUBENS**

Flemish, 1577–1640
Korean Man,
circa 1617–18
Black and red chalk
38.4 × 23.5 cm
(15⅛ × 9¼ in.)
83.GB.384

Rubens used this imposing portrait of a man in for-
mal costume as the basis for one of the background
figures in his painting *The Miracles of Saint Francis
Xavier.* The subject's woven horsehair hat identifies
him as Korean, and he appears to be among the
earliest representations of a Korean visitor to Europe.
It is one of Rubens's most finely executed drawn
portraits, with the likeness enlivened by the touches
of red in the face. The meticulous detailing of the
flesh contrasts with the much broader rendering of
the voluminous robe.

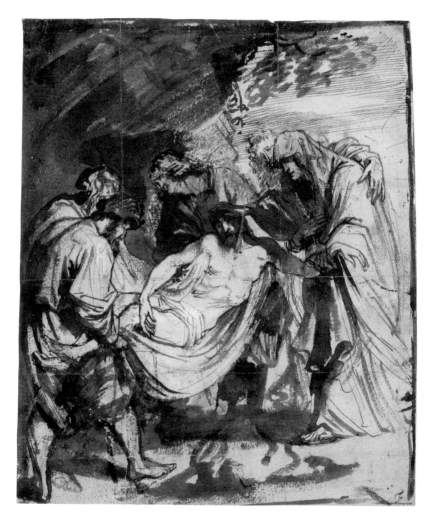

**ANTHONY
VAN DYCK**

Flemish, 1599–1641
The Entombment, 1617–18
Black chalk, pen and brown
ink, brown and reddish wash,
red and blue chalk, and
white gouache heightening
25.4 × 21.8 cm (10 × 8⅝ in.)
85.GG.97

To create this poignant depiction of Christ being
carried to his tomb, the young Anthony van Dyck
turned to Italy for inspiration. The drawing is influ-
enced by Titian's *Entombment*, which Van Dyck
would have known from a copy. Van Dyck exchanged
Titian's sweeping horizontal composition for a more
tightly integrated, vertical format, thereby depicting
a more compact, somber scene. He contrasted the
extremely fine pen lines visible on Christ's torso with
gestural strokes of brown wash. The tenebrous
use of wash, together with the grieving Virgin Mary
holding the arm of her dead son, heightens the sense
of anguished mourning. The drawing is thought to
be preparatory for a painting that Van Dyck planned
and possibly abandoned.

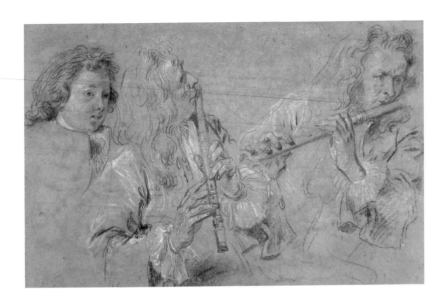

**JEAN-ANTOINE
WATTEAU**

French, 1684–1721
*Two Studies of a Flutist and
One of the Head of a Boy,*
circa 1716–17
Red, black, and white chalk
21.4 × 33.6 cm
(8 7/16 × 13 3/16 in.)
88.GB.3

Watteau was one of the most influential artists and
gifted draftsmen of the French Rococo period.
A master of lyrical themes, he invented the subject
known as the fête galante, in which elegant young
men and women in an open landscape dally to the
sound of music, captivated by feelings of love. Watteau
probably made this drawing while attending a con-
cert. He studied the flute player from different angles,
recording distinct expressions on the musician's face.
The boy at the left appears to be listening. Watteau
was a master of the technique known as *trois crayons,*
a combination of red, black, and white chalk, almost
invariably drawn on tinted paper.

FRANÇOIS
BOUCHER

French, 1703–1770
*The Birth and Triumph
of Venus*, circa 1743
Black chalk and gouache
39 × 31 cm (15⅜ × 12³⁄₁₆ in.)
2005.16

François Boucher's mythological subjects, populated
by enchanting goddesses and playful cupids, have
come to exemplify the Rococo style in eighteenth-
century France. In this rare gouache drawing, naiads
offer gifts from the sea to the reclining Venus, while
tritons trumpet her arrival. Putti romp in the sea and
sky, which Boucher depicted using a fluid technique
and a variety of whites, blues, and grays to suggest
the moving waters and the blustery skies. Boucher's
refined sense of color is also evident in his use of
red, as the red outlines and accents on the figures seem
to have emanated from the coral at the center. This
recently discovered drawing was made as an indepen-
dent work of art and exhibited in the Salon of 1745.

**JEAN-AUGUSTE-
DOMINIQUE INGRES**

French, 1780–1867
*Portrait of
Lord Grantham*, 1816
Graphite
40.5 × 28.2 cm
(15 ¹⁵⁄₁₆ × 11 ⅛ in.)
82.GD.106

This drawing of Thomas Philip Robinson, third Baron
Grantham and later Earl de Grey, is signed and
dated 1816. Ingres had a lucrative practice as a portrait
draftsman while he lived in Italy, from 1806 to 1824.
Many of his patrons were foreign residents or wealthy
travelers on their Grand Tours. The portraits drawn
by Ingres are renowned for their severity of line, which
exemplifies his strongly classical style.

**PIERRE-PAUL
PRUD'HON**

French, 1758–1823
*Study of a
Female Nude*,
circa 1800
Black and white chalk,
stumped, on blue paper
60.4 × 31.8 cm
(23 ¾ × 12 ½ in.)
99.GB.49

Prud'hon was celebrated for his series of exquisite
chalk drawings known as *académies*, or studies of
nude models posed in the studio. Made as an indepen-
dent work of art, the present example is one of his
most superb portrayals of the female nude. Her classi-
cally inspired pose, combined with the shimmering
white surface of her skin, is evocative of antique mar-
ble sculpture. Far from statuary, however, Prud'hon's
figure seemingly trembles before our eyes through a
blend of infinite tiny strokes of white chalk and smoky
passages of stumped black chalk. Her dreamy gaze
and the soft play of shadows across her flesh add to
the inherent aura of sensuality.

EUGÈNE DELACROIX

French, 1798–1863
The Education of Achilles,
1862
Pastel
30.6 × 41.9 cm
(12 1/16 × 16 1/2 in.)
86.GG.728

Delacroix was a leading painter of the Romantic movement in France. He greatly admired the work of Peter Paul Rubens, and his own paintings reflect this influence in their free handling and bright colors. Delacroix often represented exotic themes, especially those of the Orient.

The subject of this pastel, taken from Greek mythology, is Achilles learning the art of hunting from the centaur Chiron. The energy of the figures as they gallop through the landscape is matched by Delacroix's own vigorous touch. The palette is characteristically rich, consisting of dark greens, blues, and browns, which are varied by light flesh tones and reds. Delacroix completed two paintings of the same composition. He made this pastel as a gift for a friend, the writer George Sand, who had expressed her admiration for those paintings.

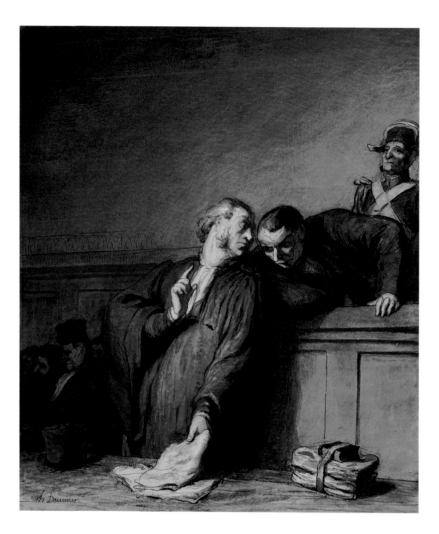

HONORÉ DAUMIER

French, 1808–1879
A Criminal Case, circa 1860
Watercolor and gouache
with pen and brown ink
and black chalk
38.5 × 32.8 cm
(15⅛ × 12¹³⁄₁₆ in.)
89.GA.33

Best known for his satirical lithographs, Daumier
also made drawings, watercolors, paintings, and
sculptures. This watercolor is datable to the later part
of his career, when his style had become broader
and his paintings more monumental in effect. It
shows a courtroom scene, with an attorney leaning
back to confer with his client, and is characteristic
of Daumier's incisive depictions of judges, lawyers,
and criminals.

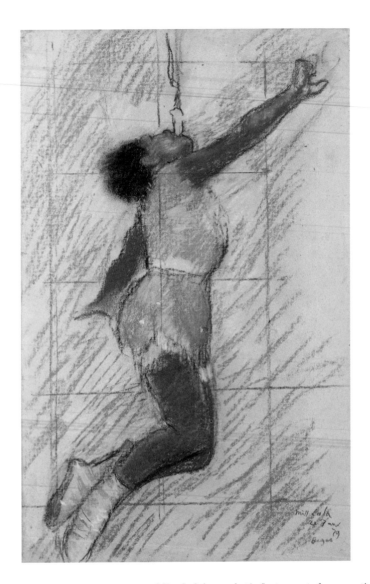

EDGAR DEGAS

French, 1834–1917
*Miss Lala at the Fernando
Circus,* 1879
Pastel on faded blue paper
46.4 × 30 cm (18¼ × 11¾ in.)
2004.93

Miss Lala's acrobatic feats created a sensation when
she performed in Paris at the Fernando Circus in 1879.
In this pastel drawing Degas depicted her during
one of her signature acts, in which she was pulled to
the ceiling by a rope held in her clenched teeth. One
of several studies he made for a painting, this work
shows Degas exploring and refining Miss Lala's pose;
he initially drew her right arm at a lower angle and
made refinements to her right hand, chin, thighs, and
feet. He also experimented with his pastel technique,
layering different colors of purple, blue, and yellow to
capture her iridescent costume and smudging the
black pastel to represent her hair. The diagonal blue
lines surrounding her figure help to emphasize the
sense of upward movement.

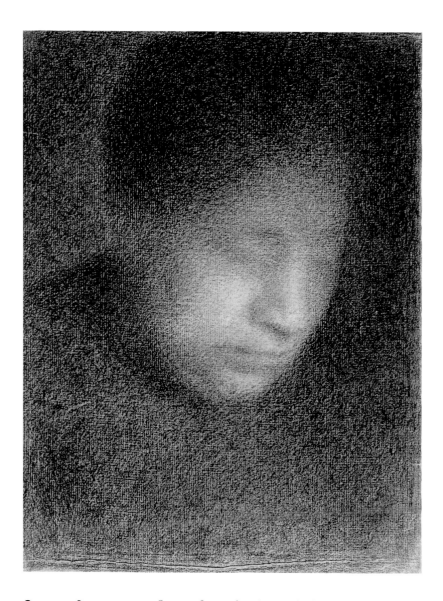

GEORGES SEURAT

French, 1859–1891
*Madame Seurat, the Artist's
Mother*, circa 1882–83
Conté crayon
on Michallet paper
30.5 × 23.3 cm (12 × 9³/₁₆ in.)
2002.51

Georges Seurat, best known for his Pointillist painting
style, was an accomplished and precocious draftsman.
He was about twenty-three years old when he made
this remarkable portrait of his mother. Seurat portrays
her as a monumental and mysterious presence: her
head, emerging from the darkness with eyes closed,
occupies most of the sheet. Seurat demonstrates his
mastery of the greasy Conté crayon medium in this
work, using subtle gradations of black to model the
simplified forms of his mother's head and body with-
out lines and allowing areas of the white paper to
show through the design. Portraits were very personal
productions for Seurat; all of his known examples are
drawings of family and friends.

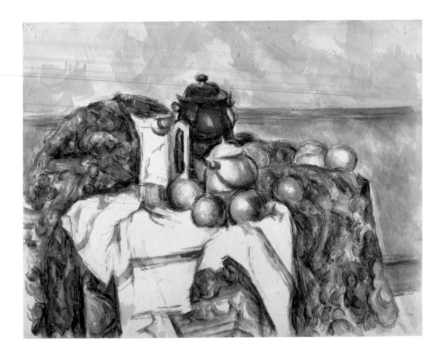

PAUL CÉZANNE

French, 1839–1906
Still Life, circa 1900–1906
Watercolor over graphite
48 × 63.1 cm
(18¹⁵⁄₁₆ × 24⅞ in.)
83.GC.221

This is one of the largest and most finished of
Cézanne's watercolors. In its complexity it shares
many of the qualities of his paintings. The technique
of superimposed layers of translucent watercolor
suggests the plasticity of forms with extraordinary
resonance, in spite of the delicacy of the medium.
The contrast between the colored washes and the
untouched passages of white paper enhances the
monumental effect.

VINCENT
VAN GOGH

Dutch, 1853–1890
Portrait of Joseph Roulin,
1888
Reed and quill pens and
brown ink and black chalk
32 × 24.4 cm (12⅝ × 9⅝ in.)
85.GA.299

Joseph Roulin was a postal worker with whom
Van Gogh became friends during his stay in Arles
from 1888 to 1889. Roulin and his wife and children
sat for Van Gogh many times. The artist wrote that
the postman's physical appearance and philosophy
reminded him of Socrates; he was "neither embit-
tered, nor happy, nor always irreproachably just."
Van Gogh's strong impression of Roulin is evident in
the sitter's close-up, frontal pose and intense gaze.
The drawing is animated by the patterns of his
clothing and beard, drawn with two different pens
and various techniques of hatching, shading, and
stippling to achieve the remarkable range of textures.

FRANCISCO JOSÉ DE GOYA Y LUCIENTES

Spanish, 1746–1828
Contemptuous of the Insults,
circa 1816–20
Brush and india ink
29.5 × 18.2 cm
(11⅝ × 7 ⅜ in.)
82.GG.96

This sheet was once part of the so-called Black Border album of drawings that Goya seems to have made for his private use. Drawn with great tonal subtlety and fluidity, it shows a gentleman expressing disdain for the insults of gnomes, possibly a symbol of Goya's contempt for the soldiers who caused great devastation in Spain during the Napoleonic Wars (1803-15). The title at the bottom is by Goya himself.

WILLIAM BLAKE

British, 1757–1827
Satan Exulting over Eve, 1795
Watercolor, pen and black
ink, and graphite over
color print
42.6 × 53.5 cm
(16 3/4 × 21 1/16 in.)
84.GC.49

Although Blake was one of the greatest British artists of the Romantic period, he is less well known than some of his contemporaries. One reason for this is the poetic and visionary basis of his art, which embodied his own personal philosophy and mythology. His powerful images reflect his visions, which he insisted were not "a cloudy vapour or a nothing; they are organized and minutely articulated beyond all that the mortal and perishing nature can produce." Yet, in spite of this subjective inspiration, the compositional formulas and figure types in his work depend on those of the great old master tradition of painting and drawing, works with which he was familiar from engravings.

Satan Exulting over Eve belongs to an ambiguous area between drawing and printmaking. It is one of twelve color prints Blake created in 1795 by drawing and brushing a design in broad color areas on a piece of millboard, printing them on a sheet of paper, and working them over considerably in watercolor and pen and ink. Each version of the various designs is therefore unique. Here, Satan flies in malevolent glory over the beautiful nude figure of Eve, who is entwined by his alter ego, the serpent of the Garden of Eden.

Blake was trained as an engraver. Most of his career was spent publishing his own uniquely illustrated poetry and prose.

Sculpture and Decorative Arts

U NIFIED INTO A SINGLE DEPARTMENT in 2004, the Sculpture and Decorative Arts Department was previously two separate departments. J. Paul Getty had begun acquiring eighteenth-century French decorative arts in the 1950s, and today the holdings of objects made between 1650 and 1800 count among the Museum's finest. Included in this are furniture, silver, ceramics, textiles, clocks, and objects in gilt bronze. The European sculpture collection, comprising work made from the fifteenth through the nineteenth centuries, was first formed in 1984 and has grown substantially in the representation of a wide range of European sculptors and media. Renaissance and Baroque bronze, French eighteenth-century terracotta and marble, and British Neoclassical marble sculpture predominate.

When Getty originally opened his small museum in Malibu, the decorative-arts holdings consisted of about thirty objects. With the prospect of filling the much larger museum that was to open in 1974, he began to acquire more actively. Gradually, the concept of forming a representative collection of French decorative arts from the early years of Louis XIV's reign (1643–1715) to the end of Louis XVI's reign (1774–92) began to be realized. With the formation of the J. Paul Getty Trust in 1982, the acquisitions policy for the decorative arts expanded to include objects made in other European countries, and from 1984 onward the Museum's collection of European decorative arts from the period prior to 1650 and in southern European works from 1650 to 1900 began to be formed. The department has important holdings in Renaissance ceramics and glass; a significant collection of medieval and Renaissance stained glass; a small number of silver, gold, and other precious-metal objects; singular examples of early-seventeenth-century German and Netherlandish furniture; and Italian furniture ranging from the sixteenth through the nineteenth century.

The collecting strategy for sculpture has been to pursue the highest-quality objects that will complement the Museum's other collections while, at the same time, taking advantage of opportunities in the art market. Through this approach sometimes surprising and provocative additions have been made, including a rare life-size Spanish figure of a saint by Luisa Roldán (see pp. 214–15); a small-scale *Fall of the Rebel Angels* displaying tour-de-force carving (see p. 215); a heartrending bust of Belisarius by Jean-Baptiste Stouf (see p. 267); a group of French and Belgian Symbolist sculpture (see p. 272); and a mesmerizing horned head by the Postimpressionist artist Paul Gauguin (see p. 273).

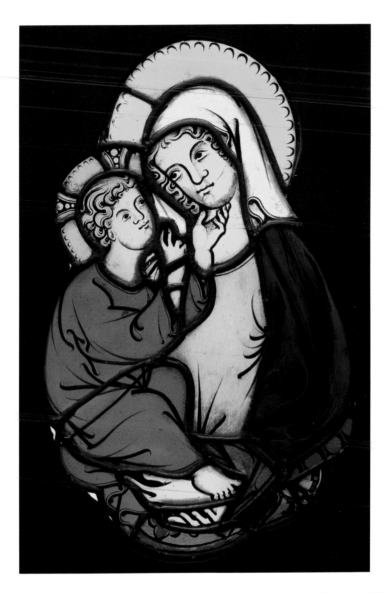

THE VIRGIN AND CHILD

Circa 1335
Master of Klosterneuburg
Austrian, active early
fourteenth century
Pot metal and clear glass,
dark brown vitreous paint,
silver stain
H: 35.9 cm (14 ⅛ in.)
2003.32

Stylistic similarities between this *Virgin and Child* and stained glass found in the Cistercian Abbey of Klosterneuburg, Austria, indicate that they were made by the same person; hence the artist's name. This rare early panel exemplifies the zenith of the medieval glass painter's art with its dramatic colorism, compact composition, and confident draftsmanship, using few but strategic lines to eloquently define drapery and facial expression. Most remarkable is the depiction of love between the two figures, suggested by the intimate gaze exchanged and by the tender gesture of the child touching his mother's chin. The artist has based this type of image on the ancient Byzantine formula for the affectionate Virgin, known as the Virgin Eleousa.

THE VIRGIN AND SAINT JOHN, FROM A CRUCIFIXION

German, circa 1420
Pot metal and clear glass,
dark brown vitreous paint,
silver stain
Each, 58.5 × 50 cm
(23 ⁷⁄₁₆ × 19 ¹¹⁄₁₆ in.)
2003.35

Given their large scale and religious subject matter, these two panels probably came from a larger ensemble of Christ on the cross, which must have been located in an important church. Such window imagery served to communicate narratives and symbolism to the congregation. Stained glass—so called because some of the glass was stained with metal oxides—first appeared around the eleventh century, and early examples were likely to have been especially inspiring and impressive as the first large-scale, nonstatic (changing according to weather and time of day), illuminated images in history. The faces and hands of these emotionally charged figures are rendered with fine lines and subtle staining, while their poses—the tilted heads, down-turned eyes and mouths, and clasped hand gestures—give the *Virgin and Saint John* a sense of silent pathos and grief.

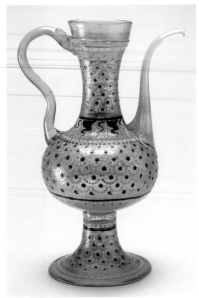

RELIEF-BLUE JAR WITH RAMPANT LIONS

Italian, circa 1425–50
Tin-glazed earthenware
39.37 × 40.01 cm
(15½ × 15¾ in.)
84.DE.97

EWER

Italian, late fifteenth or early sixteenth century
Free-blown colorless glass with gold leaf and enamel decoration
H: 27.15 cm (10¹¹/₁₆ in.)
84.DK.512

The ceramics and glass of fifteenth- and sixteenth-century Italy—called maiolica and *cristallo*—signify high points of Renaissance art production. They were groundbreaking art forms that established taste and became the envy of European courts and other collectors for the three hundred years that followed. This artistic production would not have been possible were it not for technological advances developed by potters and glassmakers of the Islamic world. The maiolica techniques of tin glaze and luster came from Islamic sources that made their way into Italy mainly via North Africa and Spain. The glass techniques of gilding and enameling also came from Islamic sources that arrived in Italy, primarily by way of Egypt and Byzantium. In addition, objects carried to Italy from the Islamic world may well have influenced the sinuous form of the glass ewer (pitcher) and the patterned surface ornament on both objects. The ceramic jar served as a container for medicine, probably in a hospital pharmacy, and the ewer may have been used for wine at a fancy dining table.

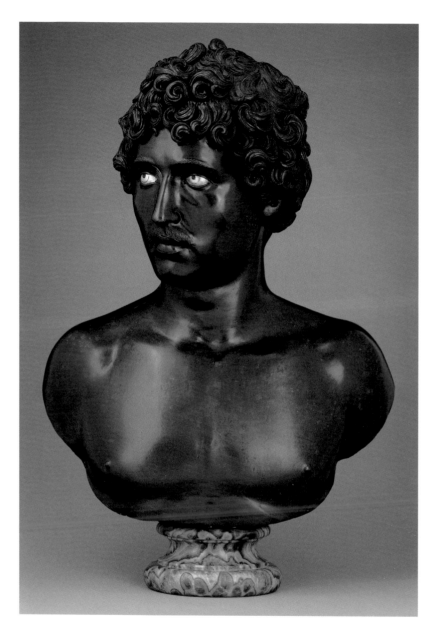

Bust of a Young Man

Circa 1520
Pier Jacopo Alari-Bonacolsi,
called Antico
Italian, circa 1460–1528
Bronze with silver eyes
54.7 × 45 × 22.3 cm
(21½ × 17¾ × 8¾ in.)
86.SB.688

Trained as a goldsmith, Pier Jacopo became the
principal sculptor at the court of Mantua in the late
fifteenth and early sixteenth centuries. He executed
many bronze reductions and variants of famous
antiquities, earning himself the nickname Antico.
The Museum's bronze is one of only seven known
busts generally accepted as being by him. It derives
from an ancient marble bust now in the Hispanic
Society of America, New York. The use of silver
for the eyes emulates a frequent practice of antiquity.

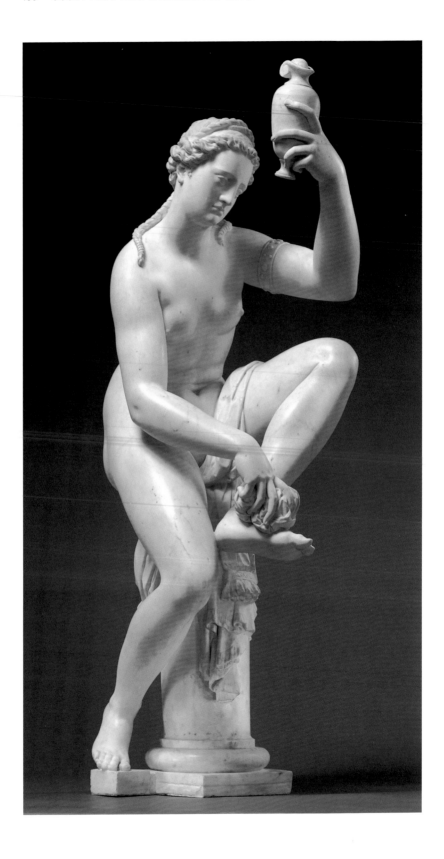

ARMORIAL DISH WITH THE FLAYING OF MARSYAS

Mid-1520s
Nicola di Gabriele Sbraghe
(or Sbraga), known as
Nicola da Urbino
Italian, circa 1480–1537/38
Tin-glazed earthenware
DIAM: 41.43 cm (16 ⅕/₁₆ in.)
84.DE.117

PLATE WITH A WINGED PUTTO ON A HOBBYHORSE

Italian, circa 1510–20
Tin-glazed earthenware
DIAM: 23.5 cm (9¼ in.)
84.DE.116

Once Italian potters learned that by adding tin to the glaze formula, they could paint intricate and colorful imagery, maiolica developed into a supremely pictorial art form. Indeed, narrative, or *istoriato,* painting—in which most or all of the ceramic surface is covered with scenes from a historical, literary, mythological, or religious text—is arguably the most notable artistic innovation to have come out of the potteries of Italy. Ceramic painters experimented with and ultimately mastered narrative painting in the first decades of the sixteenth century, under the influence of contemporary fresco and oil painting growing out of the humanist movement. The imagery on these two plates exemplifies humanism, which involved the study of ancient languages, literature, and philosophy. The Flaying of Marsyas is one of the myths recounted in the *Metamorphoses* by Ovid (43 B.C.–A.D. 17), telling the story of Marsyas, who challenges Apollo to a musical contest. Apollo was declared the winner, and he took the cruel revenge of flaying Marsyas alive. The putto, or winged infant, playing with a toy on the other plate was a common motif in ancient Rome, as were the fantastic beasts and cornucopias.

FEMALE FIGURE (POSSIBLY VENUS, FORMERLY CALLED BATHSHEBA)

1571–73
Giambologna
(Giovanni Bologna)
Flemish, active in Italy,
1529–1608
Marble
H: 115 cm (45¼ in.)
82.SA.37

Giambologna was one of the most innovative sculptors to experiment with the serpentine figure, the upwardly spiraling movement that demands to be looked at from every point of view. The figure's pose conforms to an ideal, artificial spiral achieved through the graceful but complicated twisting of limbs. For Giambologna, a natural stance was less important than the contrast between her long, smooth body and the detailed drapery folds, armband, and coiffure.

VIRGIN AND CHILD

Circa 1520–25
Andrea Briosco, called Riccio
Italian, 1470–1532
Terracotta with traces
of polychromy
64.4 × 58 × 31.5 cm
(25 ⅜ × 22 ¹³⁄₁₆ × 12 ⅜ in.)
2003.5

This moving image of the Virgin and the Christ child is one of the masterpieces by the classicizing North Italian sixteenth-century sculptor Riccio. The antique diadem worn by the Virgin denotes her role as Queen of Heaven, though her tender, yet melancholic, gesture as she offers the child to the viewer refers to her maternal status. The strong incline forward of the figures suggests that the group was originally placed high in a niche, before which the spectator would kneel in devotion. We know from traces of paint remaining in the crevices of this terracotta that originally the sculpture was painted. The group may also be the top half of what was initially a full-length composition.

BUST OF EMPEROR COMMODUS

Italian, date uncertain
Marble
Without socle:
70 × 61 × 22.8 cm
(27½ × 24 × 9 in.)
H (socle): 22.5 cm
(8⅞ in.)
92.SA.48

This bust of the ancient Roman emperor Commodus has intrigued scholars since its entry into the Getty collections. It was acquired as a work of the second half of the 1500s, when collecting images of notorious leaders held a certain fascination. Many scholars now believe it to be ancient Roman or possibly even an eighteenth-century copy after a Roman prototype. Commodus ruled as Roman emperor from A.D. 180 to 192. Although his father was the popular ruler Marcus Aurelius, Commodus was considered one of the worst emperors, comparable to the infamous Nero and Caligula. He had a passion for unseemly gladiatorial combat and spent most of his rule basking in wealth and luxury. The production and dissemination of portrait busts was part of the imperial strategy of self-promotion, and among all known busts of this emperor, the Getty Commodus is the best conserved and artistically most refined example.

LUCRETIA

1561
Workshop of Carl von Egeri
Swiss, 1510–1562
Pot metal, clear glass,
vitreous paint, silver stain,
and reddish brown
oxide paint
33 × 23 cm (13 × 9 1/16 in.)
2004.64

The classical heroine Lucretia was
raped by a corrupt Roman official and
after confessing her misfortune to
her husband and father, stabbed her-
self to death, despite all their efforts to
comfort her. She was admired for her
loyalty (to her family) and moral
righteousness (death before dishonor).
This panel may have been placed
in a civic setting to promote ethical
behavior and—since Lucretia's actions
heralded the founding of the Roman
Republic—a similar political message,
namely the establishment of a Swiss
federation of states. The fine painting
on this panel includes the monumental
and voluptuous figure of Lucretia,
as well as minutely modeled biblical
scenes of the Creation of Eve and
the Fall of Man in the upper corners.

A PREMONSTRATEN-
SIAN CANON

Swiss, circa 1520
Close to the style of
Hans Holbein the Younger
German, 1497/98–1543
Pot metal, clear glass,
and silver stain
61 × 52 cm (24 × 20 1/2 in.)
2003.66

The male figure's clothing and the
inscribed tablet above him identify him
as a member of a Catholic order of
priests founded in the twelfth century
at Prémontré, near Laon, France. This
grand figure kneels in prayer in front
of a classically inspired pair of sea
gods whose significance to the canon
has yet to be understood. The superb
use of staining and washes achieves a
great sense of form and differentiation
of material that is enhanced by the
scratching away of some areas of
wash. This panel is close in style to,
and may have been designed by, the
great German Renaissance painter,
draftsman, and designer Hans Holbein
the Younger. The scene of sea gods is
very similar to the expressive, often
humorous, drawings and prints by Urs
Graf (ca. 1485–1527?), who was active
in Basel when Holbein was working
there about 1520.

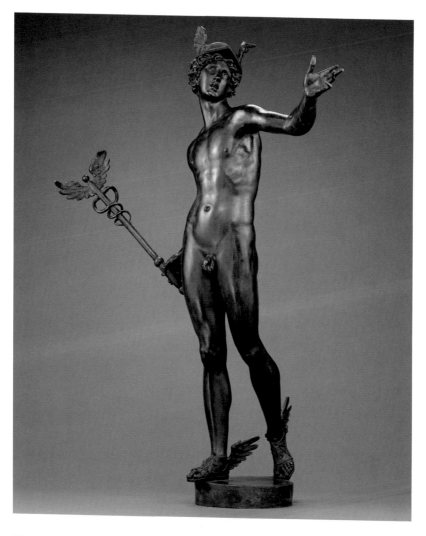

MERCURY

Circa 1570–80
Johann Gregor
van der Schardt
Dutch, circa 1530–1581
Bronze
115 × 87 × 38 cm
(45¼ × 34 × 15 in.)
95.SB.8

Van der Schardt was one of the first sculptors to
introduce the Italian Mannerist style into Northern
Europe. The influence of Italian and classical statuary
on his work can be seen in this bronze *Mercury*,
which borrows the pose of the famous Apollo Belve-
dere in Rome. Mercury played a central role in classi-
cal mythology as a divine messenger, but Van der
Schardt chose to depict this athletic youth's return to
the ground. Mercury's left arm is elegantly raised,
and his eyes follow the movement of his hand as if he
were preparing to deliver an announcement from the
gods. The academic ideal of eloquence that this figure
symbolizes must have appealed to Van der Schardt's
courtly and bourgeois clientele. This *Mercury* can be
traced back to the famous collection of a Nuremberg
patrician, Paul Praun (1548–1616), who owned numer-
ous terracotta and bronze figures by the artist.

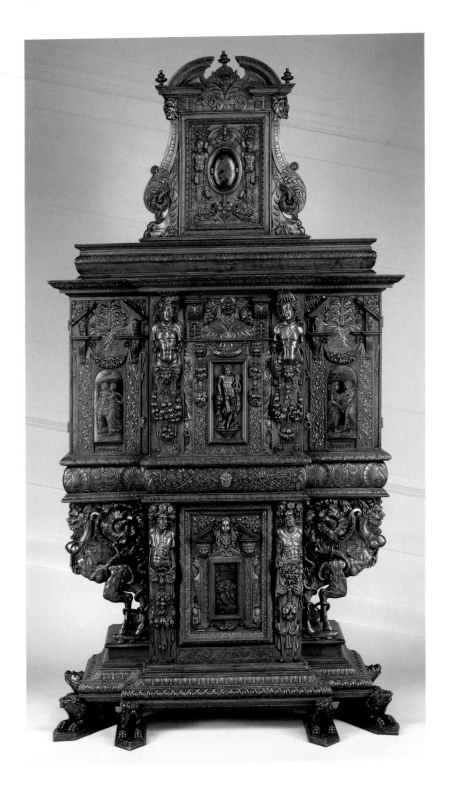

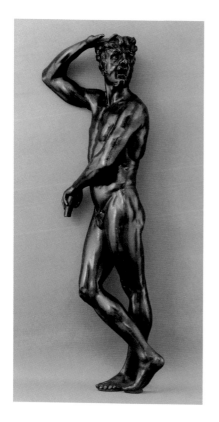

SATYR

Cast after a model
of circa 1542
Benvenuto Cellini
Italian, 1500–1571
Bronze
56.8 × 8.9 × 8.4 cm
(22⅜ × 3½ × 3⅛ in.)
85.SB.69

Cellini, a leading sixteenth-century
sculptor, traveled to Fontainebleau in
1540 to work for King Francis I. One
of the artist's major commissions was
for the Porte Dorée, the monumental
palace entrance ordered by the king
in 1542. The project called for a bronze
lunette depicting the nymph thought
to reside in the forest of Fontainebleau.
It was to be supported by two menac-
ing satyrs, one on either side of the
door, with winged personifications
of Victory in the spandrels. Although
the doorway was never completed,
the Museum's bronze was cast from
Cellini's wax model for one of the
satyrs.

CABINET

French, 1580
Walnut and oak
307.66 × 153.35 × 57.15 cm
(10 ft. 1⅛ in. × 60⅜ in.
× 22½ in.)
71.DA.89

This cabinet was acquired by J. Paul Getty at auction
in 1971 but was not put on display at the Getty Museum
until 2005 because, for many years, it was thought
to be a fake. Extensive art-historical and scientific
research has determined that it is not only authentic
but also one of the most elaborate and best-preserved
cabinets of its kind in the United States. The curious
and almost overwrought combination of sinuous
vines, grotesque figures, and fantastic beasts on this
cabinet is typical of the Italian Mannerist style, dating
to the late Renaissance period, which was made pop-
ular in France by the arrival of Italian artists, called
to decorate the château of Francis I (1494–1547)
in Fontainebleau. At its most exaggerated, Mannerist
ornament appears stylized and purposely bizarre to
create inventive and surprising effects. The style was
revived in the nineteenth century, causing scholars
to believe that this cabinet was one of the myriad
Renaissance Revival objects made at the time rather
than an exceedingly rare and unusual original object.

OVAL BASIN

Circa 1550
Attributed to Bernard Palissy
French, 1510(?)–1590
Lead-glazed earthenware
47.9 × 36.8 cm
(18⅞ × 14½ in.)
88.DE.63

Palissy was a man of many interests and talents who, in addition to being a geologist, chemist, philosopher, and ceramist, was also an outspoken Huguenot imprisoned for his involvement in the Protestant riots of the mid-sixteenth century. His subsequent freedom and protection were due to the efforts of his influential Catholic patrons, such as Anne de Montmorency (1493–1567) and Catherine de' Medici (1519–1589). As a ceramist, Palissy produced his distinctive pottery, called rustic ware, by making life casts of crustaceans, plants, and reptiles and attaching these casts to traditional ceramic forms. He then naturalistically decorated these wares, as on this example, with lead-based glazes that would melt into one another when fired in the kiln, increasing the realism of the riverlike scenes. This basin is exceptional not only for the subtle modeling of its surface—with attention given to the most minute details and surface textures—but also for its unusual ground color; it is one of only three works by Palissy with similar light-colored grounds (that is, white or yellow). The great majority of Palissy wares have backgrounds colored either dark brown or blue. Palissy's rustic works were so popular that they were imitated during his own lifetime and copied in the nineteenth century by such notable ceramic manufactories as Sèvres in France and Wedgwood in England.

ALLEGORY OF CHARLES IX AS MARS

ALLEGORY OF CATHERINE DE' MEDICI AS JUNO

1573
Léonard Limosin
French, circa 1505–1575/77
Polychrome enamel with
painted gold highlights on
copper and silver
Each, 16.8 × 22.9 cm
(6⅝ × 9 in.)
86.SE.536.1–2

Sixteenth-century Limoges, France, was the site of
workshops that specialized in painted enamels, an
art form whereby a metal panel, usually of copper, is
painted with powdered glass suspended in a paste
and then fired, with different colors requiring differ-
ent firings. These two plaques bear their date of
manufacture and the initials of their maker. Limosin
was the best-known enameler in Renaissance France
whose specialty was portraiture. Here, he depicts
the king of France, Charles IX (1550–1574), and his
mother, Catherine de' Medici (1519–1589), allegori-
cally, as Mars and Juno, Roman gods of war and mar-
riage, respectively. After the death of her husband,
Henri II, Catherine began to rule France as regent
while Charles IX was still a minor and then remained
powerful as his counselor. She may have ordered
these plaques to commemorate her political skill
in promoting peace, demonstrated by her appease-
ment of religious wars and by the orchestration of
marriages between her children and foreign heads
of state.

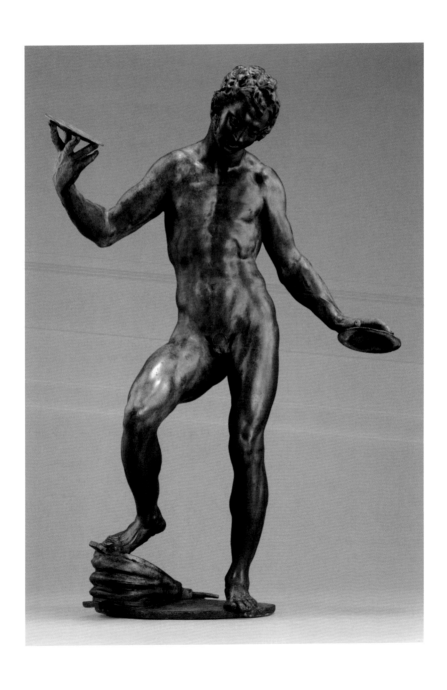

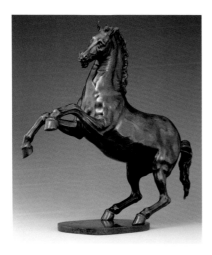

REARING HORSE

Circa 1610–15
Adriaen de Vries
Dutch, circa 1545–1626
Bronze
49.5 × 54.6 × 17.8 cm
(19½ × 21½ × 7 in.)
86.SB.488

Throughout his professional life, De Vries seems to have satisfied the dictates of princely taste, for he was courted as a sculptor by some of the most powerful, discerning patrons of Europe, such as Charles Emmanuel I, Duke of Savoy (r. 1580–1630), and Emperor Rudolf II of Prague (r. 1576–1612). De Vries worked primarily in bronze, a medium in which he achieved extraordinary virtuosity, and his bronzes are unusual for their consistently high quality and technical sophistication. The *Rearing Horse*—with its smooth musculature, expertly modeled anatomical details, richly colored, reflective surface, and daring balance of the animal's mass on two points—would have merited a prominent place in a royal or aristocratic collector's cabinet.

JUGGLING MAN

Circa 1615
Adriaen de Vries
Dutch, circa 1545–1626
Bronze
76.8 × 51.8 × 21.9 cm
(30¼ × 20⅜ × 8⅝ in.)
90.SB.44

Adriaen de Vries received his artistic training in the Florentine workshop of the Mannerist sculptor Giambologna (1529–1608). De Vries went on to become the court sculptor to the duke of Savoy and then to Emperor Rudolf II in Prague. Unlike his teacher, De Vries did not produce multiple versions of his bronzes or allow his models to be cast by other artists. The Museum's *Juggling Man* is therefore a unique composition. One of the sculptor's masterpieces, it was inspired by a Hellenistic marble entitled *Dancing Faun* in the collection of Medici dukes that is now in the Uffizi Gallery, Florence. De Vries changed the details of his prototype significantly: he eliminated the attributes of a tail and horns and replaced the foot organ with a bellows and the cymbals with plates for juggling. In De Vries's hands the faun has become a serious—but highly animated—depiction of dynamic equilibrium. The *Juggling Man* is characteristic of his male figures, with its expressionistic treatment of the hair and musculature, a pointed chin and small mouth, an almost impish facial expression, and prominent veins in the feet and hands.

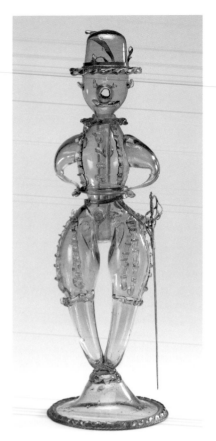

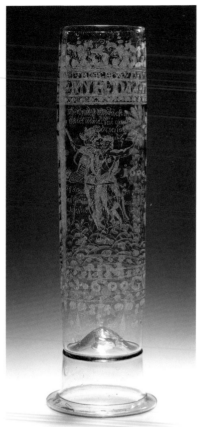

JOKE GLASS

German or Netherlandish,
seventeenth century
Free-blown pale green glass
with applied decoration
and silver mounts
33.66 × 9.21 cm
(13¼ × 3⅝ in.)
84.DK.520

FOOTED BEAKER

Southern Bohemian, 1600
Free-blown colorless glass
with diamond-point
engraving
H: 34.45 cm (13⁹⁄₁₆ in.)
84.DK.559

Both joke glass and footed beakers were made north of
the Alps and were meant to hold alcoholic beverages:
a potent liquor and beer, respectively. In habits that
may seem all too familiar to us today, the drinking of
these beverages was often a communal event that was
accompanied by games and tomfoolery. Joke glasses
were designed to be difficult to drink from, with the
goal being to amuse the onlookers at the expense of
the drinker. Here, the game was to deduce that, in
order to imbibe, one needed to suck the figure's nose,
it being not immediately obvious that a tube is
attached to the removable head. The footed beaker—
a tall, cylindrical vessel—has been decorated with
erotic images by scratching the glass with a diamond-
pointed instrument. On one side a woman holds the
tail of a fox between her legs; on the other, a man
"plays" a woman as if she were a violin. The associa-
tion of inebriation with carnal pleasure, as with jok-
ing, is a familiar one. Both examples are masterpieces
of Northern glassmaking and decoration. It is remark-
able—given their old age and rowdy usage—that they
have survived in such pristine condition.

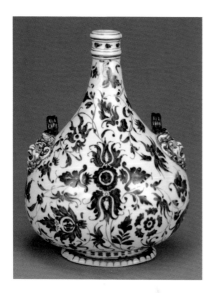

PILGRIM FLASK

Italian, 1580s
Medici Porcelain Factory,
1575–early seventeenth
century
Soft-paste porcelain
26.4 × 18.7 × 4.8 cm
(10 3/8 × 7 3/8 × 1 7/8 in.)
86.DE.630

FILIGRANA BOTTLE

Italian, late sixteenth or
early seventeenth century
Free- and mold-blown
colorless glass with opaque
white canes
H: 23.81 cm (9 3/8 in.)
84.DK.661

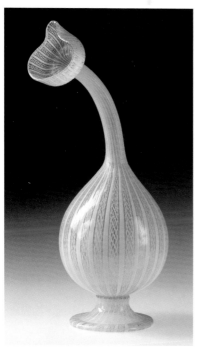

Beginning in the fourteenth century, when porcelain was first imported from China, Europeans strove to re-create it. Its rarity and beauty made porcelain highly prized: it was used to fabricate pure white and translucent vessels that are as hard as stone and as thin as glass. The fifteenth-century Venetian invention of white glass may have been prompted by the desire to find a porcelain recipe. Venetian glassmakers used this white glass for so-called filigree ware, whereby canes of white and clear glass were manipulated to create elegant striped, web, and spiral patterns. The graceful bottle shown here is a particularly fine example of this production. The first porcelain successfully produced in Europe was in the Medici factory in Florence. Grand Duke Cosimo I had set up this enterprise to encourage such sophisticated arts as crystal carving, tapestry weaving, and porcelain production, although it was not until his son, Francesco I, became director that the factory finally produced porcelain. Whereas the Venetian glass bottle may have been used as a drinking vessel for wine, the porcelain flask would have never been used as a container but rather as a prized novelty object for delectation and study.

DISPLAY CABINET

German, 1620–30
Ebony, chestnut, walnut,
pearwood, boxwood,
ivory, marble, semiprecious
stones, enamel, palm
wood, and tortoiseshell
Several carvings by Albert
Jansz. Vinckenbrinck
(Dutch, circa 1604–1664/65)
73 × 57.9 × 59.1 cm
(28¾ × 22¹³⁄₁₆ × 23¼ in.)
89.DA.28

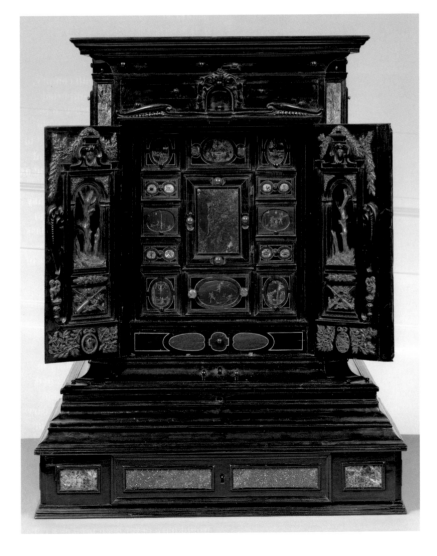

IVORY GOBLET

Circa 1680
Balthasar Griessmann
German, 1620–1706
Lathe-turned and
carved ivory
H: 52.4 cm (20⅝ in.)
2006.26

The desire to collect wondrous objects from nature and of man's manufacture dates at least to antiquity. During the Renaissance—a period that witnessed not only the revival of ancient customs but also the Age of Exploration, whereby Europeans traveled for the first time to many parts of the globe—the activity of collecting marvelous objects grew in popularity among princely and wealthy individuals. Owning these objects satisfied a need to contemplate the marvels of the world and to appreciate man's ability to rival them.

Cabinets, such as the German example on the facing page, became fashionable for storing and displaying an owner's collection of artistic and natural phenomena. The cabinet itself is somewhat of a marvel: all four sides open to reveal a surprisingly complex series of drawers and compartments that are richly decorated in a variety of materials and techniques depicting biblical, allegorical, historical, and mythological subjects.

Ivory vessels that had been turned on a lathe and sculpted, such as the one shown here, were in vogue among the princely collectors of Europe as awe-inspiring examples of a rare natural material made even more precious by the hand of man. One of the foremost ivory carvers of the second half of the seventeenth century was Balthasar Griessmann. The relief on the cup shows an allegory of the temptations of youth, conflated with a celebration of wine.

BOY WITH A DRAGON

1617
Pietro Bernini
Italian, 1562–1629
and Gian Lorenzo Bernini
Italian, 1598–1680
Marble
55.9 × 50.8 × 40.6 cm
(22 × 20 × 16 in.)
87.SA.42

According to recently discovered docu-ments, Cardinal Maffeo Barberini (later Pope Urban VIII) paid Pietro Bernini for this marble group in December 1617. This is one of the live-liest works by the father of the prin-cipal and most precocious Baroque sculptor, Gian Lorenzo Bernini. The playful scene of the life-size urchin, who cracks the dragon's jaw not in a heroic struggle but with a very human, mischievous smile, blurs the boundary between art and reality in a way that would become a hallmark of the Baroque style. Therefore, it is not sur-prising that before the discovery of the payment documents, several scholars believed that Gian Lorenzo (who may have had a helping role in its execu-tion) was the author of this sculpture. The subject of *Boy with a Dragon* is reminiscent of the ancient mytholog-ical episode of the infant Hercules defeating the snakes. The dragon was also an emblem of the Barberini fam-ily, whose Roman palace this marble originally adorned.

BUST OF MARIA CERRI CAPRANICA

1637–circa 1643
Giuliano Finelli
Italian, 1601/2–1653
Marble
90 × 62.2 × 29 cm
(35⁷⁄₁₆ × 24⅛ × 11½ in.)
2000.72

The subject of this portrait bust is Maria Cerri, who married Bartolomeo Capranica in 1637. Since coats-of-arms of both of these prominent Roman families appear on the socle, the bust must date between the time of Maria's marriage and her death in 1643. Born in Carrara and trained in Naples, Giuliano Finelli moved in 1622 to Rome, where he came to the attention of Gianlorenzo Bernini, the greatest sculptor of the Baroque period there. Finelli distinguished himself as a master carver of marble, who was able to render the most unlikely and varied textures—flesh, fabric, hair—in this intractable material. Here, Finelli has additionally transformed the stone into a sinuous string of beads, stiff lace, and curly ringlets of hair. At the same time, in the subtle carving of her features, the artist managed to invest his subject with a power-ful and stately psychological presence.

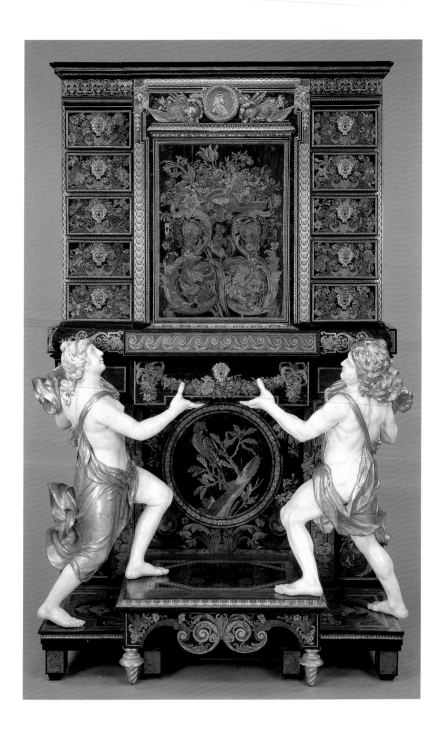

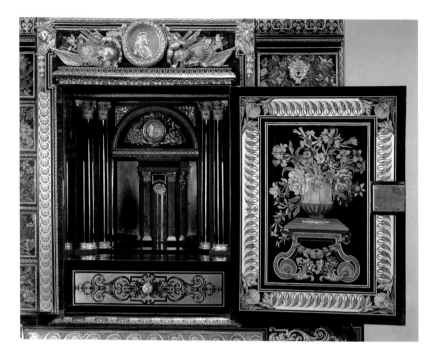

CABINET ON STAND

French (Paris), circa 1675–80
Attributed to André-Charles
Boulle, 1642–1732, master
before 1666
Oak veneered with various
woods, pewter, brass,
tortoiseshell, horn, ebony,
and ivory, with drawers
of snakewood and oak;
figures of painted and gilded
white oak; bronze mounts
229.9 × 151.2 × 66.7 cm
(90½ × 59½ × 26¼ in.)
77.DA.1

This cabinet was probably made by André-Charles
Boulle for Louis XIV (1638–1715), whose likeness
appears in a bronze medallion above the central door,
or as a royal gift. The medallion is flanked by military
trophies, while the marquetry on the door below
shows the cockerel of France triumphant over the
eagle of the Holy Roman Empire and the lion of Spain
and the Spanish Netherlands. The cupboard door
opens to reveal an interior space featuring classical
Corinthian columns. The cabinet is supported by
two large figures, Hippolyta (queen of the Amazons)
and Hercules. Clearly made to glorify Louis XIV's
victories, this is one of two such monumental pieces;
the other is privately owned.

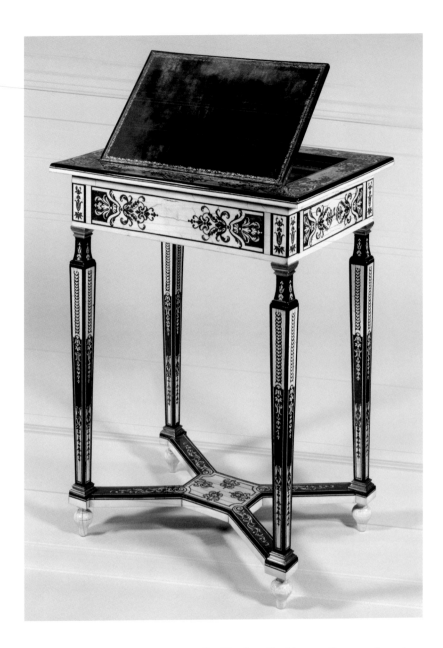

READING AND
WRITING TABLE

French (Paris), circa 1670–75
Oak veneered with ivory,
blue-painted horn, ebony,
rosewood, and amaranth,
with a drawer of walnut;
gilt-bronze moldings;
brass and iron fittings;
modern silk velvet
63.5 × 48.6 × 35.5 cm
(25 × 19⅛ × 14 in.)
83.DA.21

This small table, described in a posthumous inventory
of Louis XIV (1638–1715), is one of the few surviving
pieces of furniture to have belonged to that great
monarch. Among the rarest and earliest pieces in
the collection, it is decorated with ivory and horn
that has been painted blue underneath, perhaps to
resemble lapis lazuli. The table is fitted with an
adjustable writing surface and a drawer constructed
to contain writing equipment.

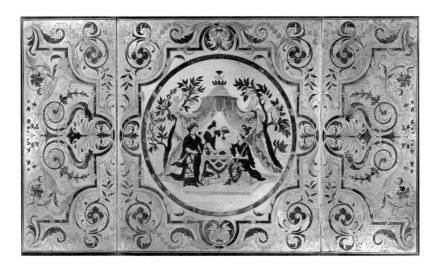

TABLE

French (Paris), circa 1680
Attributed to Pierre Golle,
circa 1620–1684,
master before 1656
White oak and fruit wood
veneered with brass, pewter,
tortoiseshell, and various
woods, with drawers of oak
and ebony; gilded wood;
gilt-bronze mounts
76.8 × 42 × 36.2 cm
(30¼ × 16½ × 14¼ in.)
82.DA.34

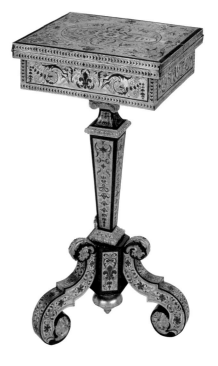

The top of this small table unfolds to
reveal a scene of three women taking
tea beneath a canopy. It is therefore
likely that the table was intended
to support a tea tray. The table is deco-
rated with four large dolphins and
four fleurs-de-lis, all in tortoiseshell.
These emblems were used by the
Grand Dauphin (1661–1711), son of
Louis XIV, for whom this table and its
pair, now in the British Royal Collec-
tion, were probably made. The scene
on the underside of the top, revealed
when the two hinged flaps are opened
(shown above), was copied after a
drawing by the Huguenot ornamental-
ist and engraver Daniel Marot, which
was later engraved in the early eigh-
teenth century.

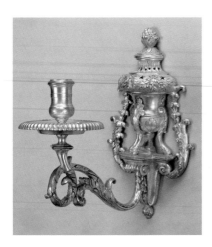

WALL LIGHT

French (Paris), 1693
Domenico Cucci,
b. before 1640–1705
Gilt bronze
21.6 × 12.7 × 19.1 cm
(8½ × 5 × 7½ in.)
2004.67

This diminutive, single-branch wall light takes the form of a classically inspired tripod incense burner. It was one of four ordered from Cucci for the Parisian townhouse of Madame de Seignelay, the fashionable daughter-in-law of the great French minister Jean-Baptiste Colbert (1619–1683). A contemporary drawing of the light records that it illuminated her private study.

MOUNTED TEAPOT

Porcelain: Chinese, early
Kangxi reign, circa 1662–90
Mounts: Possibly French
(Paris), circa 1700–1710
Hard-paste porcelain,
blue ground color,
and traces of gilding;
silver mounts
14.8 × 20.2 × 11.8 cm
(5¹³⁄₁₆ × 7¹⁵⁄₁₆ × 4⅝ in.)
2001.76

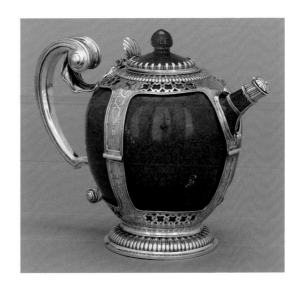

Exported from China and fitted with elaborate silver mounts shortly after its arrival in Europe, this luxurious teapot underscores the value of tea as a fashionable commodity in eighteenth-century Europe. The creative design of the mounts incorporates a silver tea leaf between the scroll of the handle and the shoulder ring of latticework.

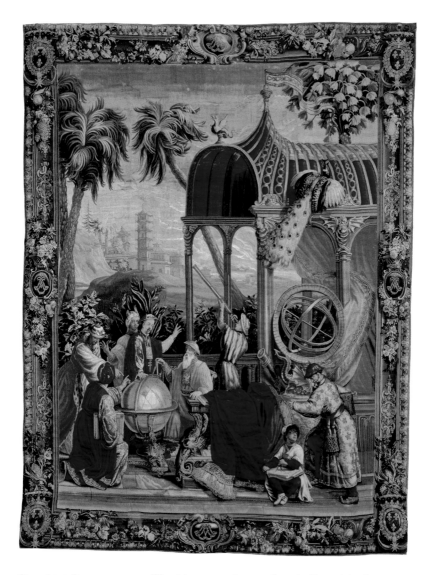

ONE OF A SET OF SEVEN TAPESTRIES

French, circa 1697–1705
Beauvais manufactory,
woven under the direction
of Philippe Béhagle,
1641–1705
Wool and silk;
modern cotton lining
424 × 319 cm
(13 ft. 11 in. × 10 ft. 5½ in.)
83.DD.338

The Astronomers is one of a set of tapestries from
the series entitled The Story of the Emperor of China.
It shows Emperor Shunzhi (Shun-chih; r. 1644–61)
standing in conversation with members of his court
and the European Jesuit missionary Adam Schall von
Bell (1592–1666) around a large globe. This was the
first French tapestry series to be created on a
chinoiserie theme; it established a long-lasting taste
for the exotic and contributed to the success of the
Beauvais manufactory. The set, originally consisting
of ten hangings, was woven for Louis-Alexandre,
comte de Toulouse (1678–1737), the second legitimized
son of Louis XIV (1638–1715). The border bears his
coat of arms and monogram.

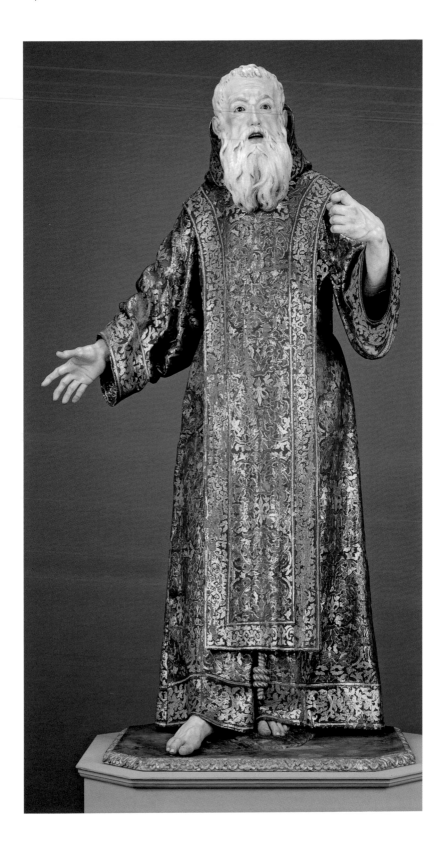

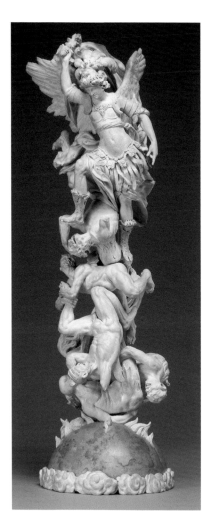

FALL OF THE REBEL ANGELS

Southern German or
Austrian, circa 1715–25
Fine-grained calcareous
limestone
55 × 16.5 × 15 cm
(21⅝ × 6½ × 5⅞ in.)
2005.48

This virtuoso exercise in small-scale carving depicts the balletic figure of Saint Michael raising his sword to smite the demons piled beneath his feet on a hemisphere depicting the burning globe. The subject matter of the falling angels, which allowed the artist to show the intermingled limbs of human bodies freely falling in the air, was particularly popular in Mannerist and Baroque art, both to the north and to the south of the Alps. The sculptor has taken full advantage of the material to create a work that is breathtaking in its finely carved details, qualities which are normally associated with works in ivory or fruitwood.

SAINT GINÉS DE LA JARA

1692(?)
Luisa Roldán, called
La Roldana
Spanish, circa 1652–1706
Gilt and polychrome
wood (pine and cedar)
with glass eyes
175.9 × 92 × 74 cm
(69¼ × 36³⁄₁₆ × 29⅛ in.)
85.SD.161

Seville artist Luisa Roldán, known as La Roldana, sculpted this image of Saint Ginés. She was primarily active in Madrid, where she was named Sculptor of the Bedchamber (*Escultora de Camara*) by King Charles II (1661–1700). Indeed, this work displays not only her exceptionally beautiful and expressive sculptural style but also an inscription that can be read [LUIS]A RO[LD]AN, ESC[U]L[TO]RA DE CAMARA AÑO 169[2?]. The rich decoration of the saint's robes is executed in *estofado*, a technique that simulates the brocade of ecclesiastic vestments by stamping patterns of foliage and fleurs-de-lis over brown pigment and burnished water gilding to mimic the texture and brilliance of the gold cloth. This sumptuous display, together with the heightened realism of the *Saint Ginés*, is typical of the emotionally expressive devotional practices of Catholic Spain.

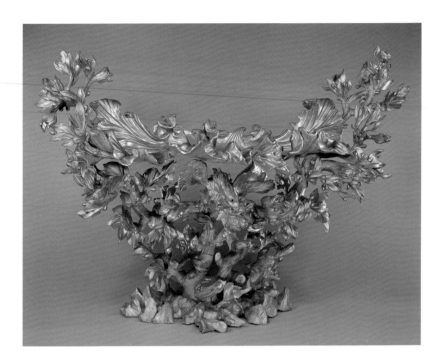

SIDE TABLE

Italian (Rome), circa 1760
Design attributed to
Johann Paul Schor
Austrian, active in Italy,
1615–1674
Gessoed and gilt wood
142.1 × 224.8 × 84.9 cm
(55¹⁵⁄₁₆ × 88½ × 33⁷⁄₁₆ in.)
86.DA.7

This remarkable table is unique in the history of
Italian furniture—its top is an undulating sculpture
of carved wood rather than a functional surface—
leading one to surmise that it might have started out
as something other than a table. Its design relates
to a number of projects by the Austrian sculptor,
painter, and designer Johann Paul Schor, who moved
to Rome from Innsbruck in the mid-seventeenth cen-
tury. Bernini employed Schor to design the coach used
by Queen Christina of Sweden for her entry into Rome
in 1655, which remains one of Schor's most famous
projects. He also designed the lower section of Bernini's
Cathedra Petri in Saint Peter's Basilica, Rome. In
addition to coaches and ecclesiastical furniture, Schor
designed garden settings and festival decorations
that attempted to blur traditional boundaries between
nature and artifice, furniture and sculpture, monu-
ment and ephemera. This blurring of boundaries is a
characteristic of the most spectacular artwork
produced under the spell of Bernini in seventeenth-
century Rome.

NIGHT CLOCK

Italian, 1704–5
Galleria de' Lavori
Italian, 1588–mid-
nineteenth century
(when it was renamed the
Opificio delle Pietre Dure)
Case and hardstone
mosaics by Giovanni
Battista Foggini
(Italian, 1652–1725)
Woodwork by Leonard
van der Vinne (Flemish,
second half of seventeenth
century–1713)
Bronze figures attributed to
Massimiliano Soldani-Benzi
(Italian, 1656–1740)
Mechanism by Francesco
Papillion (Italian, active turn
of eighteenth century)
Ebony, gilt bronze, and
semiprecious stones,
including chalcedony,
jasper, lapis lazuli, and
verde d'Arno
95 × 63 × 28 cm
(37⅜ × 24¹³/₁₆ × 11 in.)
97.DB.37

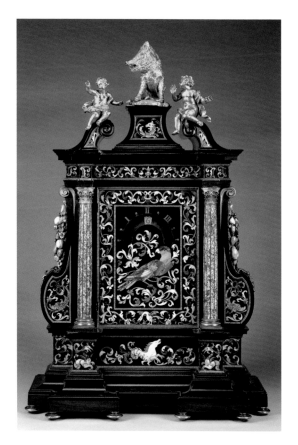

Popular in seventeenth-century Italy, night clocks were equipped with a small oil lamp that illuminated the dial from behind so that the numbers would be visible in a dark or dimly lighted bedroom. This piece takes the architecturally inspired form of a Baroque altar, with the "altarpiece" housing the face of the clock. Combining rare materials, innovative forms, and fine sculpture, this clock is the result of a collaboration among the most skilled artists active in Florence about 1700. Foggini was a major proponent of the late Baroque style in that city, where he also served as court sculptor to Cosimo III, Grand Duke of Tuscany. He was appointed director of the Medici craft workshops—the Galleria de' Lavori—where he was responsible for developing sculpted

hardstone decoration such as the fruit swags on this clock. At the Galleria, Van der Vinne worked as a cabinet-maker, specializing in masterful intarsias of floral patterns that helped spread the taste for inlay decoration throughout Europe. Soldani-Benzi was the finest bronze caster in Europe at the time. The clock's bronze boar copies a Hellenistic marble that was on display at the Uffizi by the middle of the seventeenth century. About 1700, Soldani-Benzi was producing a series of bronze reductions of ancient works in the Uffizi, and this may be a cast of one of them. Little is known of Papillion, except that he produced several other clocks and was mentioned in the Florentine clock-makers' guild in 1705.

LION ATTACKING A HORSE

LION ATTACKING A BULL

First quarter of the
seventeenth century
Antonio Susini
Italian, active 1572–1624
or Giovanni Francesco Susini
Italian, 1585–1653
After models by
Giambologna
(Giovanni Bologna)
Flemish, active in Italy,
1529–1608
Bronze
Horse group: 24 × 28 cm
(9½ × 11 in.)
94.SB.11.1
Bull group: 20.3 × 27.3 cm
(8 × 10¾ in.)
94.SB.11.2

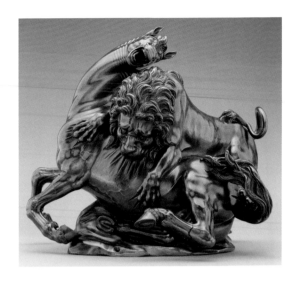

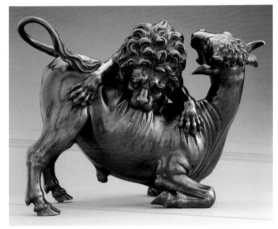

These two bronze groups of animals locked in deadly combat represent the revival of interest in ancient sculpted depictions of such subjects at the Florentine court of the Medici grandukes in the late sixteenth and early seventeenth century. Although *Lion Attacking a Horse* is based on a classical prototype now in the Palazzo dei Conservatori, Rome, the designer of this group, the sculptor Giambologna, completed the composition after his own invention. He probably provided the entire design for *Lion Attacking a Bull*, for which no known ancient model has been identified. It has been suggested that the imagery of these finely wrought bronze groups, which were often given as diplomatic gifts, had inherent political significance, serving both as a commemoration of the public animal fights mounted by European rulers and as a reminder of their might and power.

VENUS AND ADONIS

Circa 1715–16
Massimiliano Soldani-Benzi
Italian, 1656–1740
Bronze
46.4 × 49 × 34.2 cm
(18¼ × 19¼ × 13½ in.)
93.SB.4

Massimiliano Soldani-Benzi was the finest bronze caster in late-seventeenth-century Europe and a leading figure in the evolution of a Florentine Baroque aesthetic in sculpture. This bronze group illustrates an episode from Ovid's *Metamorphoses* (10:495–739) in which Adonis, despite the protests of his immortal lover, Venus, sets out in pursuit of a wild boar and is gored to death. Soldani's interpretation of the narrative emphasizes the poignant tragedy of the lovers and their final emotional exchange. Venus, having just arrived on a cloud, cradles the head of her dying paramour as she gazes into his eyes. The figures enact their drama as if on a stage, in a frontal composition oriented toward a stationary viewer. This arrangement recalls contemporary productions of theater and opera, the latter having been invented in Florence a century earlier.

Landscape details, such as the rocky ground, flowers, and clouds, enhance the scenographic quality of the bronze. Other details serve to demonstrate the artist's superlative skills as a bronze caster. For instance, the leash of Adonis's hunting dog, which is pulled by a standing cupid, seems to stretch tautly in a way that defies the rigidity and stasis inherent in bronze sculpture. By means of such features in *Venus and Adonis*, Soldani proved himself to be a master of both technique and illusion.

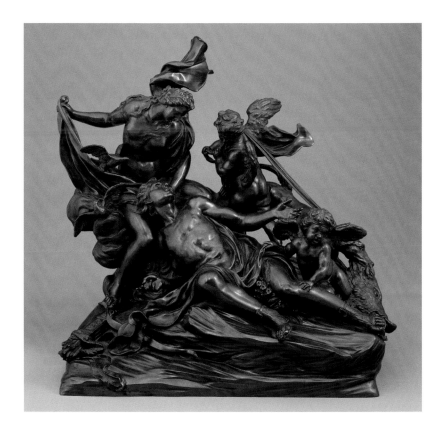

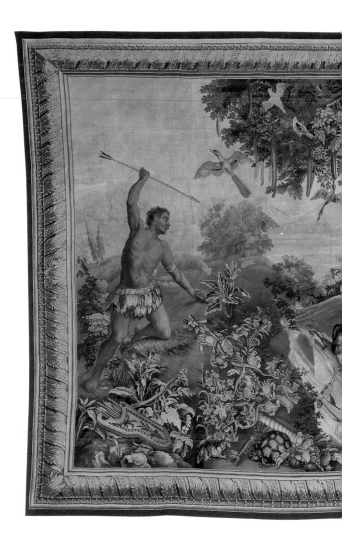

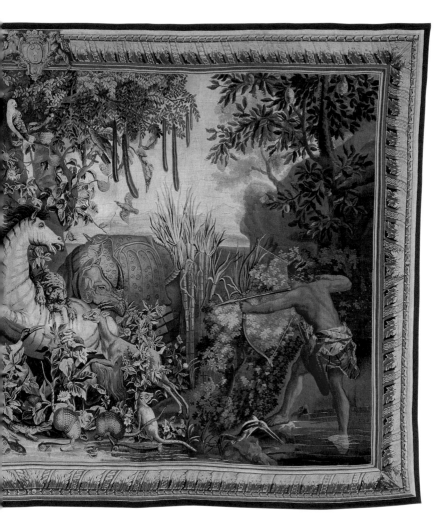

TAPESTRY

French, circa 1690–1730
Gobelins manufactory
Wool and silk;
modern cotton lining
330.2 × 574 cm
(10 ft. 10 in. × 18 ft. 10 in.)
92.DD.21

Many of the unusual plants, fish, birds, and animals visible in this tapestry, *The Striped Horse*, from The Old Indies series, can be traced to life studies made by two Dutch artists, Albert Eckhout (ca. 1610–1665) and Frans Post (1612–1680), during an exploratory expedition to Brazil from 1637 to 1644. The Dutch governor of Brazil, Johan Maurits of Nassau-Siegen (1604–1679), later presented a collection of their art to Louis XIV (1638–1715), inspiration for a tapestry set intended to represent the flora and fauna of the New World. Certain elements of this composition, however, derive from European artistic precedents for representing exotic creatures, such as the Indian rhinoceros, and for representing animal combats (see, for instance, the bronze sculptures attributed to Antonio or Giovanni Francesco Susini on p. 218).

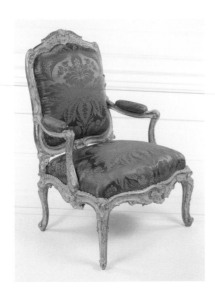

ONE OF A SET OF TWO ARMCHAIRS AND TWO SIDE CHAIRS

French (Paris), circa 1735–40
Gilded beech; modern
silk upholstery
110.5 × 76.6 × 83.7 cm
(43½ × 30⅛ × 32⅞ in.)
82.DA.95.1

This early Rococo armchair belongs to a set; one additional armchair and two side chairs exist. The chairs are not stamped with their maker's name, since they predate the guild regulations requiring this. The upholstered seat, back, and arm cushions were designed so that they could be removed and recovered according to the season.

COMMODE

French (Paris), circa 1725–30
Étienne Doirat,
circa 1675–1732
Oak and fir veneered with
kingwood and amaranth;
with drawers of fir, oak, and
walnut; gilt-bronze mounts;
brèche d'Alep top
86.4 × 168.9 × 71.7 cm
(34 × 66½ × 28¼ in.)
72.DA.66

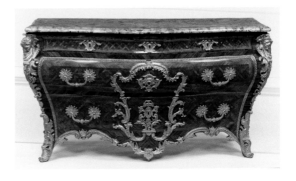

Doirat, whose name is stamped on this commode, often worked for the German market. Since the rule requiring that all works be stamped with the maker's name was only instituted by the Parisian guild of *menuisiers-ébénistes* in 1751, it is unusual to find a piece of furniture stamped at this early date.

This commode may well have been intended for a German patron who would have liked its large scale, its exaggerated bombé shape, and the profusion of mounts. The lower drawer is provided with a small wheel, located at the front in the center, to support its weight and to facilitate its opening.

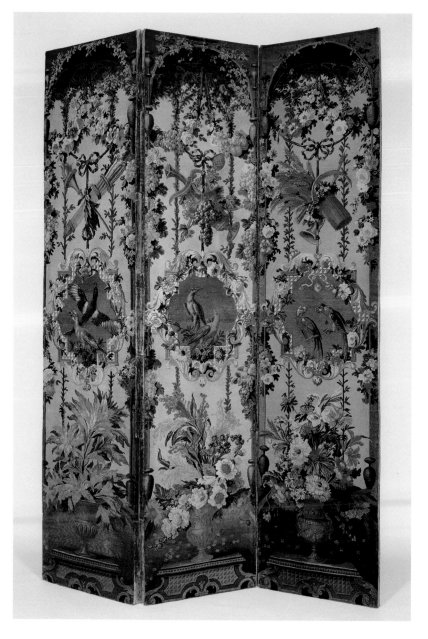

ONE OF A PAIR OF SCREENS

French, circa 1714–40
Savonnerie manufactory
Wool and linen; cotton
twill gimp; wooden interior
frame; modern velvet lining
273.6 × 193.2 cm
(8 ft. 11¾ in. × 6 ft. 4⅛ in.)
83.DD.260.1

This three-paneled screen of knotted wool pile was
made in the Savonnerie workshops, the royal manu-
factory that produced carpets, screens, and uphol-
stery covers exclusively for the French Crown.
Jean-Baptiste Belin de Fontenay (1653–1715) and
Alexandre-François Desportes (1661–1743) provided
the cartoons for this, one of the two largest models
for folding screens. This example retains its original
brilliant coloring.

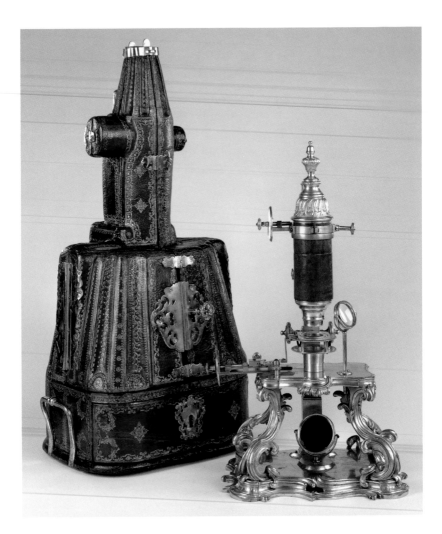

COMPOUND MICROSCOPE AND CASE

French (Paris), circa 1751
Microscope: gilt bronze;
glass and mirror glass;
enamel; shagreen
Case: wood; gilded leather;
brass closing fixtures;
original lining of silk velvet
with silver braid and lace;
slides of various natural
specimens and brass
implements
Microscope: 48 × 28 ×
20.5 cm (18⅞ × 11 × 8¹/₁₆ in.)
Case: 66 × 34.9 × 27 cm
(26 × 13¾ × 10⅝ in.)
86.DH.694

This microscope was made for a noble dilettante
scientist who would have used it in his laboratory or
cabinet de curiosités to explore the mysteries of
the natural world being revealed during the Age
of Enlightenment.

A microscope of the same form, known to have
belonged to Louis XV (1710–1774), was kept in
his observatory at the Château de La Muette. The
Museum's example is still in working condition.
A drawer in the case holds extra lenses and eigh-
teenth- and nineteenth-century specimen slides of
such items as a geranium petal, hair, and a flea.

GLOBE

French (Paris), circa 1728
Terrestrial map drawn by
Jean-Antoine Nollet (1700–
1770), engraved by Louis
Borde (active 1730–1740s)
Printed paper; papier-mâché;
poplar, spruce, and alder
painted with *vernis Martin*;
bronze; glass
110 × 45 × 32 cm
(43 × 17½ × 12½ in.)
86.DH.705.1

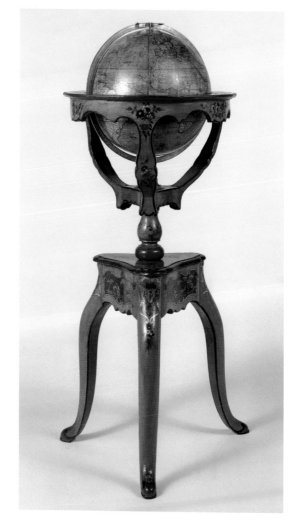

This terrestrial globe and an accompanying celestial globe were designed and assembled by Abbé Jean-Antoine Nollet, a fashionable scientist who taught physics to the royal children. The terrestrial globe bears a dedication to the duchesse du Maine, the wife of Louis XIV's first illegitimate child, and is dated 1728. The celestial globe is dedicated to her nephew, Louis de Bourbon, comte de Clermont, and is dated 1730. The stands are painted with a yellow *vernis* ground, polychrome flowers, and red cartouches bearing chinoiserie scenes. This work was probably carried out in the workshop of the brothers Guillaume and Étienne-Simon Martin (active 1727–ca. 1780).

Many contemporary portraits show the sitter with a globe close by, and such objects came to be considered essential adornments for the libraries and *cabinets* of the aristocracy.

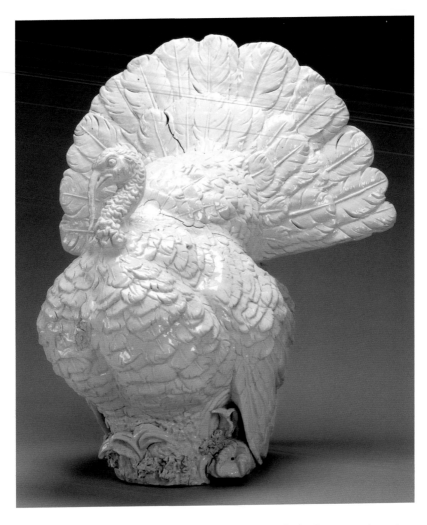

TURKEY

German, circa 1733
Meissen manufactory
Model by Johann Joachim
Kändler, 1706–1775
Hard-paste porcelain
53.5 × 51 × 20 cm
(21 1/16 × 20 1/16 × 7 7/8 in.)
(at base)
2002.48

In 1730 Frederick Augustus I, also known as Augustus the Strong, elector of Saxony (r. 1694–1733), commissioned a series of large porcelain animal sculptures from the Meissen manufactory. Intended for display in the Japanese Palace in Dresden, these porcelain figures were to be rendered "in their natural sizes and colors." The production of life-size porcelain sculptures had never before been attempted in Europe. Devising a suitable porcelain recipe and learning how to construct, glaze, and fire the pieces presented significant challenges for the manufactory. Those models that emerged from the kiln intact exhibited cracks that made a final firing with enamel colors impossible. This is one of eight turkeys made by the manufactory for the series. It was modeled by the sculptor Johann Joachim Kändler, who was hired in 1731 to assist with this extraordinary royal commission.

WALL CLOCK

French (Paris) and Chantilly
manufactory, circa 1740
Movement made by
Charles Voisin, 1685–1761,
master 1710
Soft-paste porcelain, poly-
chrome enamel decoration;
gilt bronze; enameled
metal; glass
74.9 × 35.6 × 11.1 cm
(29½ × 14 × 4⅜ in.)
81.DB.81

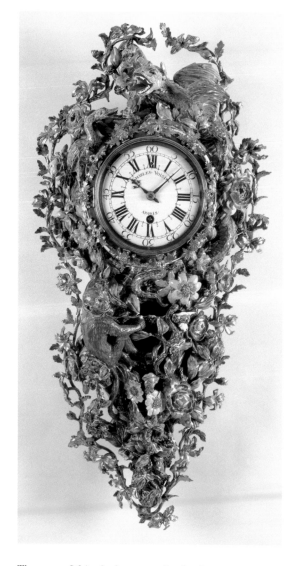

The case of this clock was made of soft-paste porce-
lain at the Chantilly manufactory, which was estab-
lished in 1725 by the prince de Condé. He was a great
collector of Japanese porcelain, and initially the
Chantilly manufactory produced wares in the
Japanese style. Although made in the most up-to-date
European style, the dragon and monkey on the clock
case are inspired by Chinese and Japanese decoration.

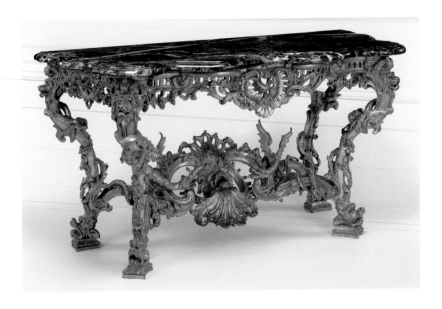

SIDE TABLE

French (Paris), circa 1730
Gilded oak; *brèche
violette* top
89.3 × 170.2 × 81.3 cm
(35⅛ × 67 × 32 in.)
79.DA.68

This table is intricately carved with lions' heads,
dragons, serpents, and chimerae (composite mytho-
logical beasts). While the carving is deep and pierced
in many areas, the table has remarkable strength and
is well able to support its heavy marble top. It was
originally part of a set including two smaller side
tables; they would have stood in a large salon fitted
with paneled walls carved with similar elements. It is
possible that chairs, a settee, and a fire screen, all
similarly carved, once completed the furnishings of
the room.

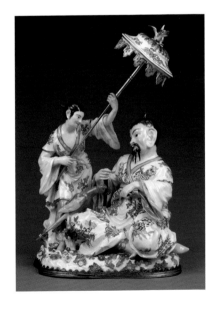

Console Table

German (possibly Bamberg),
circa 1735–45
Gilded spruce; *brèche
d'Alep* top
91.4 × 108.6 × 53.3 cm
(36 × 42¾ × 21 in.)
85.DA.319

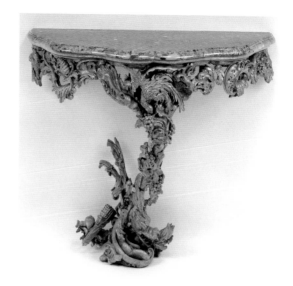

This console table exhibits the fanciful heights and
extravagant forms achieved by German craftsmen
working during the Rococo period. The decoration
combines incongruous elements—birds, a dragon,
hunting implements, lightning bolts, and fruited
vines—that appear occasionally in German expres-
sions of chinoiserie. Console tables were made to
be attached to the wall, and this example retains its
original gilded surface.

Group of "Japanese" Figures

German, circa 1745
Meissen manufactory
Modeled by Johann Joachim
Kändler, 1706–1775
Hard-paste porcelain,
polychrome enamel
decoration, and gilding;
gilt-bronze mounts
45.1 × 29.5 × 21.7 cm
(17¾ × 11⅝ × 8⁹⁄₁₆ in.)
83.DE.271

This piece is documented to have been modeled by
Kändler, who was among the foremost European
ceramic modelers of the eighteenth century and cer-
tainly the most important modeler at Meissen. An
entry in his workbook for November 20, 1745, clearly
describes this group. This unusually large work is
one of only two known examples.

The document describes this piece as "a large
Japanese Group" (*eine grosse Japanische Grouppee*)
even though the figures appear to be Chinese. This
merely exhibits the confusion that often occurred in
Europe during the eighteenth century regarding east-
ern Asia; the exoticism of the image was more impor-
tant than a specific reference. Therefore, this group
is typical of chinoiserie ornamentation (which was a
Western adaptation and interpretation of images
derived from the Far East). Indeed, this composition
may be from a series representing the five senses.

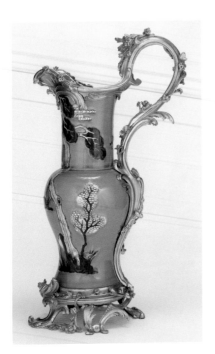

ONE OF A PAIR OF EWERS

Porcelain: Chinese, Kangxi
reign (1662–1722)
Mounts: French (Paris),
1745–49
Hard-paste porcelain,
celadon ground color, and
underglaze blue and copper
red decoration; gilt-bronze
mounts
60 × 33 × 21.5 cm
(23⅝ × 13 × 8½ in.)
78.DI.9.2

In Paris a Chinese porcelain vase
was transformed by the addition of
gilt-bronze mounts into this decorative
ewer. The combination of the gray-
green celadon background and the
underglaze decoration is unusual and
was prized by both the French and
the Chinese.

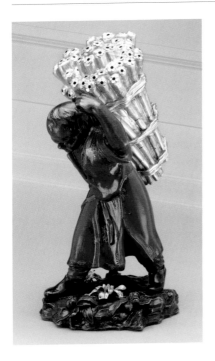

ONE OF A PAIR OF DECORATIVE BRONZES

Bronzes: French (Paris),
1745–49
Silver: French (Paris),
1738–50
Painted bronze; silver
22.8 × 11.5 × 15.2 cm
(9 × 4½ × 6 in.)
88.DH.127.2

This bronze of a boy carrying a silver
bundle of sugar cane and its pair
are ornamental figures masquerading
as sugar casters that probably were
not intended to be functional. They
may originally have belonged to
Madame de Pompadour, mistress of
Louis XV.

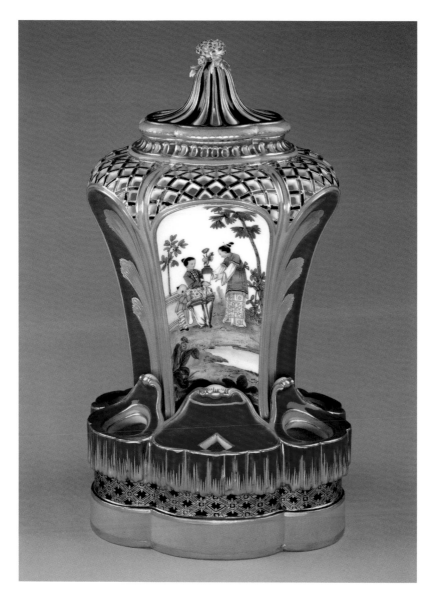

ONE OF A PAIR OF VASES

French, circa 1760
Sèvres manufactory
Painting attributed to
Charles-Nicolas Dodin,
1734–1803
Soft-paste porcelain, pink,
green, and *bleu lapis* ground
colors, polychrome enamel
decoration, and gilding
29.8 × 16.5 × 14.6 cm
(11¾ × 6½ × 5¾ in.)
78.DE.358.1

The lower section of this vase was designed to hold
small flowering bulbs, while the tall central section
was intended to hold potpourri, the scent of which
would emanate through the pierced trellis at the
top. Such vases would have formed a garniture with
others of various shapes. Chinoiserie scenes are
rare on Sèvres porcelain, and it is even rarer to find
three ground colors (pink, green, and dark blue)
on one piece. Each color required a separate firing
of the fragile porcelain. From archival records it
is known that these vases come from a set purchased
from the Sèvres manufactory in 1760 by Madame
de Pompadour (1721–1764), mistress of Louis XV.

CABINET
WITH CLOCK

French (Paris), cabinet,
circa 1740; clock, 1746
Cabinet made by Bernard II
van Risenburgh, b. after
1696–circa 1766, master
before 1730; the name of
the maker of the clock
case is unknown; clock
movement made by Étienne
Le Noir II, 1699–1778,
master 1717; dial enameled
by Jacques Decla, active
1742–d. after 1764
Oak and poplar veneered
with alder, amaranth, and
cherry and painted with
vernis Martin; painted
bronze figures; gilt-bronze
mounts; enameled metal
clock dial; glass
192 × 103 × 41 cm
(75⅝ × 40⁹/₁₆ × 16⅛ in.)
83.DA.280

The cabinet is stamped B.V.R.B. for the cabinetmaker
Bernard II van Risenburgh. The pigeonholes in the
central section and the narrow cupboards at the sides
of the base were intended to contain papers. The
black-and-gold decoration is of *vernis Martin*, a
French imitation of Oriental lacquer named after the
Martin brothers, who excelled in this technique. In the
Rococo period the use of Japanese or Chinese lacquer
panels to decorate furniture was popular; however,
the exotic lacquer was expensive for the client and
difficult to obtain, so Parisian craftsmen learned
to imitate it. The back of the clock dial is dated 1746.

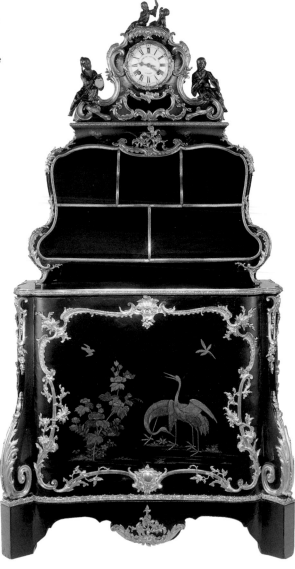

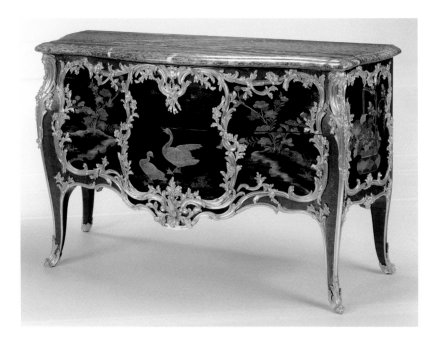

COMMODE

French (Paris), circa 1750
Attributed to Joseph
Baumhauer, d. 1772
Oak veneered with
ebony; set with panels
of Japanese lacquer
on Japanese arborvitae,
painted with *vernis Martin*;
gilt-bronze mounts;
campan mélangé vert
marble top
88.3 × 146.1 × 62.6 cm
(34³⁄₄ × 57¹⁄₂ × 24⁵⁄₈ in.)
55.DA.2

While the form of this commode (chest of drawers) is
strictly European, the commode itself is decorated
with panels of imported Japanese lacquer that are
framed by extravagant French gilt-bronze mounts.
It exemplifies the European passion for objects from
the Far East and the Parisian taste for transforming
these foreign goods into quintessentially French
pieces. A seam across the front of the commode indi-
cates that it houses two large drawers, the fronts of
which are otherwise concealed by the unified design
of the piece.

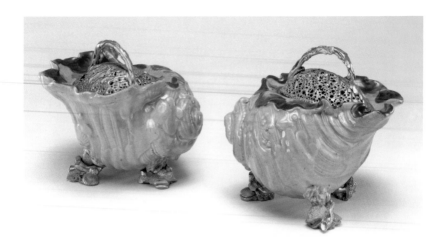

PAIR OF POTPOURRI BOWLS

Porcelain: Japanese (Arita), circa 1660–80
Mounts: French (Paris), circa 1750
Hard-paste porcelain, celadon ground color, and polychrome enamel decoration; gilt-bronze mounts
15.2 × 18.7 × 16.5 cm
(6 × 7⅜ × 6½ in.)
77.DI.90.1–.2

The shell-shaped porcelain bowls were made in Japan and were probably intended for export to the West. In Paris they were fitted with gilt-bronze feet and lids in the form of coral, shells, and seaweed. Each lid is perforated to allow the scent of potpourri to escape. Such fanciful combinations of Asian porcelain with French gilt-bronze mounts were one of the primary trades of the eighteenth-century Parisian dealers in luxury goods known as *marchands-merciers*, who would purchase the porcelain and then commission local craftsmen to provide inventive gilt-bronze mounts.

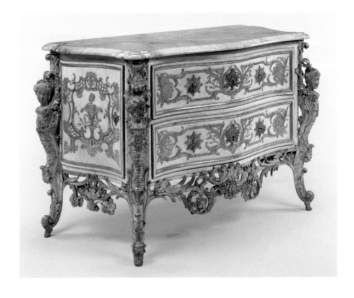

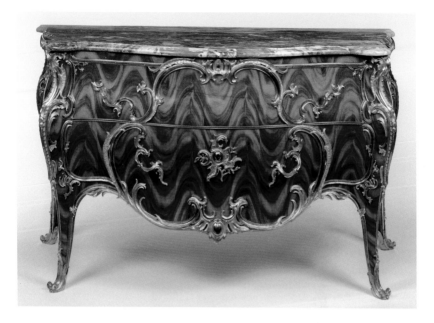

COMMODE

French (Paris), circa 1745–49
Attributed to Jean-Pierre
Latz, circa 1691–1754
Oak and poplar veneered
with bloodwood; walnut
drawers; gilt-bronze mounts;
fleur de pêcher marble top
87.7 × 151.5 × 65 cm
(34½ × 59⅝ × 25⅝ in.)
83.DA.356

This commode is distinguished by the extraordinary
pattern of the veneer. Pieces of wood were cut at an
angle to produce oval veneers, which were matched
so that the grain forms waving lines. Although the
commode is not stamped with a cabinetmaker's name,
it can be firmly attributed to Latz since his stamp is
found on a commode of precisely the same design that
was delivered in 1753 to a patron in Italy.

ONE OF A PAIR
OF COMMODES

German (Munich), circa 1745
Carving attributed to
Joachim Dietrich,
active 1736–53
Painted and gilded pine;
gilt-bronze mounts; *jaune
rosé de Brignolles* marble top
83.2 × 126.4 × 61.9 cm
(32¾ × 49¾ × 24⅜ in.)
72.DA.63.1

The design of this ornately carved German commode
and its pair was influenced by the engravings of
François de Cuvilliés (1698–1768), architect for the
Elector of Bavaria and one of the leading interpreters
of the Rococo style.

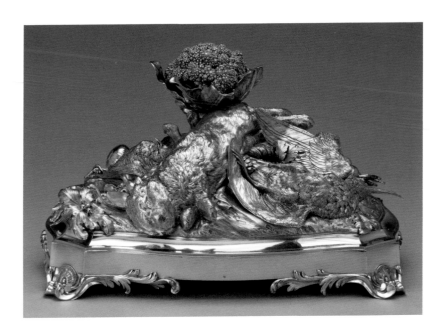

LA MACHINE D'ARGENT

1754
François-Thomas Germain
French, 1726–1791,
master 1748
Silver
21 × 36.8 × 23.2 cm
(8¼ × 14½ × 9⅛ in.)
2005.43

This silver sculpture represents a genre in the arts that celebrated trophies of the hunt. It depicts such game animals as the rabbit and two birds—an ortolan and a snipe—as well as vegetables and a variety of mushrooms, all of which together constituted the ingredients of a stew made from the catch of the day. The sculptor/silversmith Germain rendered his subject with great naturalism, rivaling nature in the texture of the rabbit's fur, the feathers of the birds, the smooth onion skin, and the rough, beaded head of cauliflower. The title of the work, *La Machine d'Argent* (literally, "the silver machine"), was understood at the time to imply "a work of genius," rather than the modern connotation of a mechanism.

ONE OF A SET OF FOUR WALL LIGHTS

Paris, 1756
François-Thomas Germain
French, 1726–1791,
master 1748
Gilt bronze
89.2 × 56.8 × 40.3 cm
(35⅛ × 22⅜ × 15⅞ in.)
81.DF.92.2.2

Signed by François-Thomas Germain, silversmith to the king (see above), these large, late Rococo wall lights were finished with an unusually high degree of attention to their casting and gilding. The lights were commissioned by the duc d'Orléans (1725–1785) for his residence in Paris, the Palais Royal. Later in the eighteenth century they were bought by Louis XVI (r. 1774–92) and hung in rooms used by Marie-Antoinette in the Château de Compiègne.

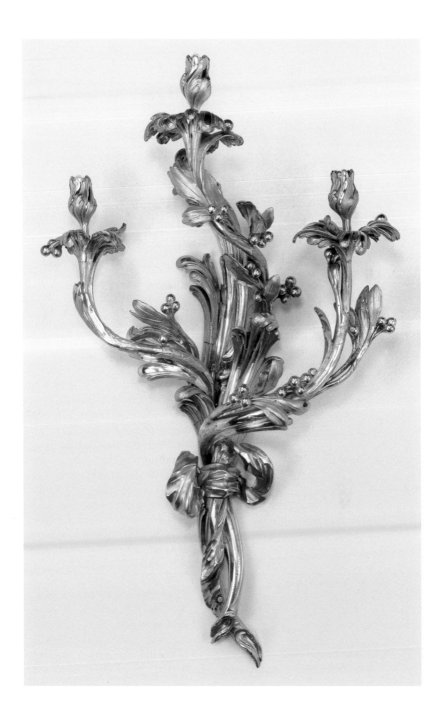

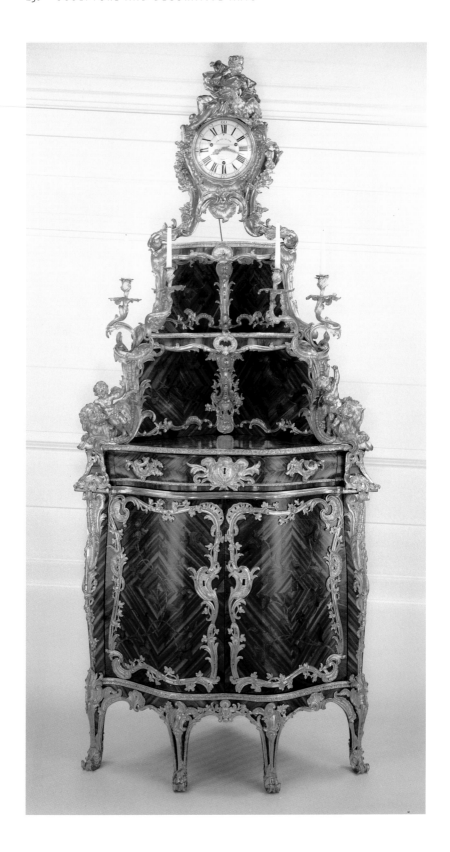

DOUBLE DESK

French (Paris), circa 1750
Bernard II van Risenburgh,
b. after 1696–circa 1766,
master before 1730
Oak veneered with tulip-
wood, kingwood, and blood-
wood; drawers of mahogany;
gilt-bronze mounts
107.8 × 158.7 × 84.7 cm
(42½ × 62½ × 33⅜ in.)
70.DA.87

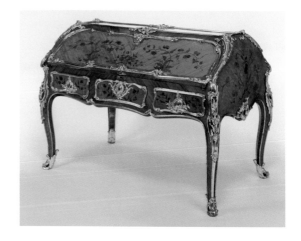

The double form of this desk is unique. The upper
angled sections of both long sides conceal large
panels that can be opened and lowered to form writing
surfaces, revealing drawers and pigeonholes inside.
The marquetry design on the desk is dominated
by patterns of floral vines that seem to sprout from
the sculptural gilt-bronze mounts. The piece was
probably made for a *fermier général* (a type of tax
collector), François-Balthazar Dangé; such a desk is
described in an inventory taken after his death in 1777.

CORNER CUPBOARD AND CLOCK

French (Paris), corner
cupboard, circa 1744–55;
clock, 1744
Jacques Dubois, 1693–1763,
master 1742; clock move-
ment made by Étienne Le
Noir II, 1699–1778, master
1717; dial enameled by
Antoine- Nicolas Martinière,
1706–1784, master 1720
Oak, mahogany, and spruce
veneered with bloodwood,
tulipwood, cururu, and king-
wood; gilt-bronze mounts;
enameled metal clock dial;
glass
289.5 × 129.5 × 72 cm
(9 ft. 6 in. × 51 × 28½ in.)
79.DA.66

The design for this unique corner cupboard is based
on a drawing by the French architect and ornament
designer Nicolas Pineau (1684–1754), who was an
early exponent of the Rococo style. However, the cup-
board's large scale and exuberant gilt-bronze mounts
reflect Eastern European rather than French taste.
The piece was made in Paris for a Polish general,
Count Jan Klemens Branicki, and delivered to him in
Warsaw. An inventory of his possessions describes
this corner cupboard in a grand reception room
of his residence placed opposite a large ceramic stove
whose design the cupboard probably echoes.

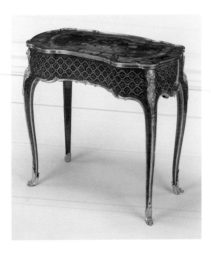

WRITING AND TOILET TABLE

French (Paris), circa 1754
Jean-François Oeben,
1721–1763, master 1761
Oak veneered with king-
wood, amaranth, tulip-
wood, and other stained
and natural exotic woods;
leather; silk; gilt-bronze
mounts
71.1 × 80 × 42.8 cm
(28 × 31½ × 16⅞ in.)
71.DA.103

The top of this table of multiple uses
slides back, and a drawer unit can
be pulled forward, revealing another
sliding top that conceals compart-
ments lined with blue watered silk.
These elaborate mechanisms and the
fine floral and trellised marquetry
decorating it are trademarks of the
table's maker, the royal *ébéniste*
Jean-François Oeben. Cosmetic pots
and writing materials would have
been kept in this table, and its surfaces
used for writing.

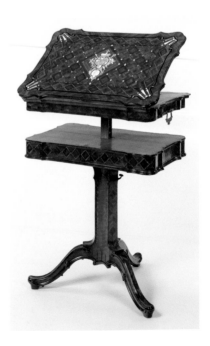

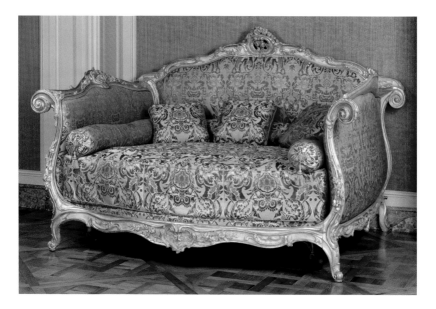

BED (*LIT À LA TURQUE*)

French (Paris), circa 1750–60
Attributed to Jean-Baptiste
Tilliard, 1686–1766
Gilded beech and walnut;
modern silk upholstery
174 × 264.8 × 188 cm
(68½ in. × 8 ft. 8¼ in. ×
74 in.)
86.DA.535

A bed of this extravagant form was known as a *lit à la turque* (Turkish-style bed) because of its resemblance to an overstuffed Turkish sofa with high scrolled sides. This example is the largest of its type known. It is elaborately carved and gilded and originally would have had a draped canopy hanging above. The body of the bed can be pulled forward on wheels, leaving the back attached to the wall. This allowed the bed to be made up more easily by servants.

READING AND WRITING STAND

German (Neuwied),
circa 1760–65
Abraham Roentgen,
1711–1793
Pine, oak, and walnut
veneered with rosewood,
alder, palisander, ivory,
ebony, and mother-of-
pearl; gilded metal fittings
77.5 × 71.7 × 48.8 cm
(30½ × 28½ × 19¼ in.)
85.DA.216

The top of this stand is inlaid with the coat of arms of Johann Philipp von Walderdorff, Prince Archbishop and Elector of Trier. Walderdorff was Roentgen's most important patron, and during the 1750s and 1760s, the latter delivered some twenty pieces of elaborate furniture to Walderdorff's palace. This stand is fitted with numerous concealed drawers that open at the press of a button or turn of a key.

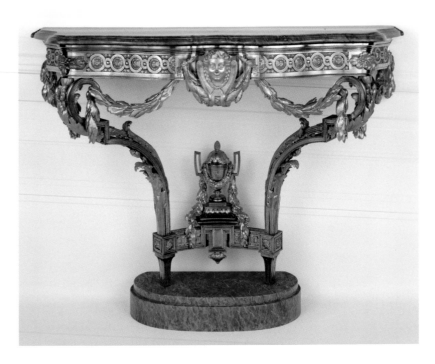

CONSOLE TABLE

French (Paris), circa 1765–70
After a design attributed
to Victor Louis, 1731–1807,
and Jean Louis Prieur, active
1765–85; table attributed
to Pierre Deumier, active
from the 1760s
Silvered and gilt bronze; *bleu
turquin* marble top; modern
marbleized wooden base
83.5 × 129.5 × 52 cm
(32⅞ × 51 × 20½ in.)
88.DF.118

This unusual silvered and gilt-bronze console table
follows a type designed for the royal palace in Warsaw
of Stanislas II Auguste, king of Poland (r. 1764–95).
The French architect Victor Louis was commissioned
to renovate this residence according to the latest
Neoclassical style inspired by the archaeological dis-
coveries at Pompeii and Herculaneum. Louis was also
responsible for designing some of the fitted furniture
to coordinate with his new interiors. This table was
probably cast according to his design by Pierre
Deumier, whose training as a locksmith caused him
to forge the metal form in many interlocking pieces.

MANTEL CLOCK

French (Paris), circa 1772
Case by Étienne
Martincourt, d. after 1791,
master 1762; movement
made by Étienne-Augustin
Le Roy, 1737–1792,
master 1758
Gilt bronze; enameled
metal; glass
71.1 × 59.7 × 32.4 cm
(28 × 23½ × 12¼ in.)
73.DB.78

Known from documents to have belonged to Louis XVI
(1754–1793), this clock is a remarkable work of cast-
ing, since details like the rosettes in the trellis were
cast together with the elements they decorate. The
usual practice was to cast all of these pieces sepa-
rately. Although the clock, which came from the Palais
des Tuileries, does not bear the name of its maker, a
drawing for it by the *bronzier* Étienne Martincourt is
extant. Through their attributes the allegorical female
figures flanking the urn have been identified as
Astronomy and Geography.

ONE OF SIX WALL LIGHTS

French (Paris), circa 1765–70
Philippe Caffiéri, 1714–1774,
master 1743
Gilt bronze
64.8 × 41.9 × 31.1 cm
(25½ × 16½ × 12¼ in.)
78.DF.263.1–.4; 82.DF.35.1–.2

A drip pan of one candle socket bears the signature of the maker, the *bronzier* Philippe Caffiéri. Signed gilt-bronze objects such as this are rare, since the craftsmen who made them only occasionally put their names on their work. This light is further documented by a surviving design drawn by Caffiéri, who signed the sketch.

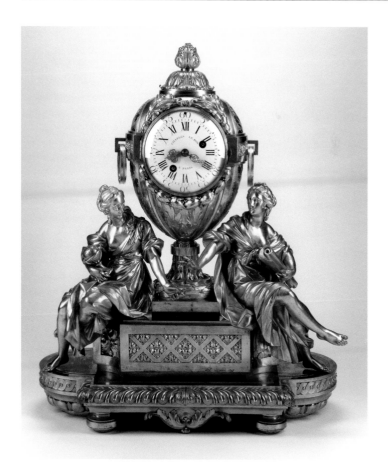

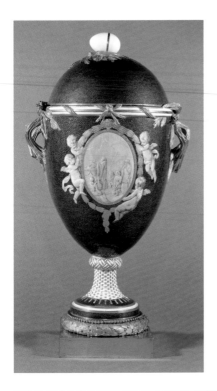

ONE OF A PAIR OF LIDDED VASES

French, 1768–69
Sèvres manufactory
Painted reserves attributed
to Jean-Baptiste-Étienne
Genest, active 1752–89
Soft-paste porcelain, *bleu
Fallot* ground color, grisaille
enamel decoration, and
gilding; gilt-bronze mounts
45.1 × 24.1 × 19.1 cm
(17¾ × 9½ × 7½ in.)
86.DE.520.1

This ornamental vase is of nearly
unique form. The grisaille reserves
and the pale blue ground strewn
with gilded dots create a subtle finish
markedly different from the strong,
brightly colored decoration frequently
employed at the Sèvres porcelain
manufactory in the late eighteenth
century.

SECRÉTAIRE

French (Paris), circa 1770–75
Philippe-Claude Montigny,
1734–1800, master 1766
Oak veneered with
bloodwood, tortoiseshell,
brass, pewter, and ebony
bandings; gilt-bronze
mounts
141.5 × 83.8 × 40.3 cm
(55½ × 33 × 15¾ in.)
85.DA.378

The front and sides of this Neoclassical *secrétaire*
(drop-front desk), are covered with large marquetry
panels of tortoiseshell, brass, and pewter dating from
the late seventeenth century. They were originally
tabletops that were reused by Montigny, who was well
known as a specialist in this type of work. The reuse
of such old panels, or the making of new ones, was
fashionable during the late eighteenth century among
the most advanced connoisseurs. This vogue is known
as the "Boulle revival," after the technique's greatest
seventeenth-century practitioner, André-Charles
Boulle (1642–1732).

It is unusual to find an eighteenth-century prove-
nance for nonroyal furniture. Two previous owners—
both courtiers at Versailles—have been identified for
this *secrétaire*.

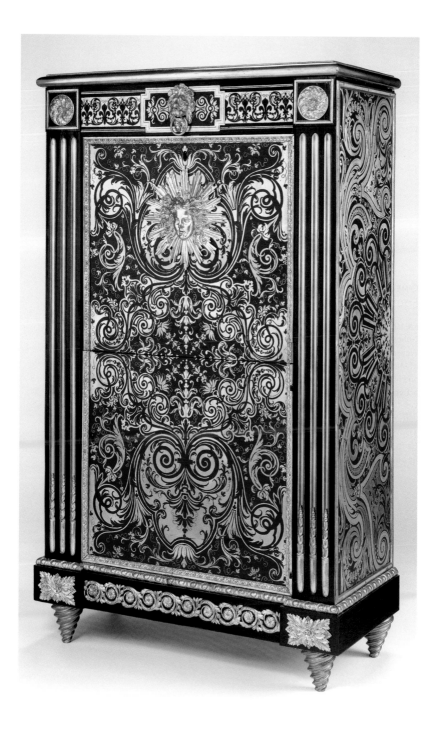

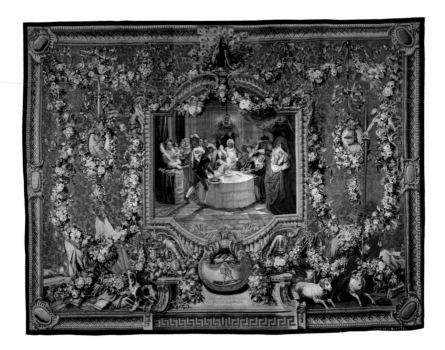

ONE OF A SET OF FOUR TAPESTRIES

French, 1770–72
Gobelins manufactory
Woven under the direction
of Michel Audran, 1701–1771,
and his son Jean Audran *fils*,
active 1771–94
Wool and silk; modern
cotton lining
371 × 507.5 cm
(12 ft. 2 in. × 16 ft. 7 in.)
82.DD.67

Entitled *The Feast of Sancho on the Island of Bara-taria*, this tapestry is from a set of four woven at the Gobelins manufactory depicting various scenes from Cervantes's novel *Don Quixote*. The four make up one of many similar sets woven between 1763 and 1787 after cartoons by the painter Charles-Antoine Coypel (1694–1752). The designs of the elaborate frames and surrounds were altered periodically as styles changed. Such tapestries were often presented by the French king to royalty and nobility from other countries in Europe. Louis XVI (1754–1793) gave this set to the Duke and Duchess of Saxe-Teschen, the governors of the Austrian Netherlands (modern Belgium), who were traveling in France in 1786 (the duchess was the sister of Queen Marie-Antoinette).

A number of examples from the *Don Quixote* series exist, but the Museum's four tapestries are unusual in that the colors remain relatively unfaded and retain many of the softer hues now lost on other examples.

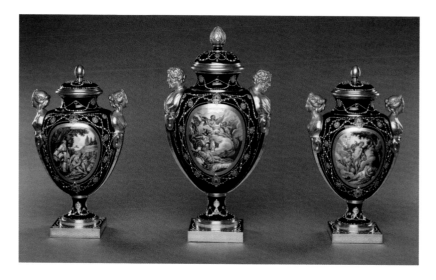

GARNITURE OF THREE VASES

French, 1781
Sèvres manufactory
Models designed by Jacques-François Deparis, active 1746–97; at least one vase finished by Étienne-Henry Bono, active 1754–81; reserves painted by Antoine Caton, active 1749–98; gilding by Étienne-Henry Le Guay, 1719/20–circa 1799; jeweling by Philippe Parpette, active 1755–1806
Soft-paste porcelain, *beau bleu* ground color, polychrome enamel decoration, enamel imitating jewels, gilding, and gold foil
40.8 × 24.8 × 18.4 cm (16 × 9¾ × 7¼ in.);
47 × 27.6 × 19.4 cm (18½ × 10⅞ × 7⅝ in.);
40.5 × 25.4 × 18.3 cm (15¹⁵⁄₁₆ × 10 × 7³⁄₁₆ in.)
84.DE.718.1–.3

This set of lavishly decorated vases (along with a similar pair now in the Walters Art Gallery, Baltimore) formed a *garniture de cheminée* that was purchased by Louis XVI (1754–1793) on November 2, 1781, and placed in his library at Versailles. These vases, prime examples of the mature Neoclassical style at Sèvres, are among the most fully documented works of porcelain in the Museum's collection. Known as a *vase des âges*, this shape was produced at Sèvres from 1778 in three sizes that differ in the rendering of the "handles": bearded male heads for the largest size, female heads for the middle size, and boys' heads for the small size (in Baltimore). The oval reserves on the front of each vase were painted in polychrome enamels with scenes based on engravings by Jean-Baptiste Tilliard (ca. 1740–1813) after designs by Charles Monnet (1732–after 1808). These engravings illustrated an edition of one of Louis XVI's favorite books, *Les Aventures de Télémaque*.

These vases are among the largest pieces of jeweled porcelain made at Sèvres. The procedure was exceptionally expensive and demanded great skill. It is clear that only the factory's most experienced and accomplished decorators were involved in producing this garniture. No directly comparable sets of vases are known.

SECRÉTAIRE

French (Paris) and Sèvres
manufactory, circa 1776–77
Martin Carlin, circa 1730–
1785, master 1766
Oak veneered with tulip-
wood, amaranth, holly, and
ebony stringing; soft-paste
porcelain plaques with
polychrome enamel decora-
tion and gilding; enameled
metal; gilt-bronze mounts;
marble top
107.9 × 103 × 35.5 cm
(42¼ × 40½ × 14 in.)
81.DA.80

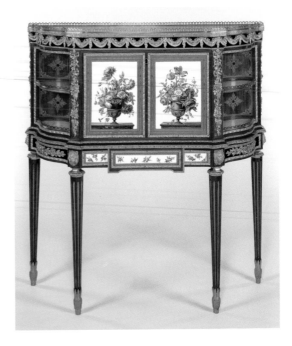

The upright *secrétaire*, a type of writing desk, came
into fashion in the mid-eighteenth century. The fall
front of this example lowers to form a writing surface,
revealing drawers and pigeonholes. This Neoclassical
secrétaire is decorated with flower-painted Sèvres
porcelain plaques, an expensive fashion introduced
by the Parisian furniture dealers in the 1770s. Its
unusually small size suggests that the piece was made
for a bedroom.

BED (LIT À LA POLONAISE)

French (Paris), circa 1775–80
Gilded and painted walnut;
gilded iron; modern silk
upholstery and *passe-
menterie*; ostrich feathers
302 × 226 × 179 cm
(9 ft. 11 in. × 89 × 70½ in.)
94.DA.72

This type of grand, formal bed was meant to occupy a
deep recess in the most important bedroom of a pri-
vate residence, where visitors were received in the
morning. It is not known who designed the bed, who
executed the frame, or for whom it was made. The
head and foot rails are carved as cornucopia, each
overflowing with fruit, flowers, sheaves of wheat, and
nuts. A repeating pattern of oak leaves and acorns
decorates the vertical posts. The modern upholstery
and *passementerie* (fringes, cords, and tassels) follow
the designs of the *ornemaniste* Richard de Lalonde
(active 1780s–90s) and historical photographs of the
bed dating from the early twentieth century, when it
still retained its original hangings.

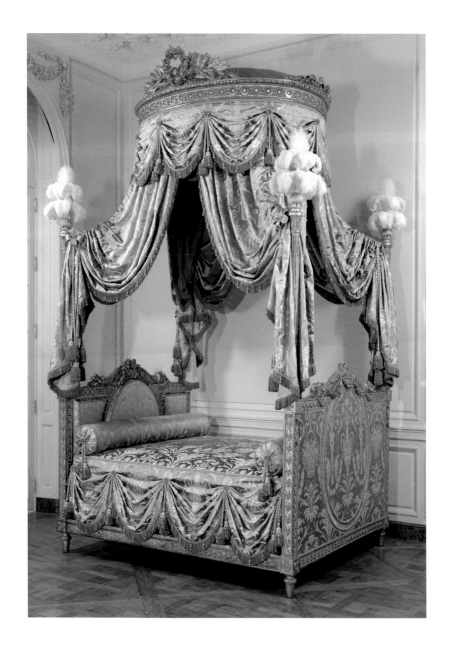

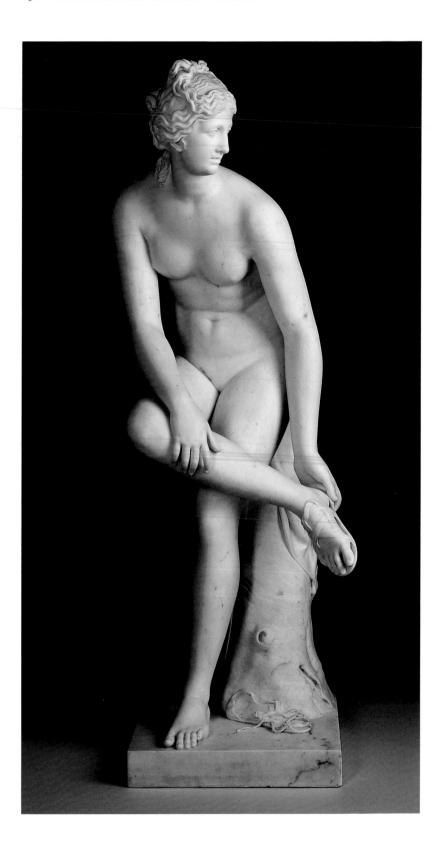

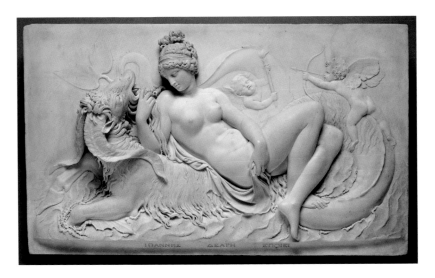

VENUS RECLINING ON A SEA MONSTER WITH CUPID AND A PUTTO

1785–87
John Deare
English, active in London and Rome, 1759–1798
Marble
33.7 × 58.4 × 11.2 cm
(13¼ × 23 × 4⅜ in.)
98.SA.4

Deare was one of the most innovative British sculptors working in the Neoclassical style. In addition to incorporating motifs from ancient art, he was highly influenced by Italian sixteenth-century sculpture, which lent his style a languid sensuousness. This relief, showing Venus reclining on a fishtailed goat, recalls traditional Renaissance emblems of Lust. The Cupid and torch-bearing putto symbolize ardent desire. Venus entwines her fingers in the sea-goat's beard, and the beast suggestively licks her hand, heightening the erotic tension inherent in the imagery. The monster's shaggy fur and the frothy waves are carved with the energy and precision typical of Deare's virtuoso technique.

VENUS

1773
Joseph Nollekens
English, 1737–1823
Marble
124 × 51 × 51 cm
(48¹³⁄₁₆ × 20 × 20 in.)
87.SA.106

Nollekens studied in Rome from 1762 to 1770, and his style, a mannered classicism inflected by coy charm, exhibits the influence of ancient and sixteenth-century Italian sculpture. *Venus* is one of a group of female deities by Nollekens in the Museum's collection. With the other figures of Juno and Minerva, the *Venus* formed part of a series sculpted for the English nobleman Lord Rockingham to accompany a marble *Paris*, which Rockingham already owned and believed to be antique. The four statues together illustrate the story of the shepherd king who was empowered to judge which goddess was the fairest. Nollekens chose to depict each of the goddesses in a different state of undress. Venus, the winner, is nude except for the single sandal she is removing.

CABINET

French (Paris), circa 1765
Joseph Baumhauer, d. 1772
Oak veneered with ebony,
tulipwood, maple, Japanese
cedar, and amaranth;
set with panels of
seventeenth-century
Japanese lacquer; gilt-bronze
mounts; jasper top
89.6 × 120.2 × 58.6 cm
(35¼ × 47⅜ × 23⅛ in.)
79.DA.58

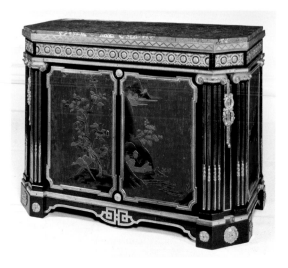

The design of this early Neoclassical cabinet is
severely architectonic and includes such classical ele-
ments as fluted pilasters and Ionic capitals. Although
fairly simple in appearance, it is made from rare
and expensive materials. The *kijimaki-e* lacquer pan-
els, sanded so that the grain of the wood shows, are
of very fine quality and of a late-seventeenth-century
date. A semiprecious hard stone, yellow jasper, was
used for the top instead of less expensive marble.

The cabinet is stamped JOSEPH, the mark of the
cabinetmaker Joseph Baumhauer.

COMMODE

French (Paris), 1769
Gilles Joubert, 1689–1775
Oak veneered with king-
wood, tulipwood, holly,
bloodwood, and ebony; gilt-
bronze mounts; *sarrancolin*
marble top
93.5 × 181 × 68.5 cm
(36¾ × 71¼ × 27 in.)
55.DA.5

In 1769 this commode was delivered to Versailles for
use in the bedchamber of Madame Louise (1737–
1787), the youngest daughter of Louis XV (1710–1774).
It is inscribed on the back with the number 2556,
identifying it in the royal inventories. Late in his
career Gilles Joubert, best known for his Rococo
work, ventured to design this commode in the newly
fashionable Neoclassical style.

VASE

Stone: French (Pyrénéese)
Mounts: French (Paris),
circa 1760
Bianco e nero antico breccia;
gilt-bronze mounts
31.7 × 50.2 × 28.3 cm
(12½ × 19¾ × 11⅛ in.)
79.DJ.183

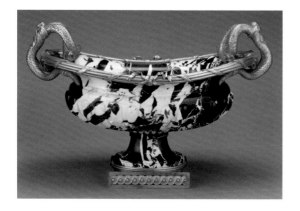

Renaissance and Baroque stonemasons worked both
contemporary and ancient blocks of hard stones
and marbles into vessels, shaping them according to
classical models, for a growing group of wealthy
princely, aristocratic, and ecclesiastical collectors.
Valued for the beauty of the stone and the enduring
qualities of the material, the vases sometimes were
further embellished with metal fittings, often in
gilt bronze, by seventeenth- and eighteenth-century
designers and collectors. This particular vase, with
coiling snakes as handles, inspired slightly smaller
versions made in soft-paste porcelain at the Sèvres
manufactory in the 1760s.

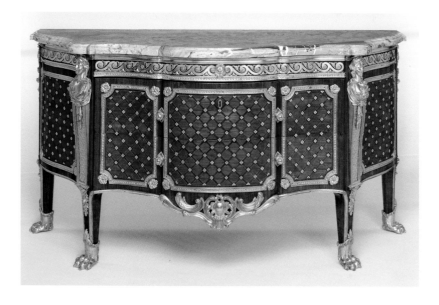

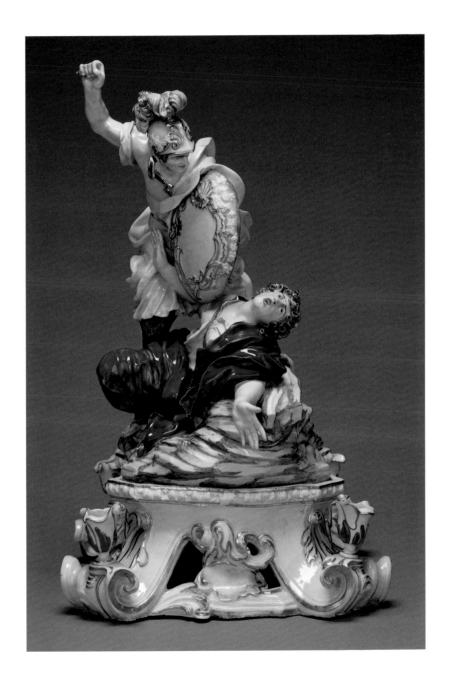

PERSEUS AND MEDUSA

MERCURY AND ARGUS

Italian, 1750–60
Ginori Porcelain Factory
Italian, 1735–present
Models by Giovanni
Battista Foggini
Italian, 1652–1725
Probably made by
Gaspero Bruschi
Italian, 1701–1780
Hard-paste porcelain,
partially gilt
Each, 45.5 × 33 × 28 cm
(17¾ × 13 × 11 in.)
94.SE.76.1-2

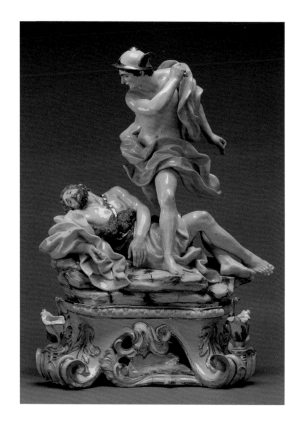

The preeminent Florentine sculptor of the early eighteenth century, Giovanni Battista Foggini first created the compositions for these figure groups as models for bronzes. After his death in 1725, the piece-molds of most of Foggini's bronzes passed to his son, Vincenzo, also a sculptor. Vincenzo then gave a number of these models to the Ginori Porcelain Factory in Doccia, outside Florence, for the production of many of the factory's early figures and figure groups. These two sculptures depict decapitation scenes that are described by the Roman poet Ovid in his *Metamorphoses*, a poetic recounting of ancient myths. The sculptures served as candelabra, with candles fitting into the sockets at the four corners of each base, and may have been part of a larger table centerpiece. Given the violent subject matter, they must have been a particularly theatrical addition to their dining-table setting.

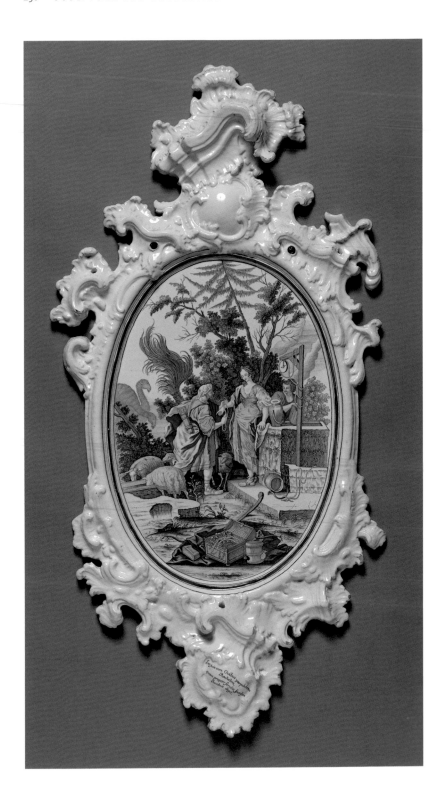

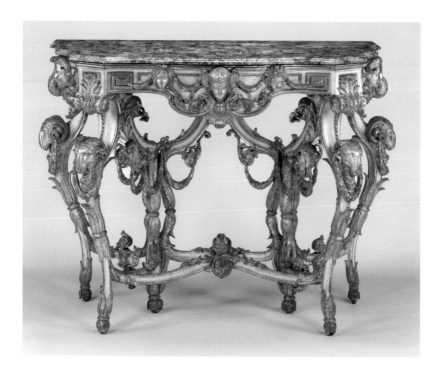

PLAQUE DEPICTING JACOB CHOOSING RACHEL TO BE HIS BRIDE

Spanish, circa 1755
Alcora manufactory,
active 1727–circa 1858
After a painting by
Jacopo Amigoni
Italian, circa 1685–1752
Faïence (eighteenth-century
tin-glazed earthenware)
94 × 47.6 cm (37 × 18¾ in.)
99.DE.10

SIDE TABLE

Italian, circa 1760–70
Gessoed, painted, and gilt
wood (spruce and limewood)
with a rosone di Trapani
marble top
104.9 × 153 × 74 cm
(41⁵/₁₆ × 60¼ × 29⅛ in.)
87.DA.135

These two objects manifest different aspects of the Rococo style, which originated in France and ultimately dominated Europe in the eighteenth century. The Alcora factory near Valencia, Spain, produced earthenware tableware and sculpture, as well as plaques, in a particularly exuberant Rococo style, with very fine painting in a wide palette of high-temperature colors. The elaborate scene on this plaque depicts a curious fusion of two stories from Genesis—Jacob choosing Rachel as his wife and Rebecca and Eliezar at the well (29:10–18 and 24:2–47)—into one event. A print with the Rebecca and Eliezar motif probably served as a source for the Jacob and Rachel subject, possibly because it has more amorous and less moralizing overtones. The curvilinear form of the Italian side table, graceful yet complex, is bedecked with Rococo swags and floral tendrils. Nevertheless, its maker was influenced by the furniture designs of Giovanni Battista Piranesi (1720–1778), a major force behind the development of the Neoclassical style in Europe. Piranesi was active in Rome mainly as a printmaker, and his published etchings of interior ornament helped promote an eclectic style combining an almost dreamlike profusion of Egyptian as well as Roman and Greek elements. The Rococo style lingered longer in Spain than it did in Italy: with its intimate connections to the classical world, Italy was well poised to embrace Neoclassicism.

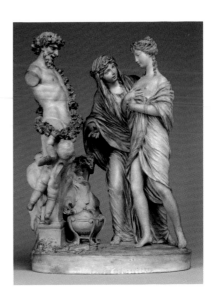

VESTAL PRESENTING A YOUNG WOMAN AT THE ALTAR OF PAN

Circa 1775
Clodion (Claude Michel)
French, 1738–1814
Terracotta
45.1 × 33.5 × 21.8 cm
(17¾ × 13³⁄₁₆ × 8⅝ in.)
85.SC.166

Through his technical brilliance and virtuoso handling of wet clay, Clodion raised to new heights the aesthetic quality of the terracotta as an independent work of art rather than a preparatory sketch or model for a sculpture in a more permanent material. The Museum's terracotta depicts the enactment of a ritual before a herm of Pan, the god of the fields, who is associated with lust. The object's playful, romantic attitude toward the classical world is typical of the work of Clodion, who preferred genre scenes involving marginal mythological figures to the epic dramas of the principal Olympian gods.

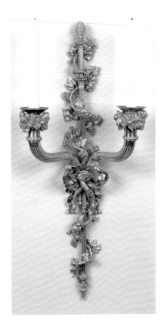

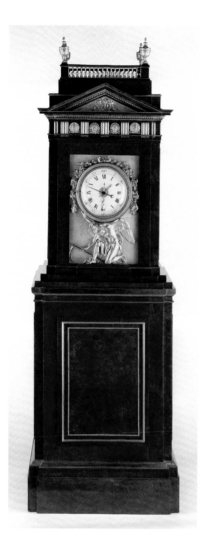

Long-Case Musical Clock

German (Neuwied), 1786
Clock case by David Roent-
gen, 1743–1807, master
1780; gilt-bronze mounts by
François Rémond, 1747–1812,
master 1774; clock move-
ment by Peter Kinzing,
1745–1816; musical mecha-
nism by Johann Wilhelm
Weyl, 1756–1813
Ash, maple, walnut, and oak
veneered with maple and
walnut; bronze; gilt-bronze
mounts; enameled metal;
glass; blued steel
192 × 64 × 54.5 cm
(75½ × 25½ × 23½ in.)
85.DB.116

About 1770 the cabinetmaker David
Roentgen began working with the
clockmaker Peter Kinzing in the
German town of Neuwied. Their part-
nership was highly successful, and
this clock is one of the most popular
models that Roentgen produced. The
clock movement includes a musical
mechanism by Johann Wilhelm Weyl,
which would play one of four melodies
when it chimed on the hour or on the
third hour. Roentgen had a large inter-
national clientele and was considered
the most celebrated *ébéniste* (cabinet-
maker) in Europe by his contempo-
raries. He made numerous pieces for
members of the French court.

One of a Set of Four Wall Lights

French (Paris), 1781
Model by Claude-Jean Pitoin,
active 1777–84, master 1778,
casting and chasing attrib-
uted to Louis-Gabriel Féloix,
1729–1812, master 1754
Gilt bronze
55.9 × 25.4 × 11.4 cm
(22 × 10 × 4½ in.)
99.DF.20.1

This finely chased wall light represents the bounty of
the harvest season through the symbols of the central
shaft as the rod (thyrsus) of Bacchus, the god of wine,
and of its branches in the form of cornucopias over-
flowing with fruit, flowers, and leaves. The set was
delivered by Pitoin to the Château de Versailles in
1781 to illuminate a small, private room, called the
Cabinet de la Méridienne, of Queen Marie-Antoinette
(1755–1793). She withdrew to this room at midday to
rest while pregnant with her second child, a son
named Louis, who was born in autumn of that year.

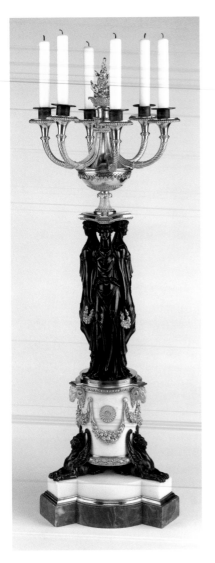

ONE OF A PAIR OF CANDELABRA

French (Paris), circa 1785
Attributed to Pierre-Philippe
Thomire, 1751–1843,
master 1772, after designs
by Louis-Simon Boizot,
1743–1809
Gilt and patinated bronze;
white and *griotte* marbles
H: 83.2 cm (32 ¾ in.);
DIAM: 29.2 cm (11½ in.)
86.DF.521.2

This candelabrum artfully combines
materials that would have shimmered
in the flickering candlelight: the bright
surface of gilt bronze, the reflective
finish of patinated bronze, and the
stark white of polished marble. The
probable designer of these light
fixtures, Louis-Simon Boizot, was a
sculptor adept at applying classical
motifs to the design of small-scale
functional furnishings. A drawing in
the Musée des Arts Décoratifs (Paris)
for a fireplace shows this model of
candelabrum together with a clock,
carried by vestal virgins, and a bronze
figure of a young maiden reading
by the light of an antique oil lamp.
As it is known that Boizot supplied
the model of the young girl reading
as an allegory of Study to the Sèvres
porcelain manufactory in 1780, it is
assumed that he was also responsible
for the design of these caldelabra.
On stylistic grounds, the refined
casting of the metalwork has been
attributed to the renowned *bronzier*
Pierre-Philippe Thomire.

CARVED RELIEF

French (Paris), 1789
Aubert-Henri-Joseph Parent,
1753–1835
Limewood
69.4 × 47.9 × 6.2 cm
(27 3/8 × 18 7/8 × 2 3/8 in.)
84.SD.76

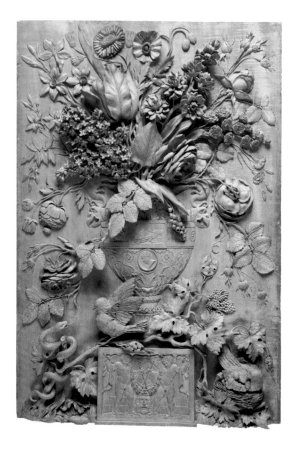

This virtuoso display piece was made both as a work
of art and as a demonstration of the maker's skill in
the art of carving. It was executed from a single piece
of limewood by Aubert Parent, who is best known for
still-life reliefs carved in fruitwoods. Parent came to
prominence in 1778 when he began working for the
French Crown. He had already traveled to Italy, where
he may have seen the work of Giuseppe Bonzanigo
(1744–1820), a famous woodcarver from Turin. After
the French Revolution, Parent left France to work
in Berlin.

Prominent elements in the decoration of this relief
exhibit an interest in Roman antiquity, which was an
important element in the Neoclassical style. The tablet
in the center of the vase represents a grasshopper in a
chariot drawn by a parrot. This motif was inspired
by an engraving reproducing a wall painting fragment
found in the excavations at Herculaneum. On the
rectangular plinth beneath the vase are represented
a pair of Loves (putti) with their torches reversed.
A putto with a reversed torch was a traditional Roman
symbol of mourning and is commonly found on
ancient Roman sarcophagi.

TABLE

Late eighteenth century
Giuseppe Maggiolini
Italian, 1738–1814
Walnut and rare wood
veneer and inlay
84 × 110 × 74 cm
(33¹/₁₆ × 43⁵/₁₆ × 29⅛ in.)
95.DA.81

Maggiolini was one of the most celebrated Italian furniture makers of his time, and he had a major influence on cabinetmakers both during his lifetime and after. In 1771 he began working for Archduke Ferdinand of Austria (1793–1875), who was governor general of Lombardy and Maggiolini's primary patron. The sophisticated marquetry and refined forms of Maggiolini's furniture gained favor in courts of the period, including those of Russia, Poland, Austria, and Parma, as well as the Napoleonic court. Here, the elegant trompe-l'oeil architectural rendering that appears to have been placed on the tabletop is based on a Maggiolini drawing currently in a Milan archive.

Inscribed on the tabletop is the name of its original owner: Laura Visconti. She may be identified as Laura Seccoborella, who married Count Carlo Visconti di Modrone in the late eighteenth century. Descendants of her husband's important Milanese family established the opera house La Scala and include the film director Luchino Visconti.

SECRÉTAIRE

German (Berlin),
circa 1798–99
Johann Andreas Beo, dates
unknown; clock movement
by Christian Möllinger,
1754–1826
Oak, spruce, and Scots pine
veneered with mahogany,
maple, Ceylon satinwood,
rosewood, ebony, and holly;
white marble; bronze; gilt-
bronze mounts; enameled
metal; glass
243.8 × 111.8 × 60.9 cm
(96 × 44 × 24 in.)
84.DA.87

Monumental in scale, this *secrétaire* was designed in an architectural style incorporating classical elements, such as columns and pilasters, made of white marble. The large center panel lowers to form a writing surface, revealing three pigeonholes inside intended to look like small rooms with parquetry floors and paneled walls of multicolored woods. Made in Berlin by the cabinetmaker Johann Andreas Beo, the piece incorporates a small clock by Christian Möllinger, who became the chief clockmaker at the Prussian court. He specialized in clocks fitted with flute and organ pipes: such a musical mechanism was once housed in the base.

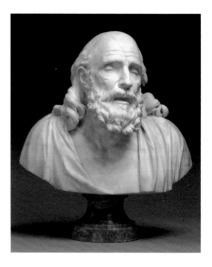

BUST OF BELISARIUS

Circa 1785–91
Jean-Baptiste Stouf
French, 1752–1826
Marble
60 × 55 × 30 cm
(23¾ × 21⅝ × 11¹³⁄₁₆ in.)
overall
H (without socle):
46 cm (18⅛ in.)
2005.19

The myth of the renowned Byzantine general Belisarius derives from the popular novel *Bélisaire*, published by Jean-François Marmontel in 1767. In that account Emperor Justinian ordered Belisarius's blinding to discredit the popular general, who was thus reduced to the status of a homeless beggar, condemned to asking passersby for alms. In eighteenth-century France the subject of Belisarius was used both as a political allegory and as an opportunity to depict the deep emotion of the blinded yet steadfast hero. Here, Stouf employs the format of an antique Roman bust. The crinkled skin around the eye sockets and the sunken cheeks are rendered with touching realism. Belisarius's heavy eyelids and the open mouth emphasize the pathos of the expression and are a perfect illustration of the "passions" that preoccupied several artists at this date.

BUST OF MARIE-SÉBASTIEN-CHARLES-FRANÇOIS FONTAINE DE BIRÉ

1785
Jean-Antoine Houdon
French, 1741–1828
Marble
H (overall): 82.3 cm (32⅜ in.)
H (without socle): 67.7 cm
(26⅝ in.)
2003.102

Houdon's bust of Monsieur de Biré (1727–1803) epitomizes the imperious image of a high-level public servant at the end of the ancien régime. The sculpture may have been commissioned to commemorate Biré's assumption of the position of *Trésorier payeur général des dépenses au département de la guerre* in Paris in 1782. Houdon depicted a sitter who is elegantly restrained in his pose, yet with the hint of a smile playing around his mouth. In addition, the sculptor incorporated the traces of age on this man's face—the fine wrinkles, the slightly sagging flesh, and the imperfections of his skin—all rendered in marble in a breathtaking display of sculptural virtuosity. As a newly rediscovered work by Houdon, this bust takes its rightful place in this sculptor's celebrated pantheon of male portraits, including George Washington, Benjamin Franklin, and Robert Fulton.

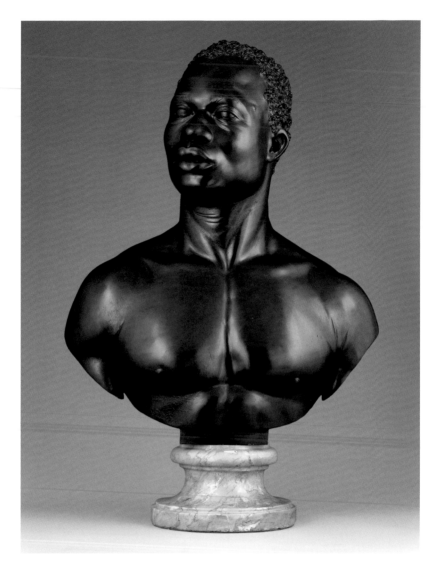

BUST OF A MAN

1758
Francis Harwood
English, active in Florence
1748–83
Black stone (*pietra da paragone*) on a
yellow Siena marble socle
Bust (with socle):
69.9 × 50.2 × 26.7 cm
(27½ × 19¾ × 10½ in.)
Socle: 12 × 22.2 cm
(4¾ × 8¾ in.)
88.SA.114

In contrast to the stereotypical "blackamoor" busts produced in the eighteenth century, this work portrays a specific individual and therefore ranks as one of the earliest European sculpted portraits of a black man. Very little is known of the artist's training. By 1748 he had moved from England to Florence, where he became one of the major sculptors for English aristocrats visiting that city on the Grand Tour. Harwood's classicizing style is rarely as distinguished as it is in this beautiful and powerful portrait.

HERM OF A
VESTAL VIRGIN

1821–22
Antonio Canova
Italian, 1757–1822
Marble
49.8 × 31.9 × 24.1 cm
(19⅝ × 12⁹⁄₁₆ × 9½ in.)
85.SA.353

Conceived as one of Canova's "ideal heads," this work is one of three versions the sculptor is recorded to have carved. This version is purported to have been executed by 1822 for a Neapolitan patron, Cavalier Paolo Marulli d'Ascoli. In the series of ideal heads (or *teste ideali*, as Canova termed them), which also included depictions of mythological, historical, literary, and allegorical personae, the sculptor refined his portrayal of ideal female beauty. The notion of perfection was especially appropriate for the representation of a vestal virgin, since her status as a priestess of the goddess Vesta required her to be chaste and pure of mind and body. This subject became popular in eighteenth- and nineteenth-century art in response to the excavation of the House of the Vestals at Pompeii.

CHANDELIER

French (Paris),
circa 1818–20
Gérard-Jean Galle,
1788–1846
Gilt bronze; enameled
metal; glass
H: 129.5 cm (51 in.)
DIAM: 96.5 cm (38 in.)
73.DH.76

The design of this chandelier resembles a hot-air balloon, such as was launched by the brothers Joseph-Michel and Jacques-Étienne Montgolfier from the grounds of the Château de Versailles in 1783. The large blue enameled globe at the center of the chandelier is painted with gold stars and encircled by a gilt-bronze band fitted with the signs of the zodiac; six of the eighteen candleholders are in the form of winged griffins. When the chandelier was displayed in an 1819 Paris exhibition, Galle described how the glass bowl suspended below was intended to contain goldfish swimming in water. The continuous movement of the fish was meant to give "agreeable recreation to the eye."

PAIR OF CANDLESTICKS

Circa 1830–40
Filippo Pelagio Palagi
Italian, 1775–1860
Gilt and chased bronze
Each, 90.2 × 43.2 × 22.9 cm
(35½ × 17 × 9 in.)
85.DF.22.1.–.2

Architect, portrait painter, furniture designer, orna-
mentalist, and collector, Filippo Pelagio Palagi worked
early on in Rome, where he developed an interest in
archaeology, from then on a characteristic of his
work. This interest coincided with the concurrent
Empire style, which was being diffused throughout
Italy by the Bonaparte courts. Palagi designed these
candlesticks about the time that he was commissioned
by Carlo Alberto, duke of Savoy and king of Sardinia,
to redecorate the Royal Palace in Turin. Their soph-
isticated yet inventive form—with extremely fine
classical ornament and winged Victories that seem to
hold the candle sockets while airborne—is in keep-
ing with the king's taste as reflected in his redecorat-
ing projects.

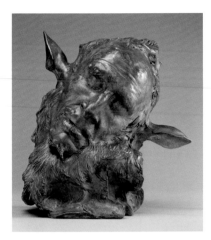

Self-Portrait as Midas (also called Sleeping Faun)

1885(?)
Jean-Joseph Carriès
French, 1855–1894
Painted plaster
34.5 × 34 × 23.5 cm
(13 9/16 × 13 3/8 × 9 1/4 in.)
98.SE.8

Adolescent I

Circa 1891
George Minne
Belgian, 1866–1941
Marble
43 × 33.5 × 14.3 cm
(16 15/16 × 13 3/16 × 5 5/8 in.)
97.SA.6

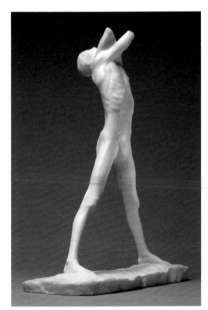

During the last two decades of the nineteenth century, such artists as Carriès and Minne took part in a movement known as Symbolism, which flourished in European art and literature. Rejecting the literal representation of nature that was central to contemporary academic and Impressionist art, Symbolists sought instead to depict an inner world of intuition, spiritualism, and imagination. In the era of Sigmund Freud, Symbolist artists strove to see beyond superficial appearance and to imbue art with a deeper psychological significance and reality. Carriès uses traditional imagery to depict himself as the foolish mythological king Midas, while Minne adopts a novel and striking pose to convey the angst of adolescence. Asserting emotion over reason and the individual over social conformity, Symbolist artists responded to the anxiety of an age approaching the turn of the century.

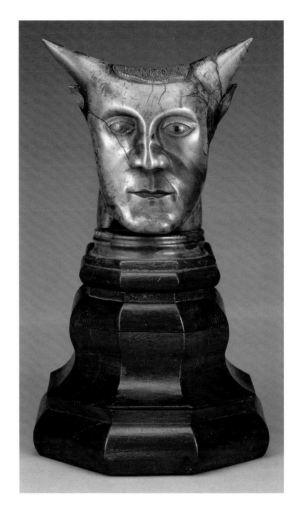

HEAD WITH HORNS

1895–97
Paul Gauguin
French, 1848–1903
Wood with traces of
polychromy
Head: 22 × 22.8 × 12 cm
(8¹¹/₁₆ × 9 × 4¾ in.)
Base: 20 × 25 × 17.5 cm
(7⅞ × 9⅞ × 6⅞ in.)
2002.18

Long thought to be lost, Gaugin's *Head with Horns* was known only from two photographs that he had pasted into his personal copy of "Noa Noa," a manuscript written by Gaugin in collaboration with the poet Charles Morice and illustrated between 1896 and 1898. Untitled and not referred to in the text, this sculpture has eluded precise interpretation. In his search for an unspoiled, natural, and "primitive" artists' community, Gauguin found his way to Tahiti in the early 1890s. He was dismayed to find that European colonization was corrupting the indigenous culture, and he sought to reverse it.

In European art, a horned head is often associated with images of the devil or of various animals or mythological creatures such as a faun, a bull, or Pan; thus, here it may be an expression of Gauguin's negative feelings toward the colonists. In the Polynesian islands, however, the horns of this sculpture resemble a style of hair—bunched in knots at either side of the head—worn by young men as an expression of power. A third interpretation is that the sculpture is a self-portrait of Gauguin as a "savage" with a broad, Polynesian nose: a presentation of himself as indigenous and untouched by civilizing influences. His synthesis of religious, political, ancient, and modern themes produced an enigmatic and captivating piece.

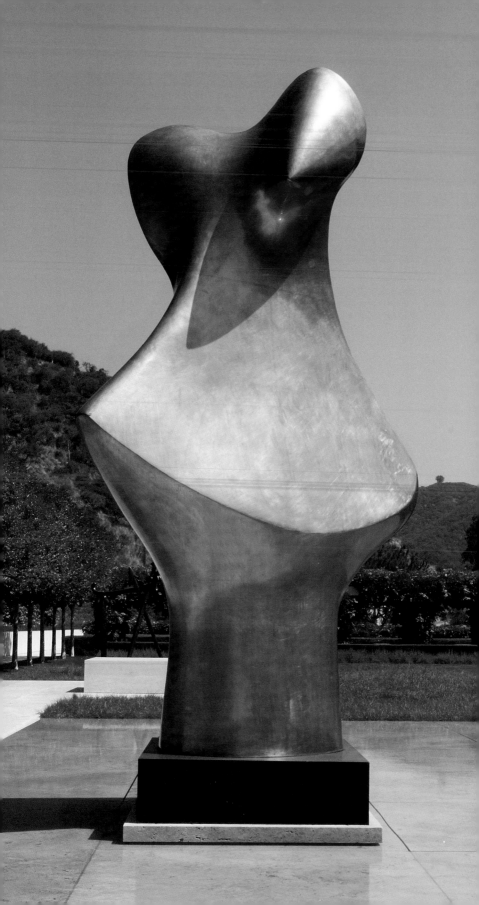

The Fran and Ray Stark Sculpture Collection

THE TWENTY-EIGHT TWENTIETH-CENTURY sculptures that constitute the Fran and Ray Stark Sculpture Collection were generously donated to the J. Paul Getty Trust by the Trustees of the Fran and Ray Stark Revocable Trust and are installed throughout the Getty Center site in the city where the Starks made their home for more than sixty years. Many of the century's foremost sculptors are represented, including Alexander Calder, Alberto Giacometti, Barbara Hepworth, Ellsworth Kelly, Roy Lichtenstein, Aristide Maillol, Joan Miró, Henry Moore, and Isamu Noguchi. Integrated with the environment and architecture of the site, these sculptures are an impressive addition to Richard Meier's celebrated design and are a rich complement to the renowned collections of the J. Paul Getty Museum.

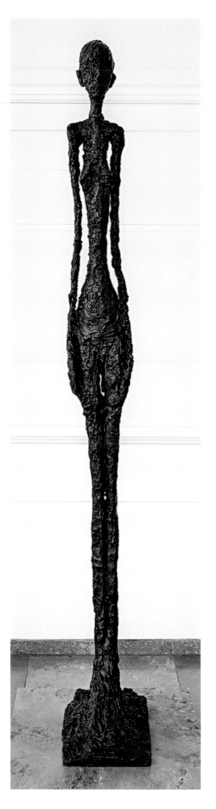

ALBERTO GIACOMETTI

Swiss, 1901–1966
Femme Debout I
(Standing Woman I), 1960
Bronze, edition 4 of 6
266.7 × 34.3 × 54.3 cm
(9 ft. 9 in. × 13½ × 21⅜ in.)
2005.107, Gift of Fran
and Ray Stark

Alberto Giacometti's most recogniz-
able works are tall, thin figural
sculptures, which he produced after
World War II. The style of *Femme
Debout I* is typical of his female fig-
ures: attenuated, lanky, and rigidly
frontal, with a rough surface and
large, firmly anchored feet. An obses-
sive perfectionist, Giacometti would
carve and pick away at his sculptures
until only a gaunt rough-hewn shape
remained. The highly textured sur-
face and uncomfortable posture can
be attributed to Giacometti's feelings
about the war, violence, and sexual-
ity—common themes explored in
Surrealism. The figure is inaccessible
and withdrawn, conveying a fragile
and frail human presence.

 Femme Debout I was conceived as
one of a set of four similar sculp-
tures that were intended for the plaza
of the Chase Manhattan Bank in
New York but were never installed.

BARBARA HEPWORTH

British, 1903–1975
Figure for Landscape, 1960
Bronze, edition 7 of 7
271.8 × 132.1 × 68.65 cm
(107 × 52 × 27 in.)
Base: 8.9 × 66 × 68.6 cm
(3½ × 26 × 27 in.)
2005.108, Gift of Fran
and Ray Stark

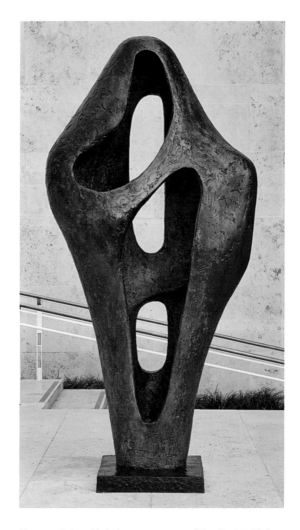

Hepworth is widely known as one of the first British
sculptors to produce abstract, as opposed to figural or
representational works. She believed that art should
be enjoyed for the sake of its shape; hence the decid-
edly abstract and free-form style of *Figure for Land-
scape*. As with many of Hepworth's sculptures, *Figure*
was inspired by natural forms and was conceived to
fit in an outdoor, public ambience. The inner, con-
cave space of *Figure* was a recurrent element in Hep-
worth's style and exemplifies maternal protectiveness.
Additionally, the inner space is sometimes thought
to echo the rhythmic and sloping qualities of an ocean
inlet or cove, while the large and majestic overall
form is reminiscent of Neolithic, wave-worn rocks.

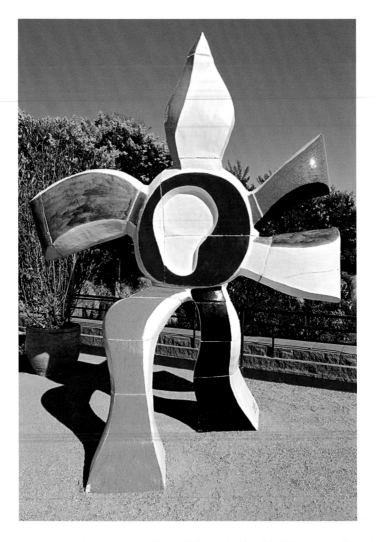

FERNAND LÉGER

French, 1881–1955
*La Grande Fleur qui marche
(Large Walking Flower),*
designed 1952–53,
cast 1982–83
Glazed ceramic,
edition 3 of 4
312.4 × 137.2 × 167.6 cm
(123 × 54 × 66 in.)
Base: 20.3 × 167.6 × 144.8
cm (8 × 66 × 57 in.)
2005.110, Gift of Fran
and Ray Stark

Toward the end of his life, Léger, an influential Cubist
painter, began to create his first ceramic sculptures,
such as this one, many of which were based on imag-
ery from his earlier paintings. In fact, the *Walking
Flower* motif can be seen in several of his paintings
from the late 1930s, the only difference being the
ceramic's more vivid and purer colors, a feature he
explored in many of his later works. Léger made
several versions of *Walking Flower*, all of which vary
in size and color while retaining the same vivacious
and approachable presence. Like Barbara Hepworth's
Figure for Landscape (p. 277), Léger intended this
piece to be displayed outside in a public space, where
the shape and colors would interact with its surround-
ings. *Walking Flower* is certainly one of his most
popular works, and reproductions of it can be found
worldwide.

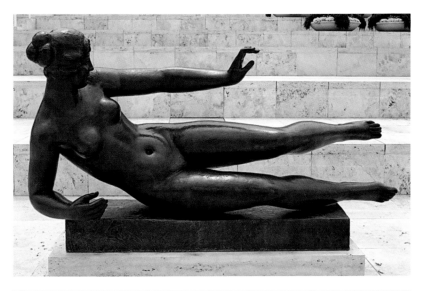

ARISTIDE MAILLOL

French, 1861–1944
L'Air (*Air*), designed 1938,
cast 1962
Lead, 1 of 2 artist's proofs
129.5 × 233.7 × 86.4 cm
(51 × 92 × 34 in.)
Base: 20.3 × 176.5 × 45.7 cm
(8 × 69½ × 18 in.)
2005.113.1, Gift of Fran
and Ray Stark

A well-known and accomplished French painter, tapestry designer, draftsman, and sculptor, Maillol was commissioned to sculpt *L'Air* in 1938 by the city of Toulouse to memorialize pilots killed in the line of duty for L'Aeropostale, France's first airmail service. While he did not seek to imitate classical models, Maillol's choice of subject was most often a nude female figure reminiscent of Greek and Roman nudes. The soft curves and sensuality of the work reflect Maillol's appreciation for and admiration of the female body. The woman appears caught by a gentle gust of wind and gracefully surrenders her limbs to the breeze, as her body elevates slightly.

HENRY MOORE

British, 1898–1986
Seated Woman, 1958–59,
cast 1975
Bronze
203.2 × 101.6 × 129.5 cm
(80 × 40 × 51 in.)
2005.117.3, Gift of Fran
and Ray Stark

Seated Woman represents Henry Moore's untiring
interest in mature womanhood and female fertility.
She evokes the ancient figure of the *Venus of Willen-
dorf*: both women's bulbous, volumetric bodies
suggest a maternal figure of protectiveness and safety.
Moore intended his abstract works to prompt study
and thought, never revealing the complete story
at first glance. He used the lost-wax method to cast
this monumental bronze, achieving a dynamic work
that is simultaneously serene and visceral.

ALEXANDER CALDER

American, 1898–1976
Spiny Top, Curly Bottom, 1963
Painted steel
226.1 × 149.9 × 139.7 cm
(89 × 59 × 55 in.)
2005.104.1, Gift of Fran
and Ray Stark

Spiny Top, Curly Bottom was made from five pieces
of machine-cut steel, welded together and painted
Calder's trademark red. It is one of Calder's stabiles—
completely stationary abstract forms. Though Calder
is often admired for his mobiles, which are kinetic
and easily moved to rotation by the wind, the stabiles
are notable for their stability, without the need
for a base or support. This strength, contrasted with
its elegance, is one of the allures of the *Spiny Top,
Curly Bottom*.

Photographs

I N MID-1984 THE MUSEUM ESTABLISHED a new curatorial department dedicated to the art of photography. The opportunity to acquire several of the most important private collections of photographs in the world may be compared to the establishment of the Department of Manuscripts through the acquisition of the finest gathering of illuminated manuscripts then in private hands. The Museum decided to form a photography collection for reasons similar to those advanced in favor of collecting manuscripts and drawings: photography is an art fundamental to its time in which individual works of great rarity, beauty, and historical importance have been made.

Among the collections acquired in their entireties were those of Samuel Wagstaff, Arnold Crane, Bruno Bischofberger, and Volker Kahmen/George Heusch. The gathering of these collections, along with other block acquisitions made at the same time (including a substantial proportion of the collection of André Jammes) and a continuing program of individual acquisitions, has brought to Los Angeles the most comprehensive corpus of photographs on the West Coast.

The photographs reproduced in the *Handbook* represent a survey of some of the strengths of the collection, which is particularly rich in examples dating from the early 1840s and which includes major holdings by William Henry Fox Talbot, David Octavius Hill and Robert Adamson, Hippolyte Bayard, and other early practitioners in England (in the circle of Talbot) and in France. The collection also includes significant works by some of the most important photographers of the first half of the twentieth century. International in scope, its guiding principle is the belief in the supremacy of certain individual master photographers and in the timeless importance of individual master photographs.

For conservation reasons, photographs, like manuscripts and drawings, cannot be kept on permanent display. The collection is available to the public by appointment, and rotating exhibitions from the collection are shown in the photographs galleries at the Museum.

CHARLES R. MEADE

American, 1826–1858
*Portrait of Louis-Jacques-
Mandé Daguerre*, 1848
Half-plate daguerreotype
16 × 12 cm
(6 5/16 × 4 13/16 in.)
84.XT.953

One of the unresolved mysteries in the history of photography is why Daguerre, who was a painter, became interested in light-sensitive materials about 1824. By 1829 he had formed a partnership with Nicéphore Niépce, who had successfully worked with sensitized metal plates. By New Year's Day, 1840, just four months after the first daguerreotype was exhibited in Paris, Daguerre's instruction manual had been translated into at least four languages and printed in at least twenty-one editions.

The daguerreotype was enthusiastically accepted in the United States. Charles R. Meade was the proprietor of a prominent New York photographic portrait studio. He made a pilgrimage to France in 1848 to meet the founder of his profession, and while there, he became one of the few people to photograph Daguerre.

UNKNOWN
AMERICAN
PHOTOGRAPHER

Edgar Allan Poe,
late May–early June 1849
Half-plate
daguerreotype
12.2 × 8.9 cm
(4¹³⁄₁₆ × 3½ in.)
84.XT.957

For reasons that are unclear, few daguerreotypes
of notable poets, novelists, or painters have survived
from the 1840s, and some of the best we have are
by unknown makers, as is the case with the Getty *Poe.*

Four of the eight times that Poe is known to have
been photographed occurred within the last year
of his life. This portrait was presented by him to
Annie Richmond, one of two women to whom he made
romantic declarations in the months following the
death of his wife. Poe, who has been described as
a libertine, a drug addict, and an alcoholic, is repre-
sented here as a man whose haunted eyes and dishev-
eled hair reveal the potential for mercurial emotions.

WILLIAM HENRY FOX TALBOT

British, 1800–1877
Oak Tree in Winter,
most likely 1842–43
Salted paper print
from paper negative
19.4 × 16.6 cm
(7 ⅝ × 6 ⁹⁄₁₆ in.)
84.XM.893.1

Talbot's most important invention was one that is easily taken for granted today: the negative from which faithful replicas can be produced. He patented his procedure, which came to be known as the calotype process. He intended his invention to be clearly distinguished from the daguerreotype. Daguerre's procedure resulted in pictures on metal plates that could not be multiplied easily. Daguerreotypes were used almost exclusively for studio portraiture, as sitters generally required but a single example, while calotypes required less-fussy procedures and therefore were favored when a particular subject had an audience of more than one. There is no known early daguerreotype of a single tree. Yet trees were a favorite subject for photographers who were influenced by the aesthetic of picturesque romanticism evident in Talbot's treatment of this image.

HIPPOLYTE BAYARD

French, 1801–1887
Arrangement of Specimens
(from Bayard Album),
circa 1842
Cyanotype
27.7 × 21.6 cm
(10¹⁵⁄₁₆ × 8½ in.)
84.XO.968.5

Bayard occupies a position in the shadow of his fellow countryman Daguerre, and also of Talbot, from whom he learned some important techniques. Neither an inventor nor a follower, he was a satellite in the sphere of invention. Bayard was introduced to the work of Sir John Herschel and Talbot and soon abandoned his own direct-positive-on-paper prints in favor of Herschel's cyanotype and Talbot's calotype processes. Talbot was fascinated with nature's power to give form, while Bayard's arrangement of specimens seems to say that nature's design is elevated to a higher power by an organizing human intelligence. Both men proved that the choice of subject is fundamental to the art of photography.

ANNA ATKINS
AND ANNE DIXON

British, 1799–1871;
1799–1877
*Cypripedium (Pink Lady's
Slipper),* 1854
Cyanotype
25.9 × 20.2 cm
(10³⁄₁₆ × 7¹⁵⁄₁₆ in.)
84.XP.463.3

Atkins was the first woman to create an extensive body of photographic work. She came to the new medium through her father, John George Children, who presided over a February 1840 meeting of the Royal Society at which Talbot disclosed the workings of the positive-negative process. Children's friend Sir John Herschel instructed Atkins in the production of cyanotypes. Atkins combined Herschel's and Talbot's methods to create a visual lexicon of British ferns, algae, and plants, arranging her specimens in contact with light-sensitive paper and exposing the sheets to achieve cameraless negatives. From these negatives, editions of positive cyanotype prints were made.

**DAVID OCTAVIUS
HILL AND
ROBERT ADAMSON**

Scottish, 1802–1870;
1821–1848
James Linton, 1843–47
Salted paper print
20.2 × 14.6 cm
(7 $^{15}/_{16}$ × 5 $^{3}/_{4}$ in.)
84.XM.445.1

Hill brought his abilities as a portrait painter to the partnership in photography he formed with Adamson in 1843. Adamson brought his skills in the manipulation of the calotype process, which he had learned indirectly from its inventor, William Henry Fox Talbot. In the four years before Adamson's death, the partners produced the first corpus of photographs made as art rather than experiment. Their prints are characterized by a Rembrandtesque chiaroscuro in tonalities enhanced by gold chloride, which also gave the prints permanence.

JOSEPH-PHILIBERT
GIRAULT
DE PRANGEY

French, 1804–1892
*Temple of Hercules,
Rome*, 1842
Panoramic daguerreotype
9.4 × 24 cm
(3 ¹¹/₁₆ × 9 ⁷/₁₆ in.)
2003.82.1

Girault de Prangey, an excellent draftsman and lithographer, exhibited and published drawings and plans of Moslem architecture from Spain and North Africa. He learned to make daguerreotypes in 1841 from an unknown photographer, but probably an associate of Daguerre's. After practicing in Paris and near his home in Langres, he began an extended and difficult three-year trip through Italy, Egypt, Syria, Palestine, Turkey, and Greece, recording monuments of antiquity and Islamic architecture. The nearly two thousand images he made are the largest extant body of work by a single daguerreotypist and the first significant photographic work to be made by a classically trained artist. They are often the earliest surviving photographs of the most important sites of the classical world and are characterized by his innovative use of formats specifically shaped to suit his subjects and his careful choices of viewpoints and times of day. His view of the Temple of Hercules on the banks of the Tiber skillfully shows its circle of columns thrown into high relief by gradations of shading, as if revolving into the light, like a carousel, and minimizing the presence of its later roof. Traditionally known as the Temple of Vesta, it has recently been discovered to have been originally dedicated to Hercules.

JOHN PLUMBE, JR.

American (b. Wales),
1809–1857
The United States Capitol,
1846
Half-plate daguerreotype
8.9 × 11.9 cm (3½ × 4¹¹⁄₁₆ in.)
96.XT.62

Plumbe's 1846 view of the east front of the United States Capitol is one of three that he made of the building, as part of a pioneering series documenting the principal buildings of Washington, which were then few in number. Although the building he shows is comparatively simple in contrast with the present-day behemoth on the site, it had already had four architects: William Thornton, Benjamin Henry Latrobe, Charles Bulfinch, and Robert Mills. The dome is the work of Bulfinch, whose commission was the result of his earlier success with the Boston State House. The wings at the end of the building, which were the original chambers of the House of Representatives and the Senate, now serve as ante-chambers that connect the present chambers with the central rotunda and its dome. This is the only view that Plumbe made of the building in which the White House is visible in the distance and is the only picture of any kind before 1900 that includes both monuments.

NADAR (GASPARD-FÉLIX TOURNACHON)

French, 1820–1910
Self-Portrait, circa 1855
Salted paper print
20.5 × 17 cm
(8¹⁄₁₆ × 6¹¹⁄₁₆ in.)
84.XM.436.2

Before he dedicated himself to photography in the early 1850s, Nadar was—as he tells us in his autobiography—a poacher, a smuggler, a bureaucratic functionary, and a fighter for the cause of Polish liberation. *Nadar* was the nickname Gaspard-Félix Tournachon used in the 1840s to sign his stinging lithographic caricatures. While his drawings depended on bold exaggeration for their success, his photographs are marked by a spontaneous naturalism. Here, gentle light falls from above, leaving the right side of his face in partial darkness. His deeply shadowed eyes gaze at the observer, as though the camera did not exist, and his hands are equally expressive.

JULIA MARGARET CAMERON

British, 1815–1879
Ellen Terry at Age Sixteen,
negative, 1864; print,
circa 1875
Carbon print
DIAM: 24.1 cm (9½ in.)
86.XM.636.1

Cameron is renowned for her portraits of famous men such as Carlyle, Tennyson, and Herschel. This image of Ellen Terry, however, is one of her few known photographs of a female celebrity. Terry, the popular child actress of the British stage, was sixteen years old when Cameron photographed her. She had just married an eccentric painter, George Frederic Watts, who was thirty years her senior and an artistic mentor to Cameron. The ill-fated union lasted less than a year.

Cameron's portrait echoes Watts's study of Terry entitled *Choosing* (1864). Here, as in the painting, Terry is shown in profile with her eyes closed, an ultrafeminine, ethereal beauty in a melancholic dream state. In this guise she embodies the Pre-Raphaelite ideal of womanhood rather than the wild, boisterous teenager she was known to be. Terry's enchanting good looks, if not her personality, suited this ideal perfectly. The round format of the photograph (referred to as a tondo in painting) was popular among Pre-Raphaelite artists.

ALEXANDER GARDNER

American, 1821–1882
Lincoln on the Battlefield of Antietam, Maryland, 1862
Albumen silver print
21.9 × 19.7 cm (8⅝ × 7¾ in.)
84.XM.482.1

After the Second Battle of Bull Run, Robert E. Lee crossed the Potomac River in early September 1862 to occupy positions in Maryland and Virginia. The invasion was checked at Antietam by the forces of General George McClellan, whose failure to pursue Lee back across the river after the battle cost him his job.

Lincoln was the first American president to make time in his schedule to be photographed. Here we see him conferring with Major General John McClernand and Major Allan Pinkerton, who organized an espionage system behind Confederate lines. The genius of this photograph lies in Gardner's skillful composition built around the visual details of camp life. The tent and tent lines dominate. The eye is thus drawn equally to the fastenings on the lines and the faces of the principals. Despite compositional interruptions, the imposing figure of Lincoln remains the center of interest.

GUSTAVE LE GRAY

French, 1820–1884
*Cavalry Maneuvers,
Camp at Châlons*, 1857
Albumen silver print
31 × 36.7 cm
(12³⁄₁₆ × 14⁷⁄₁₆ in.)
84.XO.377.12

Le Gray was a seasoned landscape and portrait photographer. In 1857 Napoleon III commissioned him to commemorate the inauguration of, and chronicle life in, the vast military camp established that year on the plain at Châlons-sur-Marne. Designed to accommodate twenty-five thousand imperial guards and staff, the camp sprawled over thirty thousand acres of mostly flat terrain. This series of photographs consists of images of cavalry exercises on a grand scale and includes genre studies of troops in bivouac, formal portraits of officers, records of ceremonies (including High Mass), and multipart overall panoramas of the camp as seen from the emperor's central pavilion. In this photograph, lines of cavalry behind a field bulwark are cloaked in an atmospheric mist new to photography. They occupy a narrow band across the center of the picture, leaving a great empty swath of pale sky and a dark, nearly vacant foreground. Le Gray romanticizes the scene by miniaturizing the figures—a practical necessity to mitigate the blurring effect caused by men and horses in action.

HENRI-VICTOR REGNAULT

French, 1810–1878
Sèvres, the Seine at Meudon,
negative, circa 1853;
print, 1855–60
Carbon print by
Alphonse-Louis Poitevin
(French, 1819–1882)
31.1 × 42.7 cm
(12¼ × 16¹³⁄₁₆ in.)
92.XM.52

Regnault, a professor of physics at the Collège de France, where he performed classic experiments in thermodynamics and the properties of gases, obtained samples of Talbot's calotype printing papers from Jean-Baptiste Biot. Biot was the chief advocate of Talbot's method in France, and Regnault's good luck may have resulted from the meeting between Talbot and Biot in Paris in 1843. By 1852, the year before this negative was made, Regnault had become director of the porcelain factory at Sèvres and was hopeful that photographs could be as permanent as painted porcelain.

Regnault experimented with different printmaking processes, including Alphonse Poitevin's carbon ink process, which was related to lithography. This unusual collaboration between Regnault, who created this image with a waxed-paper negative, and Poitevin, who made the carbon print using the process he invented, is a benchmark in the history of the photomechanical printing of photographs.

This scene is an important complement to Silvy's *River Scene—La Vallée de l'Huisne* (see facing page), where a similar interest in idyllic landscape composition related to the Barbizon School and early Impressionist painting is evident.

CAMILLE SILVY

French, 1834–1910
*River Scene—La Vallée de
l'Huisne*, negative, 1858;
print, 1860s
Albumen silver print
25.7 × 35.6 cm (10⅛ × 14 in.)
90.XM.63

Silvy, who lived and worked in France and England in
the 1850s and 1860s, is best known to the twentieth
century through his *River Scene*. Inspired by paintings
of the Barbizon School, Silvy's four versions of this
subject each show a different treatment of sky and
atmosphere, changes that were achieved by utilizing
multiple negatives and different toning methods.
He appears to have created two master negatives, one
for the clouds and the other for the landscape. Some
prints, including this one, may have been copied from
the originals using skillfully made paper negatives
that introduced a grainy image structure. This print
was perhaps made in the 1860s, when the Barbizon
School was giving way to Impressionism.

ROGER FENTON

British, 1819–1869
Pasha and Bayadère, 1858
Albumen silver print
45 × 36.2 cm
(17¹¹⁄₁₆ × 14¼ in.)
84.XP.219.32

Even though his career as a photographer lasted only ten years, Fenton had a strong impact on the history of the medium. A founder of what became the Royal Photographic Society, Fenton is best known for his images of the Crimean War, which were among the earliest photographic war reportage. He also made photographs that represent fictional situations.

He often drew inspiration from painting, which he studied before turning to photography. In creating this image Fenton looked to the Orientalist works of, among others, Eugène Delacroix. These European depictions of the Islamic world were romanticized inventions rather than accurate representations of Middle Eastern life. Fenton's imaginary harem scene was staged in his London studio with his friends as models. The dancer's graceful pose was achieved with the aid of wires.

OSCAR GUSTAVE REJLANDER

British (b. Sweden),
1813–1875
*The Infant Photography
Giving the Painter an
Additional Brush*, circa 1856
Albumen silver print
6 × 7.1 cm (2⅜ × 2¹³⁄₁₆ in.)
84.XP.458.34

Rejlander's allegory of painting is one of the most
direct treatments by a photographer in the 1850s of
the interaction between painting and photography.
His title for this image refers to the idea that an artist
could use photographs of posed models as preparatory
studies for paintings. The photograph is also a clever
self-portrait, with the artist's own silhouette reflected
in a parabolic mirror. Like Fenton, Rejlander had
been trained as a painter, and both this allegory and
Fenton's tableau on the facing page reflect the efforts
of British photographers of the period to make the
new art of photography more closely resemble the
traditional art of painting by adopting similar kinds of
subject matter and pictorial tactics, which both media
would share for the rest of the century. For artists
the camera miraculously enabled them to shorten the
time between perceiving a scene and recording it in
enormous detail.

CARLETON WATKINS

American, 1829–1916
*Cape Horn,
Columbia River, Oregon,*
negative, 1867;
print, circa 1881–83
Albumen silver print by
Isaiah West Taber
40.5 × 52.3 cm
(15 ¹⁵⁄₁₆ × 20 ⁹⁄₁₆ in.)
85.XM.11.2

While his Eastern contemporaries—Gardner and O'Sullivan—photographed the Civil War, Watkins, who ranks among the greatest American photographers, had the leisure in the tranquil West to ripen his style to full maturity between 1861 and 1868. He had the gift of creating complex compositions from very simple motifs and the power of perception to apprehend ephemeral forces in nature that comprise a seamless web of formal relationships. The three key elements of this picture are the massive rock formations, the transient quality of the boat loaded with a box of enormous fruit, and the delicacy of the light reflected from the water's surface.

Watkins designed photographs brilliantly to achieve a painterly interplay between surface pattern and spatial dimensions. The network of intricately connected compositional elements is chiefly responsible for this picture's palpable sense of space and is typical of this concern. His photographs were used as references by painters such as Thomas Hill and Albert Bierstadt.

Watkins was an excellent technician in a variety of materials. He frequently made stereographs (a pair of identical miniature photographs), which functioned for him as a sketching medium. After visualizing his subject, he would proceed to make mammoth-plate negatives that yielded his celebrated presentation prints.

TIMOTHY O'SULLIVAN

American, circa 1840–1882
*Desert Sand Hills near Sink
of Carson, Nevada*, 1867
Albumen silver print
22.4 × 29 cm
(8¹³⁄₁₆ × 11⁷⁄₁₆ in.)
84.XM.484.42

While employed by Alexander Gardner beginning in 1862, O'Sullivan was present at most of the chief military engagements of the Civil War, from the Second Battle of Bull Run to Appomattox. When Gardner published his *Photographic Sketch Book of the War* in 1866, forty-five of the one hundred photographs were by O'Sullivan—many of them simultaneously social documents and landscape compositions.

O'Sullivan left Gardner in 1867 to join the newly formed Fortieth Parallel Survey, the first federal exploring party in the West after the Civil War. O'Sullivan was allowed to roam the wilderness apart from the main party in order to prospect for motifs that would fulfill the survey's scientific needs. We see here a kind of self-portrait showing the wagon that served as his rolling darkroom, pulled by four mules, positioned on a hill of windblown sand near the Carson Sink, a shallow marshy region in western Nevada. The wagon has just made a U-turn, and the viewer sees the footprints leading from the vehicle to the spot where O'Sullivan erected his camera to compose this heroic image of exploration and discovery.

P. H. EMERSON

British, 1856–1936
Gathering Water Lilies, 1886
Platinum print
19.8 × 29.2 cm
(7¹³/₁₆ × 11½ in.)
84.XO.1268.10

"Wherever the artist has been true to nature, art has been good. Whenever the artist has neglected nature and followed his imagination, there has resulted bad art," Emerson wrote. He called his aesthetic position Naturalism, and his preferred mode of presentation was the album or book, in which texts could accompany the photographs. One of his most important albums, *Life and Landscape of the Norfolk Broads*, was issued as a limited edition of carefully printed platinum photographs, mounted by hand onto pages, where *Gathering Water Lilies* was first seen. Emerson achieved compositional unity out of a great variety of competing elements that include distracting reflections of light off the water, the foreground branches, and the randomness of the lily pads and the river grasses. The composition is highly intuitive and yet admits to analysis. The structure of the photograph is built upon the diagonal axes that move corner to corner, from the bow through the stern of the wherry, and toward the opposite corners through the oars intersecting at the man's left hand, which is the center of the image. The point of sharpest focus is at the surface of the woman's hat; its concentric circles of braided straw echo the circular field of focus established by the physics of lenses. "The image which we receive by the eye is like a picture minutely and elaborately finished in the center, but only roughly sketched in at the borders," Emerson wrote. This composition binds tender emotion to aesthetic form with poetic simplicity.

THOMAS EAKINS

American, 1844–1916
*Eakins's Students at the Site
for "The Swimming Hole,"*
1884
Albumen silver print
9.3 × 12.1 cm
(3¹¹⁄₁₆ × 4¹³⁄₁₆ in.)
84.XM.811.1

Photography was invented just when painters seemed to require a new way of seeing the world. Although many nineteenth-century painters dabbled in photography, very few carried their experiments far enough to produce a significant corpus of work. Two painters who did, and who are still universally respected, were Thomas Eakins and Edgar Degas (see p. 304).

Eakins began to photograph in the late 1870s. Interested in the poses and gestures of static nude figures, he made this study of seven young men at a swimming hole about 1884. Male nudes were then very uncommon in photography, and Eakins was among the first to experiment with this subject. His models were students at the Pennsylvania Academy of the Fine Arts, which censured him for this practice. Eakins's painting *The Swimming Hole,* now in the Amon Carter Museum, Fort Worth, was created from sketches based on these photographs; it is probably the most famous nineteenth-century painting known to have been based on a photograph.

EDGAR DEGAS

French, 1834–1917
*After the Bath, Woman
Drying Her Back*, 1896
Gelatin silver print
16.5 × 12 cm (6½ × 4¹¹⁄₁₆ in.)
84.XM.495.2

Degas was an inveterate experimenter in the graphic arts, creating major works in monotype, drawing, etching, and lithography before turning his talents to photography between 1894 and 1896. However, twenty-five years before, at about the time he first met Nadar, Degas used carte-de-visite photographs as the sources for several portraits. In 1874 he drew a pastel of a dancer posing in a photographer's studio, which led to his 1896 study of a model drying herself after her bath. The movement shown here is complex and contorted, almost acrobatic. The photograph is related to a startling, almost voyeuristic series of Degas's drawings devoted to the motions of women dressing, bathing, and twisting their bodies while drying themselves.

FREDERICK H. EVANS

British, 1853–1943
Kelmscott Manor:
In the Attics (No. 1), 1896
Platinum print
15.6 × 20.2 cm
(6⅛ × 7¹⁵⁄₁₆ in.)
84.XM.444.89

Evans found poetic and artistic inspiration in the architecture of the past, particularly by the nearness of the designer-craftsman of the Middle Ages to his product and by the essential equality of craftsmen to each other. In 1896 Evans visited the home of William Morris, the proselytizing medievalist. Kelmscott Manor dates from 1280 and is highly representative of the medieval manor house, an institution in which the role of the craftsman was central to all of everyday life. Evans methodically recorded the exterior and interior (including the attics) and selected decorations.

Evans photographed architecture and its ornaments using a vocabulary of light, volume, and texture. In this photograph he isolated the intersecting network of posts and beams, choosing his point of view carefully so as to make clear that they were carved by hand out of the trunks and branches of trees. Almost a decade later, Evans wrote that he hoped people would exclaim upon seeing his photographs, "What a noble, beautiful, fascinating building that must be, and how priceless an art is that sort of photography that can so record one's emotional rapprochement to it!" In focusing his attention on the details of architecture, Evans proved that a photographer could join in a single artistic temperament the classic and the romantic, the linear and the painterly, the objective and the abstract.

ALFRED STIEGLITZ

American, 1864–1946
*Georgia O'Keeffe:
A Portrait,* June 4, 1917
Platinum-palladium print
24.4 × 19.5 cm
(9⅝ × 7¹¹⁄₁₆ in.)
91.XM.63.3

A catalyst for Stieglitz was Georgia O'Keeffe, a young painter whose art and personal style influenced him and his circle enormously. She was living in New York during the first half of 1916 and was included in a group exhibition at Stieglitz's gallery. Toward the end of the exhibition she visited the gallery for the first time, appearing "thin, in a simple black dress with a little white collar [and with] a sort of Mona Lisa smile," as Stieglitz recalled. This study was among the first of a series that eventually amounted to more than 325 photographs of O'Keeffe that probed different aspects of her persona. Hands are an important motif in the series. Here, Stieglitz shows us hands that shape art, and he challenges us to imagine how they could also stroke and caress, grasp and hold, or scratch and claw. In visual language they stand for everything in nature that is subject to change.

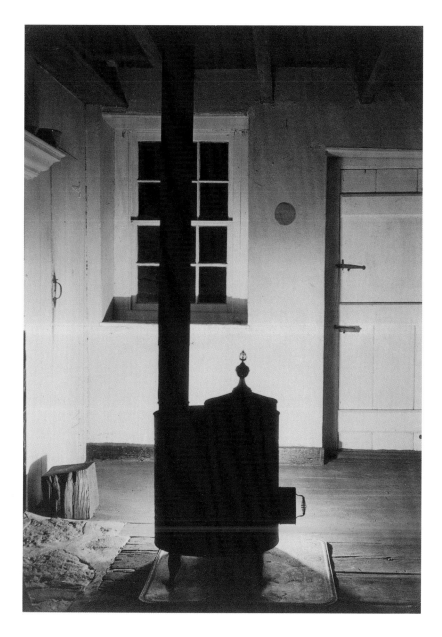

**CHARLES
SHEELER**

American, 1883–1965
*Doylestown House—
The Stove*, 1917
Gelatin silver print
22.9 × 16.2 cm (9 × 6⅜ in.)
88.XM.22.1

This photograph displays a concern for the symbolic value of pure light, along with the status of the found object in the spirit of Duchamp. The interior is photographed at night, with a single source of artificial light blasting from the belly of the stove via the electric bulbs that had recently come into use by photographers. Sheeler reconciles the perennially opposing forces of light and dark, of mass and line, and of nostalgia and modernity. "[The photographs are] probably more akin to drawings than to my photographs of paintings and sculptures," wrote Sheeler to Stieglitz.

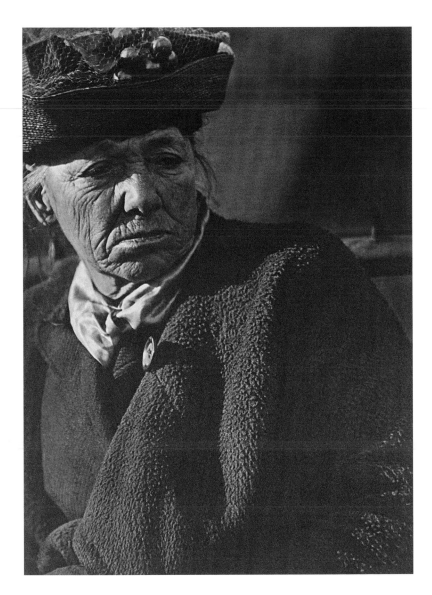

PAUL STRAND

American, 1890–1976
Portrait—New York, 1916
Platinum print
33.3 × 23.7 cm
(13⅛ × 9⁵⁄₁₆ in.)
89.XM.1.1

When Strand first visited Stieglitz in 1910, he had been listening to the advice of Lewis Hine, who was one of the most socially concerned photographers of the twentieth century. One of Strand's contributions to a new aesthetic was to bring together Hine's humanism with Stieglitz's formalism (see p. 306). This photograph shot in New York's Washington Square Park is less a portrait than an archetype of old age and urban survival. The woman has been photographed without her knowledge. The composition is off-center, with hard-edged light and an oblique viewpoint that establishes a sense of sculptural immobility. Strand turned to socially conscious themes in the 1930s and never returned to complete abstraction.

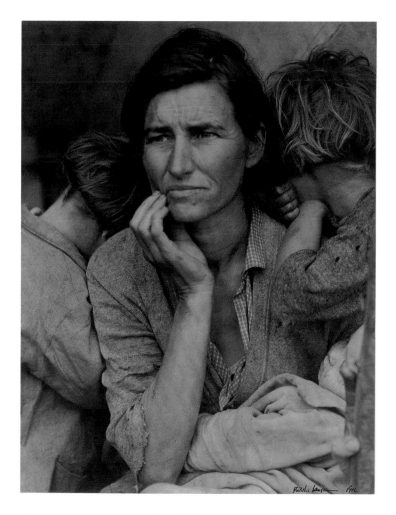

DOROTHEA LANGE

American, 1895–1965
Human Erosion in California (Migrant Mother), 1936
Gelatin silver print
34.1 × 26.8 cm
(13 7/16 × 10 9/16 in.)
98.XM.162

One of the most respected photographers of the New Deal era, Lange eloquently captured the desperation of poverty-stricken Americans during the Great Depression. At a pea-pickers' camp in the Cayuma valley in San Luis Obispo County, Lange photographed a woman of Cherokee descent from Oklahoma who was living with her husband and seven children, eking out a livelihood from the land. On the back of this print, Lange inscribed the following: "This family had just sold the tent from over their heads and the tires from their car to buy food.... They were living in an open field, [in] cold and rainy weather, in the hope of getting some work to do picking peas, along with hundreds of other families."

Lange's photographs were designed to effect social change and, in a modest way, they did. She subtitled this picture *Facing Starvation* and considered it part of a larger project on the subject of migrant labor that she called "Human Erosion in California."

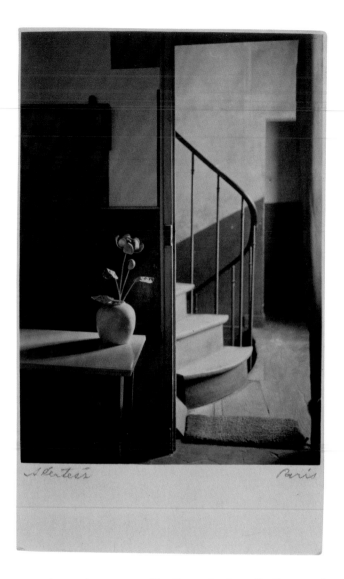

ANDRÉ KERTÉSZ

American (b. Hungary),
1894–1985
Chez Mondrian, 1926
Gelatin silver print
10.9 × 7.9 cm (4⁵⁄₁₆ × 3⅛ in.)
86.XM.706.10

The Hungarian-born Kertész once described himself as a "Naturalist-Surrealist." In his most characteristic photographs, an abiding interest in the prosaic aspects of life blends with a surrealistic perspective. His work is marked by an ability to surprise us by addressing familiar subjects in unusual ways. If the subject was a still life, Kertész chose his viewpoint deftly and occasionally made a subtle alteration to gain his desired effect. He described for a friend the shaping of this particular composition: "The door to [Mondrian's] staircase was always shut, but as I opened it in my mind's eye the two sights started to present themselves as two halves of an interesting image that I thought should be unified. I left the door open, but to get what I wanted I had to move a sofa."

AUGUST SANDER

German, 1876–1964
Frau Peter Abelen, Cologne,
1926
Gelatin silver print
22.9 × 16.4 cm (9 × 6⁷⁄₁₆ in.)
84.XM.498.9

Sander's photographs are enigmatic, simultaneously traditional and modern. He used a tripod-mounted plate camera when handheld cameras were attracting many photographers, and he usually posed his figures in an environment that revealed something about their life, a strategy appropriated from painting and professional portraiture. Sander was skilled at getting his subjects to project a sense of expectation and then arresting that moment. Dressed in stylish culottes, Frau Peter Abelen stands in a gallery surrounded by her husband's paintings. She is about to light the cigarette between her teeth with the match and striker she holds. The image projects a powerful sense of tense psychological reality. The woman is androgynous, and her expression falls somewhere between anticipation and anger. We do not know whether Sander accuses or praises her.

EDWARD WESTON

American, 1886–1958
Two Shells, May 1927
Gelatin silver print
24.1 × 18.4 cm (9½ × 7¼ in.)
88.XM.56

Tabletop still-life arrangements were a favorite subject for amateur photographers, but very few achieved the powerful form and masterful control of technique that Weston did. Bored with portraiture, he experimented with the symbolic and formal potential of found objects. Here, by nesting one chambered nautilus shell inside another, he created a powerful form not seen in nature. Viewing his subject close-up from below, with a camera designed for eight-by-ten-inch sheets of film, Weston was challenged to keep all the visual elements in sharp focus. He wrote: "It is this very combination of the physical and spiritual in a shell . . . which makes it such an important abstract of life."

**ALBERT RENGER-
PATZSCH**

German, 1897–1966
*Flatirons for Shoe
Manufacture*, circa 1926
Gelatin silver print
22.9 × 16.8 cm (9 × 6⅝ in.)
84.XM.138.1

In choosing such unexpected subjects as industrial artifacts, Renger-Patzsch risked having their meaning misunderstood, for he was expressing himself as a poet, not as a reporter. Like the lyrical poet, the photographer possesses an acute and exhilarating respect for the eminence and reality of the object; the new object that has been created in the form of a photograph has no other reason to exist than the pleasure it brings. Poet-photographers make up their own language from picture to picture and keep us interested in spare and unusual compositions by not photographing in the ways we expect. The poetic photograph has the power—sometimes brutally direct—to create deep and unnameable feelings about commonplace objects.

EUGÈNE ATGET

French, 1857–1927
Staircase, Montmartre, 1921
Albumen silver print
21.8 × 17.8 cm (8⁹/₁₆ × 7 in.)
90.XM.124.1

Atget created this study of a group of apartments in 1921, the same year Berenice Abbott first saw one of his photographs and became the most devoted apostle of his art. Trees were a favorite Atget subject, and this elegant and well-proportioned specimen stands in definite contrast to another favorite subject, architecture. In this block we see neither noble materials nor heroic design but rather journeyman production that attempts to reconcile utility and beauty. The eye is teased by the elegance of the leafless tree that dominates the picture; it is intrigued by the askew chimney pipes and by an agglomeration of textures ranging from mildew to decaying wood and from decomposing plaster to scarred stone. The tree by comparison seems ageless, like the sculpture at its base.

WALKER EVANS

American, 1903–1975
*License Photo Studio,
New York*, 1934
Gelatin silver print
18.3 × 14.4 cm
(7³⁄₁₆ × 5¹¹⁄₁₆ in.)
84.XM.956.456

Best known for his images of Depression-era rural life, Evans was a pivotal figure in American documentary-style photography. His seminal work of 1938, *American Photographs*, consists of eighty-seven images of people, architecture, and vernacular art made over the course of a decade in the eastern United States and Cuba. The book is ostensibly a proclamation of American culture, but its underlying theme is photography itself. Evans presented the photographs in a sequence intended to be "read." This view of a run-down photo studio is the opening image. With it, Evans set the tone for the entire book. The harsh frontal view, unidealized subject, and fascination with commercial signs recur throughout.

MANUEL ALVAREZ BRAVO

Mexican, 1902–2002
*The Good Reputation
Sleeping 1, 2, 3*, 1938
Gelatin silver prints
First: 8.8 × 19 cm
(3 7/16 × 7 1/2 in.)
Second and third:
8.9 × 18.9 cm (3 1/2 × 7 7/16 in.)
92.XM.23.37

Alvarez Bravo created this version of the work he called *La buena fama durmiendo*—the only one to survive in its original three-part format—at the suggestion of André Breton. Breton was in Mexico City in 1939 to help organize an exhibition of Surrealist art at the Galería de Arte Mexicano. Alvarez Bravo imagined his triptych as the cover of the exhibition catalogue. The negatives were made on the roof of the national arts school. As the photographer recalled on a visit to Los Angeles in 1992, the bandages were supplied by a physician friend, and the symbolic cactus pears were procured from a local outdoor market by the school porter. Posed in bright sunlight in a position of unnatural vulnerability, the model was dressed in a costume that focuses our attention on the tufts of pubic hair, which caused censors to declare the work unacceptable for reproduction on the cover.

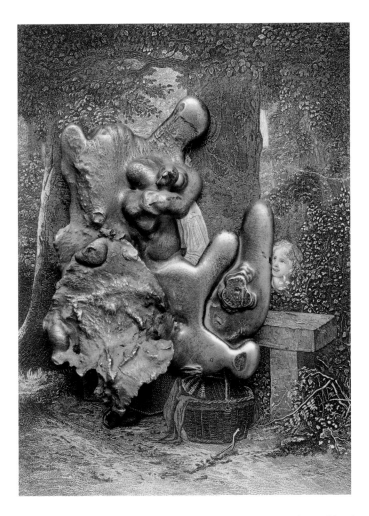

FREDERICK SOMMER

American, b. Italy,
1905–1999
*Virgin and Child
with Saint Anne and
the Infant Saint John*, 1966
Gelatin silver print
24 × 17.6 cm
(9 7/16 × 6 15/16 in.)
94.XM.37.39

Working in a singular style informed by the contra-
dictory sources of Dada and Surrealism and West
Coast naturalism, Sommer's approach to photography
is encapsulated in his statement: "If you can really
understand why you take a photograph, you don't
do it. You do it for the margin of the unstated . . . you
hope to be able to come back to it—and find a wider
statement." Sommer has made an art of collecting
refuse that he has carefully selected and then studied
for years, sometimes even decades, before finding
a place for it in his art. The peculiarly formed lump
of metal that appears in his *Virgin and Child* was once
part of the melted remains of a burned-out, wrecked
automobile. By combining it with a Victorian book
illustration, Sommer invites us to recall Leonardo
da Vinci's painting of the same name. If the word
imagination means "one thing seen in the form of
another," this is a perfect example of the photogra-
pher's imaginative process.

Index of Makers